Caves of God

The Monastic Environment of
Byzantine Cappadocia

There is scarcely a place in the entire world that can boast of as many churches
as there are churches in Cappadocia, through which the name of the Lord is glorified.

Gregory of Nyssa
Letters, VI (Migne, *PG,* 46, col. 1012)

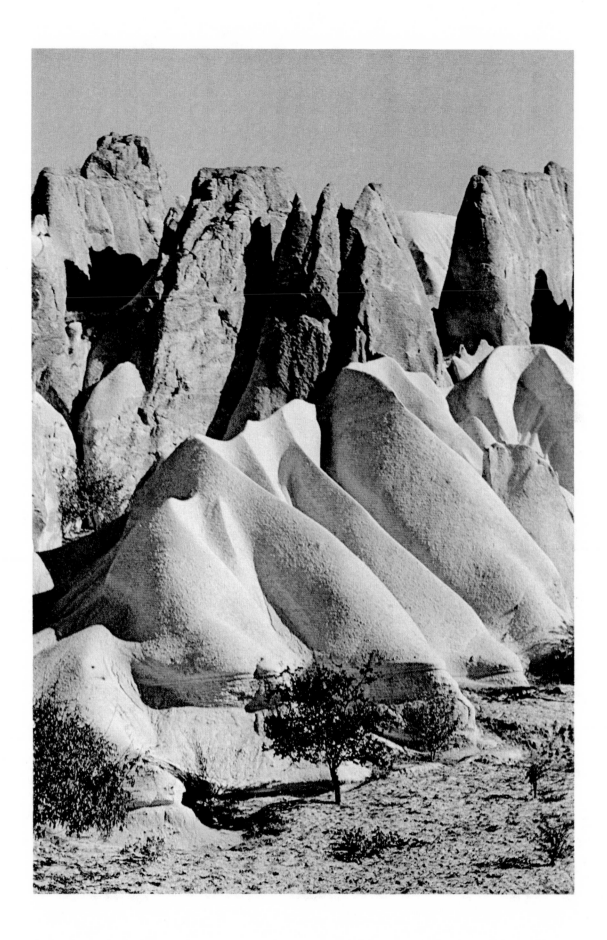

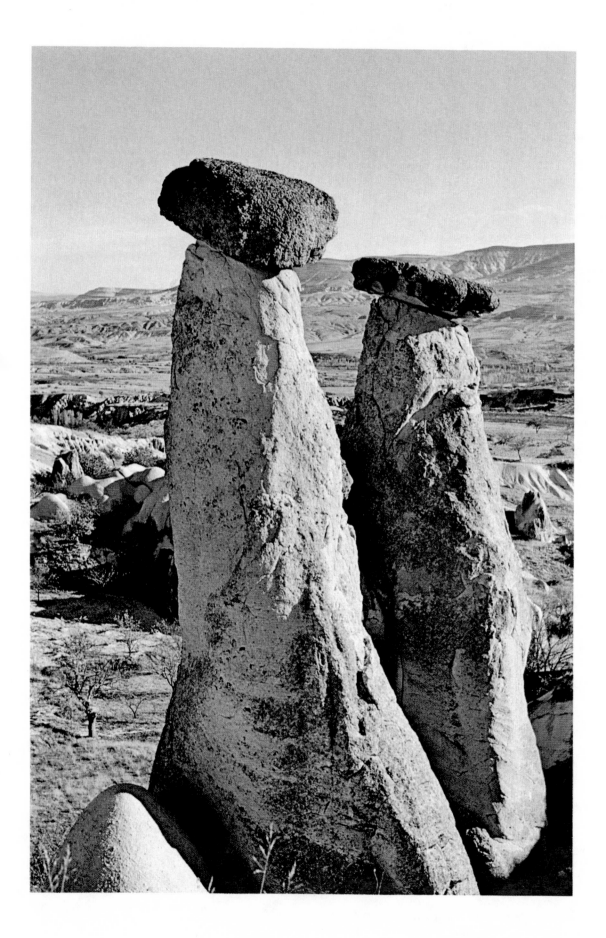

Caves of God

The Monastic Environment of
Byzantine Cappadocia

Spiro Kostof

drawings by
Malcolm C. Carpenter

The MIT Press Cambridge, Massachusetts, and London, England

MIT Press

0262610299

KOSTOF
CAVES OF GOD

This book was set in Fototronic Zenith (Optima)
by York Graphic Services, Inc.
printed on Oxford Sheerwhite Opaque
by The Halliday Lithograph Corp.
and bound by The Halliday Lithograph Corp.
in the United States of America.
Color inserts printed by Fabag and Druckerei, Switzerland.

Plates 21, 22, 23, 28, 29, 32, 34, 39, 44 from *Byzantine Wall Paintings in Asia Minor,* by Marcell Restle. New York: New York Graphic Society, 1968. Originally published *Byzantinische Wandmalerei in Kleinasien.* Recklinghausen: Verlag Aurel Bongers, 1967. Plates 335, 334, 409, 505, 488, 196, 229, 501, 440. Reprinted with permission.

Library of Congress Cataloging in Publication Data

Kostof, Spiro K.
 Caves of God.

 Bibliography: p.
 1. Cave churches—Cappadocia. 2. Mural painting and decoration, Byzantine—Cappadocia. 3. Christian art and symbolism. I. Title.
NA5869.C3K6 726'.5'09565 73-155322
ISBN 0-262-11042-3

To my Turkish friends and Greek relatives

Contents

Illustrations

Plates

Preface

There is perhaps no site more arresting for the traveler in the Middle East than the strange rock-scape of Cappadocia in central Turkey. Its beauty is not so much natural as phantasmagoric, an irreal and incredible vision of shapes and colors that often draws forth the epithet "lunar" to describe it. One is hard put to think of it in human terms at first sight; against one's knowledge, the eye refuses to see in it a setting for complicated historical circumstance, which it has been. The drama is inevitably visual. It is inherent in the daedalic configuration of rock and the eerie expanse of a sere, outlandish view. Only secondarily does one register the fact that this seemingly conjured environment is inhabited by actual men, that it has always been so peopled in its long past. Their drama is memorably human, real, and credible. It involves much distant history and renowned names. It involves, above all, the protracted struggle of Christianity for survival, from the time of St. Paul down to the near-present.

The evidence is in the heart of the unlikely land, rockbound. Explore the prickly stretch of cones and the smooth folds and you will find hundreds of monasteries and churches buried in them, where Christian communities lived and prayed for the greater part of two millennia. This excavated architecture is as specific in historical content as the panorama itself is unfamiliar externally, a design of hauntingly unique bizarrerie. But the two are of course inextricable. It would be unjust, not to say impossible, to speak of the monuments without yielding to the extraordinary beauty of the setting: and equally unjust if one were to be inordinately absorbed by the setting which, without the manmade environment of faith that informs it, would become merely another phenomenon of nature like the rocks of Utah or Death Valley.

This book is about Christian Cappadocia, the land and its hidden monuments. It is primarily an effort of synthesis and not a contribution to Anatolian archaeology. With minor exceptions, it presents no unpublished buildings or paintings. Its purpose is twofold: to provide, for the interested layman, a readable introduction to the rockcut architecture of Cappadocia and its painted decoration; and for the student of Byzantine art, to present a critical review of the current state of scholarship on the subject and a reordering of its results.

Our first intention is obvious. There exists at the moment no detailed account of the region and its monuments for the general English-speaking reader. (M. Restle's *Byzantine Wall Painting in Asia Minor,* published in 1967, is broader in geographical scope than the present volume, inasmuch as it covers territory beyond Cappadocia, and it is much more limited in its subject

since its concern is only with paintings and, within that, only with style.) The want is the more serious today than it might have been ten or even five years ago, when a visit to Cappadocia would have seemed improbable to all but the most hardy of tourists. This is not so any longer. Pictures in popular books and magazines have recently been exposing the visual lure of the rockscape. The would-be tourist is given reassuring nudges by the travel section of newspapers. And the local authorities have been duly responding to the challenge with new roads and hotels. One should expect the trickle of visitors to swell in the near future, into a stream.

It is hoped that this book might serve as scholarly enticement to go, and that it might prove useful to the decided visitor who plans to have more than a brief passing involvement with the region. Readers who approach the book for these purposes are cautioned, however, not to expect a conventional guide. I have tried to evoke for them a sense for the physical setting, and to discuss the buildings and painting programs in the total context of their creation. What was the nature of monasticism in Cappadocia, and what was the historical background of its existence? Who were the builders, the artists, and their patrons? I have discussed in detail building types and painting programs, their sources and their meaning. In all this, I have aimed at keeping the argument straightforward and not excessively technical, without eviscerating it or veiling the complexities of the scholarly questions involved. The Glossary should assist with the handful of specialized terms that are unavoidable.

But for the art historian too the book may not be unwelcome. Since 1950, when the Turkish hinterland became relatively easy of access, much has been uncovered and studied of the Byzantine environment of Asia Minor. As a result Father Guillaume de Jerphanion's magisterial work on the rockcut churches of Cappadocia has been significantly revised. The monuments he investigated several decades ago with such painstaking and conscionable scholarship are now receiving fresher documentation. At the same time, hitherto unknown churches are coming to light yearly. They furnish material that cannot but reshape the general picture of Byzantine archaeology and art history in Cappadocia. The steady growth of research in the last decade can be gauged by the Bibliography.

And discovery is by no means confined to this province alone of Asia Minor. The recent activity of the Turkish authorities, and of foreign scholarly organizations like the British Institute of Archaeology at Ankara, has been abundantly fruitful in the surveying and publishing of

Byzantine antiquities in adjacent areas, in particular the region of the Pontus on the Black Sea and Lycia and Cilicia in the south. This new material bears upon Cappadocia, and is bound to modify our notions about the contributing sources in its architecture and art.

For every new church regained two or more previously known ones are, alas, disappearing. The destruction comes in part through natural causes, but more often the instrument is human. Several churches of Jerphanion's day have since caved in; they include Chapel 6 at Göreme (Cat. no. 19) and two chapels in the complex known as Belli Kilise at Soğanlĭ Dere (Cat. no. 24). Several others have been mutilated beyond recovery by their current owners. The paintings of Ballĭk Kilise (Cat. no. 28) were gone as of 1958; so were the paintings of the main nave of Canavar Kilise (Cat. no. 66). But another class of destroyers, thieves these of painted fragments, is rarely native. Ayvalĭ Kilise, not far from Göreme (Cat. no. 16), was first published in 1962: it of the Flight into Egypt were removed in 1963–1964; some other fragments, in 1968.

It is in view of such fluidity, both physical and scholarly, that it has seemed fit to attempt a critical summary of our present knowledge on the monastic environment of Byzantine Cappadocia and a reassessment of its implication. The section on the architecture (Part 2) is intended to correct the disproportionate attention devoted to it by Cappadocian scholars. Since almost all of them have been art historians rather than architectural historians, their concern has been, overwhelmingly, with the mural decoration; a look at the Bibliography will attest to that. Much of the discussion in Part 2 is therefore new, or at least fresh. In Part 3, which concentrates on the paintings, I have tried to bring together the more enduring elements in the work of my predecessors, eschewing inbred controversies of detail. Major issues, of influence and chronology, have been clarified and revised, but in a subject as actively studied as this, claim to definitive solutions would be foolish. I hope the text makes it clear where I diverge from past scholarship and what I propose as corrective. The Catalogue is designed to set straight the somewhat tangled nomenclature of the churches; to gather in one place the references to each specific monument; and to minimize the reliance upon footnotes.

I am grateful, first of all, to Malcolm C. Carpenter, for his patient collaboration; his drawings have been a major aid to my work. It should be noted that our aim in preparing them was less directed toward archaeological precision than it was toward helping the reader visualize descriptive and analytical passages in Part 2. John Burchard and Anthony Cutler have read through

one version of the manuscript and offered helpful suggestions. I value their encouragement. Two of my colleagues at the University of California, Harold Stump and David Gebhard, were most generous with their photographs of Cappadocia, and permitted me to use some of them. To these friends, and to Melvin Charney at the University of Montreal and Carol Baldwin at Berkeley, who also helped with the illustration of the book, my thanks. During much of the long preparation of the manuscript, Erika Dreisch-Chaine was a dedicated research assistant; my warmest appreciation goes to her, and also to Joan Carpenter and Brooke Horgan. Sunday Von Drasek prepared the typescript.

S. K.
Berkeley, California

Caves of God

The Monastic Environment of
Byzantine Cappadocia

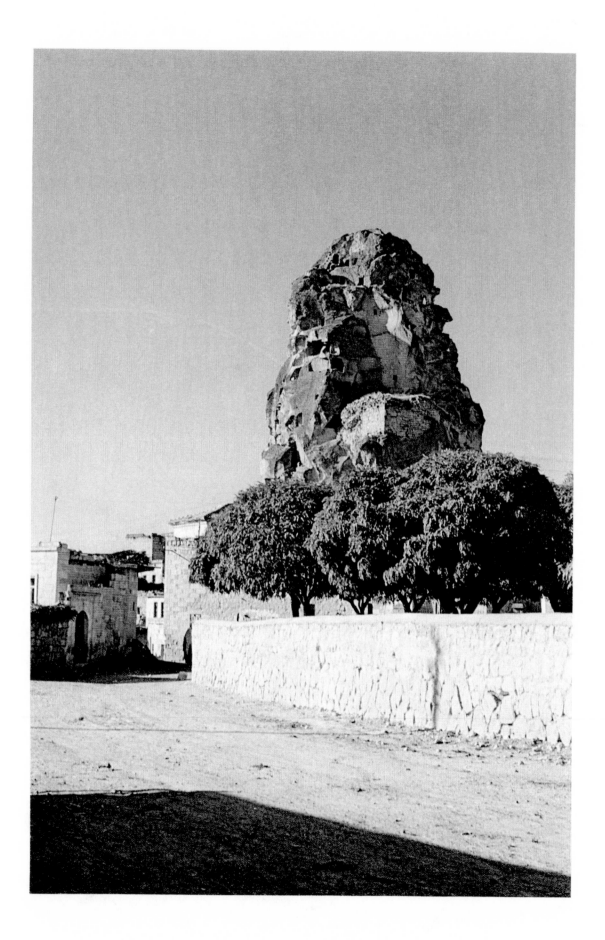

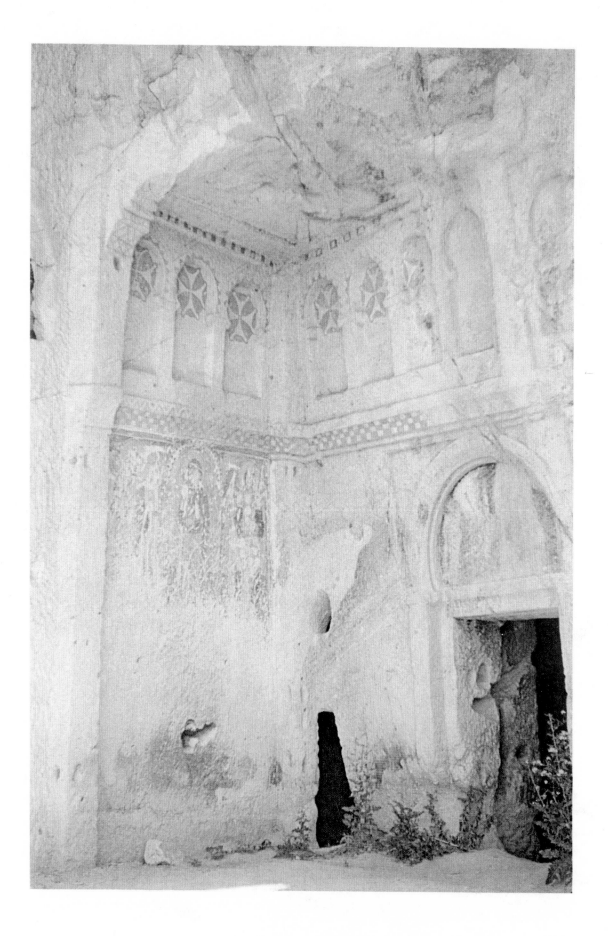

1
The Setting

The central part of Asia Minor, or Anatolia, has been called a "little Iran." It is a rocky plateau, naked and mournful, and like Iran it reaches up at its extremities to the verdant mountain chains with which it is ringed. The contrast of barren tableland and wooded mountain is, if anything, more poignant in Anatolia. For here, on three sides of the land beyond the mountain range, lies the openness of the sea whose long stretch of shore has bustled for centuries with urban activity. The fertile valleys of the Aegean coast to the west, the forest-clad slopes of the Black Sea and the Mediterranean, have drawn with steady rhythm colonists from abroad and invaders from the hinterland. They came for the mild climate and the freedom of the open waters and the great gift of the seaboard, trade. They settled down and prospered.

But prosperity comes hard at all times in the land bowl of Anatolia. Cities are exceptional. Life tends to the nomadic. It fights against the odds of a difficult soil, of inclement and capricious seasons, and the passage and movement of armies and peoples. Today as two thousand years ago, the cornfields are at the mercy of timely rains. But not uncommonly it will be torrential downpours instead, which build quickly into floods disastrous for the crops. These fast and useless waters are a mockery to the great plains which bake and crack under the blistering heat of the long summer months. They leave behind them swamps and malaria.

And sometimes the rains might not come at all. Nowadays relief from the government is relatively prompt, but this is recent. The drought of 1873 is said to have killed about 150,000 people. And as far back as there are documents the incident of drought is recorded. St. Basil the Great, bishop of Caesarea and the most renowned son of central Anatolia, attributed this costly unpredictability of the seasons to God's justice on a sinful people.[1] But even he lost patience at times when droughts, like the one of 368, ravaged his fold, or again when severe winters cut him off from neighboring districts and impeded his trouble-shooting expeditions. "Shall I give thanks," he would say, "even when frozen with the cold?"[2]

The land for the most part is flat. A few solitary mountains stand sheer on the monotonous expanse of the plains. They are naked but for dry aromatic scrub: wormwood, wild lavender. Their foothills comprise often fantastically shaped rock formations, accidents of volcanic action and the wear of the elements. These isolated mountains are the only solid reality on the dreary horizon, especially in the summer, when mirage effects are inescapable as one approaches, say, from the west, across the long stretches of salt deposits in the Plain of Konya

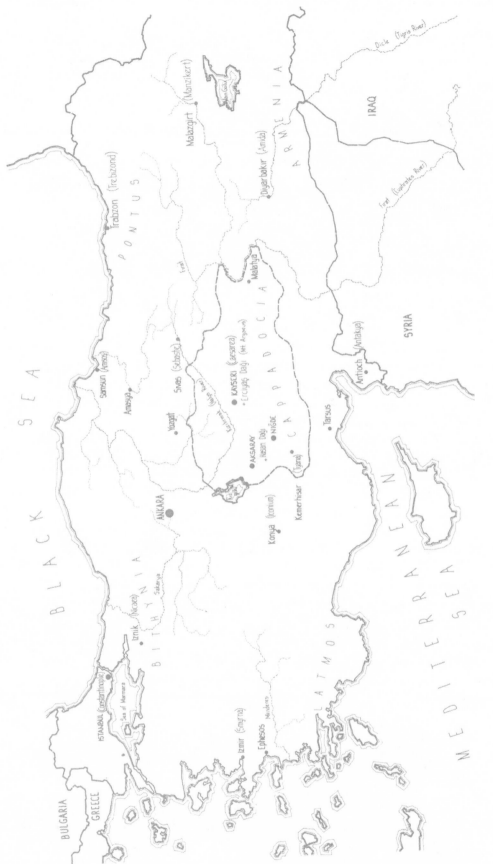

BULGARIA

GREECE

BLACK SEA

PONTUS

Trabzon (Trebizond)

Samsun (Amisos)

Amasya

Yozgat

Sivas (Sebaste)

KAYSERI (Caesarea)
• Erciyaş Dağı (Mt Argaeus)

CAPPADOCIA

AKSARAY
Hasan Dağı

NIĞDE

Kemerhisar

Konya (Ikonium)

ANKARA

BITHYNIA

İznik (Nicaea)

Sakarya

ISTANBUL (Constantinople)

Sea of Marmara

İzmir (Smyrna)

Ephesos

Menderes

LATMOS

MEDITERRANEAN SEA

Tarsus

Antioch (Antakya)

SYRIA

Malatya

Diyarbakır (Amida)

Malazgirt (Manzikert)

ARMENIA

IRAQ

Dicle (Tigris River)

Fırat (Euphrates River)

Fırat

north

0 100 Miles

(Fig.1). An occasional town may take shelter at the outskirts of one such snowcapped mountain, as does Kayseri (Caesarea) to the north of Erciyas Daği, the ancient Mount Argaeus, the tallest in central Anatolia. But by and large it is small, sparse villages, unsheltered from the elements, sitting precariously at the side of a stream in the flatland or on the path of some roadway of the past.

This is then the beginning of the continent of Asia, just beyond the Aegean coast which represents the furthest reach of Europe. "It is Asia," as one of its greatest travelers, Gertrude L. Bell, has written, "with all its vastness, with all its brutal disregard for life and comfort and the amenities of existence; it is the ancient East, returned, after so many millenniums of human endeavour, to its natural desolation."[3]

Cappadocia, with which we are here concerned, lies on the eastern half of the Anatolian plateau. Its area formed one of the Roman provinces of Asia Minor: it has no administrative meaning in present-day Turkey. The name goes further back than Roman government of the province, which began at A.D. 17. It is at least as old as Herodotus, who used it first,[4] and may be the Greek version of Katpatuka, which is what the region was called by the Persians when it became a satrapy of theirs a century or so before Herodotus' time. And before the Persians, by whatever name it may have been called, the region had been occupied by Medes, by Assyrians, and earliest of all by Hittites, an Indo-European people who arrived in Asia Minor about 2000 B.C. At sites like Alişar and Alacahöyük, settlements precede even the advent of the Hittites. Like every other corner of Asia Minor, Cappadocia has borne a long unbroken chain of occupants who moved in, established states, and saw them invaded and shattered.

Early Christianity

Our interest is in the more recent, Christian phase of Cappadocia's history. This began here, as throughout the Roman empire, with an invasion of faith first, and more than two centuries of struggling were necessary before the faith could be identified with the State. Christianity came early to Cappadocia. Most probably it traveled along a line which led from Syrian Antioch through the Cilician Gates, the only negotiable pass in the Taurus chain, and into Asia Minor (Fig. 1). The main route was across Lycaonia, the province to the west of Cappadocia, to Ephesos; and thence across the waters to Corinth and Rome. But a subsidiary route followed from the Cilician Gates to Tyana (the modern Kemerhisar) and Caesarea, the two chief cities of Cappadocia, and passed on to Amisos (Samsun) in the Pontus, which was then the great harbor of the Black Sea.[5]

We know that on his so-called "third journey" St. Paul traveled through Cappadocia, probably reaching Ancyra via Tyana, and that for a time he was held prisoner in Caesarea before being shipped off to Rome. An Anatolian himself, from Tarsus on the seaboard side of the Taurus mountains, he was carrying the message in Greek that for once and always would establish that Christianity was not to be an exclusive provincial religion of the Palestinian desert but a universal faith, open to all who will hear of it. "There is neither Jew nor Greek . . . for ye are all one in Christ Jesus." (Galatians 3:28) And: "Circumcision is nothing, and uncircumcision is nothing, but the keeping of the commandments of God." (1 Corinthians 7:19)—passages well known and always worth quoting from the man who, in the words of Wilamowicz, unconsciously completed the legacy of Alexander the Great in uniting the known world by one strong and binding idea.

From the start the Word seems to have found sympathetic audiences in the terse Cappadocian land. The First Letter of Peter already mentions the Christian community here, together with those of the Pontus to the north and Bithynia and Galatia to the northwest. (1 Peter 1:1) In the second century A.D. there were reputed to be Christians in Legion XII of the Roman army, stationed at Melitene.[6] About A.D. 200 a certain bishop Alexander traveled to Jerusalem from his see in Cappadocia.[7] And very soon afterwards the province became a center of Christian theology. Yearly synods were organized. From here the Christianization of Armenia to the east was undertaken. Even Ulfila, the apostle of the Goths, was said to have originated in Cappadocia.[8] Persecutions took their toll and created local martyrs: Hyacinthus, a *cubicularius* of the

emperor Trajan, who was martyred at Caesarea; Kyrillos and Merkurios "the Scythian"; Eustratios; Auxentios; the sisters Chreste and Kalliste; the three sons of Neonilla; and the Forty Martyrs of Sebaste.[9]

It is perhaps not surprising that Christianity should score here an early success. As a religion that appealed to the poor it could find no more propitious footing. Cappadocia lacked a great urban tradition. The Hellenism of the coast arrived late, and when it did it had no lasting effect. Strabo reported that at his time (the second century A.D.) there were only two cities: Tyana, and Caesarea, which was the seat of government.[10] Instead, there were numerous forts where the landed gentry lived. In the days of the later Roman Empire a large portion of Cappadocia consisted of imperial estates, termed the *divina domus* and in the charge of a *comes divinarum domorum*. The land has some mineral resources, like crystal and onyx, and a highly prized white translucent stone called *phengis* which was discovered in the reign of Nero and used to rebuild the temple of Fortune within his Golden House in Rome.[11] But for the most part it was the production of grain that occupied the gentry's attention, some cultivation of vine, and foremost of all the raising of the horses for which Cappadocia had always been renowned. The rich who owned the land and the livestock were very rich; the poor who worked for them very poor. St. Basil, of a notable family himself, could never say enough against the landowner and his luxury and greed. His anger swells at the hoarding of grain, at the arrogant display of wealth, the clothes and jewelry, the fancy carriages. He waxes pathetic when he takes on to describe the lot of the poor reduced by the existing social imbalance to a condition almost of slavery. And he pleads insistently for sharing. Like many a moralist before and since, he argues for just distribution of material things and the social contentment that will result from this. "For if each one, after having taken from his wealth whatever would satisfy his personal needs, left what was superfluous to him who lacks every necessity, there would be neither rich nor poor."[12]

Now for some decades past a new movement, outside Church and State, was working to realize such communal equality. Monasticism was the child of the poor and pious East. Renunciation of the worldly way had begun, at first, as a matter of individual conviction. Since the days of St. Anthony, who fled civilization for the sobering wilderness of the Red Sea desert, hundreds of hermits had sought similar loneliness and self-inflicted tribulation. The eremitical ideal of Christianity, once started, never died out. But alongside it a trend toward organized

pietism was fast taking root. In the monastic centers of Egypt and the Holy Land groups of men and women came together to practice the teachings of the Scriptures for a life of basic necessities and of virtuous retirement from the distractions of citified life. St. Basil took note. He did try something of a hermit's isolation at one point in his life, secluding himself for a spell in a Pontic retreat by the river Iris (Yeşilĭrmak). But having traveled for nearly two years to observe firsthand the functioning of monastic communities, he grew convinced that "no one man is sufficient in himself to receive the gifts of the Spirit"; that the common life where "each man's gift becomes the common property of his fellows" was the only selfless way. The Rule he founded on his return was destined to become central to Eastern monasticism.[13] It spread fast in his own land and beyond, and later was transplanted to the West by exerting a lasting influence on the monastic thought of St. Benedict.

The Land

The hermit and monk in Cappadocia did not have far to travel to get away from the worldly scene. Nowhere on "the great earth-sea" of the Anatolian plateau is the desolation of nature more pronounced. To the east, starkly dominant, stands Erciyas with its prickly pinnacles of red porphyritic rock. From its summit, so antiquity liked to believe, one could glimpse on a fine day both the Mediterranean and the Black Sea. Between this anchor of volcanic rock and another, Hasan Dağı to the southwest, the plain stretches inexorably—caked in the summer, muddy and slippery in the rain seasons, and in the winter frozen solid for several months under a sheet of ice and snow. Streams, briefly exuberant with the thaw, peter out before long in marshes or the dry land. Only Kīzīlīrmak, the Halys river of antiquity, passes through the province and beyond. It winds through stripped countryside, now smooth earth, now escarpments of red and green rock. Its lazy loop, murky and unreliable for most of the year, is crossed here and there by a few picturesque bridges (Pl. 1).

But there is much more to the Cappadocian landscape. And this is unsuspected. One discovers upon crossing the river that the south bank and beyond is a vast rock sculpture of unlikely complication (Pl. 2). Much of the tableland here consists of tuff, a soft porous rock that readily yields to running waters. And Kīzīlīrmak and its tributaries have been at work for centuries, since the land was formed by volcanic action in the late Tertiary period, cutting deep valleys, carving out fortlike crags above them, splitting and splintering the tuff into hundreds of small fragments which are then turned and polished into startling shapes (Pl. 3). Often as far as the eye can see there stretches the complex and calculated pattern of rock folds, its rhythm slack for a spell, then forceful and irregular like a tossed sea. The colors are shifty, unchartable. Around Ürgüp the dominant hue is red, but Nevşehir is white. These blaze or blur under the sun, with every cleft and recess catching streaks or pools of black, blue, green. Then the hour shifts: the scene is bathed in a mild pink. Lengthening, muted shadows change with them the associative powers of the rock formations. What seemed like elaborately folded drapery may turn out to be the giant paw of an unknown beast after all. And the water and wind will continue their obsessive carving until each toe is worked around, disengaged and rounded, so that a series of cones will shape up, each rising sharply to a point (Pl. 4).

The cone is the most frequent form in Cappadocia's rockscape. A field of hundreds of them will suddenly open up to view as one gains the top of a ridge. They continue indefinitely, their

Plate 1
Cappadocian landscape,
near Avcīlar (Maçan).
[Photo Carol Baldwin]

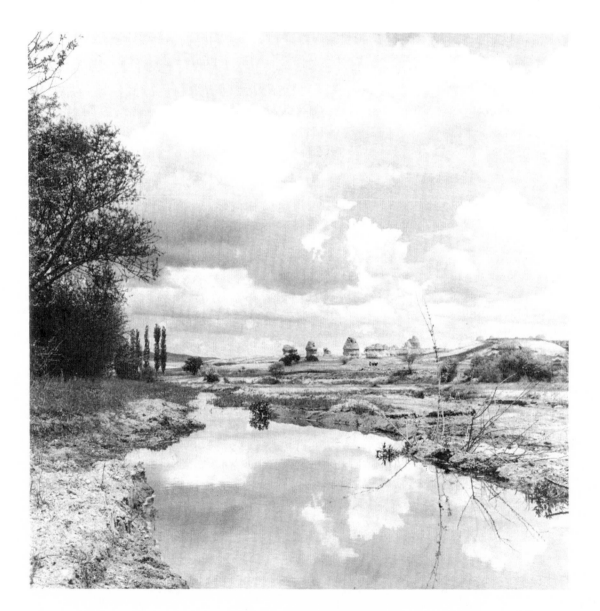

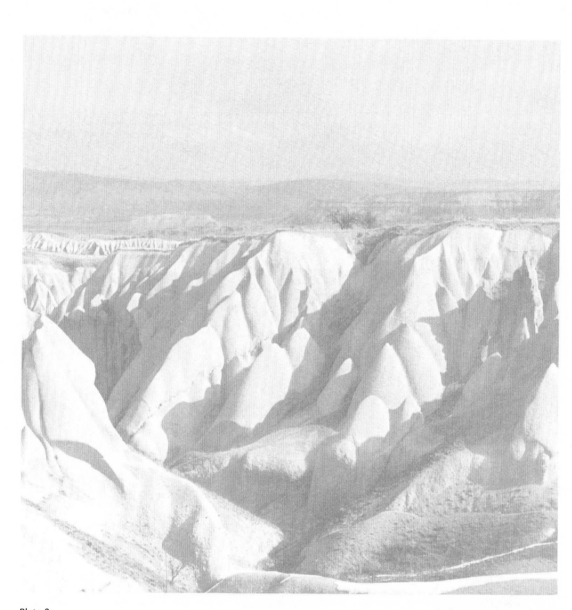

Plate 2
Cappadocian rockscape,
near Göreme.
[Photo Harold Stump]

Following pages
Plate 3
Ürgüp, rockscape.
[Photo Harold Stump]

Plate 4
Göreme, excavated rock-
cones.
[Photo Harold Stump]

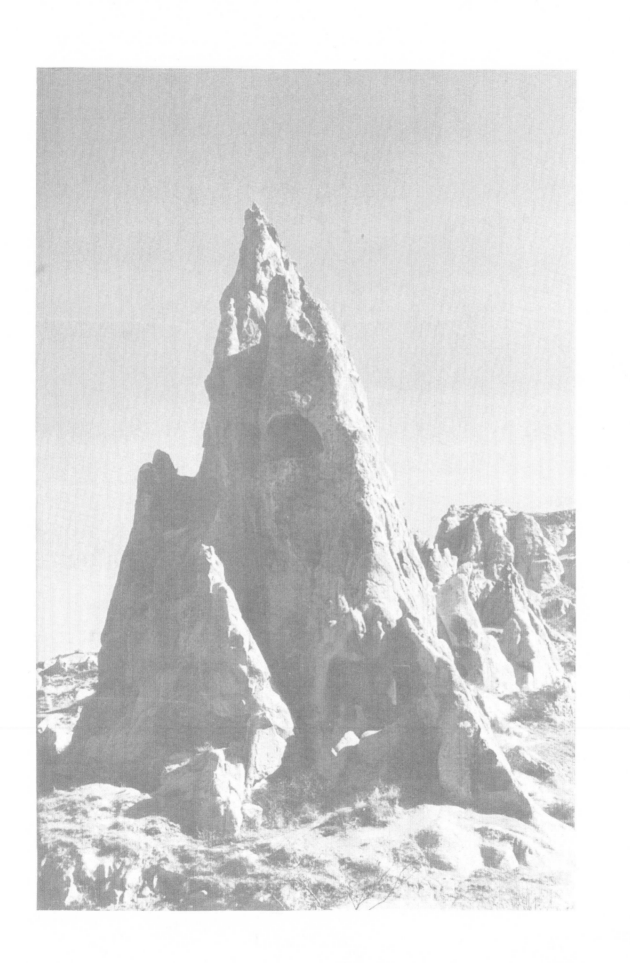

Plate 6
Ortahisar, rock formations
called "fairy chimneys."
[Photo Harold Stump]

Plate 5
Avcīlar (Maçan), cones.
[Photo Harold Stump]

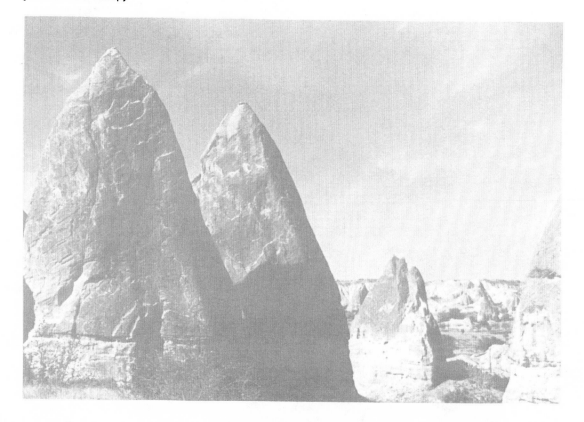

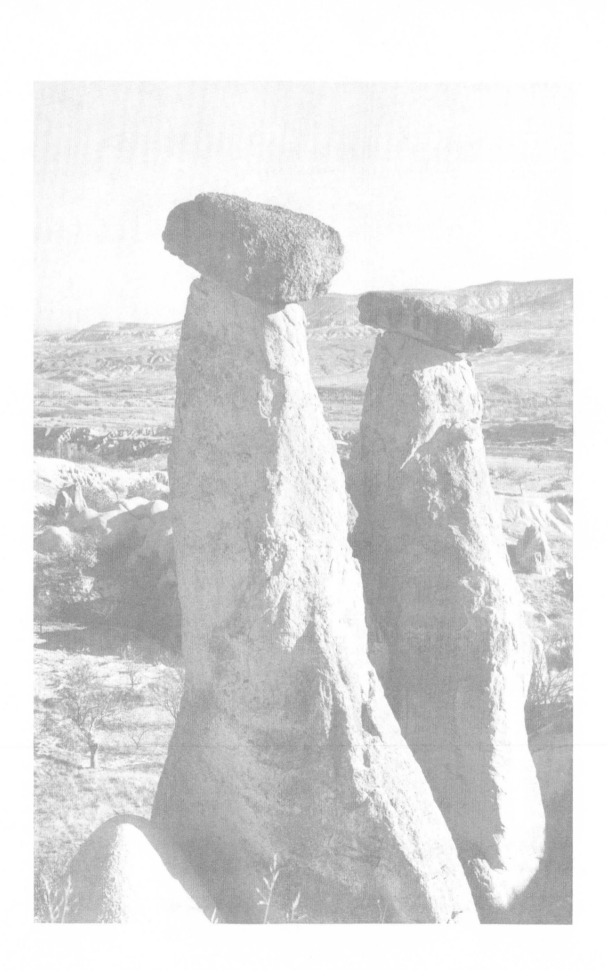

Plate 7
Göreme, close-up of
rockscape.
[Photo Harold Stump]

shape echoed by the flat, black shadows they cast. Their bases touch—or miss barely. At other times there will be two or three lone ones, or simply one cone on a level stretch of land, like an unexpected tent in the wilderness. At Maçan (Avcīlar) the thick bed of tuff has been so deeply undercut that a group of fat sturdy cones, the tallest among them about one hundred feet, stands out regularly on the horizon, amply spaced, and topped each one by a cap of hard rock, a bit of basalt, which has resisted the elements longer than its surroundings (Pl. 5). The caps stay put as the cones dwindle. The base is vulnerable, and now and again the cone will be cut sharply and made into a monumental slab like a manmade obelisk. Or it will be evenly and roundly eaten away as though thrown and thinned on a potter's wheel until nothing is left of it but an elegant upright pipe form with a rakish cap tentatively balanced at the summit (Pl. 6).

The peasants now call these *peri bacalarī,* fairy chimneys. They are inhabited by spirits which must not be disturbed. Many myths in the region of Ürgüp attest to the harm that might come from them if loosely treated. There is in any case nothing to be done when one of the fairies, as happens from time to time, falls in love with a young man of Ürgüp and decides to take him. Like the shapes of the rocks so too their legendmaking powers seem limitless. They become the visual source for touching or ribald fantasy. They are named and renamed. Here is Three Towers, Midtower, the Valley of Swords: Üçhisar, Ortahisar, Kīlīçlar. It is what children else-where depend on cloud formations to supply. But those images are fleeting: they move along and are dissipated within minutes before you could decide to call them camels or weasels. These stay. Or rather they change slowly, so that the nicknames of one generation may lose some of their warrant in the next, but are retained from habit (Pl. 7).

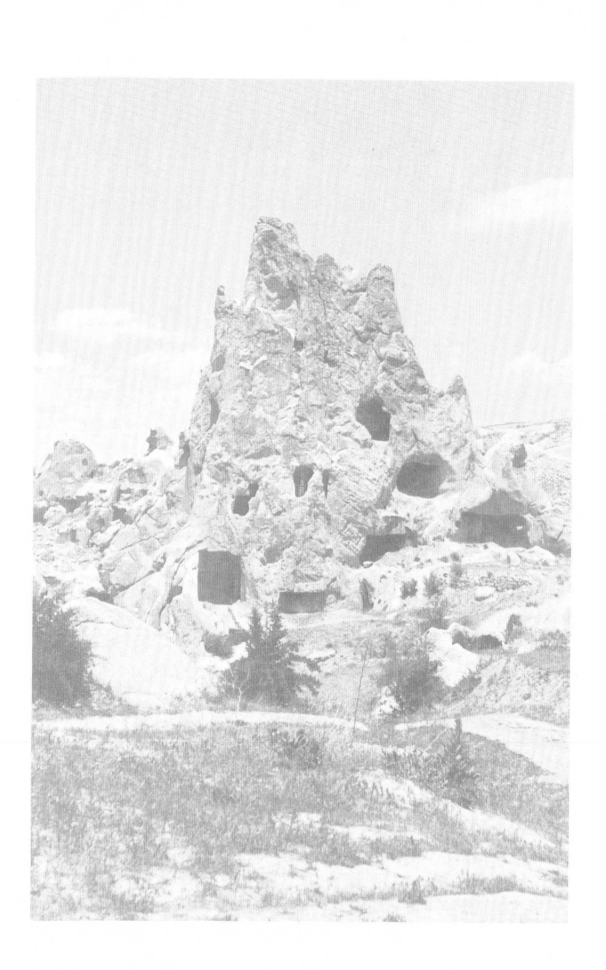

The Architecture

Not the least incentive to legendmaking is the knowledge that the cones and pleats of stone have from an early time been used for shelter, burial, and sanctuary. The tuff is easy to carve. As water and wind freed the larger shapes from sheets as thick as 4500 feet at places, so human hands burrowed in for small protective hollows to serve as homes for the living and the dead, and to ensconce divinity. The practice of scooping out an environment from natural features is a primeval one. At its simplest, advantage is taken of hollows in the earth like natural caves; but often too, and even in the most advanced of cultures, rural folk communities will make these hollows by cutting into natural matter usable shapes, mostly hidden from view, which are the exact opposite of much architecture as we have come to know it. They stress not *constructed form,* built up in defiance of the law of gravity, but rather form that is dug, i.e., created with interior space as the main objective. Columns and vaults, when they exist, are no more than structural symbols, liberated from natural matter in the same way a sculptor liberates the human form from a slab of limestone or marble. To speak of the columns as "holding up" entablatures, or of the vaults as "resting" on walls, is only to demonstrate the tenacity of the traditional view of architecture which centers on burdens and supports (Pl. 8).

Instances of this sculptured architecture, so to call it, are numerous, and the practice of making it universal. Written sources record excavated environments that we have lost. Agatharchides, a Greek geographer of the third century B.C., spoke of the rock dwellers of the Red Sea; Herodotus, of Ethiopia; and Xenophon, of Armenia.[14] In the vision of Obadiah the Lord admonishes the land of Edom, "thou that dwellest in the clefts of the rock, whose habitation is high." (Obadiah 3) And the Koran, in one of its several mentions of the wicked city of Thamoud, refers to its people as those "who hewed out their dwellings among the rocks of the valley." (89:9)[15] But we have, of course, also actual remains. Rock tombs abound in the Near East. Those of Petra in the south of Jordan are famous.[16] In Sicily whole towns are rockcut: Siculiano, Caltabelotta, Rafadalle, Bronte, Maletto. Further afield, in the loess belt of China, a large area comprising the Honnan, Shansi, Shensi, and Khansu provinces, about ten million people live in dwellings hollowed out of the silt that has been transported and piled up by the wind.[17] The rock churches of Ethiopia, most notably those at Lalibela, were the subject of very recent books.[18]

When this anonymous architecture had its start in Cappadocia is hard to say. Of the thou-

Following pages
Plate 8
Üçhisar, rock caves, detail.
[Photo Harold Stump]

sands of burrowed spaces in the pliant tuff that have survived, few seem to antedate Christianity, and mature Christianity at that. But there is no reason to disbelieve that the practice was more ancient. From the seventh century onward, however, we have countless hermitages, monasteries, and independent chapels to prove that the land had become by then as holy as Mount Sinai or the desert of Sohag, and one of the most concentrated regions of Eastern monasticism.

There were also villages here and towns whose people chose to live apart from the small valleys and riversides, in dim caverns carved in the native rock. This arrangement made architectural sense in the absence of wood, and it had the advantage over constructed housing of being cool in the summer and relatively sheltered when the formidable Anatolian winter came around. Wood was used only for doors and, on occasion, as flooring between superposed rooms.[19]

Two such towns are specifically mentioned in the first written record we possess on the rock-cut architecture of Cappadocia. They are Korama and Matianoi, the predecessors in fact of the present rock towns of Göreme and Maçan (Avcĭlar) in a region where many of the churches we will be reviewing are to be found. The towns are referred to in the *Acts of St. Hieron,* a document which in its existing form dates from about A.D. 600. But the actual martyrdom of this local saint took place during the Diocletianic persecutions at the end of the third century A.D. The existence of the two towns in the tuff landscape could therefore probably be postulated for this early date. Hieron was a native of Matianoi. He was arrested by Roman soldiers, together with eighteen others, as he worked in the vineyards that comprised his regular occupation. He managed to escape from their hands and after a pursuit through the fields hid for a time "in a mighty cavern in the flank of a hill, which had been carved out of the rock with great skill."[20] The account has topical credibility even today. The name of still a third town in the region, Hagios Prokopios (present day Ürgüp), is referred to in relation to the Council of Chalcedon in 451: Among those attending was a certain Elpidius with the title of "memorophylax of Prokopiu" and a contingent of other monks.[21]

A parenthetical reference in Leo the Deacon's narrative of the years 959–975 shows how general excavated dwellings had become by the tenth century. The people of Cappadocia were once called troglodytes, Leo wrote, on account of their inhabiting caves, holes, and labyrinths.[22]

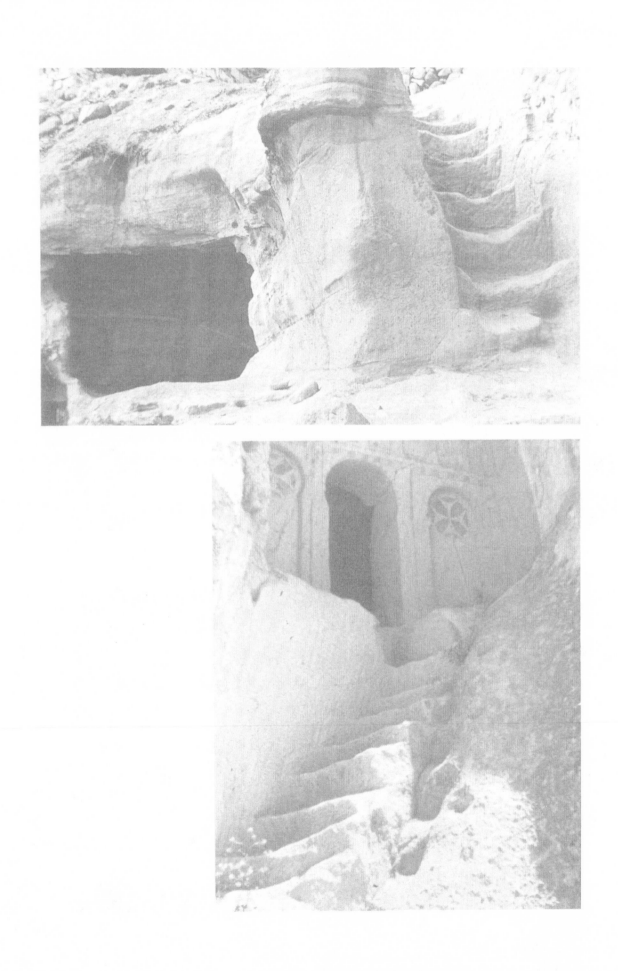

Plate 9
Ürgüp, rockcut house,
detail showing entrance
steps.
[Photo Harold Stump]

Plate 10
Göreme, entrance to
Chapel 27.
[Photo David Gebhard]

The anonymous writer of the *Synopsis Chronikē* in the thirteenth century commented more informatively that troglodytic dwellings were favored as protection against the winter and the snows.[23]

He might also have said protection against man. For Cappadocia never remained safe from raids for long, and at least in the case of monasteries, and probably also for villages and towns too, troglodytic architecture was conceived of as shelter in more than an environmental sense. The houses often had one entrance only, high above ground level, and access to it was had by a removable ladder. If rockcut stairs were available they would be steep, narrow, and unobtrusive (Pl. 9). In monastic compounds, clearly vulnerable to non-Christian invaders, precautions are even more obvious. On the walls, grooves in the form of a ⌐ to hold large beams in place across the closed doors are still in evidence. Passages leading to stairs were often provided with large stones that could quickly be rolled into place, between the entrance and corresponding piers, to block the way. Behind these the rooms were ingeniously carved out on several levels and had labyrinthine interconnections. To reach some of them, one had to slither up or down narrow shafts or crawl along barely negotiable tunnels. Common too was the practice of situating the entrance hole not on the face of the rock overlooking the pathway, but further up beyond sight of the passers. In this case, having gained the hole by means of a rope ladder, you would have had to drop down through a chute.

Rock facades of architectural pretension, of which there are some, should probably be assigned to peaceful intervals in the turbulence of Cappadocia's frontier existence (Pl. 10). These were times when the Eastern Roman, or Byzantine, empire was able to keep bordering countries at bay and to maintain adequate defense for the east flank of the province and the breaches in the Taurus chain to the south. Until the middle of the seventh century the empire extended far enough beyond Cappadocia to surround it with buffer territory. Dozens of churches were built in this time, of cutstone masonry above ground. Their impact was felt as far afield as Armenia, where distinctly Cappadocian details can still be detected by the observant visitor.[24] Evidence for this jubilant building activity survives in fragments scattered throughout Cappadocia.[25] They are fast disappearing. The sixth-century cruciform basilicas of Forty Martyrs at Skupi[26] and of the Panagia at Tomarza, described by H. Rott in 1908, are now razed. So too is the impressive octagon at Sivasa. Next to the site of Akkilise ("White Church") at Soğanlï Dere

one is now shown a house built of its materials: Rott's picture of the church has already become a historical document.

But our sources speak of many more, early churches connected with famous names like St. Basil, "light of the Cappadocians, or rather of the world," [27] and the other two members of that splendid triad of Cappadocian theology in the fourth century: Basil's brother, Gregory of Nyssa, and his close friend and associate, Gregory of Nazianzus. There was the octagonal martyrium with cross arms that Gregory of Nyssa described in detail in a letter to Amphilochios, bishop of Iconium. There was the great complex of buildings that St. Basil built at some distance outside his see of Caesarea. It was named after him, Basileias, and included, besides a church and episcopal residence, hospitals and hospices for the poor, administered according to a precisely planned system of relief. When the saint died he was buried in a new basilica on the south of two peaks that gave Mount Didymos its name in antiquity. Not far off was the imperial estate at Macellum, where the princes Julian and Gallus were sent by their cousin the emperor Constantius II, ostensibly to be given a strict Christian education but more likely to be kept out of the way. To display their piety the boys built with their own hands a church there to St. Mamas; or they started to. But whereas Gallus' part was building wonderfully, Julian's kept falling down: a certain sign, it was thought, of his later treachery to Christianity when, now emperor himself, he would set about to revive the pagan gods whom Constantine the Great had given up for the Son of God a mere generation ago.[28] It was apostasy and heretical movements like Arianism, not foreign attacks, that the Church had to fight against in Cappadocia in these early Christian centuries.

Islam

The attacks, when they came, were another invasion of faith. Six hundred years after the lonely passage of St. Paul, a new religion—the last, it was said—sprang up with astonishing vigor in Arabia and in a matter of years was lashing the apostle's hard-won territories with fanatical and determined hordes of Believers. The first Arab raid came in 642, and from then on Cappadocia became the embittered frontier between two rival faiths. Islam was now the new East, Byzantium the beleagured West. The capital, Constantinople, proved impregnable by two sieges, stood fast at the very tip of Christian Europe, and Anatolia became the battleground for the Western cause. Under the continual threat of annihilation and the long internal conflict of Iconoclasm, to which we will return, Cappadocia's church-building slowed down almost to a halt. It is thought that many thousands of monks fled to Italy in this dire period,[29] there to find peace in newly established monasteries.

For two hundred years the raids swept in, destructive as the floods and drought. Cities and castles were taken, abandoned, retaken; their inhabitants were carried into slavery. The people dug deep into the tuff. In 1965, three entirely rockcut towns were discovered in Cappadocia, of which one, penetrated through a single entrance, extended over an area of six square kilometers.[30] Thousands took refuge in the comfort of the earth. Monasteries fended for themselves or became headquarters of *akritai,* frontier knights to whom the defense of the land was left. The story of Omar al Neman in the *Thousand and One Nights* tells of a king of Caesarea, Hardovios, a terrible warrior and the father of a most beautiful girl, who had a monastery as a fortress.

It was a good age, from then on, for legends of valor. Border wars created heroes for both sides, and as always when the conflict is intimate, the praises of these legendary men were sung by both sides. The battling faiths were reconciled through single deeds whose standing was universal. At the same time a similar union of opposites was achieved in the popular mind by devising for the heroes mixed ancestry or mixed marriages. The great Seid el Batal el Ghazi, who was killed in battle at Akroenos and whose memory is hallowed in all parts of Anatolia but especially on the top of Erciyas Dağı, was married to a Greek princess. His Byzantine counterpart Digenis Akritas had for a father an Arab emir who had been a convert to Christianity. "Byzantium," the poet Séféris once wrote, "fashioned its own adversaries."[31] So also did the Muslim raider fashion his Byzantine adversaries.

Signs of this alien Muslim presence in Cappadocia are not hard to find. In the paintings of the rock churches Arabic motifs like bands of Kufic ornament make their appearance before long. Kufic borders also line the edges of robes or liven the surfaces of objects like the shields of the soldiers guarding the Tomb of Christ or Salome's ewer in the Nativity. A new type of long narrow overgarment with a frontal slit at the skirt, seen here as well as in the art of Armenian churches, seems to have been common for the dominions of the Abbasid caliph at Baghdad. We must note, too, while on this subject, the Christ in the west arm of Yĭlanlĭ Kilise (Cat. no. 31) in the valley of Peristrema, not properly enthroned as he should be but seated cross-legged on the floor in the Arab manner.[32]

Middle Byzantine
Renascence

In the second half of the ninth century the tide turned in favor of Byzantium. First under Petronas, the general of Michael III, and then under Basil I, Byzantine armies began to hold the Arabs at bay. With the conquest of Cilicia by Nikephoros Phokas and the victories of John Tzimiskes in Syria and Mesopotamia, once more Cappadocia was wrapped safely in new frontier lands. Church building resumed in earnest behind a triple line of defensive forts, some still visible, that was established to arrest raids across the Taurus chain.[33] The great majority of rock-cut churches in Cappadocia date from this time of extended peace between the reign of Constantine VII Porphyrogenitos and that of Constantine Dukas, that is from about 900 to 1070. This political lift coincided with the triumph of images throughout the empire, following upon the final defeat of Iconoclasm in 843. The numerous painted programs of the rock churches are proof that Cappadocia—"a Byzantine Pompeii," H. F. Tozer called it[34]—participated in the general revival of monumental painting usually referred to by modern scholars as the Middle Byzantine period. At the same time, a school of manuscript illumination was also active in the region. At least five manuscripts have been assigned to this school by K. Weitzmann, two of them recording the owner and the date of execution. All five are characterized by extraordinary initial letters formed of interlocked beast designs.[35]

The Church flourished as never before. Several new bishoprics were created to reestablish order in areas ravished by the Muslim onslaught. Of these, three were in the troglodytic area with which we are concerned; Hagios Prokopios (Ürgüp), Sobesos (Suveş?), and Matianoi. The number of suffragan bishops to the metropolitan of Caesarea increased, under Leo VI the Wise, from five to fifteen, and though it was reduced by his son Constantine Porphyrogenitos it remained at eight.[36] To underline the resurgence of Cappadocia, the great scholar Arethas was appointed bishop of Caesarea in 906. A native son, Nikephoros Phokas, rose later in the century to occupy the throne of the Empire. The only other emperor of Cappadocian origin had been Maurice at the end of the sixth century.

Some historians have seen in this period of renascence and evident surge of population an influx of Armenian colonists from the east who settled newly rebuilt towns like Lykandos, Tzamandos, and Symposion.[37] There is no historical evidence that this Armenian colonization ever reached west of Caesarea. The attempt to identify Symposion with Suveş has not been universally supported. Nevertheless some circumstantial evidence is not lacking in the

churches themselves, and N. Thierry's recent rejection of any possible Armenian influence in the troglodytic region is needlessly negative. Belli Kilise at Soğanlǐ Dere (Cat. no. 24) has a pointed dome on a high drum, typical of Armenia; it is the only rockcut church in Cappadocia where the dome as an exterior form can be seen. Paintings in some churches represent similar building types that may betray the provenance of their executors. In the large church at Çavu-şin (Cat. no. 38) a painting depicts an Armenian donor. He is one of two riders advancing, a lance supported on his shoulder, at the end of a line of standing figures who represent the Forty Martyrs of Sebaste (modern Sǐvas). An invocation gives his name and title: *Melias magistros.* He has been identified as a descendant of the great Armenian Melias, or Mleh, who founded the theme of Lykandos.[38] A frontier general in the employ of the Byzantine emperor, like his ancestor, this younger Melias fought hard and well against the Muslim, taking the cities of Nisibis and Malatya, and in 973 laying siege to Amida. But there he met with defeat. He was carried in chains through Amida together with his principal officers and later transported to Baghdad, where they were all put to death. There were forty of them, as there had been forty Christian martyrs who were left to freeze in the icy waters of a lake in Sebaste some centuries before. It is probably the painting of Çavuşin, in which Melias is shown in the company of the Forty Martyrs of Sebaste, that inspired the chronicler Matthew of Edessa, who tells the story, or his source, to create the forty new martyrs of Amida—a beautiful case of a visual image inspiring an image of historical legend.

The Turks

But peace did not long endure in Cappadocia. It was broken anew with the sudden arrival of the Seljuk Turks. Actually their approach was not so sudden. They had been active in the eastern periphery of the Byzantine empire for at least two centuries. But an unexpected and decisive event, of one day's duration, trumpeted their entry into the Anatolian plateau and was branded in people's minds as a turning point. This was the pitched battle at Manzikert (Malazgirt) in 1071, where the emperor Romanos Diogenes, having arrived with a huge army to stop the infidel's progress into Byzantine territory, suffered a humiliating defeat at the hands of a Turkish army led by Alpaslan, and became their prisoner. It was the most shameful day of Roman history since the emperor Valerian capitulated to Shapur I of Persia in 270 in these same parts of the empire.

The two dates show how long the struggle had been for possession of Asia Minor, how long fate had favored the Romans. But Manzikert marked the beginning of the end for Roman rule. It receded now, for the last time, as the Turks moved in and made for the shores. The passage of the First Crusade in 1097 brought no lasting relief. The business of the European knights was in the Holy Land. There were no famed relics or memorials of Christ in the Anatolian plateau, no cities of great wealth; the arid soil did not invite lordships. So they passed quickly on, through Iconium, Tyana, Caesarea, and headed for the lands beyond the Anti-Taurus range.[39] What Greeks and Armenians had not been dispossessed were left to the care of the Turks. Turkish states succeeded one another, and the few Christian cities of former renown in the great plains like Iconium, now Konya, and Caesarea (Kayseri) served them as capitals and metropolises (Fig. 1).[40] New towns were built and flourished. Aksaray, straddling the Melendiz in the midst of woods of white poplars, and Niğde to the southeast are Cappadocian examples. To the Roman roads others were added to take in the new towns. The Great Highway, Ulu Yol, led from the capital Konya to Kayseri, by way of Aksaray and İncesu; it forked at Kayseri to continue in one direction toward Sĩvas, Amasya, and the Black Sea, and eastward toward Malatya and Maraş. Alongside it vast caravanserais announced that the Seljuk Turks were come to stay.[41] There were more than twenty between Kayseri and Sĩvas alone. The handful that survive— Horozluhan near Konya, Sultanhan, Zazadin Han—are imposing piles even in their dilapidation. At the same time dozens of funerary monuments, or *türbes*, were put up in honor of Muslim rulers and saints to exorcise the land, as it were, after the long Christian domination.

They stood simply and proudly, with their customary conical roofs and their brilliant decoration, next to Greek martyria in the old cities and the countryside. Mount Didymos was renamed Ali Dağ, and St. Basil had to share it with the prophet Ali as a resting place.

But the latest masters of Anatolia were a tolerant people. The Church, impoverished and on the decline, was allowed to survive nonetheless. Except for a brief reprieve which seems to have come when Sultan Keykhusrev was defeated and died at the battle of Antioch-on-the-Meander in 1210 and emperor Theodore Laskaris extended his authority perhaps as far as Cappadocia,[42] the Christian communities learned to make their peace with the Turk and carry on under his rule as best they could. Many served in the Seljuk armies and were promoted to high office. A telling dedicatory inscription, in the rockcut church of St. George (Kîrk Dam Altî Kilisesi; Cat. no. 64) recently discovered in western Cappadocia, illustrates the forbearing attitude of the Seljuk hierarchy toward their Christian subjects. It mentions as donors a certain lady Thamar, and a Basil who is dressed in caftan and turban and holds the Turkish title of *emir;* both Seljuk sultan and Byzantine emperor are hailed. "This most venerable church dedicated to the holy and great martyr St. George was magnificently decorated through the assistance, the high wish, and care of the lady Thamar, here pictured, and of her Emir Basil Giagoupes, under his high Majesty the most noble and great Sultan Masud at the time when Sire Andronikos reigned over the Romans."[43]

The church held on even after the death blow had been dealt to the Byzantine empire with the fall of Constantinople to the Ottoman Turks, the successors of the Seljuks, in 1453. While the patriarchate in the great city, now called Istanbul, sustained the high tradition of the Orthodox Church with the Ottomans' blessing, the hinterland, whose spirit had always been demotic, barely kept alive a mongrelized Christianity. Greek as a spoken language was slowly being forgotten. The Bible was most often written in Turkish but with Greek characters. The old churches were abandoned where Greek population was absent; a few served on as needed. There was something debased, unheroic now, something essentially unedifying, even in the infrequent creation of a modern Christian saint. At Ürgüp one was shown the relics of one John the Russian, Ioannes Rossos. He had been taken prisoner during the Ottoman war with the Russians at the time of Peter the Great and was sent with many others to inner Asia Minor. In the face of general conversion to Islam among his companions, only he held fast to his faith. One day,

when his master was away on the pilgrimage to Mecca, the lady of the house said as she dined: "I wish my husband had, where he is now, his favorite dish to eat which you John prepared so well again today." John fell on his knees and prayed to Jesus, and at once the pot disappeared from the table. It was learned upon the husband's return that exactly at that same hour the pot had materialized in Mecca and all the pilgrims there were fed. John died in due time. Later, some miracles took place at his tomb.

A very few villages remained exclusively Greek. Such for example was Misli, whose population was relatively independent of the Turks and subject to the bishop at Niğde. They paid no taxes to the Ottoman government, and never married outsiders.[44] Sinassos was also predominantly Greek. It became rich through commerce with Istanbul, and came to be viewed as the chief center of an ephemeral revival of Orthodoxy in the nineteenth century. But more usually, Christian communities lived in separate parts of Turkish towns, more or less in harmony with the ruling majority. When an occasional new town was built it would be populated by Greeks and Armenians from neighboring villages, so that main centers of the older cultures became completely Turkish. This is what happened with Nevşehir for example, the only new town of importance in the troglodytic region of Cappadocia. It was founded in 1720 over the village which had been the birthplace of Ibrahim Paşa, son-in-law and grand vizier of Sultan Ahmet III. In populating it with Greeks from nearby, Christian tradition retired finally from such places of documented antiquity as the town of Matianoi, the birthplace of St. Hieron. Names were turkicized, by phonetic adjustment or direct translation. Matianoi changed to Maçan, Korama to Göreme, Melas remained the "Black River" in the new tongue: Karasu. Much was freshly renamed. The frequence of the Turkish words for "church" (kilise) and "fort" (hisar) in these baptisms attests to the unavoidable physical presence of the older, Christian, culture. The churches themselves were nicknamed by the Turkish peasants, perhaps in deference to that unwritten law that a fresh name is the greater part of the act of propitiation.

Western Travelers

A little before the time of the founding of Nevşehir, the first Western traveler passed through Cappadocia. He was Paul Lucas, a Frenchman on an investigation tour of the Middle East at the orders of the Sun King. His brief mention of the troglodytic architecture in the region of Kayseri and the thousands who lived in this manner must have been thought by some as one of the customary tall stories of pioneer travelers in the mysterious East. On a subsequent trip, published in 1718, Lucas asserted, for the sake of the incredulous, that the caves did indeed exist as he had initially noted but that he had underestimated their number, which he now put at 200,000.

No one in this century of Reason sought to verify these claims. But with the opening of the next century a line of travelers from France, England, Russia, and Germany braved acute discomforts and danger to recover and chart the legendary plateau of Anatolia. They moved from place to place excitedly, with compass, aneroid barometer, and Strabo's *Geography* in their pack, scaling altitudes, hunting down rumored marbles or inscriptions, bargaining with native boys for coins, and everywhere feverishly trying to identify past theaters of history. Was Soğanlī Dere the Soandus of Strabo? Where was Xanxaris, the famed watering place to which Gregory of Nazianzus repaired to seek recovery? And Nazianzus itself, called "Anathiango" in the Jerusalem Itinerary and placed on the road from Ancyra to Tyana? And Tyana? They were a motley collection of men, the now practically extinct race of the educated and curious generalist: at once geologists, geographers, archaeologists, classicists, epigraphists, and journalists—in short, Wandering Scholars, as one of their number put it. "With so many stepping stones to set in the stream of ignorance, the Scholar had best not take too professional a view of his ostensible calling: maps and political reports, customs and types and folklore, eggs and bulbs and butterflies and rocks—all these fill his day with amateur occupations for which his professional interest is probably not the worse . . . The 'Remains of Distant Times' are various enough, and the Wandering Scholar may neglect a coin as little as a city."[45]

These twenty or so travel books of Anatolia, even the dullest among them, make good reading. They tell with relish of the trials of early scholarship: bandits, the plague, rapacious and shiftless officials like the local *mutessarif* Fekham Paşa, who not only ordered Ernest Chantre and his colleagues out of the country on some trumped-up charge but also forbade the natives from putting them up or selling them food. Most of the Wandering Scholars endure such hard-

ships philosophically, although not always with modesty. Some draw the astonishing moral lesson, that child of an undying Western chauvinism, that this rough-and-tumble land needs the civilizing hand of Christianity to set it on the right course again. One almost blushes to read today, at the end of the excellent account of Anatolia by William J. Hamilton, a fervent statement to the effect that the Turks' only hope lies in embracing Christianity so "that the shackles of the Koran may be unloosed—the religion of Christ be established from Constantinople to the far East—and that the countries which first saw the effects of the Word will no longer be behind the Gentiles in adoring His holy Name."[46]

Hamilton's wish was, of course, the avowed Purpose of Christian missions. With the relative loosening up of the Ottoman East in the nineteenth century a number of them initiated proselytizing activities. Their work was at first encouraged by the Porte, presumably in the hopes of resolving the Armenian question with their help. It was hoped that by converting the Armenians of Asia Minor, and to a lesser degree the Greeks, into Protestants and Catholics the missions would succeed only in dividing the number of these peoples and frustrating their national aspirations. The Americans entered the field in 1820 with missionary operations throughout the Middle East administered by the American Board of Commissioners for Foreign Missions in Boston. In 1826 the missionary Gridley visited Cappadocia as far as Kayseri, and died of fatigue after an attempt to climb Erciyas. Soon three main missions were established. Of these the Western Turkey Mission covered Istanbul, Edirne, most of Asia Minor until Cilicia, and also Sĭvas and Trebizond. Cappadocia was a crucial part of this Mission. Caesarea Station was founded in 1854. It included a boarding school for girls in Talas (the ancient Mutalaske) which by the end of the century had ninety-one students, a high school for boys in Caesarea itself with fifty students, and another in Yozgat with thirty students.[47] Their success was considerable—but not along the lines that the Porte envisaged. Rather than being divisive, the effect of the Mission was to produce, slowly, a small educated class of minorities which transcended its differences and turned its attention against the abuses of the central government. And so, with perverse logic, the gains of the civilizing West contributed to the sad ultimate decision of the Porte to solve the Armenian Question with violence and blood.

At this time, when the Western traveler was most suspect and the missionary or priest anathema to the Turks, a young Jesuit, Father Guillaume de Jerphanion,[48] visited the troglodytic

area of Cappadocia in the company of Father Joannès Gransault. The year was 1907. This first visit marked for Jerphanion the start of a long and moving involvement with the rockcut churches and their paintings, an involvement that continued for more than three decades. By now the heyday of the generalist was passed. Travel books packed with incident, fact, and observation were making way for the special documented treatise. Systematic excavation was breathing life into the dim memory of the Hittites, whom the Turks would soon welcome as honorable ancestors. Jerphanion's period of interest happened to be the one that, in the mind of local and central authorities, had best be forgotten. It is to his lasting credit that he persevered tirelessly, recording each church with method and love in the few years before the outbreak of World War I.

Then no more visits were possible. After much trouble, the modest account of which can be read in his preface, Jerphanion's first volume of text and first portfolio of plates appeared in 1925. Two years later he somehow managed a brief hasty visit to the region, the first since the war. He found the last tenuous link of Cappadocian Christianity with the present broken. The "smooth-tongued Armenians" (Hamilton's phrase) were no more. Under the treaty of Lausanne in 1923 the newly founded Republic of Turkey had agreed to an exchange of minorities with Greece. The Greeks had left. Their villages and towns stood empty, awaiting new occupants. The metropolitan see of Caesarea, together with many other sees of Asia Minor, ceased to exist; the episcopal residence at Zencidere and the adjacent monastery of St. John were closed. New bishoprics in Europe and on the Greek islands were hastily being created by the Patriarch of Constantinople to take the place of the ones lost.

The rock churches themselves had registered the vicissitudes of the war and of the evacuation. Some were destroyed. Some were lost among the complicated folds of the rockscape: without the aid of Greek guides, Jerphanion, who had recorded them fifteen years ago, could not now locate them. Many churches were sealed up and transformed into pigeon houses, the guano of pigeons being an important commodity in the region. And Cappadocia became again inaccessible to the scholar and the curious until 1950.

The Present

Following pages
Plate 11
Üçhisar, general view from Ürgüp.
[Photo Harold Stump]

Plate 12
Çavuşin, view showing part of the modern village and the columnar porch of St. John the Baptist (top center).
[Photo Harold Stump]

The struggle for the spiritual possession of Asia Minor is now over. Today Christianity, and its architecture, have no live relevance in Cappadocia. After many centuries of more or less happy survival, the hollowed churches and monastic establishments can now disintegrate or adjust to new expediencies. In the last few years the luckier ones are being proclaimed archaeological monuments. By this process they are historically neutralized: they become things for dispassionate attention. Only chance objects, here and there, like the minarets at Zilve and Çavuşin in the form of Byzantine *ciboria,* serve as poignant reminders of the long episode of engagement between the two great faiths.

But in the cone colonies and bluff rock slopes, villages and towns go on as they have since early Christian times (Pl. 11). The houses are now more ambitious. They have rectangular projecting fronts built of regular blocks of tuff and neatly whitewashed, with one or more rows of small windows (Pl. 12). In contrast to the mud dwellings elsewhere in the Anatolian plateau, indistinguishable from the brown earth, these look cheerful, pert. An occasional arcade graces their facades. Sometimes an exterior staircase leads up to an open-air platform above street level from which the constructed front room is entered. Beyond this the house extends into the natural rock. Here grain is stored, as always, and animals kept, pots thrown and textiles woven. Yearly the layer of soot from the flueless chimney is chipped away from walls and ceiling, and a new coat of whitewash completes this sensible upkeep. And one carves as need arises. Vertically, the houses may go up to several stories.

If the prospect of these communities looks at first sight hopeless, in fact it is not so. The land has never been entirely arid. Wandering through the intricate rockscape, one comes upon vineyards and fruit trees, hanging on to the sides of valleys, as well as vegetable gardens hidden away in the bottoms of clefts and among the rock cones. Their green in season stands in happy contrast to the white or yellow tuff. The softness of the tuff land encourages excavation; its makeup helps to nourish such selected plant life. Being porous the rock absorbs and holds water easily. Within, mineral nutrients are loose, among them a high quantity of potassium. These conditions are excellently suited for the cultivation of fruit—pear, walnut, apricot— vegetables, and grapevine. So paradoxically, you can grow things more easily on the tuff than you can in the flatlands beyond, where corn-growing and cattle-raising are more at home. And so too the tuff landscape is more densely populated than the neighboring flatlands.

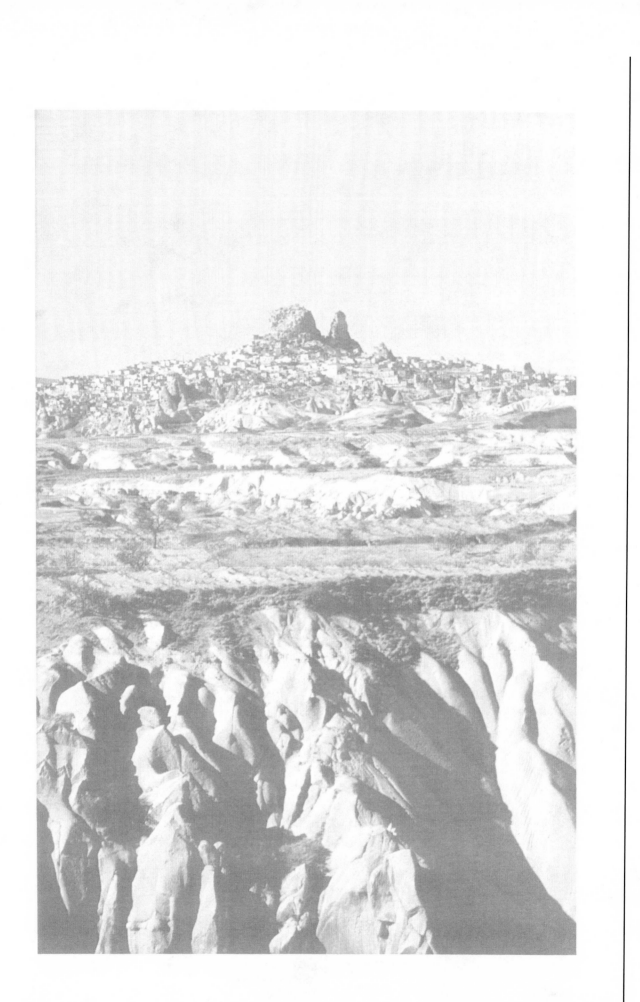

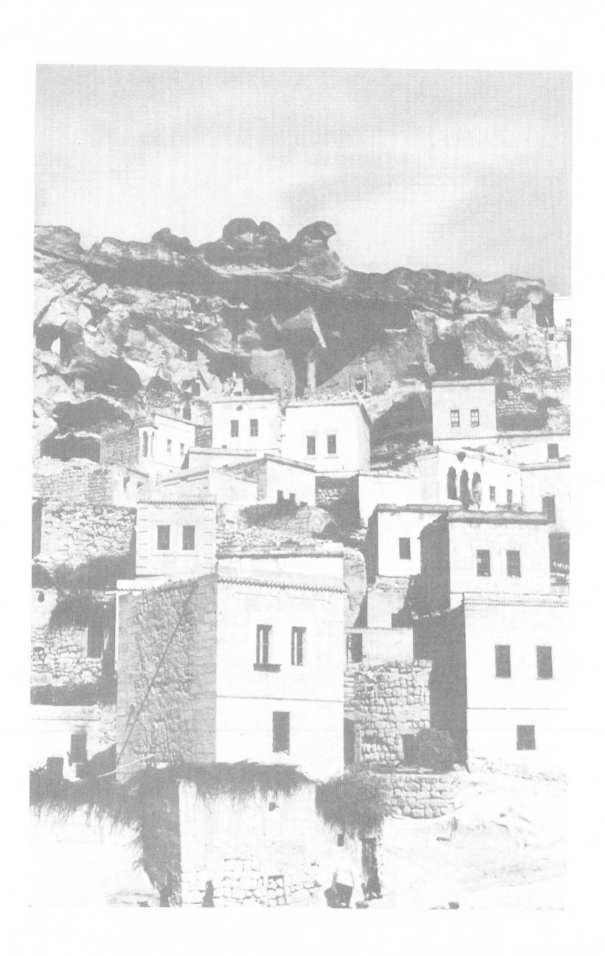

Plate 13
Ortahisar, central rock.
[Photo Harold Stump]

Cappadocia is now easily visited. One can go by jeep from Ankara and get a quick feel of the rockscape and its art in a day or two. Beginning at Gülşehir (formerly Arabsun), signs announce the more important of the monuments. Or one can make Kayseri the base for a profitable month, or more, of unhurried excursions. The troglodytic towns are a delight, the proverbial hospitality of the Turk intact (Pl. 13). There is a good hotel at Ortahisar, and at Ürgüp a comfortable new one has recently been built. A third at Üçhisar, partly rockcut, is under construction at this writing. At Göreme one has the luxury of taxi service, a refreshment stand, and souvenirs. Adequate roads join the Jerphanion territory with the region of Hasan Daği, about ninety miles to the southwest, where a little-known group of rockcut churches, recently published by M. and Mme. Thierry, can be seen.

And above all, there is the landscape, naked and mournful as ever, with its Arizona-like desert plain and the few insular mountains. Here the political and social upheavals of past and recent history are, of a sudden, meaningless. As always the parched soil waits patiently for the rains which will usher in snow and freeze which then will yield, after some obdurate months, to flood the springs with gushing waters and force the rivers to reclaim their retired brooks again. All this is one's own. Despite the Wandering Scholars and the learned publications and the *Guide Bleu*, crossing the Plains remains a pristine experience. One is always the first outsider to enjoy it.

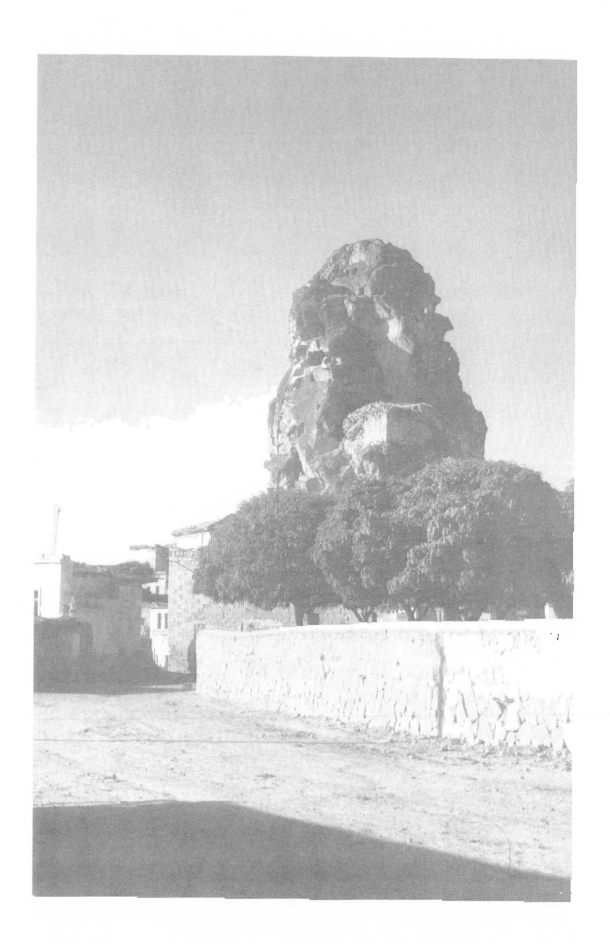

2

The Buildings

The number of rock churches so far recorded in Cappadocia exceeds seventy—and this accounts only for those of them that were decorated with a more or less elaborate system of painting. Undecorated chapels and churches have not been paid much attention to. They must count in the scores. And yearly, now that the region has been effectively opened to visitors and students, new ones, both painted and not, are brought to light, and others which had been reported briefly in the past and then lost sight of are rediscovered and published. Already the notion that troglodytic Cappadocia can be circumscribed within a radius of twenty kilometers around Ürgüp—Father Jerphanion's territory—has become obsolete. It was being noted since the end of the last century that the valley which the Greeks called Peristrema, at the foot of Hasan Daği in the west, was riddled with religious excavations. This site, a short canyon of about twelve kilometers between the villages of Selime and Ihlara cut through the volcanic rock of Hasan Daği by the river Melendiz, is now established as a secondary center thanks to the recent publication of its churches by M. and Mme. Thierry (Fig. 2). At the same time, field trips by Jacqueline Lafontaine-Dosogne and others have extended the bounds of this new center northward until Mamasun, and Jerphanion's territory itself beyond Kayseri, to the east, until the modern village of Aǧırnas, just off the highway that links Kayseri with Sīvas. Finally, one rock church at Eski Gümüş, near the modern town of Niğde, published by Michael Gough in 1965, has brought attention to southern Cappadocia and given hope of fresh finds there.[1]

Jerphanion and the renewed zeal of the last decade notwithstanding, our study of this provincial Byzantine treasury of monuments has not advanced much beyond the archaeological stage: a record of the architecture and description of the pictorial cycles. Debate of dates and of iconographic sources is itself archaeology; so also the physical and chemical analysis of plaster beds and paint and binding media recently undertaken by Marcell Restle. The art history of Byzantine Cappadocia, however, remains largely unwritten. When it begins to be forged, it will be around questions of *form* in building and picture—form as it illuminates intention. What was the intended program of this sculptured environment of faith? How close were the aspirations of architect and painter to those of their counterparts in Constantinople, say, or other metropolises? What constitutes originality and what inept aping in this remote province? Is the attempted approximation of *constructed* churches and metropolitan schemes of decoration in

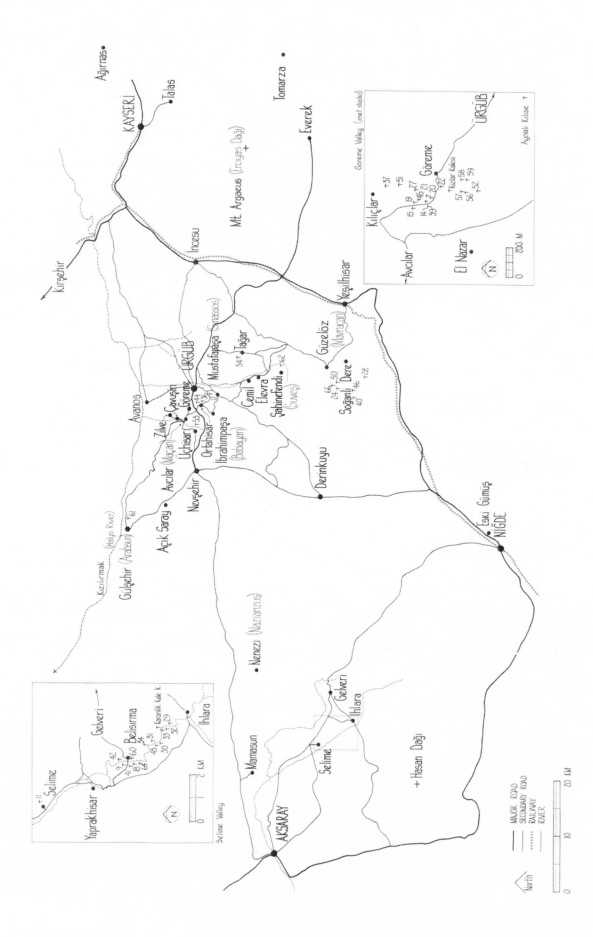

Ağırnas•

KAYSERİ
•Talas

Kırşehir

İncesu

Mt. Argaeus (Erciyas Dağı) +

Tomarza•

Everek•

Yeşilhisar

Güzelöz (Mavrucan)

Tağar 54+

Mustafapaşa (Sinasos)

Cemil • +62
Ürgüp
Göreme
Çavuşin +56
Zilve (Açıksaray)
Uçhisar +55
Ortahisar
İbrahimpaşa (Babayan)
Elevra
Şahinefendi (Suvaş)

Soğanlı Dere
66+
24+ +50
40 +46 +28

Avanos

Avcılar (Maçan)

Nevşehir

Açık Saray
Gülşehir (Arabsun) +61

Derinkuyu

Eski Gümüş
NİĞDE

Kızılırmak (Halys River)

Nenezi (Nazianzus)•

Mamasun•

Selime•

İhlara
Gelveri

Hasan Dağı +

AKSARAY

Göreme Valley (most shaded)

Kılıçlar•
+57
15+ 19 27 +51
14+ 45 21
39+ 20
Göreme
+22 Kızılar Kalesi
57+ +58
56 +52 +59

Avcılar•

El Nazar•

ÜRGÜP

Ayralı Kilise +

N
0 200 M

Selime Valley

Selime•
Yaprakhisar•
Gelveri

42+
9+
48+ 60 Belisirma
41+ 67 51
45 31
30 33 29
32
Taşarlık Kale k.

İhlara

N
0 2 KM

North
N

MAJOR ROAD
SECONDARY ROAD
RAILWAY
RIVER

0 10 20 KM

Figure 2
Detailed map of the
troglodytic region in
Cappadocia.

the rockcut architecture the outcome of liturgical necessity, or is it rather the reflection of some perhaps not altogether witting symbolism of form, a tenacity of the physical, so to speak, to ensure the continuity of immaterial affinities? For the truth is that, in contrast to the growing body of fact, we know little as yet of the meaning of Cappadocian Christianity and of the monuments which it informs.

This is not surprising. Art history proceeds upon the factual groundwork provided by archaeology; and in the case of Cappadocia the systematic documentation of the churches, which started with Jerphanion, Rott, and Grégoire more than a half century ago, has been exceptionally difficult. The inaccessibility of the region for long periods of time was of course one reason, the great number of the monuments another. A less obvious factor, however, has been the extraordinary variety in the types of buildings and decorative schemes, which makes generalization and orderly deduction hazardous. Every program of painting offers some idiosyncrasy of style or iconography, often of both, which is not necessarily indicative of a chronological slot, nor is it necessarily to be attributed to a specific source of influence. We shall discuss this problem later. But architecture, our present concern, is at least as unobliging to the student who wishes to reconstruct a reliable development.

The Cappadocian carver-architect was not inhibited (as was the *builder*-architect here and elsewhere in Anatolia) by statics or the nature of materials. His structure stood, a monolith, before he started to work on it. And he could cut into this monolith quickly, effortlessly. It might take a single man about a month to carve out a large room of two to three thousand cubic feet. Loads and thrusts were negligible. One was free to try any structural symbol with little concern for structural safety (Pl. 14). Cupolas could bubble from flat ceilings, or be placed over square bays by means of the most cavalier transition elements. No shape need be perfect: extemporaneous geometry is everywhere the rule. Wall lines sag; one-half of an arch does not quite match the other; carefree deviations, here and there, mark the general outline of the building.

Plate 14
Göreme, unpublished
chapel, detail of interior
showing cupola.
[Photo David Gebhard]

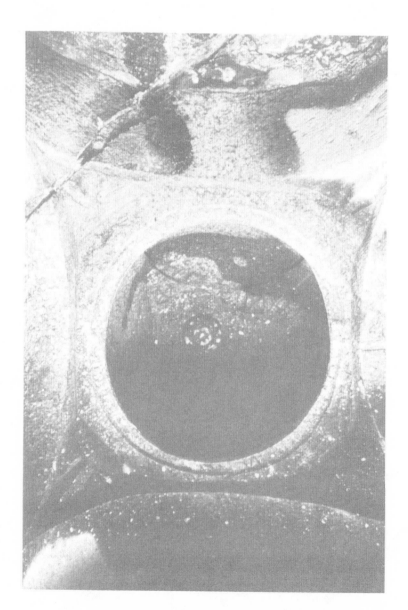

Hermitages

Now in the case of chapels and churches, as we shall presently see, this general outline was governed by a certain number of canonical types in usage through various parts of the East. But with hermitages and monastic establishments, for which no cut-and-dried types existed, the carver was on his own. This was especially true of hermitages where the "architect" and the user were of course one. Pretentious form, or architectural sophistication, could hardly be of interest to the anchorite. Even if he were capable of such, they would have been renounced and left behind together with things owned, family, wordly ambition. Rockcut hermitages are therefore of the simplest kind.

There were a great number of them. Monasticism, which very early dominated religious life in the East and continued to do so until the end of the Byzantine empire, had been unable to eradicate the will to go it utterly alone. In Cappadocia, from the start, both sides had their apologists. At the same time that St. Basil was arguing for responsible communality, close associates like St. Gregory of Nazianzus saw merit in the hard, uncompromising isolation of the hermit.

Blessed he who lives the solitary life and keeps apart
From those who walk the earth, but godward lifts his thought.[2]

The spectacular success of St. Simeon the Stylite in the following century, alone for years under the sky atop his tall column, served as fresh inspiration, if such was needed, for the eremitical philosophy. The one hermitage studied by Jerphanion, less simple than most, recalls this great Syrian saint.[3] It is at Zilve, near Çavuşin, in an odd insular rock with three chimney-like pinnacles (Fig. 3). A vertical shaft of space reached by a few narrow steps leads up to a first room. One climbs with the aid of notches on opposite sides of the shaft. The room, lighted by one opening in the rock, is a rough rectangle from one corner of which three irregular niches push out. In one there is a rockcut seat; in another starts a steep stair which mounts to a second room, approximately oval in shape, with rock seats and benches, and three openings which serve as windows. A rock table in a recessed corner is surmounted by five painted crosses; several more, in relief, are seen here and there in both rooms.

At ground level, below the hermitage and entered separately, is a small oratory with a badly

damaged pictorial program that includes a cycle illustrating the career of St. Simeon. Long inscriptions derived from a life of the saint written by his disciple Anthony enable one to decipher the subject of the pictures. First, without regard to chronology, come the episodes of his tenure on top of the famous, miracle-working column outside Antioch: the woman delivered of the serpent she has swallowed; the death of Simeon's mother who had been forbidden by him to go beyond the wall which kept all women away from the column, with the promise that the two were sure to meet in another life. She is shown twice: standing, an arm imploringly outstretched toward her elevated son, and again recumbent, dead, presumably on the spot she yearned for in life, the foot of the column, where Simeon had her buried. Then follow earlier events of the Stylite's life. The young Simeon enters a church in time to hear the lection, which is on continence. When its meaning is explained to him by an old man who is present, Simeon's mind is decided. He joins a monastery and sets about to mortify the flesh. He rings his body with a rope so tight as to cut through the skin. The flesh rots, and the stench alerts his superior, who has him forcefully unbound.

About three hundred feet away is another hermitage inhabited by one with the clearly emulative name of Simeon.[4] It is a small cavern with a depression in the floor to contain water, and niches in the wall, the smaller ones to serve as cupboards, one large one with a bench for a bed, and another to serve as the tomb. On the walls, prayerful exhortations.

Christ is the gate of those who are here:
Who banishes sadness and heralds joy.

And a long epitaph which ends with the plea:

While yet alive I dug this burial cave:
Receive me, tomb, as you have the Stylite.

The shape of the rock and the high position of the living space within it become significant in the context of St. Simeon's elevated existence. Tall "needle-rocks" of this kind were in fact *styloi,* columns, formed by nature rather than man; and their inhabitants, legitimate spiritual

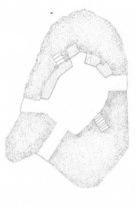

second floor

Figure 3
Hermitage at Zilve:
exterior of the rock and
plan of three levels.

first floor

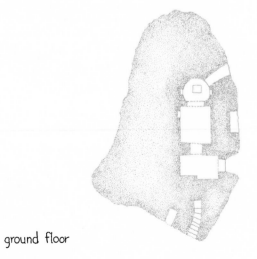

ground floor

feet
metres

north

children of the first stylite. Outside of Cappadocia, this same identification of specific natural forms with eremitical columns is documented in places such as Latmos to the southwest and Meteora in Greece. Sometimes needle-rocks with a cell of the type we have just described were distinguished from those without, but the distinction between an *inclusus* or inhabitant of the first type and a stylite proper was never very sharp.[5]

Monasteries

It is possible that some of the hermits at Zilve, and elsewhere in the troglodytic region, lived apart for most of the year but gathered in a monastic establishment on feast days for services and meals. This arrangement would be consonant with the *lavra* system of Eastern monasticism, which was first developed in Palestine. It existed concurrently with the more orthodox *coenobitical* system whereby monks lived and worked together at all times, according to the dictates of a rule. One recalls that the great Basil had himself attempted to reconcile the eremitical and the common life by founding cells for hermits and ascetics close to monasteries, "that the life of contemplation might not be divorced from community life or the active life from contemplation, but, like the land and the sea, they might interchange their blessings and be united in their sole object, the glory of God."[6] Later, in fact, the monastic bond was formalized by decree. One was not permitted to live alone without first spending a minimum of three years in a community (special legislation by the emperor Justinian, 535–546). And even then one was often dependent on a monastery for one's nourishment. With the lavra system operative in Cappadocia, it would be easier to understand the sense of communality in the plural of "those who are here" in the inscription at the hermitage just described. The system would also explain why, frequently, the rockcut monasteries do not seem to have sleeping accommodations, but always include an ample refectory. It would, however, be unwise to insist on this point since the monasteries have been inadequately studied and since the purpose of most of the rooms in them is impossible to identify.

The church and the refectory are in fact the only obvious spaces in the layout of the monasteries, the latter because of a long table and benches, fashioned from the same continuous rock as the hall itself (Pl. 15). At one end of the refectory, or at both as in the case of the monastery of Karanlïk Kilise ("The Dark Church"), an apse marked the seat of honor (Fig. 4). This was clearly for the *higoumenos* or superior, who was given autocratic power in the Basilian Rule. The disposition is similar to the refectories (*trapezai*) of Middle Byzantine monasteries in Greece. Sometimes, as at the monastery of the Archangelos near Cemil, the refectory would be divided into two by an arcade down its length. Non-Cappadocian parallels for this feature can be found close at hand. One instance is at Değile in the region of Kara Dağ, not far from Konya, an area imaginatively explored more than a half century ago by Sir William Ramsay and Miss Gertrude Bell; another is at the monastery of Akkale ("White Fort") on the Cilician coast.[7]

Plate 15
Göreme, monastery near
Karanlīk Kilise, view of
refectory.
[Photo David Gebhard]

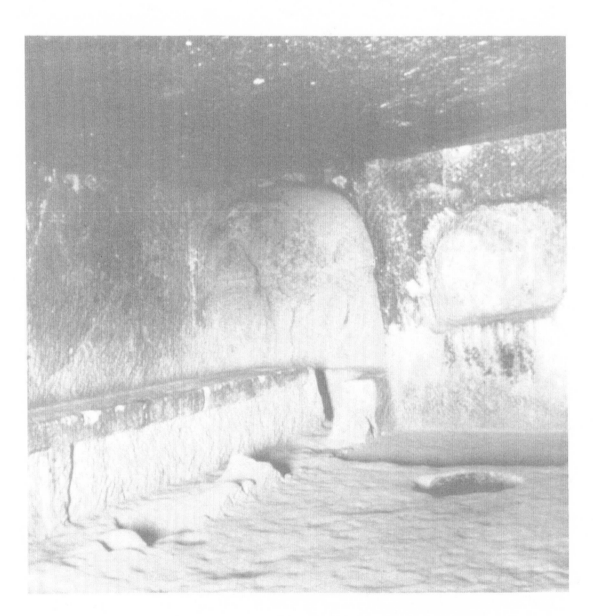

Most of the remaining rooms are not particularly interesting. They were usually small, of erratic shape, and seem to have served humble functions like storage. On occasion, however, one imposing hall, in addition to the church and refectory, would be singled out for special treatment. At the monastery of Bezirhane near Maçan (Avcīlar),[8] dedicated, according to an inscription, to St. Theodore, this hall is centrally disposed at right angles to an entrance vestibule of considerable size. The hall measures somewhat over thirty feet in either dimension and is divided into three aisles by arcades on columns. The central aisle culminates in a barrel vault, carved of course, the flanking ones in flat ceilings. (The two apses which give the hall the general appearance of an early Christian basilica are actually additions of a later time.) Both the vestibule, itself barrel-vaulted, and the hall are soberly decorated with plain moldings and some painted ornament (see Fig. 20). The church, to be discussed later, opens out of the right side of the vestibule.

This same arrangement of vestibule, hall, and church is repeated at the monastery of Karanlĭk Kale ("The Dark Fort") in the valley of Peristrema (Fig. 5).[9] The complex, one of the largest monastic establishments of Cappadocia yet studied, is carved deep into one of two sheer cliffs of rock which define this forbidding canyon, and is distinguished from the outside only by two simple entrances. The right one marks a direct approach to the church, which is reached by means of a corridor, its flat ceiling enlivened by a pattern of crosses in relief inscribed in sunken lozenges (Fig. 6). The other entrance is to the monastery proper. It opens into a sizable vestibule which leads, at one end, to the church, and toward the north to three rooms of which the westernmost communicates with a series of further rooms by means of a narrow passage, now blocked. The hall is on an axis with the main outer entrance, again set at right angles to the vestibule. This hall, too, has a decorated ceiling, and in its walls are sunk shallow rectangular niches between engaged piers joined by horseshoe arches; of this feature more later. The Thierrys consider the hall to be perhaps a kind of chapter house, though a meeting space of this kind is not a regular feature of eastern monasteries.

The double approach to the church at Karanlĭk Kale, directly from the outside and again from within the monastery, reflects a dual responsibility. It demonstrates that monastic establishments in Cappadocia were not wholly introverted. Wherever they were to be found, monasteries were often closely identified with villages. Monastic churches, with few exceptions, were

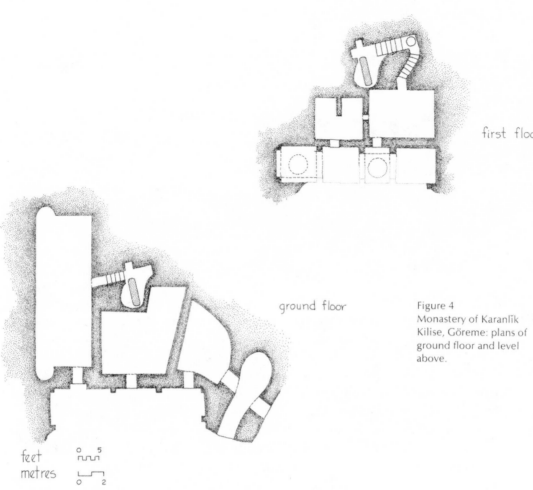

first floor

ground floor

Figure 4
Monastery of Karanlïk
Kilise, Göreme: plans of
ground floor and level
above.

feet
metres

Figure 5
Monastery called Karanlïk
Kale ("The Dark Fort"),
valley of Peristrema:
ground plan.

feet
metres

north

Figure 6
Monastery called Karanlĭk
Kale: interior view of cor-
ridor leading to church
from the outside.

attended also by the villagers, and the distinction between these and parish churches must never have been rigid. In the absence of a strong and continuous civil administration, it was natural for monasteries to become the dominant force in this provincial society. Monasticism was a powerful political force in the cities as well, throughout the Byzantine empire, and this position was sustained even after the ninth century, when the ranks of the once populous centers were drastically thinned—partly because of the exodus of monks during the hundred years of imperially directed Iconoclasm, and partly because of fiscal difficulties. In Cappadocia monasteries had, in the main, always been very modest in size. It is doubtful that any of them could accommodate a community of more than twenty or so. St. Basil himself had insisted on a modest scale for coenobitical units so that the monks would know each other well and be in personal contact with the superior. It is true that later restrictions (under Emperor Basil II in 987) established that only those would be deemed officially monasteries which had a minimum population of eight to ten monks with evident means of support. But the purpose of such imperial legislation was to correct financial abuses by private individuals who took advantage of the fact that monasteries were tax exempt, and these backwater communities would hardly have been affected. And yet, despite the lack of large corporate organization, or is it really because of it, monasteries were central to the life of the secular society. In an area where isolation from the influence of the capital was acute and danger from the outside a constant threat, the villages and small towns looked to the monk, imitator of Christ and the embodiment (in theory at least) of selflessness, for preeminent leadership in all aspects of their difficult existence.

This closeness of monastic and lay communities figured in Basilian thought from the beginning. Retreat from society was not intended to be equated with retreat from social responsibility. The Rule provided that the brethren be mindful of the welfare of the sick and poor. In it, too, the education of children and the care of orphans were deemed relevant monkish tasks. The entrance porches of monastic chapels and churches at Göreme contain a good number of tombs obviously carved for little children. (Most of them seem too young to have been inmates; the minimum age for entering a monastery, as fixed by the Council *in Trullo* meeting in Constantinople in 691 and reaffirmed by Emperor Leo the Wise in the ninth century, was ten; tonsure came at sixteen or seventeen.) And social contact would not be exclusively charitable. There were, as an instance, specifications for work outside the monastery, and for the sale of

produce and handicraft in public markets. Furthermore, and this is important, in contrast to Egypt and the Holy Land, the Rule did not attempt to divorce monastic ritual from the ritual of the official church. In Egyptian monasteries, away from all contact with villages and towns, a separate order of daily services had early been introduced: the required two daily *synaxes* had no parallel in normal church office. Not so in Cappadocia. Here St. Basil adopted morning and evening services from the general usage of the church, and added to these a monastic cursus comprising tierce, sext, nones, and compline, and a midnight service called *mesonyktion*.[10] Even these, however, were no more than the institutionalization of general early Christian church practice, as recommended, for example, in the *Didachē*.

The morning service, which was parallel to the *orthros* of nonmonastic churches, consisted of hymns and canticles. It came at daybreak, in fulfillment of the Psalmist's words

My voice shalt thou hear in the morning, O Lord; in the morning will I direct my prayer unto thee and will look up. (Ps. 5:3)

Then the monks began the day's work. But prayer did not cease. All through the long day there was mental prayer or contemplation, and vocal prayer or divine psalmody when the brethren would sing hymns in unison to relieve drudgery and fatigue. To St. Basil it was more. It was proof of the joy of doing. The brethren, by coupling physical labor with prayer, were emulating angels, who honored God in this same way.[11] Work in fact was a form of prayer. Tierce, sext, and nones served merely as formal recesses until the day's work was done. Then came the only meal of the day, which opened with a prayer of thanks to God for whatever had come to pass since dawn that was good and an expression of contrition for sins of word and deed and for sins of thought. Compline, which followed the meal, consisted of the recitation of Psalm 90:

Lord, thou hast been our dwelling place in all generations.

And the brethren could retire until the *mesonyktion*, with which the long day closed.

Monastic Centers

For purposes of defense, among other reasons, monasteries (including apparently communities of women, if one can judge from certain inscriptions)[12] tended to exist in clusters. So far, four principal monastic centers have been investigated: Peristrema, Soğanlĭ Dere, Göreme, and Açĭk Saray.

The valley of Peristrema is the least known and the hardest to explore. The Greek name, no longer in use today among the sparse Turkish population, is undoubtedly descriptive of the sinuous path of the Melendiz river which determines the valley. This frigid stream trickles or roars, depending on the season, over a narrow bed of rocks fringed with poplars and willow trees. From here upward two tall vertical cliffs follow the whims of its sinuosity, monuments in tuff to its millennial, single-minded course. Their faces are cut into sharply arrised pillars and look, to the person scrambling on the rough edges of the riverbed, like a giant natural order. The monasteries find shelter in these sheer bluffs. Their entrances, hard of access, are often camouflaged by shrubs.

A landscape of like roughness, probably this very valley, as I would like to believe, is humorously described in a letter written in 361 by St. Gregory of Nazianzus to his friend St. Basil, then secluded still in his Pontic retreat. I cannot resist quoting it in extenso. Nazianzus, where Gregory was born, is a stone's throw from Peristrema; never a strapping town, its memory is now retained in the miserable village of Nenezi (Fig. 2). Nearby, a little distance to the southeast, is Sasima, another humble town of which Gregory was to be made bishop, much against his will, soon after Basil acceded to the see of Caesarea. So Gregory knew well this wild of western Cappadocia by the Melendiz and the tenuous string of hamlets that passed for towns. In answer to a letter from St. Basil,[13] then—in which Basil gives a rapturous account of the savage and beautiful spot in the Pontus where he had found infinite tranquillity, and jocularly dismisses Gregory's own district as "that pit of the whole world"—Gregory reworks Basil's description to mock it and to show that he had not been taken in by it. What results is a word picture of the savage and beautiful spot that might be Peristrema.

"I admire, too, (Gregory writes) your straight and narrow path—I don't know if it leads to the Kingdom of Heaven or to Hell, but let's for your sake say Heaven—and in the midst of all this, what would you have me call it? Would you have me lie and call it Paradise with its spring that

sends forth the Four Rivers to water the earth? Or, rather, arid and waterless desert which only a Moses can tame bringing water out of the rock with his rod? For all that is not rock is gullies and all that is not gullies is bramble, and what is not bramble is precipice. And the road above all this, craggy and tortuous, boggles the wayfarer and for safety's sake makes an acrobat of him. Down below roars a river . . . teaming less with fish than rocks, and instead of running into a lake it plunges into the abyss . . . It is huge, this river, and terrible, and its reverberation drowns out the psalmody of the brethren who live above it. The cataracts of the Nile are nothing to it, so it rages day and night against you. Being unruly, it is unnavigable: being murky, undrinkable. You are lucky if your cell doesn't get swept away when torrents and winter storms set it going."[14]

Two separate clusters of monasteries may be distinguished here. At the south end of the canyon, beginning with the modern village of Ihlara, the group of monasteries and their churches seems to be older. The decorative programs, to be discussed later, are of a robust crudity and painted in a manner encountered nowhere else in Cappadocia. Their affinity is with remote provincial traditions of the Christian East—Coptic, Armenian. After the second bend of the Melendiz north of Ihlara, the monasteries and churches become more sophisticated and their painted programs show clear familiarity with metropolitan trends of Middle Byzantine decoration. Karanlïk Kale, described on p. 53, belongs to this group. Still further north, by the village of Selime on the right bank of the river, the monasteries remain unexplored. The Thierrys briefly comment on one, a vast monastic establishment arranged about an open court.[15] Its church is a three-aisled basilica, like those of the early Christian centuries.

Now the notion of an inner court is worth attention. It introduces an organizing principle in apparent contrast to the common concern in the monasteries for catacombal sequences—that is, the random and serial arrangement of rooms, all but the ones closest to the rock surface almost totally deprived of natural light. The inner court serves at once as a light well for rooms, including the church, that open out from it on all four sides, and also as a cloisterlike private open space for the brethren, in the midst of their honeycombed gloom.

There are at least two other known examples of a court. At the newly published monastery of Eski Gümüş near Niğde (Cat. no. 49), the walls of the inner court are forty-five feet high and

60
Monastic Centers

each side is of equal length. The north wall is worked to look like a facade. Beamholes suggest that the court was begirt with wooden galleries. At Aynalĭ Kilise ("Church of Mirrors"), near Göreme, I am not sure that we can speak of an inner court (Fig. 7).[16] As is evident from the plan, three sides only survive. The north wall may have caved in or been washed away. More probably it did not exist at all. The rock was rather hewn to form a kind of forecourt, exposed to the daylight, with rooms opening out on three sides. The church here too is a three-aisled basilica; it is preceded to the west by a barrel-vaulted hall divided into three bays by diaphragm arches. A little corner room where the stairs were that connected the ground floor with upper rooms could be blocked off, in time of danger, by a huge stone tightly fitted between the door and two freestanding piers.

Aynalĭ Kilise overlooks a small valley in Göreme, just off the road to Ürgüp. It lies in the east part of the troglodytic area under review in this book, the territory made famous by Jerphanion. All three of the remaining centers of monasticism, to return to them, are located here: Soğanlĭ Dere, Göreme and its periphery, and Açĭksaray ("Open Palace") beyond Nevşehir on the left bank of a tributary of Kĭzĭlĭrmak.

Soğanlĭ Dere, like Peristrema, is a valley. But unlike it, the bed here is broad, admitting of traversable roadways, and the sides are gentle slopes crowned by a continuous band of vertical tuff. This natural cornice, so to call it, represents the beginnings of a triangular ridge that separates this valley from the valley of Dereköy, in which one finds the little towns of Ortaköy and Güzelöz (Mavrucan) (Fig. 2). Again unlike Peristrema, the monasteries of Soğanlĭ Dere are carved, for the most part, not in the vertical faces of this crowning band of tuff, but rather in clusters of cones sitting lightly on the edges of the valley bed between the roadway and the bare slopes beyond. We shall have occasion to speak of some of these constellations further on when the discussion centers more specifically on churches and their decoration. An example is the group of cones called Belli Kilise ("The Obvious Church"; Cat. no. 24) where the tip of one cone has been fashioned externally in the semblance of a conical dome on a drum, and given a polychrome coat of painting—the only rockcut church in Cappadocia, as we mentioned on p. 28 in another context, to exhibit its dome as an exterior form.

Göreme and its periphery, the third principal center of monasteries, is less sweeping. It has neither the drama, the elemental majesty, of the valley of Peristrema, nor the ample if arid

Figure 7
Monastery called Aynalï
Kilise ("Church of Mir-
rors"), near Göreme:
ground plan.

Following pages
Plate 16
Göreme, monastery near
Karanlïk Kilise, entrance
vestibule, detail of upper
story.
[Photo Harold Stump]

Plate 17
Göreme, monastery near
Karanlïk Kilise, entrance
vestibule, detail of lower
story.
[Photo David Gebhard]

feet
metres

0 5

0 2

north

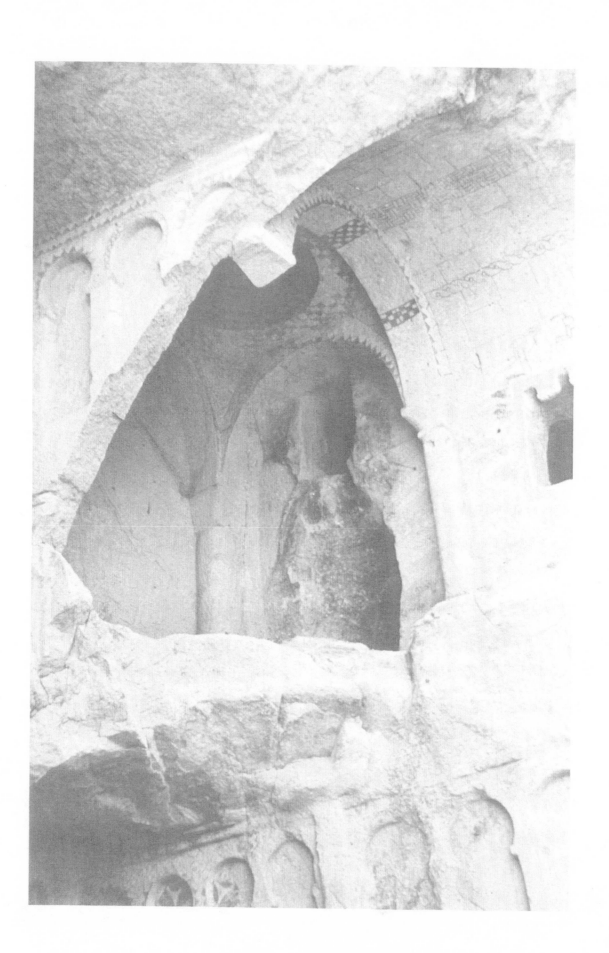

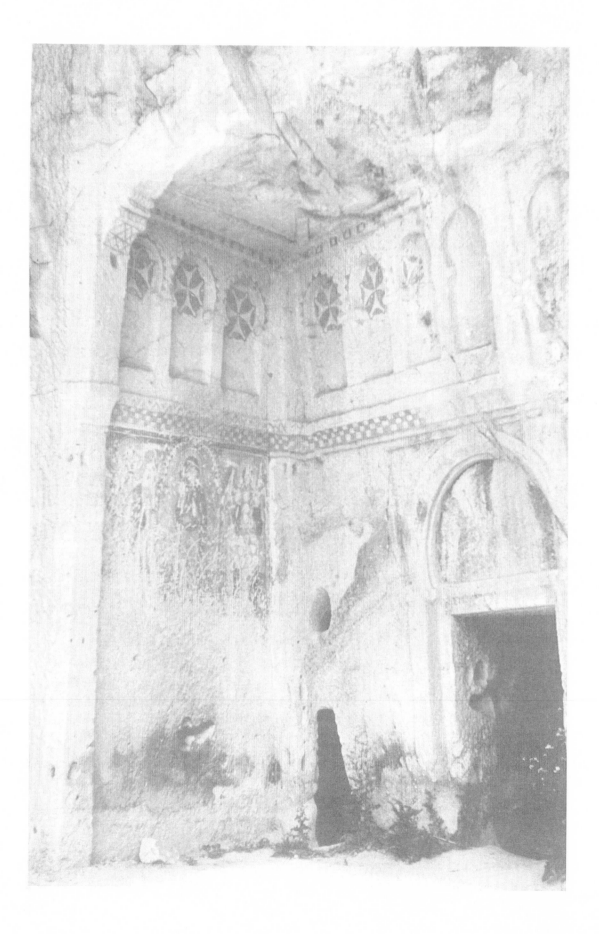

definition of Soğanlĭ Dere. The level of usable paths rises and falls along an intricate pattern. There are intimate ravines with enough greenery to make them seem inhabited. No continuous lines of escarpment unite their banks. Rather, many sculptured shapes, large and small, pointed, knobby, or slabbed, crowd in around the clearing and climb up picturesquely toward the open sky. The complex, turreted skyline is the stuff of fairy castles: to each man his own fantasy. It is not difficult to see how to Hans Rott in 1908 they should have evoked Hansel and Gretel, the cookie houses of his childhood, and bewitched castles and twilight grottoes of the Walpurgis-nacht. In this kaleidoscopic scenery, the monasteries have claimed firm, large shapes. Kĭzlar Kalesi, whose name ("Fort of Maidens") may retain the memory of a monastic community for women, is a gothic crag gouged with black openings. Its multistoried excavations include several chapels. Nearby, in a massive stretch of rock hides the monastery of Karanlĭk Kilise, which has already been mentioned in relation to its refectory.

In point of fact, this monastery "hides" no longer. The whole entrance side has collapsed some time ago (all but for an upper corner) to reveal to the sunlight a two-story vestibule running the length of what must have been an ambitious facade (Fig. 4). The features of this vestibule might well serve to introduce us, at this time, to the architectural language of the Cappadocian carver-architects, a language we shall often encounter in the monuments yet to be described. The upper story is composed of four bays marked by pairs of columns and piers, both engaged, and roofed by cupolas and barrel vaults arranged alternately (Pl. 16). Contours of the architecture are picked up in red paint: some show purely ornamental motifs—chevron, guilloche, or checkerboard; others attempt to simulate structural details like cutstone masonry and sawtooth cornices. In the lower story, the long wall that has been exposed to view is divided into three bays by two main pilasters which run from floor level to the beginning of the vault (Pl. 17). A simple molding marks out the top of the wall as a blind gallery. Here, there is a frieze of flat arches grouped alternately into twos and threes by the main pilasters and by subsidiary dividers at gallery level. Small Maltese crosses in red medallions fill the tympana of the arcades.

Facades

Pilaster strips, friezes of blind arcading, and painted ornament—these were undoubtedly the design elements of the destroyed two-story façade of Karanlĭk Kilise that once corresponded to the two-story vestibule just described. The effect of such a splendid frontispiece in this rock wilderness must have been extraordinary. Most other monasteries, one must remember, communicated with the outside by simple entrance openings, hardly to be distinguished from entrances to chapels and habitations. The monumental proclamation of Karanlĭk Kilise was exceptional; but nevertheless, it was not unique. We are fortunate to have still extant a small number of facades that demonstrate that modesty and inconspicuousness, though formally prescribed, were not universally sought by the monkish population of Cappadocia.

The best preserved of them are at Açĭk Saray, the fourth and final monastic center to be considered. One is illustrated (Fig. 8). Two piers boldly project from the sunken plane of the facade to define vertical bays of two stories. The tall ground story comprises three doors, one in each bay, surmounted by horseshoe arches. A double cornice of some elegance runs through the length of this story at the level of the door lintels. Above this the arched openings of the side bays are flanked by small keyhole-shaped arches, while the central arch is inscribed in a pediment and has a solid tympanum perforated by a pair of the same small arches. This central focus is carried upward into the second story where a blind window topped by a segmental arch stands in the middle of a delicate frieze of arcading, also blind. Finally, on a forward plane, slightly off center over the main bay, rests a narrow panel of blind arcading denoting, as it were, an attic story. Behind this emphatic facade lies a transverse vestibule of the kind we have met in Karanlĭk Kale at Peristrema and in Karanlĭk Kilise near Göreme (Figs. 4–5). Except for a flat ceiling marked by a huge cross in high relief, its decoration is identical with the latter of these.

The elements with which the Açĭksaray facade is articulated are typical. They appear, in different compositions, in all the other facades that survive, both at Açĭksaray and elsewhere: in the valley of Peristrema, for example, a facade at Yaprakhisar, another at Belisĭrma, and a third halfway between Belisĭrma and Ihlara, to the north of Sümbüllü Kilise (Figs. 9–10). The last of these is only one story high, surmounted by a continuous attic frieze of small arches: unusually, they are not noticeably horseshoe-shaped. The attic frieze, considerably salient, rests on rectangular piers whose angles are beveled. At the top they have deep concave side indents that define a simple capital form. Between the piers there are, alternately, arched entranceways and

Figure 8
Monastery "E", Açïk Saray:
facade.

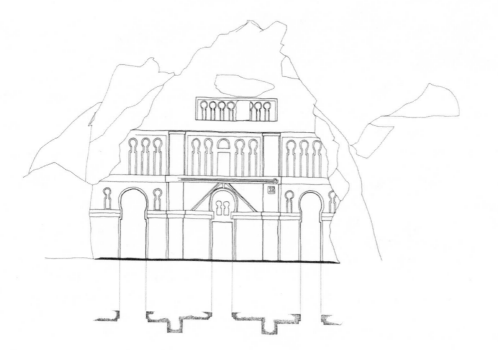

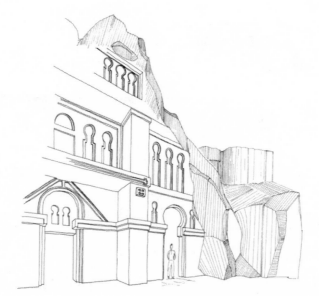

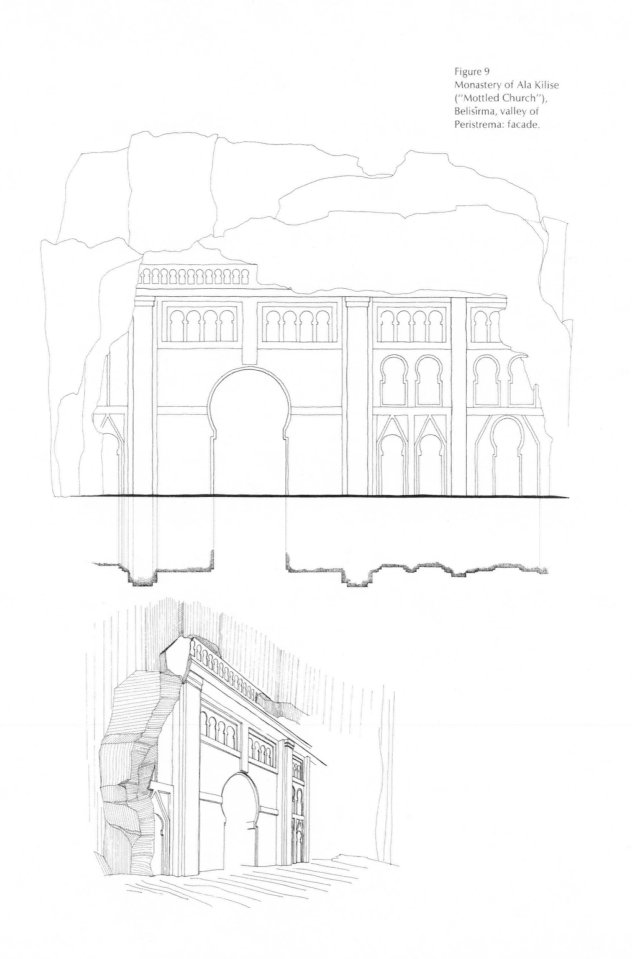

Figure 9
Monastery of Ala Kilise
("Mottled Church"),
Belisırma, valley of
Peristrema: facade.

Figure 10
Nameless monastery,
south of Belisĭrma, valley
of Peristrema: facade.

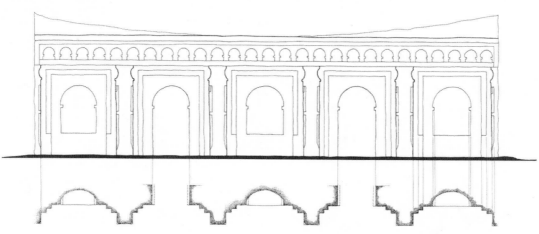

semicircular niches with segmental tops. Both entranceways and niches are set neatly in rectangular frames of double-line moldings.

The feeling of this stately wall composition is remarkably Classical; its civilizing order is made more potent by contrast with the brutish cliff that broods above it. To separate the man-made from the raw, the carver-architect has provided a sweeping concave ledge whose ends flare out over the attic frieze in a gesture of solicitous protection. This is no product of rustic imagination. The monk who envisaged it could not have been innocent of monumental architecture. Indeed, there can be little doubt that the original progenitors of this and all the other Cappadocian frontispieces to monasteries are Late Antique facades to palaces, formal fountains (*nymphaea*), and theater stages (*scaenae frontes*). Examples still survive in the Near East, as well as North Africa, in Greco-Roman provincial cities like Gerasa, Aspendos, and Miletus.

The descendance is not, of course, direct. The lighthearted, skeletal piling of Late Antique facades is gone here in favor of a frigid, opaque order. At the same time, the lush Classical entablatures and the fluting of upright members have also disappeared. In the Cappadocian facades, upright members are, with two or three exceptions soon to be considered, never columns, free or engaged, but rather prosaic pilaster strips and piers. In fact, at Cappadocia the grid of upright and horizontal elements which frames the facade composition, although eventually derived from Greco-Roman column orders and entablatures, has been so abstracted as to forfeit all but the most general Classical affiliation.

There are, to be sure, significant intermediaries in this transformation of the Classical. Between Peristrema and Açĭk Saray on the one hand and Late Antique facades like the *scaenae frons* of the theater at Aspendos, say, or the market gate at Miletus on the other, lie eastern interpretations and recastings of the Classical schemes, whether in lands under Byzantine rule or outside it. Thus, to speak of details first, the arch circumscribed by a triangle, a motif we encounter more than once in Cappadocia (Fig. 8), was a recurrent theme in the Christian architecture of Syria. To this source, too, may be attributed some of the linear moldings, and also the system of diaphragm arches, noted in the case of the vestibule of Aynalĭ Kilise (Fig. 7), that compartmentalize a transverse barrel vault.

But in general effect, the monastic facades of Cappadocia seem closest to Persian facades of Parthian and Sassanian times, themselves of Classical derivation. We might cite the Parthian

Plate 18
Avcĭlar (Maçan), rock-cone
with columnar facade.
[Photo Melvin Charney]

palace at Ashur (as reconstructed in the Berlin Museum) and the familiar facade of the Taq-i Kisra at Ctesiphon.[17] These share with the rockcut monasteries an architectural scheme of blind arcades grouped and framed by a grid of horizontal and vertical elements. The type was continued in the East by Muslim architects in facades like the north front of the central court at the palace of Ukhaidir, dating in the eighth century.[18] But note that in Cappadocia, the arches are almost invariably horseshoe-shaped. This feature (and the employment of pediments to mark the entrance or crown the facade) are alien to Persian design. The horseshoe arch, although probably of Syrian origin, had a wide currency in the Muslim East by the time the Cappadocian monasteries under discussion were being carved. It is the most persistent theme of the troglodytic monuments—in plan (e.g., horseshoe-shaped apses) as well as in elevation— and may well have been absorbed from the architectural vocabulary of the Muslim neighbors.

We mentioned exceptions: Cappadocian facades, that is, where the upright members are not rectangular as is the rule, but are full-blown columns instead. Let us now briefly look at these. Early travelers, at first blush, took them to be relics of pagan antiquity, temples perhaps or tombs; and this is not impossible. One such is the small facade at Maçan (Avcĭlar), a panel really, set halfway up in the face of a stout cone, Jerphanion's "grand cône de Matchan" (Pl. 18).[19] Two single columns in a frame, nothing more; and of these most of the shaft has been knocked off, so that the top parts hang from the dark cone cap like a pair of icicles. From an identical arrangement in another cone, one whole column stands.[20]

Much grander than these two, though equally damaged, is the columnar facade in the nearby town of Çavuşin. The town is cradled in a broad cyclorama of rock. The houses, gay white cubes with sash windows and trim, scramble upward all the way to the basalt cresting that rims this steep container. They stand out in their neat geometry, and also by contrast to the earth tones of the raw cliff behind, and look as if they were proud to have freed themselves of rocky bondage. The old caves and fissures are still used of course, as storerooms, cellars, and stables. At one end of the hemicycle, under the dangerously riddled curve of rock, is the mosque. It looks in most ways like the houses among which it nestles, except for the odd, wispy minaret—a baldachin of four colonnettes holding up a pinnacle—of a type that we have earlier linked to Byzantine *ciboria*.

The facade in question is a little higher, flush with the curve of rock (Pl. 19). It was, more

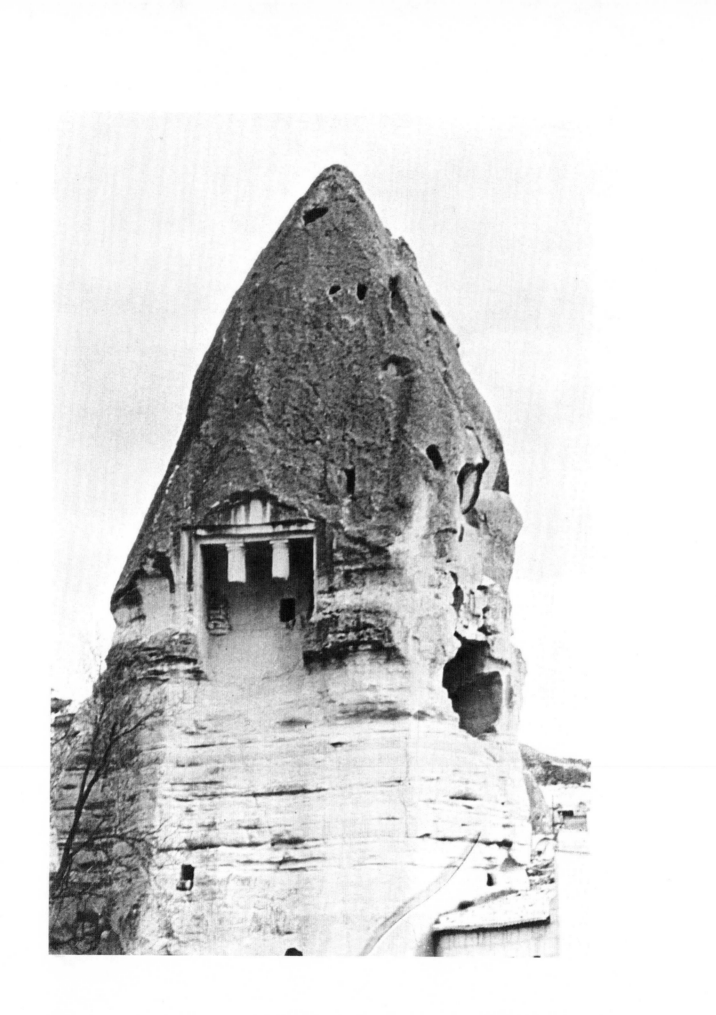

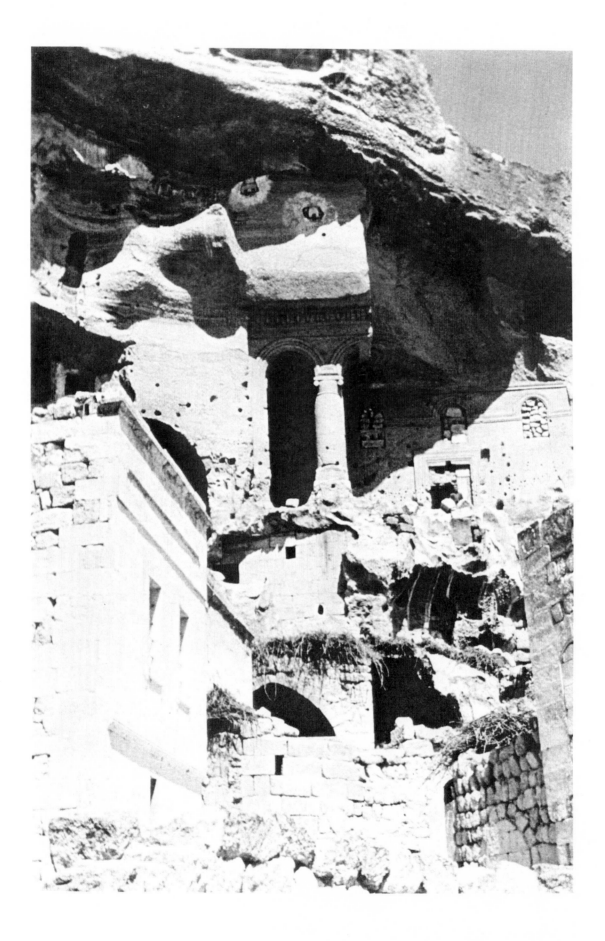

Plate 19
Çavuşin, St. John the
Baptist, facade.
[Photo Melvin Charney]

Figure 11
St. John the Baptist,
Çavuşin: reconstruction of
facade.

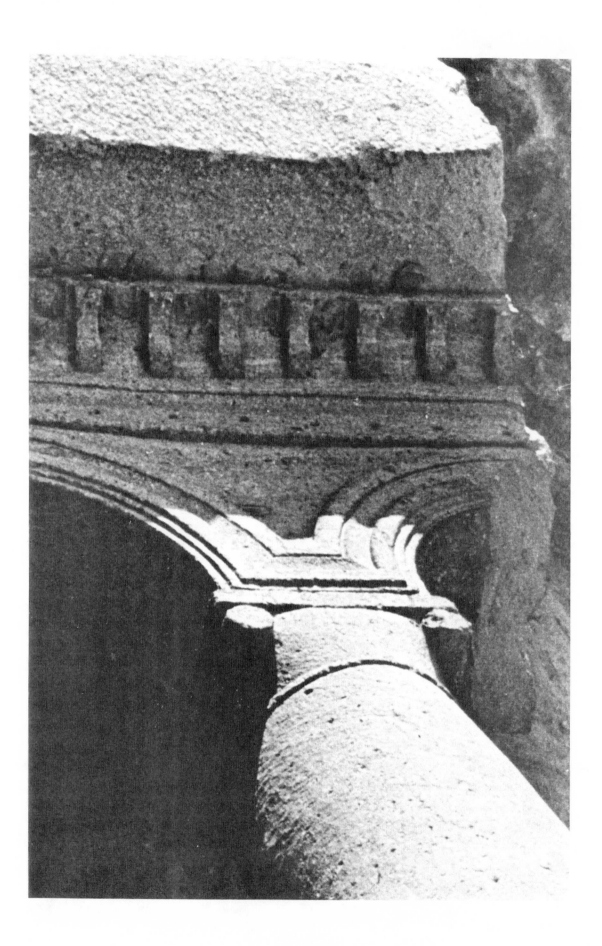

Plate 20
Çavuşin, St. John the
Baptist, close-up of facade.
[Photo Melvin Charney]

properly, an open arcaded porch *in antis* of which one end still stands. This fragment will suffice to reconstruct its original aspect (Fig. 11). The columns were stubby and unfluted. There were perhaps as many as five. They stood on thickset bases, rectangular and very high in comparison to the length of the shaft. After a simple fillet that served as necking, the shaft bulged out to form an uncarved capital of an order that may be termed rustic Ionic (Pl. 20). Actually the shape is precisely that of one of the sixth-century capital forms used in Hagia Sophia at Constantinople, but without the deeply undercut foliage which graces it.[21] In the rock churches it was quite common for carved ornament of this kind to be rendered in painting; this may well have been the case, or the intention, at Çavuşin. The arches rested on these capitals without the intervention of impost blocks. A string course of several parallel bands traced their outline, and above this in turn came a rudimentary cornice with prominent, concave dentils. These details are in the Syrian manner of the sixth century.

All this is, true, far removed from Late Antique architecture. But that it *precedes* the facades of Açık Saray and Peristrema discussed earlier is beyond doubt (Figs. 8–10). For these last, P. Verzone has recently suggested a date between the beginning of the eighth century and the middle of the ninth. If this estimate is anywhere near being accurate, the Çavuşin facade should be placed perhaps as much as two hundred years earlier, but in any case probably before the advent of the Arabs in 642. Jerphanion considered it one of the oldest rockcut structures to survive in Cappadocia, and his contention is upheld not only by the nature of the facade we have described but also by what lies behind. Here we do not have an architectural preface to a monastery but to an independent church. And being so early in the sequence of troglodytic monuments, we might take it as our starting point for a description now of churches, hitherto mentioned but not discussed, as a separate class of buildings.

Churches

As rockcut churches in Cappadocia go the Çavuşin specimen, some twenty-seven feet deep, is not small. You enter it through one of three identical doors. These, together with a row of roundheaded windows above, comprise the church facade proper once you have gone beyond the columnar porch we have described. Each door corresponds to a vessel, the central and main one being a squarish nave with an enormous apse, a horseshoe in plan; the vessel to the north being an apsed aisle; and that to the south also an aisle, but wider than its companion and with a rectangular room, perhaps of later excavation, in place of an apse.

At present solid walls divide the vessels. But the original scheme, embedded in them, is easy to reconstruct: arcades very like those of the porch resting, at each side of the nave, on two columns and a large pier. All three vessels had flat ceilings with carved ornament upon them, of which traces are still evident. The central apse, raised above the nave floor, was articulated by a cornice which divided the conch from the lower wall. The apse was closed off initially by a chancel screen. Behind it, in the center of the arc, there was a large notable throne flanked by curved benches, all cut from the same rock fabric. To judge from the stress in its painted program upon the iconography of St. John the Baptist, the church would appear to have been dedicated to him.

Now both the plan and the "furniture" of St. John deserve comment in assessing the building's antiquity. Let us begin with the plan. The three-aisled hall-like basilica, with its many variations, was the most pervasive scheme in early Christian church architecture throughout both East and West. It was overcome slowly, beginning with the famous architectural experiments of the age of Justinian in the sixth century, such as Hagia Sophia and SS. Sergius and Bacchus in Constantinople. What replaced it was a variety of domical schemes in which the nave relinquished its single-minded directional drive toward the apse in favor of a progressively more centralized space composition.

Three-Aisled Basilica,
One-Aisled Basilica

In Cappadocia itself, contrary to coastal Asia Minor, the three-aisled basilica was not common.[22] When employed, nave and aisles would almost invariably be vaulted and not timber-roofed, as was also the case in other regions of the East lacking in ready wood. The standard type here was simpler, more intimate: one single rectangular chamber with an oversized apse (Fig. 12). At times there would be two small side apses too, but in the rockcut examples they were filled entirely by their altars.[23] The aisleless nave culminated in a barrel vault, or occasionally in a flat ceiling: the latter is probably, though not necessarily, the older of the two. But whether flat or vaulted, the ceiling—and we are now talking of the rockcut churches—did not rest directly on the walls but rather on a continuous corbelling that appreciably relieved the oppression of the physical appearance of these serried and confining interior spaces.

This aisleless scheme suited the tiny scale of country churches. They were designed to embrace small local congregations, mere handfuls of rural folk and monks. Few churches had drawing power beyond their immediate community. And even then there were too many. Practical community needs hardly account for the scores of little churches built up quickly of cut-stone by local masons or excavated in the live rock, and as quickly grown familiar and perhaps ignored. The act of building was need enough. For the rich the building of a church could stand for the fulfillment of a vow: a disaster safely hurdled, a long disease lived through. Or it could be a pious offering, no more than that, to honor the memory of a deceased spouse or parent or to help defray the high cost of sin. To the monk, no doubt, the hallowing of mute stone into sanctuary was more. It was physical expiation. The wealthy landlord might torture his purse to secure the spiritual comfort or advantage to be derived from a new cult building; the monk worked for the same gain. Much of monastic time and labor was expended to this end. The propriety of the effort had official sanction. St. Basil's Rule recognized architecture as one of the licit activities for monks along with agriculture, cobbling, carpentry, and blacksmith work. They were all useful arts, and as such free from the taint of luxury or naked profit; but architecture alone among them could bring forth products directly demonstrative of the maker's faith.

But to return to plans. What we are trying to establish is that the simple aisleless basilica with apse was the preferred scheme in Cappadocian church building for more reasons than the size of the congregations. As a form it was without pretense. It was the utmost reduction that the

Figure 12
Haçli Kilise ("Church of
the Cross"), valley of Kīzīl
Çukur: plan. (Cat. no. 5)

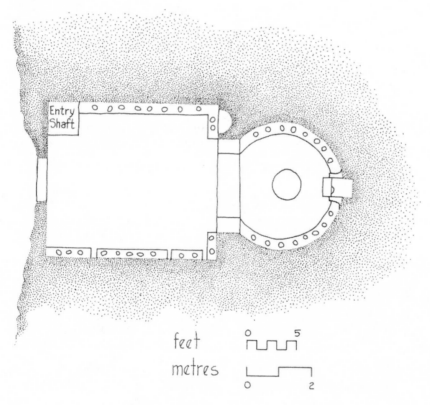

feet

metres

Christian basilica could undergo and still retain the symbolic validity of a church. It came within the means of the single donor or the single monk or hermit. And even when there did exist a program that might require more involved accommodation, the region chose to multiply this basic unit rather than complicate the plan. A common arrangement in the troglodytic area is to have pairs of aisleless chambers, two boxlike naves side by side joined by an arcade on piers. More often than not there is a common entrance placed either axially in front of one of the naves or else on the south side. Of the two naves, the north one is usually smaller; it serves as a funerary chapel, its floor lined with small and large tombs. But there may be more than two units to a complex. Karabaş Kilise at Soğanlï Dere (Cat. no. 50) has a series of four naves, apparently all part of a single effort of excavation.

It must be underlined at this point that the scheme of the *one-aisled basilica with single apse* (as we shall clumsily call it to distinguish it from the three-aisled basilica) persevered to the end, as the last churches listed in our Catalogue should demonstrate. This being the case, the form is in itself not always susceptible to precise dating. By contrast, the rare appearance of the three-aisled basilica, especially when it attempts to show flat ceilings, can be taken to be emulative of this typically early Christian form, and in any case probably no later than the seventh century. We are therefore justified in assigning an early date to St. John the Baptist at Çavuşin. This early Christian form also reflects upon the chronological standing of the monasteries to which it may be attached. Thus, given its basilical church with nave and two aisles, the monastery of Aynalï Kilise already discussed cannot be too far removed in date from St. John (Fig. 7).

The Early Christian
Phase

I would like to call this first chronological period in troglodytic Cappadocia the Early Christian Phase, and to assume that judging by the nature of the surviving monuments it applies to the time from about 500 to about 700. We have only a very few monuments that we can include here with any confidence. The three-aisled basilica is one relatively safe index. Architectural details like the columns, dentils, and molded string courses in St. John's porch, familiar from the early church architecture of Syria, may in themselves reveal the antiquity of some rockcut structure whose plan might otherwise be noncommital (Fig. 11). The separation of the conch from the lower wall of the apse by means of a cornice is usually also to be taken as a sign of early date. But in addition, scraps of decoration here and there, sculptured or painted, recall the vocabulary of early Christian art: crowns of martyrs, palms, deer, and of course the fish, that Christian symbol par excellence which owes its existence to the fact that the first letters of the formula "Jesus Christ, Son of God Savior," in Greek, yield the word for fish in that language, IXΘYC.

Based on such telltale fragments, we might add several unimportant chapels to the buildings of the Early Christian Phase. They are to be found at Zilve and in the small ravines of Balkam Dere and Güllü Dere near Göreme. One of these, a cruciform chapel at Balkam Dere (Cat. no. 1), seems to have escaped the eye of Jerphanion and has only just been published. The surviving south arm carries painted ornament, including a frieze of palmettes, that belatedly recalls Greco-Roman precedent. A complicated composition in the cupola, badly damaged, combines two triumphal themes, the Ascension and the Second Coming: it echoes pre-Byzantine schemes such at those of Coptic churches and of Hosios David at Thessaloniki.

You will notice that Zilve, Balkam Dere, and Güllü Dere are quite close to Çavuşin and to the location of Aynalï Kilise. Maçan (Avcïlar), where we noted two very early columnar facades, is also in this vicinity. It seems clear, therefore, that the geographic nucleus so defined represents one of the oldest monastic settlements in troglodytic Cappadocia. Some documentary support for this claim is afforded by the *Acts of St. Hieron*, about 600, our earliest written record for the rockcut architecture. It mentions, as you will recall (p. 19), two of the towns that fall within this nucleus: Göreme and Maçan (Korama and Matianoi).

No Christological cycle of any elaborate nature can be assigned to this Early Christian Phase. Of two possible candidates, the paintings of Açïkel Ağa Kilisesi (Cat. no. 9) near Belisïrma,

though strongly Early Christian in character, cannot convincingly be dated before the eighth century. And at the cruciform church at Mavrucan (Cat. no. 2), the oldest of two superimposed figural programs seemingly pertains to the Early Christian Phase, but the surface deterioration is quite advanced, so we cannot be positive.

But beyond plans, architectural details, and the symbolism and character of the decoration, we have still a further indication of early date, and that is the nature of the devotional atmosphere created by the "furniture" within the church. The cavernous central apse itself, often as wide as the nave, was of course standard for a very long time in the region. It was prominently horseshoe-shaped in plan. Its effect was ponderous and close. The disproportionate size may have been a consequence of the scale and simplicity of the nave. In the roomy metropolitan basilicas most of the nave space had been appropriated by the clergy as the stage of the elaborate liturgical drama; the congregation attended the proceedings from the aisles and galleries that wrapped themselves around the nave. In the absence of such ancillary spaces in the small rock churches, the apse absorbed much of the ritual function of the nave. A step or two led up to it; a triumphal arch, rising almost to the level of the nave ceiling, framed it. But there was usually room enough for a picture between the crown of the arch and the nave ceiling. That this was a special place, distinct from the public space of the nave (and aisles, when they existed), was further clarified by a chancel screen standing across the lower portion of the triumphal arch. It was made up of two panels of rock that left a passage gap in the middle. Through it the congregation could glimpse the altar—a rectangular block of rock left attached to the floor, and sometimes also to the apse curve at the back. Here in this sanctum, behind the visual barrier of the chancel screen (and sometimes also of drawn curtains), the mystery of transubstantiation, to which only consecrated persons may bear witness, took place with every celebration of the Mass.

All this was common for sanctuaries until the close of the tenth century. Not so the throne or *cathedra*, however, such as the one we have noted in St. John the Baptist, and the accompanying rock benches (*synthronon*) that follow the contour of the apse. It was here that the bishop, or the superior if the church was strictly monastic, sat during the celebration of Mass, flanked by his presbyters or council of elders. This liturgical furniture was usual for the churches in the East only during the early Christian centuries. There are numerous examples in extant

churches of northern Greece and Syria, as well as Constantinople (Hagia Irene) and Asia Minor (St. John at Ephesos). Probably the latest known instance is the sanctuary of St. Nicholas at Myra (Demre) in Lycia on the south coast: the date is disputed but may be in the eighth century.[24] In these non-Cappadocian churches the sanctuary projected into the nave by means of a short chancel which was circumscribed by parapets. A small ramp attached to the chancel led to a pulpit or *ambo,* set deeper still in the nave.

Only one example of the ambo is so far known in Cappadocia, in the as yet not adequately published basilical church near Maçan, called Durmuş Kilisesi after its present owner. This is a large three-aisled structure once lighted by windows cut in the side of the rock over the ceiling of the north aisle. The two-story high central nave is covered by a barrel vault; the aisles have flat ceilings. The decoration is architectural in nature and similar to that of St. John the Baptist. Without much effort we can link this ambitious building, which may have been the cathedral of ancient Matianoi, both with the Thousand and One Churches in nearby Karadağ and with three-aisled Early Christian basilicas in Syria. The ambo, on the other hand, points toward Greece. It is attached to the apse by a ramp and consists of a circular platform reached by stairs from east and west. Its axial location in the middle of the nave corresponds to Greek usage.[25]

But cathedra and synthronon figure in several rockcut churches besides Durmuş Kilisesi and St. John at Çavuşin; all these churches are clearly early. In one unusual case the synthronon is continued into the nave. This is the church called Haçlï Kilise near Çavuşin (Cat. no. 5), discovered only four years ago and published by the Thierrys (Fig. 12). It is a small monastic chapel, of the usual type. There are no aisles, only the deep apse and one broad rectangular nave with a flat ceiling that is covered by a carved Latin cross. The synthronon (or at least a rock bench like it) follows all along the north and south sides of the nave, and then turns inward toward the apse. Small hollows, regularly spaced, mark the actual seats. In the middle of the apse, on line with the superior's cathedra, is a deep circular hole about two and a half feet in diameter. Its purpose is unclear. It might perhaps be related to the *confessio* of early Christian churches in the West: a subterranean recess to contain relics. Finally, on the apse curve itself, taking up all of the conch semidome, an apocalyptic vision is painted.

On a lyre-shaped and bejeweled throne, set on a carpet of paradisiac green, Christ sits in majesty. His feet rest on a footstool as resplendent as the throne: above him arches the blue

canopy of the skies. He is swathed in an imperial robe of purple worn over an undergarment of a different color. In place of a diadem, a nimbus frames his sober face. One hand is lifted in benediction; with the other he supports the Book on his left knee which is raised to receive it. Surrounding this glorious image are the four beasts of the Apocalypse, nimbate and holding books: symbols, that is, of the four evangelists with their Gospels. The identity of each is inscribed, not with the saintly names, but, reading counterclockwise around the enthroned Christ, with the words ΑΔΟΝΤΑ ("singing") for the eagle, ΒΟΩΝΤΑ ("crying out") for the ox, ΚΕΚΡΑΓΟΤΑ ("shouting") for the lion, ΚΑΙΛΕΓΟΝΤΑ ("and saying") for the man. The source of these words is a prayer in Byzantine liturgy that introduced the chant of the *Trisagion* (Sanctus).[26]

The vision of the throne of God in heaven with its attendant beasts is common to Ezekiel and the Revelation of St. John the Divine. From these biblical sources, and in addition from the apocalyptic passages of Daniel and Isaiah, derive the remaining features of the apse composition we are describing. There are the two pairs of wheels "like unto the color of a beryl" and "full of eyes round about"; the sea of crystal; tetramorphs, each four-faced and four-winged; and six-winged seraphim. All these lie outside of an aureole that embraces the enthroned Christ and his evangelists. The hand of God figures at the summit of the aureole. Finally, at the outermost edges of the conch stand the lordly persons of the archangels Michael and Gabriel, clad in the garments of Byzantine emperors. In one hand each holds the globe, in the other a standard inscribed with the words of the Trisagion: Holy, Holy, Holy.

Now in the context of this heavenly vision the apse arrangement of Haçlĭ Kilise acquires new meaning. The humble rock cathedra for the superior becomes the liturgical antiphon to the throne of Majesty above: its occupant is seen to draw his authority from the Heavenly Ruler. The brethren seat themselves on the rock benches in the nave and on the synthronon that follows the contour of the apse. Between the synthronon and the apocalyptic vision in the conch comes a row of saints who stand to the enthroned Christ in a relation comparable to that of the brethren vis-à-vis their presiding superior. And the instrument of alliance between the heavenly hierarchy and the monastic is the Mass.

The Archaic Phase

But we must confess that this sympathetic correspondence of the vision painted in the semi-dome of the apse and the liturgical setting below may not have been envisaged at the start. It would seem, according to the Thierrys, that the paintings of the apse at Haçlï Kilise are not coeval with the actual carving of the chapel, that may have occurred sometime in the seventh century or the eighth. The sculpted cross on the nave ceiling clearly belongs to the original decoration. Then, perhaps as much as two centuries later, the apse received its picture cycle.

Now this picture cycle in all its essential details figures in the apses of many rockcut churches: the Haçlï Kilise version is the best-preserved example. We illustrate two details from the theme as it is depicted in the apse of the Church of Three Crosses at Güllü Dere (Cat. no. 8). (Pls. 21–22). Sometimes the formula is amplified to include the seraphim purifying the lips of Isaiah with a live coal (Isaiah 6:6–7) and Ezekiel eating the scroll that the Lord God sent down to him "written within and without: and there was written therein lamentations, and mourning, and woe" (Ezekiel 2:9–10, 3:1). Busts representing the sun and the moon often accompany the divine Hand that points at Christ. All this rich iconography is present in the elaborate version of the Church of Three Crosses. In the humbler chapels the vision, conversely, might be stripped of everything but the central idea: Christ seated on the throne of Heaven. Jerphanion long ago characterized all these churches as belonging to a group he called "Archaic,"[27] whose approximate chronological limits may be set at 850 to 950. Apocalyptic visions were frequent in early Christian art. They returned to favor, in modified form, after the restoration of images in the later ninth century.

It must be stressed that the term "Archaic," which we have retained in our Catalogue, refers only to the painting and not to the architecture itself. The actual execution of a building falls into the same period only if there is not other evidence to upset the evidence of the painted program. In the cases of Haçlï Kilise and the Church of Three Crosses there is such evidence, and we will come back to it shortly. Archaic churches, then, to repeat, are those which had a more or less detailed vision of Christ in Majesty in their sanctuaries. In the naves proper their decoration often consisted of figures of male and female saints in the lower parts of the walls, and further up a narrative cycle of the life of Christ. This last was disposed in continuous bands placed one above the other on the upper walls and on the vaults or flat ceilings. The narrative read from left to right, each band beginning with the apse corner of the south wall, proceeding

to the entrance at the west, then passing on to the north side to end again with the apse. The scope and richness of the program varied from church to church. The Christological narrative was, however, always grouped into three sequences: the Infancy, the Miracles, and the Passion. To these we shall return at length in the next section of the book.

Plate 21
Güllü Dere, Church of
Three Crosses (Cat. no. 8),
detail of apse paintings
showing Christ in Majesty.
[Restle plate 335]

Plate 22
Güllü Dere, Church of
Three Crosses, detail of
apse painting; *polyom-
maton* and wheels of fire.
[Restle plate 334]

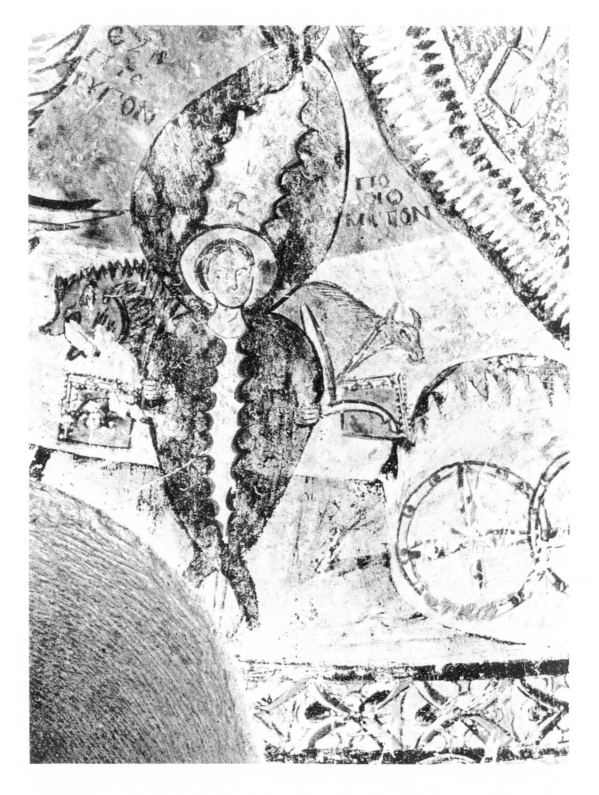

The Iconoclastic Phase

But what was the decoration of churches like before this time? What intervened between the few isolated scraps of decoration we have from the Early Christian Phase and these extended cycles of the period which, following Jerphanion, we shall call the Archaic Phase? The answer is that there was probably little figural decoration—and for good reason. Between 726 and 843 the empire, as is well known, was wracked from end to end by the bitter dispute over holy images, the so-called Iconoclastic Controversy. The imperial administration maintained officially that the representation of religious themes was tantamount to idolatry. Iconodules, or supporters of images, were resolutely persecuted. Many figural programs in churches were destroyed and replaced by large crosses and aniconic ornament like vine scrolls, trees, and the like. St. Irene in Constantinople still retains its large Iconoclastic cross on a gold ground in the conch of its apse. At the apse of the church of the Dormition at Nicaea a similar cross replaced the pre-Iconoclastic image of the standing Virgin.

The ban was not altogether successful, and some religious painting continued to be produced, mostly in areas outside the immediate supervision of the capital. Rather than being carefully organized picture cycles, however, these contraband programs seem to have been composed of individual votive pictures, the great majority of them saints and their life legends. In the struggle of the images, monasteries often stood out as the chief stronghold of iconodules. It is to be expected then that in Cappadocia too figural painting, though greatly reduced, did not stop altogether.

In at least two churches some independent pictures are sprinkled in decoration that is essentially aniconic. They are St. Stephen near Cemil (Pl. 23) and Chapel 3 at Göreme. Jerphanion had thought that the pictures were added later, over parts of the aniconic decoration, once the Iconoclast ban had been lifted. But the thorough study of plaster layers by M. Restle a short while back proved him wrong. In Chapel 3 the frieze of the Forty Martyrs of Sebaste was painted on the same bed and in the same colors as the cross and the ornamental decoration. At St. Stephen (Cat. no. 4) too a scene perhaps representing the Communion of the Apostles on the south wall lies on the same plaster layer as do the cross and vine scrolls painted on the flat ceiling.[28] One other picture in the church seems in fact to have been polemical. It represents the Cross of St. Euphemia as it appeared to her in her prison cell after she had endured a first

Plate 23
Cemil, St. Stephen (Cat. no. 4), view of the interior looking east.
[Restle plate 409]

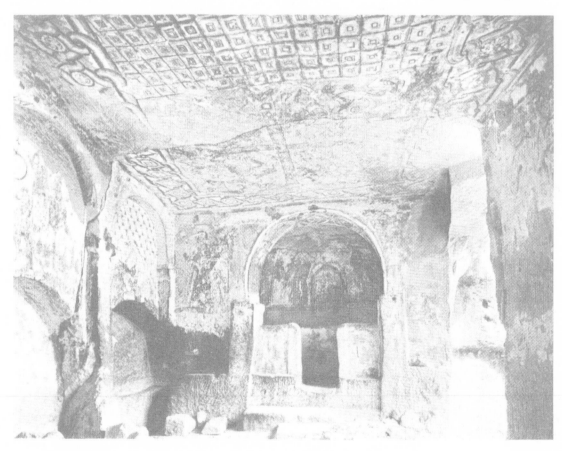

series of torments in the hands of her captors. Now the incident was described by Asterios, bishop of Amasia, as early as the fourth century in his account of a picture cycle he knew, in the entrance to St. Euphemia's memorial at Chalcedon, that represented the martyrdom of the great saint.[29] Asterios' account had great popularity among the upholders of images since it proved the existence of religious pictures so early in the history of Christianity. The text was cited, in two separate sessions, in the deliberations of the Seventh General Council, which met at Nicaea in 787. The monks of St. Stephen invoke this same argument pictorially.

But even so, the inhabitants of troglodytic Cappadocia were by no means united in their defiance of central authority on the question of images. A small number of rock churches bear witness to official Iconoclasm. The clearest example is St. Basil at Elevra (Cat. no. 3). The interior is decorated throughout with abstract designs and with the Cross, the sanctioned symbol of iconoclasts, obsessively repeated everywhere. It is (according to the inscription in a small chapel at Zilve) the sign of God, title of peace, gate of Paradise, appeasement for trespasses, the courage of the sick, the calling of nations, weapon unconquerable, high as the heights of heaven.[30] There is a huge cross on the flat ceiling, within a painted pattern of simulated coffering. Three others, surrounded by foliage and flowers, occupy the apse. An inscription identifies the central cross as the one that was seen by Constantine the Great in the prophetic dream before the Battle of the Mulvian Bridge—the symbol of the god in whose name he triumphed over his rivals and whose Word he made the official religion of the Roman empire. Higher up in the conch are three more crosses in medallions: they are labeled Abraham, Isaac, and Jacob. Last, a cross on the right wall of the nave is accompanied by a rather garbled inscription whose meaning, however, is not difficult to see. The image here depicted, it says, is not unworthy of Christ, who is himself unimageable.

Literary, pictorial, and symbolic clues of this kind then allow us to assign churches like St. Basil and St. Stephen (and a handful of others) to what we might call the Iconoclastic Phase, roughly 700 to 850. And then it was over. After more than one hundred years of defamation, the image triumphed in the empire. In one or two churches of Cappadocia proud statements expose freely now the basic argument of the iconodules: that the painted image and its prototype were identical only in meaning but differed in essence, and that consequently one adored not the image itself, which would constitute idolatry, but the essence of the prototype that was

rendered visible thereby. In St. Theodore at Ürgüp (Cat. no. 12) a cryptic inscription below an image of the enthroned Christ manages to convey all this in a few words:

ΜΙΚΡΟΣ Ο ΤΥΠΟΣ. ΜΕΓΑΣ Ο ΦΟΡΟΝ
ΑΠΕΡΑΝΤΟΝ ΤΥΠΟΝ. ΤΙΜΑ ΤΟΝ ΤΥΠΟΝ.

Translated, this says:

The image itself is insignificant (which you have before your eyes). But mighty is He who carries upon Himself the image of the Infinite. Worship the prototype (of which you have here only an image).

And one is reminded that, several centuries earlier, St. Basil had said substantially the same: "The reverence for the icon reverts to its prototype" (ἡ τῆς εἰκόνος τιμὴ ἐπὶ τὸ πρωτότυπον διαβαίνει [De spiritu sancto XVIII.45]).

Within this chronological framework that we have been guardedly constructing, it is not difficult to understand the history of those churches like Haçlï Kilise and the Church of Three Crosses at Güllü Dere that have a mixed pattern of execution. In fact, Haçlï Kilise neatly summarizes for us the three chronological phases we have established so far. (1) The presence of cathedra and synthronon link the origin of the church to the period we have labeled the *Early Christian Phase*. (2) But the giant carved cross on the nave ceiling indicates that the monks by whom the church was being executed were fully awakened to the struggle of images that had been precipitated by Constantinople. A date of about 700, therefore, that is somewhere between the end of the Early Christian Phase and the beginning of the Iconoclastic Phase seems tenable. (3) Much later, after the victory of the images—the Triumph of Orthodoxy, as it came to be called—the monks of Haçlï Kilise added to the sanctuary that elaborate vision of Christ in Majesty that we have described above. This picture already belongs to the third chronological phase, which we have called the *Archaic Phase,* roughly 850 to 950. At Güllü Dere the pattern is similar: large sculptured crosses on the ceiling of the nave, and later the elaborate apocalyptic vision painted in the apse.

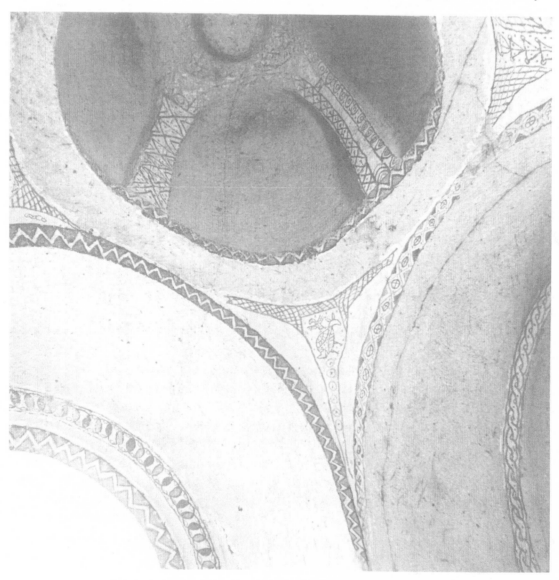

Haçlĭ Kilise and the chapel at Güllü Dere are not the only rock churches to modernize themselves, as it were, after the Triumph of Orthodoxy. Other sanctuaries too substituted the spare, emblematic cross of official Iconoclasm with the visually much more exciting imagery of Christ in Majesty; and the unstoried decoration of Iconoclast naves was likewise overlaid totally or in part by saintly figures and narrative painting. But the evidence is not plentiful and not always conclusive. Beneath painting cycles in many churches, to be sure, there are evident traces of an earlier decoration that reveals itself to be aniconic. In the presence of such patches of abstract ornament, scholars have been too ready to assume for the original building a date in the Iconoclastic Phase. These deductions are in most cases demonstrably erroneous. Often the architecture of the church will clearly prove it to have been excavated centuries after the controversy over images was over. The cross-in-square plan, to be discussed in due time, is a good instance.

The fact of the matter is simple. It was customary in Cappadocia from the start to decorate a newly excavated building with a crude pattern of ornament in red ocher, or a combination of red and green, applied directly upon the rock (Pl. 24). This decoration was probably executed by the carver-architect himself. The repertory was limited to linear designs (lozenges, herringbone, zigzags, checkerboard, and interlacing circles or semicircles) that helped to quicken the freshly cut forms; some vegetal and animal motifs, including bats and eagles; and the ever-present small Maltese crosses in medallions to signify that the structure had been duly consecrated. We have already noted this kind of ornament on facades as well. There, and in spaces of lesser importance like entrance vestibules or funerary chapels, the red and green designs were often meant to stay. But in churches the aim was to impose upon them as soon as practicable a richer, permanent scheme of decoration, painted with care on a coat of plaster with which the rough rock surfaces were treated. It should be clear, therefore, that the practice of enlivening rock churches with simple aniconic designs has in itself little to do with true Iconoclasm.

With this discussion of decorative schemes we have drifted away from the task at hand: the study of rock churches qua buildings. To this task we must now return. What we have, I hope, established by this necessarily extended digression is that, with the exception of the Early Christian Phase, where purely architectural criteria are also available to determine dates, we are

dependent in the main upon the nature and content of the decoration, and not the architec-
tural form, to be able to pinpoint a church chronologically. Now since an indeterminate span
of time might elapse between the excavation of the church and the execution of its permanent
decorative program, one can see how hard it is to be positive about the exact date of any one
church. Only the three-aisled basilica is indicative of a fairly narrow time span, the seventh
century. The commoner type of the one-aisled church, as far as the architecture is concerned,
can belong anywhere from the seventh century to the thirteenth. A similarly broad margin holds
for most of the other church types yet to be considered. But these should be distinguished now,
as follows.

Church with Transverse Vault: Tokalĭ

The three-aisled basilica, as we have commented earlier, was a type universally adhered to in the early Christian world and varied to suit local conditions and building techniques. It would be unnecessary to assign its infrequent use in Cappadocia to the influence of any one outside source. The same can be said of the one-aisled basilica that was common currency for small churches, at least in the East. What the Cappadocian carver-architect did was to stamp these two generic schemes with certain formal preferences all his own; we might refer in particular to the horseshoe plan of apses. One finds scattered examples of this feature elsewhere too, but in no other place is it taken quite to heart as it is here, both in the frequency of its use and in the pronounced manner as well in which the form exhibits itself.

The church type we are about to describe, however, is alien to most of the Christian lands and an obvious import into Cappadocia. Even there it is limited to the region around Göreme; it was not, for example, encountered by the Thierrys in the valley of Peristrema. The type, in brief, consists of a single rectangular chamber, wider than it is long, covered by a barrel vault that has a lateral axis, not a longitudinal one. At the east end are three apses, the central one deeper than the rest. We do not encounter the type in the constructed architecture of the region. Simple rockcut versions are Chapels 6 (Cat. no. 19), 16, and 18 at Göreme,[31] and an unpublished church at Kepez, southeast of Ortahisar, near the church called Sarĭca Kilise (Cat. no. 36).[32] But the most developed example by far, and one of the largest and most imposing structures in all of troglodytic Cappadocia, is the church of Tokalĭ.

We give here a ground plan and two sections; the church has remained intact since Jerphanion's day (Fig. 13). In 1960 a large crypt, including a chapel and funerary chambers, was discovered beneath the main level.[33] It is as yet unpublished and is therefore not shown in our drawings. At some time before the first publication of the church (by H. Rott), the facade had disappeared and with it part of a vestibule that leads, toward the north, to a very irregularly cut chamber without any decoration that led in turn to the crypt, and toward the east opens up almost through its entire width to a small nave with unmatched oblique walls (Pl. 25). The nave is barrel-vaulted and carries an archaic narrative cycle in several superposed bands, indicated in our longitudinal section. That is all there was to the church originally, with the exception of an apse or apses, undoubtedly horseshoe-shaped in plan, separated from the nave by a cross

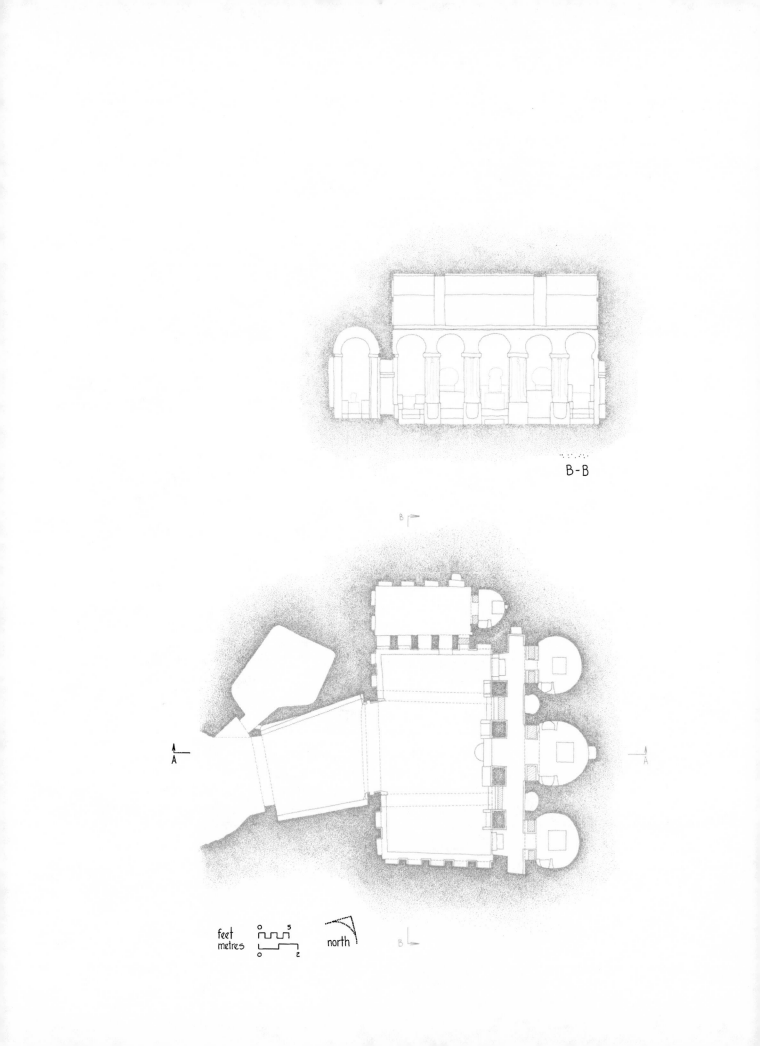

B-B

B

A
A

A
A

B

feet
metres

0 5

0 2

north

B

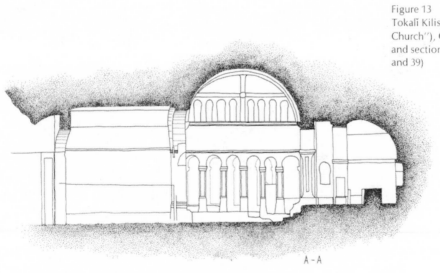

Figure 13
Tokalī Kilise ("Boss Church"), Göreme: plan and sections. (Cat. nos. 14 and 39)

A - A

passage. In the scholarly literature this small building, which conforms to the type we have called the one-aisled basilica, is referred to as *Tokalĭ I* (Cat. no. 14).

To judge from parts of the decoration that were destroyed in the process, the apse of Tokalĭ I underwent an enlargement at some point in its early history. But this alteration was nothing in comparison with what followed. The new apse was completely obliterated so that Tokalĭ I could become absorbed into a spacious new church, almost twice as broad as the old, set at right angles to it in the manner of an extravagant transept (Pl. 26). A transverse barrel vault extends throughout the width of this new church which is designated in the literature as *Tokalĭ II* (Cat. no. 39). Two diaphragm arches starting at the corbel frieze from which the vault springs divide it into three bays, but this division has no effect upon the spatial unity of the transverse nave. The short south side features an applied arcade on piers standing on a stylobate that runs all around the interior. Above this arcade comes one continuous band of narrative painting, part of the vast Christological cycle that sheaths walls and vault. The cycle is the most elaborate in all Cappadocia. Between the band and the vault curve, the tympanum-like panel bears a huge cross in high relief that imitates a *crux gemmata* of enamel and pearls, with a painted bust of Christ in the center. Of the four subdivisions so formed, the lower two are taken up by standing figures in a frieze of blind arcading (not unlike the original ninth-century arrangement of the north and south tympana of the nave of Hagia Sophia at Constantinople), while the upper subdivisions hold medallions with angels.

This scheme is mirrored on the north side with this exception, that the major ground-level arcade is perforated so that one can look toward a funerary chapel of the one-aisled variety with an aniconic program of decoration in red and green upon its untreated rock surfaces (Pl. 27). The floor level of this chapel is higher than that of Tokalĭ I and II, which was lowered at a later date, to the detriment of the vaulting of the crypt. An inscription in the chapel gives the date of completion as February 20, but the year is not stated. Where the narrative painting has peeled off in Tokalĭ II, one can still see traces of the same kind of aniconic ornament, which here, however, was later plastered over and superseded by the Christological cycle already mentioned and, in addition, by a narrative cycle of the life of St. Basil. Judging by this cycle and the prominent position of a portrait of St. Basil in the central apse, the church must have been dedicated

Plate 26
Göreme, Tokalī Kilise II
(Cat. no. 39), view of
interior looking toward
apses.
[Photo David Gebhard]

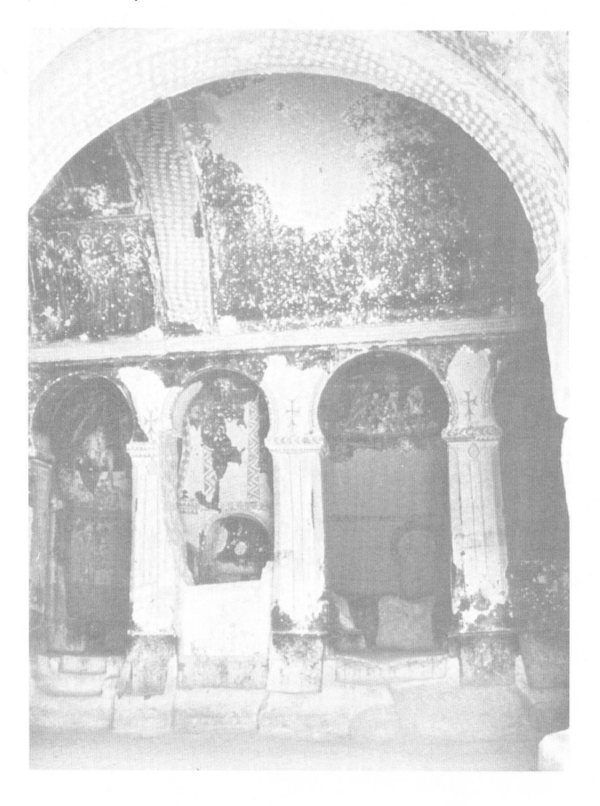

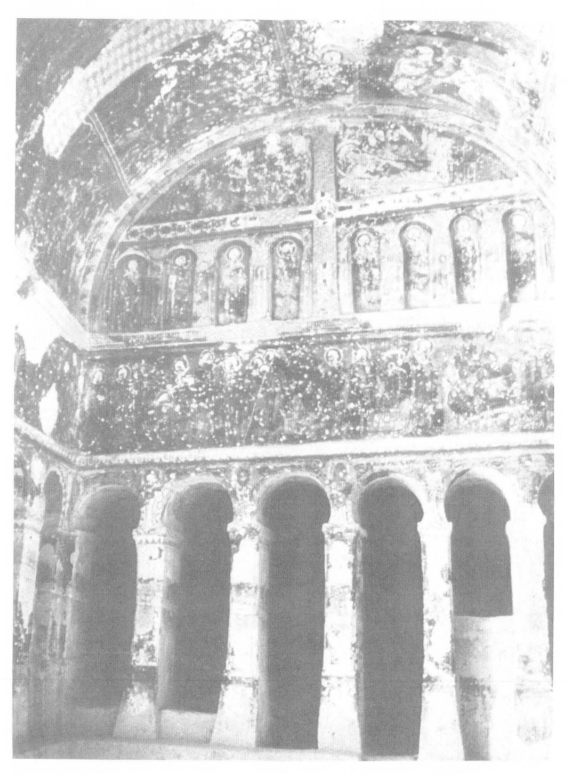

Plate 27
Göreme, Tokalï Kilise II
(Cat. no. 39), view of the
interior looking toward the
north wall and the funer-
ary chapel.
[Photo David Gebhard]

to him. Here too the rough early decor has a date, June 15, and a short invocation: "May the Lord have mercy on the master."

And now we turn to the east or sanctuary end of Tokalï II. The arrangement is complex and constitutes a major part of the total scheme. Four enormous piers with beveled corners and carrying horseshoe arches create an architectural screen of grand scale between the nave and the sanctuary. The bases of the piers are carved into seats with arm rests. The second and fourth intercolumniations are blocked off by low chancel screens above which peer the conches of two small apses, or rather apsidal niches. Through the other intercolumniations, at the center and the two extremes, one gains a long passageway running the entire length of the east side. From this in turn open out the three major apses, each containing an altar and barred by chancel screens of its own.[34]

Daylight does not penetrate far into this complicated sanctuary. It reaches the transverse nave obliquely from an only source, the damaged vestibule to the west, having crossed first the small nave of Tokalï I. Here it softly bathes the lower stratum of space; pushes to insinuate itself tenuously into the passageway and, when the angle is opportune, into a corner of the funerary chapel; picks out a detail or two beyond the corbel frieze; and is then swallowed up by the thick gloom. The spongy dimness so produced deludes the sense of size. Lighted from below, the tall piers on their sharply tapering bases take on added slenderness and soar inordinately. Through them more piers and horseshoe arches swim into view; it is as though the transverse nave were a clearing you happened into in the heart of unfathomed reaches of excavation. And above it all, glimmering teasingly on the periphery of your strained vision, dark haloed images svelte as the piers move across a backdrop of sky blue.

It would be impossible to know the conditions that induced the monks of Tokalï to expand their unnoteworthy but doubtless serviceable first church with a new one three times its size. But whatever else may have been on their mind, simple enlargement of available space cannot account for the particular form selected by them for the new church. Its design evinces sophisticated architectural thinking and its soigné detail is a far cry from the uncouth execution of Tokalï I. The plain walls of the older church are here richly articulated with the plastic projection of arcades on piers; in place of the one apse three large ones are provided for, accompanied by the two apsidal niches. But much more significantly, Tokalï II alters the standard spatial ex-

perience of the one-aisled basilical church, which depends on directional movement down the length of the nave toward the containing pouch of a semicircular apse, a movement enhanced by the tunnel-like deployment of the nave vault. The interest of Tokalï II is, on the contrary, in lateral spread. The width of its nave makes this clear, as well as the axis of the vault, which has now been turned sideways in relation to the sanctuary. The continuous wall arcades ensure the visual coherence of this transverse hall; so also does the broad band of narrative above them that turns angles to surround the nave on three sides uninterruptedly, with the exception of the leap necessary because of the triumphal arch between the older nave and the new. On the fourth, or sanctuary, side the arcades rise higher, but the painting cycle is continued on the flat imposts, which are of course at the same general level as the band of narrative. There is no longer a directional urge toward the sanctuary; nor is there the single return curve of an apse to receive the movement eastward and fold it back upon the nave. Instead, a string of cusped receptacles of varying size line up the entire east end, while the intervening passageway diffuses the bond between nave and sanctuary.

The inspiration for Tokalï II could have come only from the East, and more specifically from Mesopotamia. This was the sole Christian province to develop the transverse hall as a regular church type, evidently on the basis of local pagan precedent. Mesopotamian churches conformed, broadly speaking, to one of two generic schemes.[35] The first applied to parish churches. The congregational nave space in these was longitudinal. Upright supports stood in front of the north and south walls to form niches vaulted at right angles to the barrel vault of the nave. The prototype for this layout was probably the longitudinal imperial hall in Parthian and Sassanian palaces, of which the best-known instance is at Sarvistan. At the east end of the church there was a single apse, or sometimes a tripartite sanctuary raised above the level of the nave. Between the two spaces, the congregational and the ritual, stood an architectural curtain of four columns carrying an architrave. The central intercolumniation was open, those on either side blocked off by low parapets. Texts refer to this monumental screen as *qestroma* in Syriac, *katastroma* in Greek.

The other Mesopotamian scheme is largely though not exclusively monastic, and its source has been determined to be the plan of pagan temples in Mesopotamia and Syria. The triple sanctuary here is standard and the niches along the walls remain in force: but the nave is now

transverse. This is the arrangement of the monastic church of Qartamin and of the church of Mary Ya'qub al-Habis at Salah, to mention but two examples. In the former of these, the nave vault is divided into three by diaphragm arches, exactly as at Tokalĭ II. Indeed, most of the general features of the Cappadocian church derive from the two Mesopotamian schemes we have just distinguished. One will notice, for example, the niches along the walls formed by the arcades on piers: a detail that is not confined, by the way, to Tokalĭ, nor to the type to which it belongs, but that is to be found in several examples of the one-aisled basilica as well (Holy Apostles near Sinassos, Belli Kilise and Karabaş Kilise at Soğanlĭ Dere, Cat. nos. 17, 24, 50, etc.), and also in nonecclesiastical halls like the one already described in the discussion of Karanlĭk Kale at Peristrema. But there is more. The eastern screen of piers and arches at Tokalĭ has much in common with the Mesopotamian *qestroma,* as does also the idea of a tripartite sanctuary. At Tokalĭ, to be sure, local preference makes of the three units deeply horseshoed apses, in place of the small rectangular chambers with barrel vaults customary to Mesopotamia. Further, in contrast to the direct communication among the sanctuary chambers in a Mesopotamian transverse church, here the passageway between nave and apses serves as the means of unification. But the concept of a long east wall leading to three interconnected ritual spaces of which the central is the larger remains the same.

Actually, the presence of two flanking units subsidiary to the main apse goes back to early Christian times. They were born of ritual need. One, usually that to the north, served for the ceremonial preparation of the Eucharist species, the bread and the wine, at the beginning of Mass. It was called *prothesis.* The south unit, called *diakonikon,* housed the archives, the library, liturgical vestments, the treasury, and the Gospel. It was not itself indispensable, and its function often tended to be merged with the prothesis. In later Byzantine times, in the East, the Gospels and the Eucharist species figured as the principal sacramental objects in two solemn processions by the officiating clergy: the Lesser Entrance so-called, when the Gospels were exhibited to the congregation followed by the appropriate reading from them; and the Greater Entrance, when the paten and the chalice were borne aloft from the apse down the nave, and back to the altar, where the central mystery of the Mass, the transubstantiation of the bread and wine into the body and blood of Christ, unfolded, away from the eyes of the faithful.

In Cappadocia the three-aisled basilicas of the Early Christian Phase, with one apse for each aisle, were properly equipped for the demands of the liturgy. The one-aisled basilicas made do with a niche, carved to the left of their single apse, that served them as prothesis. Sometimes a separate chamber might be excavated at a later period for this purpose. Churches that are made up of pairs of aisleless chambers, a frequent variety of the one-aisled basilica as we pointed out above, also exhibit this additional chamber.[36] Consequently, the north apse of these double naves should not be confused for a prothesis: this apse served as the sanctuary proper of the north nave, which of course was a funerary chapel. Finally, in the transverse church type like Tokalĭ II, the elaborate tripartite arrangement of the sanctuary comes back into its own.

Göreme appears to be the furthest extension to the north and to the west of the monastic transverse scheme of Mesopotamia. It must have arrived in Cappadocia via the province of Commagene immediately to the south, and this is not mere conjecture since at least one monastery was uncovered there that had a Mesopotamian transverse church as its katholikon. The church, published by S. Guyer as early as 1912,[37] was dedicated to Surp Hagop and is dated through an inscription between 818 and 845. The introduction of the type to troglodytic Cappadocia may have come about then or a little later. We have no reliable evidence on the question, except for the decoration of the churches that belong to this type which puts them all in the Archaic Phase and later—anywhere, that is, from about 850 onward until the eleventh century.

Cruciform Churches

If the transverse church, of which Tokalĭ II is the prime example, has been characterized as a rather tardy importation, the church type we are about to describe, a free cross in plan, made its appearance so early in Cappadocia and attained such general usage that until recently some students were inclined to consider it autochthonous, an invention of the Anatolian plateau that spread from here to East and West alike. This contention is surely exaggerated. The first cross-shaped church on record was Holy Apostles at Constantinople, founded by Constantine the Great and completed by his immediate successors after his death in 337. The first surviving free cross was uncovered not long ago in Syria: the memorial structure over the tomb of the local martyr Babylas at Kaoussié, just outside Antioch, built in 378. But be that as it may, central Asia Minor, and Cappadocia in particular, embraced the form almost at once and for centuries studded the countryside with cruciform cult buildings, small and large, of which dozens are still in evidence. They are too numerous to need citation.[38]

Already a couple of decades before the close of the fourth century, in describing a cruciform martyrium in his homeland, St. Gregory of Nyssa pronounced the type usual.[39] And at about the same time it was another Cappadocian, St. Gregory of Nazianzus, who first observed in relation to the cruciform church of the Holy Apostles at Constantinople that its form evoked the prime symbol of the Christian faith, the cross.[40] Now whether this symbolism was forever present in the minds of those who designed cruciform churches by the score, its relevance must have been obvious from the moment the formal similarity had been pointed out. And its appropriateness could not have been in doubt. The instrument of the Passion, the Cross, was inspiring the shape of memorial structures over the holy places and relics of martyrs, and what were martyrs but witnesses of the Passion, men and women who proudly enjoyed like suffering to attain empathetic identity with Christ and establish, for all to see, the primacy of Faith? The martyr's tomb or else the spot of his martyrdom became the architectural center from which four equal arms spread out toward the four points of the compass. To furnish adequate space for services the west arm may be extended further out than the other three; but the altar stood in the middle, canopied by a dome or marked by a lantern tower, and underneath it lay the source of veneration: the hallowed spot, the saintly body. Was it not said in the Revelation of St. John, "And when he had opened the fifth seal, I saw under the altar the souls of them that were slain for the word of God, and for the testimony which they held"? (Revelation 6:9).

With time, and a short time at that, what began as a martyrial scheme was adopted by congregational churches too, both parochial and monastic. Since these were meant as vessels for routine liturgy and were not in any sense occasional buildings, the altar was moved to the end of the east arm for the convenience of saying Mass and set within the arc of an apse, and the cross itself surrendered its programmatic logic but retained its form. In our rockcut environment the cross-shaped cult building is certainly not memorial but is always a regular church or chapel. In fact so much had the form been domesticated by then and rendered so familiar a unit of design that it was indifferently used for vestibules and similar chambers as well.

The two churches we illustrate should suffice to indicate the general disposition of the type and its variations. Yĭlanlĭ Kilise (Cat. no. 31) in the valley of Peristrema represents the type in its simplest form. Four equal barrel-vaulted arms, a little less than three feet deep, slope gently down toward the central square bay, which has a flat ceiling, probably a sign of relative antiquity, with a large Greek cross carved upon it in low relief (Fig. 14). A spacious horseshoe-shaped apse is attached to the east arm; its floor level is slightly higher than the church. To the south, a tiny window is the only source of direct light. The church is preceded by a huge rectangular narthex; its vault and walls are sheathed with a representation of the Last Judgment in an elaborate iconography that includes standing figures of the twenty-four elders of the Apocalypse (Revelation 4:4), standing figures of the Forty Martyrs of Sebaste, the weighing of the souls presided over by St. Michael and the devil, and visions of Heaven and Hell. We recall St. Basil's admonition to the monks: "Shall we not set before our eyes that great and terrible Day of the Lord, on which those who by their good works have grown near to the Lord shall be received into the kingdom of heaven, but those who by their lack of good works have been set on the left hand shall be enveloped in the fire of Gehenna and everlasting darkness?"[41]

The fate of the elect is symbolically rendered: they are little children held in the laps of the good Old Testament patriarchs Abraham, Isaac, and Jacob. But no mere symbolism for the damned. The monastic mind revels in picturing the fine particulars of temptation and of the consequences for those who yield. The rewards of Christian heaven are cast in prose; what more is there, after all, than "the beholding face to face," some white garment perhaps, a crown? Poetic imagination favors the damned. Cappadocia is no exception. Here at Yĭlanlĭ the horrors are spread wide. Right behind the devil at the scales comes a three-headed monster

Figure 14
Yĭlanlĭ Kilise ("Church of
the Serpents"), valley of
Peristrema: plan and inte-
rior perspective. (Cat.
no. 31)

Figure 15
Chapel 27, Göreme: plan.

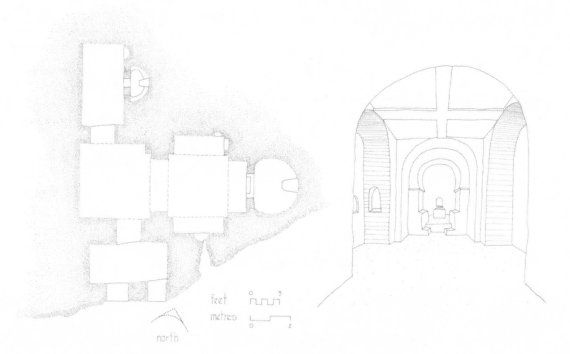

feet

metres

north

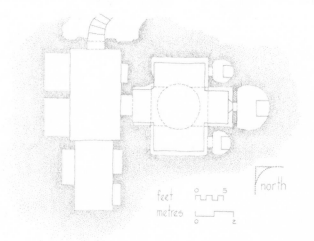

feet

metres

north

with the body of a serpent: from its mouths protrude extremities of those being devoured. The next panels dispose of more of the wicked in the River of Tar and the River of Fire, so labeled (Pl. 28). Four superposed tiers of heads are visible above the waves. Tartarus is next, this one a river too where many are shown drowning. And then the painter, with monkish vengeance, attacks women in particular. Four of them, nude and statuesque, are depicted thoroughly embraced by long serpents. Inscriptions explain the sins they represent. We lack the inscription that goes with the first woman, but the sin was doubtless major since she is being besieged on all sides by no less than eight serpents—probably adultery. Next is the mother who abandons her offspring: serpents attack her breasts and the caption identifies her as "she who would not feed her children." The third woman is guilty of calumny and the fourth of disobedience; they are bitten respectively on the mouth and on the ear.

Our second example of the cruciform type is Chapel 27 at Göreme (Fig. 15).[42] The little arcaded facade (visible in the middle of Plate 10), reached by an exterior flight of steps, leads to a rectangular vestibule that extends to the south and west into funerary chambers or *arcosolia*. The differences from Yĭlanlĭ Kilise are obvious. There is a dome over the central bay instead of a flat ceiling, and two subsidiary apses are attached to the east sides of the lateral arms. In some other cruciform chapels, for example the one at El Nazar (Cat. no. 25), the central apse replaces the east arm altogether. When, additionally, the west arm is prolonged, as it is at Ağaç Altĭ Kilisesi (Cat. no. 30) in the valley of Peristrema, the resultant form is a Latin cross. Both varieties, the Greek cross with equal arms and the Latin cross, have left us instances among the constructed masonry churches of the province. Their size is usually larger than the rockcut churches, their date often earlier. Two splendid cutstone churches of the Latin cross variety, Forty Martyrs at Skupi and the Panagia at Tomarza, mentioned in Part I, have only recently been destroyed.[43]

The vaulting of the central bay in Ağaç Altĭ Kilisesi (Pl. 29) should not pass unremarked. We are dealing with a domed square, but the dome, quite small and hemispherical, sits atop a dominant tall drum in two registers—and that is of great interest.[44] The lower register embraces the curves of the four arches that frame the square bay. This square is changed into an intermediate octagon by means of four corner squinches. A series of twelve pilasters, eight flanking the squinches and one in the middle of each side of the bay, divide the register into small panels.

Plate 28
Ihlara, Yĭlanlĭ Kilise (Cat. no. 31), paintings of the vestibule, detail showing tortures of Hell.
[Restle plate 505]

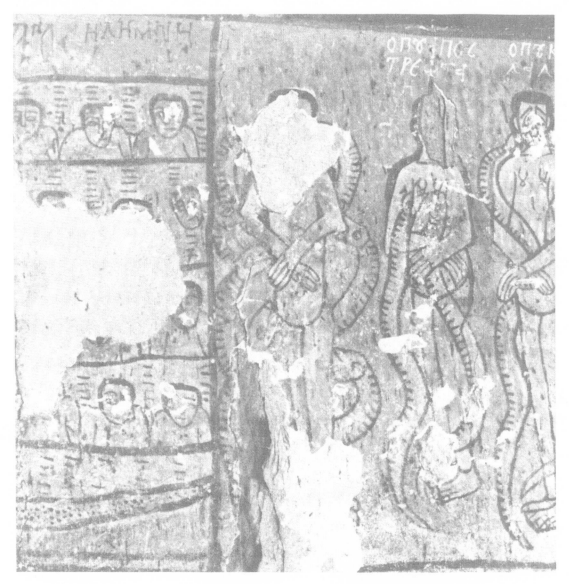

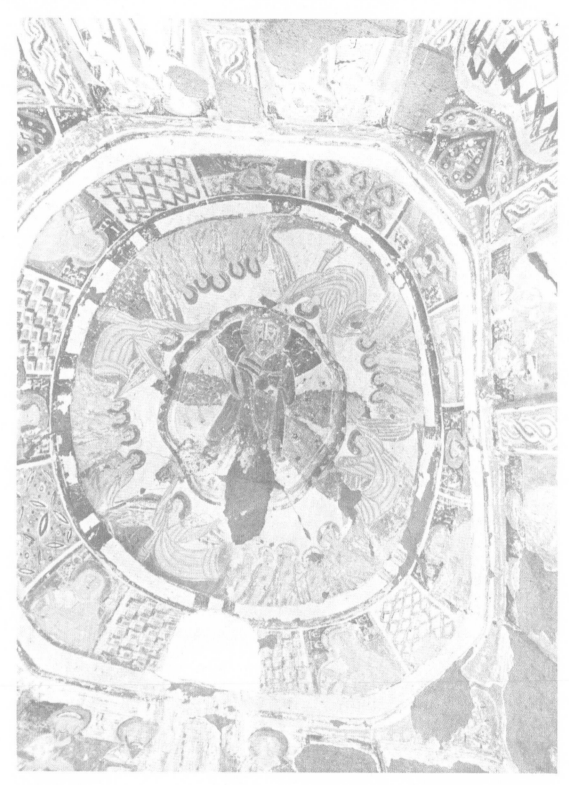

Plate 29
Ihlara, Ağaç Altı Kilisesi
(Cat. no. 30), general view
of the dome and its
paintings.
[Restle plate 488]

All but the squinch panels contain painted figures of the apostles and of the four doctors of the Church, grouped in twos. The next register, which is free of architectural features, inclines inward and completes the transition to the circle of the dome. It is pierced by a small window on the east side, above the conch of the central apse, now destroyed. Here purely ornamental panels alternate with panels containing busts of Old Testament prophets. Finally, in the dome itself, the Ascension of Christ is represented. Dressed in a tunic of sky blue, Christ stands in a luminous mandorla held up by four archangels flying above a host of angels.

Now these paintings of Ağaç Altī Kilisesi are extraordinarily primitive. Faces are orange, with white staring eyes and catatonic expressions; Christ's has two small triangles painted on the cheeks. Sketched with raw vigor in a profusion of red ocher, this strange design is not quite akin in spirit to any other painted program in Cappadocia except its immediate neighbors, although the subject of the Ascension appears often in the rockcut churches and is in fact a standard theme of Archaic and later decoration. The ornamental motifs themselves are more allied with distant traditions like Coptic, Muslim, and even Visigothic than they are with the common repertory of the Byzantine world. The Thierrys, who were the first to publish Ağaç Altī Kilisesi in detail, were encouraged by this crude and retarded character of the paintings to assign the church a rather early date, closer to the Iconoclastic Phase than to the Archaic.

And here is where the architecture comes in. It seems to me that, stripped of its decoration, the vaulting system of the central bay is very unlikely to predate the mid-ninth century and would be much more comfortably placed in the tenth. The domed square with squinches as transition elements was nothing new in Anatolia; it had been known here and in Armenia early enough, and certainly before the seventh century. But the intervening tall drum in two registers, and especially the articulation of the lower register by an order of pilasters, is a mature development of this vaulting scheme. The height itself of the drum should remind us of churches in neighboring Armenia, like the cathedral at Marmashen, the church of the Holy Cross at Aght'amar, and the cathedral of Ani—all of the tenth century. In any case, crudity of execution in paintings and retarded ornament should not be equated with antiquity in this provincial backwater, Cappadocia. It is much more revealing to recognize an attempt by the carver of Ağaç Altī Kilisesi to mold his rock into the semblance of an advanced vaulting scheme, for which constructed examples nearby, like Kīzīl Kilise at Sivrihisar, probably served as inspiration. And

with this relatively late date for the architecture, we need not (as the Thierrys had to) puzzle over the presence of the Dormition of the Virgin in one corner of Ağaç Altı Kilisesi—a theme that was developed as part of the post-Iconoclastic iconography in Byzantium sometime after the Triumph of Orthodoxy. I shall return to this matter of date in Part 3, in relation to a more thorough look at the decoration of Ağaç Altı and adjacent churches.

The Triconch of Tağar

One extraordinary church in Cappadocia should be considered a variation on the cruciform scheme, and is therefore properly dealt with at this point (Cat. no. 54). It is ensconced in an isolated rock cone to the north of the lovely little town of Tağar, sufficiently away from the region of Göreme to be excluded from the beaten track of troglodytic tourism developing in recent years. The fallen dome is now replaced by glass, and a wooden door has been installed and is kept under lock and key to discourage prowling.

It is worth the trouble. Three capacious semicircles extend the square central bay to the east, north, and south (Figs. 16–17). The arches by which they open in toward the central bay are wide enough to be taken for barrel-vaulted interludes. They are graced with painted interlocking medallions containing busts of Old Testament prophets, while lower down the flat surfaces of the piers are occupied by standing figures disposed frontally: archangels on the sanctuary side nobly framed by parenthetical wings, hieratic saintly presences on the opposite side. There is no curve to the west arm. The barrel vault is narrower here and beyond it is a flat-roofed bay that dips into a shallow recess, also flat-roofed, with an oblique end wall. This is where the entrance would have been had the proper orientation of the church not made it necessary to have the sanctuary toward the outer surface of the rock. The original entrance, therefore, was carved to the north of the church and the worshiper had to go down a corridor and turn left in order to reach the west arm of the cross.

Across from him as he entered was a triple arcade through which he could glimpse an ancillary space of indeterminable size. It was in fact a tiny passage giving off to a stair. Had he been privileged to take it, he would have climbed steeply, hugging the curve of the south arm, and come to a room overlooking the open air. From here a corridor led back into the rock and debouched, startlingly, into a gallery that wrapped itself around the central bay of the church.

But doubtless this uncommon path was exclusively monkish. The parishioner of Tağar would have seen the gallery only from below, when he had turned himself about to face the sanctuary upon entering the west arm. Looking up, he would have noticed that the gallery did not in fact continue on the south side of the central bay. The other three sides thus formed a kind of midspace theater oriented toward the apse of the south arm; this apse was in itself noteworthy in that it was lined with eight semicircular niches containing thrones. Or rather seven niches,

since the third one from the left, if it ever existed, was destroyed in order to open up a passage that led to a small rectangular chamber.

What the ritual relation could be between the gallery and this side apse with the subsidiary chamber it is impossible to tell, but that they were related seems evident to me. Could we perhaps be dealing with a singing gallery? It was barely high enough to stand in. On each of the three sides five arched openings faced inward. They were dark but for the tapers of those who might have used the gallery. The only natural light in the church came through a small window above the altar of the principal apse, in the middle of a row of doctors of the church, and it illuminated dramatically from below the Deisis in the semidome: the enthroned Christ flanked by the Virgin and St. John the Baptist, their hands imploringly outstretched in his direction, enacting their roles as intercessors on behalf of a wicked humanity. At the corners of his footstool are small medallions with Sts. Joachim and Anne, and further out, beyond the Virgin and the Baptist, stand the towering guardians Michael and Gabriel. This is a very different composition, in iconography and in spirit, from the apocalyptic Christ of Archaic apses, and we shall return to it before long.

The apses of the side arms were also painted. In the north arm, where the decoration survives there was again a Deisis, but minus the archangels and with a huge bust of Christ instead of the enthroned All-Ruler of the main apse. Below this ran a continuous frieze in the form of a triptych, with the Crucifixion in the center, the Annunciation to the right of it, and the Nativity to the left. Further down, above a painted dado, busts of saints, once again in medallions. The painters in fact, and there were at least three of them working in the church, seem veritably obsessed with the circular form; the profusion of tondi is one of the first things to strike the visitor today, an impression only magnified by the haloes of the many saintly figures, which are rendered as ripe, almost perfect circles.

If the dome of the crossing was given its own painting scheme, no trace of it is now visible. This is a blessing of a kind, at least for the present discussion, since it allows us to see the precise configuration of the intermediate zone from which the dome originally took off. It is rather an odd arrangement. The transition from square to circle is made by four corner elements that are neither proper squinches nor pendentives but bunches of triangular strips that radiate from the

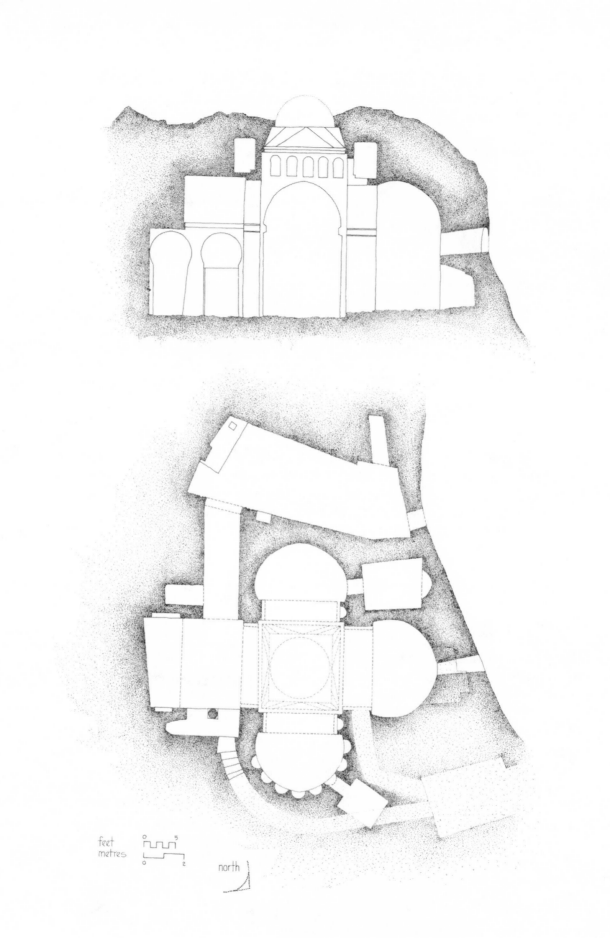

feet
metres

north

Figure 16
The triconch church,
Tağar: plan and east-west
section. (Cat. no. 54)

Figure 17
The triconch of Tağar: in-
terior perspective from
northeast.

junctures of the gallery. Visually they remind one, if anything, of so-called Turkish pendentives employed as means of transition in the domes of Seljuk buildings in Anatolia. I wonder whether the Tağar articulation might be linked to these. It would seem that the first documented use of this device is at the Mosque of Alaeddin in Konya, in the dome of the *mihrab* bay.[45] Since this part of the building is attributed to Izzeddin Kīlīçaslan (1156–1192), it would trail Tağar by at least a century if Jerphanion's mid-eleventh century date for this church is accepted. But what survives is never fully informative about what was, and the possibility that the Turkish pendentive had been put to use earlier then the mosque at Konya is not out of the question. Nor is the date of Tağar unassailable. It was based by Jerphanion on the style of its paintings, a criterion of relative merit at best, and Lafontaine-Dosogne has already suggested that the date should be moved forward to the late eleventh or early twelfth century. I myself prefer to place the building and its paintings to the second half of the twelfth century.

The triconch scheme of Tağar is unique among the rock churches. Its only manifestation in the constructed architecture of Cappadocia is the church of St. George at Ortaköy, next to Mavrucan (Güzelöz), a short distance to the south of Tağar.[46] It too is late: three burial inscriptions cite the year 1292/93, and the painted program cannot be much earlier. With this as a *terminus ante,* St. George might well postdate Tağar, rather than vice versa. There are no other examples known to me in the central plateau (with the exception of a tiny trefoil martyrium at Binbirkilise[47]), though some must have existed. The sixth-century *Life of St. Theodore* mentions one, also dedicated to St. George.[48] But in any case it could not have been a very popular form, then or later.

And yet the triconch had a long history in early Christianity. It originated in the trefoil chapels of the Roman catacombs and was widely used in North Africa for funerary structures. These *memoriae* were freestanding buildings; but the trefoil plan was adopted fairly promptly for the sanctuary end of congregational churches, the first known example being the church of St. Felix at Nola (Cimitile) near Naples, built by bishop Paulinus in 401/2. Paulinus wrote at length to describe his buildings at Nola, and it is here that we find expressed a contemporary rationale for the trefoil layout: one side apse was to serve as prothesis "where the venerable viands are kept and from which are produced the all-beneficent essentials for divine service"; the other would serve as a chapel for meditation.[49] During the fifth and sixth centuries, the trefoil sanctu-

ary became fashionable in Egypt, Syria, and Palestine, apparently traveling eastward from the regions of its origin. From one of these three provinces it found its way into the coastal land of southern Turkey. There are several obscure examples in Lycia, published recently by R. M. Harrison, one of them, at Alacahisar, being rockcut.[50] They date in the sixth and seventh centuries. Then the type seems to die out everywhere in the Christian East. Only one triconch stands out afterward, the church of al-Adra at Hah in Mesopotamia,[51] a Syrian import, and for several reasons I am inclined to favor a connection between it and Tağar. Unlike all other churches of the type, the al-Adra triconch is not merely the east terminus of a longitudinal nave but stands as a complete form in itself. This is the case with Tağar. Also, semicircular niches sunk in the wall of the main apse at Hah recall the similar treatment of the south arm at Tağar. And last, in both triconch churches the side apses could not have performed the function assigned to them by St. Paulinus, since al-Adra already has two rectangular chambers for prothesis and diakonikon, flanking the main apse in the Mesopotamian manner, and since at Tağar a prothesis chapel was added on, perhaps as an afterthought, to the east of the north arm.

Cappadocia and the Capital:
The Cross-in-Square Churches

The one-aisled basilica, single or double, and the free cross—these were the enduring types in the rockcut architecture of Cappadocia from the close of the Early Christian Phase to the advent of the Seljuk Turks. They were envelopes of ritual sanctioned by use throughout the Anatolian plateau, and the carver-architect respected their authority in the general outline of his churches while in the actual execution of them he blithely indulged his fancy and invention. And on occasion he looked beyond the plains, eastward to Armenia and Mesopotamia, coveting forms that were unusual, and therefore special. To work with such alien material whetted his architectural ambition. The triconch, the transverse basilica urged a scale upon him inconsistent with his modest circumstances. Tağar and Tokalı II are not merely adequate: they are monumental. And this is all the more impressive since their makers could depend neither on the sculptural possibilities of exterior massing nor on sheathing matters like mosaic and marbles to express the monumental nature of their design.

It would be as wrong to magnify the standing of this work as it would be to dismiss it with impunity. The province was far removed from the critical developments of the empire. Its finest hour came early, with St. Basil and the Gregorys, and after their death it was over quickly. Sunk for long stretches of time in poverty and unmitigated superstition, resigned and unlettered, Cappadocians had no hope of making history: they sat by for it. They were backward, provincial in the sad sense, and so they persisted. The Greek they spoke was an abomination to cultured ears. Their manners were notoriously outlandish. The renowned sophist Libanius in Antioch, to whom St. Basil sent many Cappadocian youths, "reeking with garlic and snow," to be educated, found it difficult to "transform them from wild pigeons into tame doves," and cringed with Greek distaste when they prostrated themselves before him in the way of oriental "barbarians" and said "I make obeisance to thee."[52] Soon afterward, to be sure, prostration would be refined into a courtly art at Constantinople as emperors and their gilded bureaucracy progressed into that involute eastern absolutism once despised as uncivilized. But none of the new splendor rubbed off on the wild pigeons. In the hinterland simple piety stood by where power and intellect lacked, and those became heroes among the people who glorified by their behavior the daily sufferings of the common man: hunger, physical discomfort, and dirt. These were the heroes who sublimated misery: saints and near-saints who, as it was said about one of their number, "nobly mortified the body, keeping it under and wearing it down, as though it were

some alien thing which warred against the soul."[53] They taught by example that wretchedness cannot only be lived with, it can become a way; that deprivation can be a privilege that brings hope in its wake and not despair. And so by enduring, willingly and proudly, much more than the common man, they rose above him, took hold of him. They pitted miraculous faith against culture, sophistication, and wealth.

The rockcut churches do not exist abstractly, independent of this context. To fix their sources and classify them by type, as we have been doing, does not suffice to release their true meaning. That derives from the land and those upon it: the isolation, the ascetic fervor, and the faith which must be blind and visceral because it cannot be learned and wise. A cruciform church here, with its ham-handed paintings and barbarously spelled inscriptions, cannot meaningfully be compared to a church in Constantinople or Thessaloniki for having a like form or similar iconography. And conversely the size and care of Taǧar or Tokalï have a private stature because of their given context, incommensurate with the absolute size and care of their models. It is, I think, a historical irrelevancy to contrast provincial monuments to metropolitan if we have only physical form in mind. But when we recognize that provincial monuments must be viewed as being creations for a setting and an audience that are discrete, that their appeal is unique, then we will need neither condescension nor charity in giving them their due.

Now these remarks are specially apropos in assessing the relationship of Cappadocia and the capital. Being part of the empire, albeit a marginal part, Capadocia could not of course be completely isolated from central policy, nor even from Constantinopolitan fashion. Repercussions were retarded but not unfelt. We have already reviewed the evidence in the troglodytic churches for Cappadocia's involvement with the Iconoclastic Controversy, a revolution that, politically and philosophically, was fought outside it. And now once again we must take cognizance of a related movement that emanated from the capital: the revised church architecture and decoration which grew under its leadership following upon the Triumph of Orthodoxy.

The precise development will probably remain unknown. But it is clear that by 1000, a century or so after the reaffirmation of figural art for religious decoration, a new system had been forged in the capital for the setting of the liturgy—a system that affected both the architectural skeleton of the church and the choice and arrangement of religious subjects to be pictured upon its surfaces. The new skeleton is typified by the *cross-in-square* scheme, also called *quincunx*

(a term invented by K. J. Conant). It is a system of nine bays of which the center one is covered by a high dome; the corner ones by small cupolas or groin vaults; and the rest, making up the arms of the inscribed cross, are barrel-vaulted. As for the decoration, it now abandons its narrative principle and serial composition common to pre-Iconoclastic programs, in favor of a select number of Christological subjects arranged in a hierarchy consonant on the one hand with the order of the Kosmos, that is, Heaven and earth, and more practically with the festival cycle of the Greek Orthodox calendar. The architecture of the cross-in-square scheme in fact provided now a specialized construct that would hold images in prescribed relationships to one another and to the celebration of the liturgy below.

Christ as Pantokrator, or the All-Ruler, occupied the central dome, attended by apostles or prophets. The squinches or pendentives had four archangels as supporting figures or else the four main events of Christ's childhood: the Annunciation, the Nativity, the Baptism, and the Presentation in the Temple. These were four of the twelve most important feasts of the calendar year; the others, disposed lower down, being the Transfiguration, the Raising of Lazarus, the Entry into Jerusalem, the Crucifixion, the Descent into Limbo (*Anastasis*), the Ascension, Pentecost, and the Death of the Virgin (*Koimesis*). To these were added some more subjects to round off the Passion cycle, notably the Last Supper, the Washing of the Apostles' Feet, the Kiss of Judas, and the Descent from the Cross. Further down still, on the flat surfaces of piers and lower walls, was arrayed a series of single figures showing Old Testament prophets, saints, and doctors of the Church. In the apse ruled the Virgin: alone in her own right as the Mother of God (*Mēter Theoū*), or else holding the Christ Child in her arms.[54]

This brief description is of course ideal. To describe actuality would take much space, and would not in any case be germane to the scope of this book. Suffice it to say that the cross-in-square or quincunx was in fact only *one*, but by far the most prevalent, scheme of central-planned churches developed in the post-Iconoclastic overhauling of religious architecture; that as a building type it was not wholly unknown before this time and its initial adoption in Byzantine territory may well have preceded the Triumph of Orthodoxy; and that consequently, as new evidence slowly mounts, it might be proved that Constantinople was not itself responsible for the scheme of the cross-in-square but was merely adopting it and endowing it with the full weight of its authority.[55] And on the side of the decoration, the creation of the ideal arrange-

ment was slow and complex, its variations were numerous, and the Constantinopolitan pre-
scriptions were flaunted the farther one got from central influence.

What is important for our purposes is that the cross-in-square and the newfangled concepts
of religious decoration that accompanied it penetrated into Cappadocia in a number of ways
perhaps as early as about 960. Sometimes pictorial style and iconography traveled without the
architecture, and sometimes the reverse happened. Our main concern at this point is with
architecture. We know presently of nineteen rockcut cross-in-square churches, all but four in
Jerphanion's territory.[56] Only two are dated by inscription: Direkli Kilise (Cat. no. 41), where
a dedicatory inscription names Basil II and Constantine VIII as corulers (976 to 1025); and
Chapel 17 at Göreme, where a series of graffiti gives us a *terminus ante quem* of 1055. The time
corresponds to that peaceful interlude in Cappadocian history when the imperial armies had
stemmed Muslim raids from the south and had the upper hand in Anatolia generally, until the
crushing defeat at Manzikert of 1071. Whether intercourse between the capital and Cappadocia
at this time had become more lively or not, the new churches are confirmation that the province
felt, or wished to feel, spiritually within the empire again.

The first trials were halfhearted. The new church type, insufficiently understood, was imitated
with a heavy hand. Four thick columns with blocky capitals (or piers, as is the rule in western
Cappadocia, at and around Peristrema) supported the main dome, and the four corner bays
were given flat ceilings or mere bubbles instead of being properly domed. There were three
apses in accordance with central practice, but the main apse was screened with low chancel
screens still, rather than the tall *iconostasis,* the screen wall covered with icons, which had been
in use for some time in Byzantine churches as a pronounced divider between sanctuary and
nave. Instances of this early phase are Kīlīçlar Kilisesi at Göreme and Direkli Kilise at the valley
of Peristrema (Cat. nos. 37 and 41; figs. 18–19). At the same time, the Archaic scheme of decora-
tion was not always given up but was sometimes forced into the new architectural frame, ill-
suited though this frame was for long narrative bands. Thus at Kīlīçlar, the apse still showed
Christ in Majesty surrounded by the four evangelical beasts; the vaults and the east arm of the
cross were reserved for the cycle of Christ's Childhood; the Miracles took up the first two bays
of the south wall; and the remaining wall space was given to the Passion.

In the absence of secure dates we cannot calculate how long it might have taken to attain

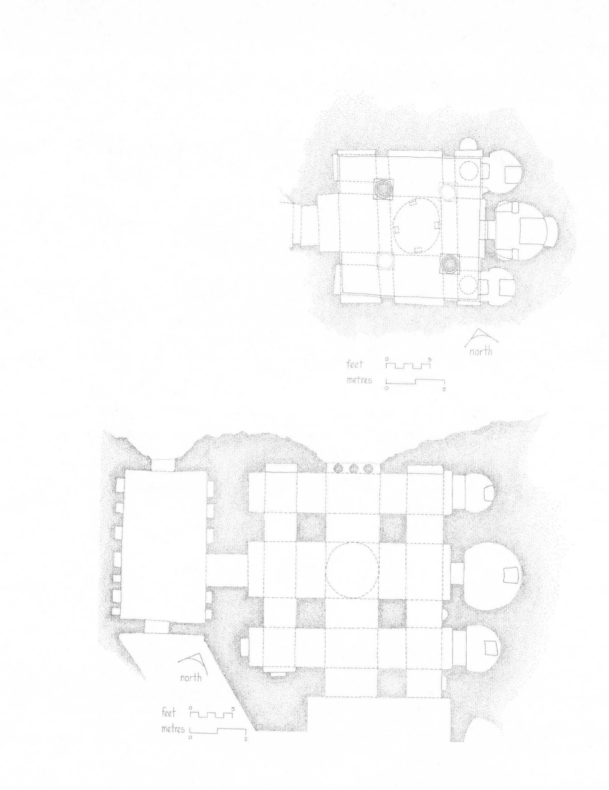

feet
metres

north

north

feet
metres

Figure 18
Kılıçlar Kilisesi ("Church
of the Swords"), Göreme:
plan (Cat. no. 37)

Figure 19
Direkli Kilise ("Pillared
Church"), valley of Peri-
strema: plan (Cat. no. 41)

Figure 20
Monastery of Bezirhane,
near Avcılar (Maçan),
church: plan and section.

Figure 21
Çarıklı Kilise ("Church of
the Sandals"), Göreme:
plan. (Cat. no. 58)

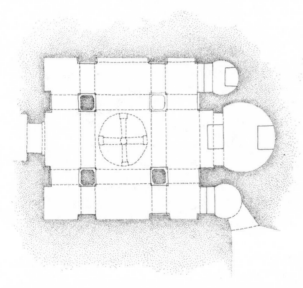

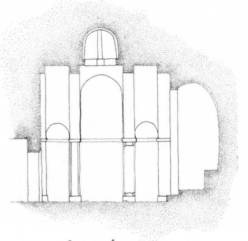

feet
metres

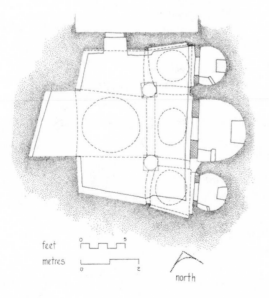

feet
metres

north

to the mature formulation of the cross-in-square. For all we know it might not have been a process of gradual development at all but a question of some carver-architects being more able and perceptive than others, or of some monastic communities being more progressive and permissive. In any event, there are several rockcut examples that show a sense for the subtleties of the type: that wonderfully light, disburdened, immaterial effect of interiors such as we still have them in Middle Byzantine churches like Hosios Lukas at Stiris for example, or the church at Daphni. Actually these are not the best parallels to invoke, even though they are the most effectively preserved, since the architectural system in these is not strictly speaking a cross-in-square, and since the four supports for the main dome are L-shaped piers and spurs of wall. The Cappadocian churches employ four delicate columns instead, or in one case—the church at Bezirhane—elegant piers with beveled corners (Fig. 20); in this respect, they are closer in spirit to churches in the capital itself like Christ Pantepoptes (Eski Imaret Cami) or St. Theodore (Kilise Cami) that have piers of this variety, and to the small eleventh-century churches in Athens and its periphery.

For the excellence and preservation of their paintings three of these mature cross-in-square churches stand out in the troglodytic region: Elmalĭ Kilise, Çarĭklĭ Kilise, and Karanlĭk Kilise (Cat. nos. 57–59). They are all at Göreme, very close to one another, and unquestionably related in character and style. Çarĭklĭ has the least regular architecture (Fig. 21). The entrance is lateral. The corner bays of the west side are missing altogether, and the central dome consequently rests on two east columns and the angles of the west arm.[57] The east arm, instead of being barrel-vaulted, is covered by an oval-shaped cupola. This last feature is true of Karanlĭk too, but for the rest its plan describes a perfect quincunx. Elmalĭ deviates from the norm in having all nine bays domed, a solution which would be improbable in a masonry building (Fig. 22). Its tall iconostasis, with one opening only at the center, survives in part.

As with the architecture, so too in the decoration these churches sedulously ape metropolitan models. We present enough illustrations from each of the three to help the reader form an aggregate image of this decorative scheme. One will notice that long narrative bands and with them serial chronology, canonical for Archaic programs, have now been definitely relinquished (Pl. 30). The organizing principle is liturgical, and those subjects preponderate for which there are important church feasts. Among them the Nativity (always conjoined with the

Adoration of the Magi, in the spirit of the Byzantine Liturgy), the Crucifixion, and the Ascension are preeminent. They are awarded generous space so as to make them promptly remarkable. In Elmalĭ and Karanlĭk, Nativity and Crucifixion take up the entire wall space of the north and south arms, respectively, while the Ascension occupies a position by the entrance. At Elmalĭ this is the dome over the west arm of the cross; at Karanlĭk, the vault of the narthex. The placement differs in the third church, Çarĭklĭ, because of its peculiar architecture and lateral entrance, but it is nonetheless prominent: Crucifixion over the entrance wall on the north side, Ascension in the vault of the corresponding bay on the south, and Nativity on the end wall of the dangling west bay.

About these three subjects the painter groups complementary scenes that enhance the content of each. To the Nativity is appended the Voyage to Bethlehem; the Kiss of Judah, Calvary, and the Women at the Tomb surround the Crucifixion panel; while the Ascension is coupled, at least in the case of Karanlĭk, with the Benediction of the Apostles. Subjects of minor feasts are distributed less prominently through the church. They are the Baptism, the Transfiguration, the Raising of Lazarus, the Last Supper, and the Descent into Limbo or *Anastasis.* Most of the domes are left for busts of archangels; the central dome excepted, of course, where Christ the All-Ruler reigns at the summit of the whole construct of images (Pl. 31). The pendentives that invariably figure as elements of transition in this center bay hold busts of the four evangelists, while the soffits have pairs of standing prophets of the Old Testament. And in the apse conch, behind the tall iconostasis, where in Archaic churches the apocalytic vision of Christ in Majesty forever kept before the worshiper's mind the dreaded *dies irae,* a new note of compassion is struck by eliminating the creatures and props of Revelation—tetramorphs, wheels of eyes, crystal seas, and six-winged seraphim—and flanking the enthroned King of Kings with the interceding images of his Mother and St. John the Baptist (Pl. 32). To underscore the theme of mediation, prostrate donors would be included exceptionally (as at Karanlĭk) to this tableau of Deisis.

How unlike are these interiors from the ponderousness of Archaic schemes. Four supports tenuously stand in the floating space, too slender and too far apart to circumscribe a nave area as distinct from aisles. Above them billow domes of varying size and barrel vaults, and from their depths archangelic visages direct their piercing gaze to the void they dominate. These

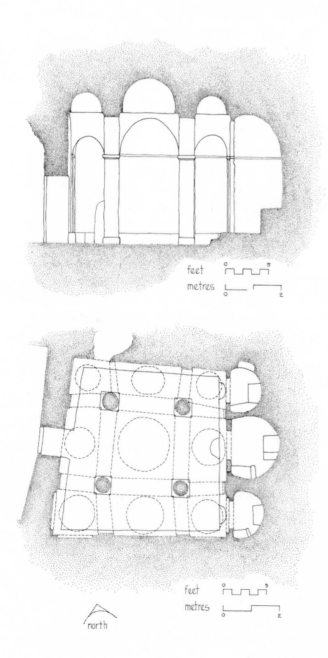

feet

metres

feet

metres

north

Plate 30
Göreme, Çarĭklĭ Kilise
(Cat. no. 38), view of the
interior.
[Photo David Gebhard]

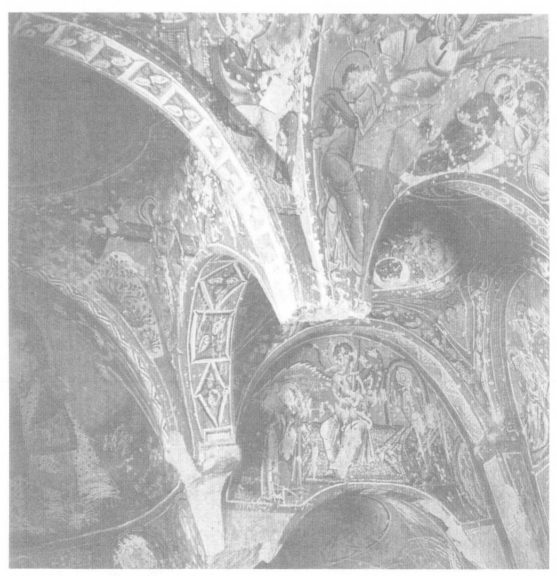

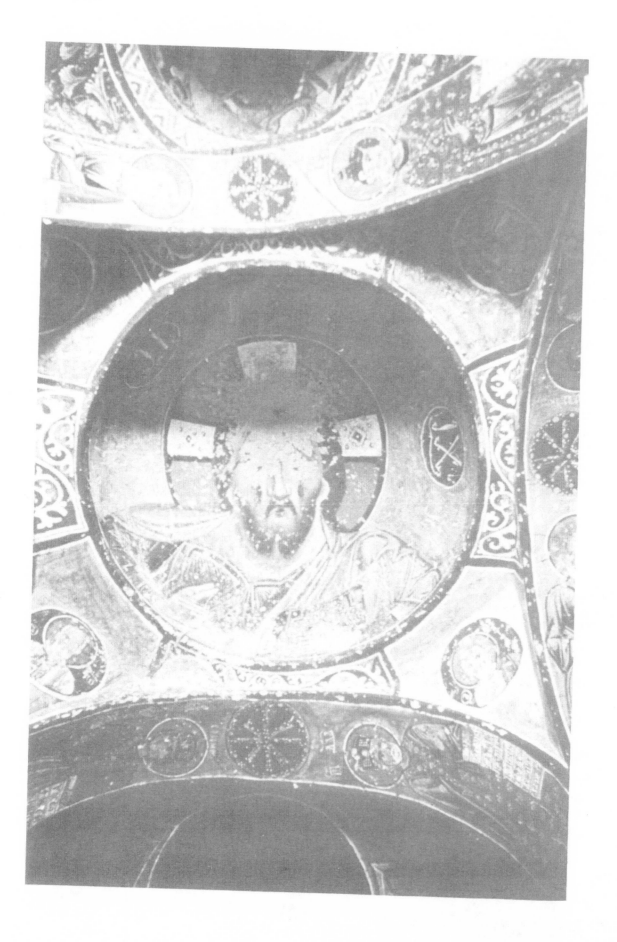

Plate 31
Göreme, Elmalī Kilise
(Cat. no. 57), view of
central dome showing
Christ the All-Ruler.
[Photo David Gebhard]

Plate 32
Göreme, Çarīklī Kilise
(Cat. no. 58), Christ
flanked by the Virgin and
St. John the Baptist.
[Restle plate 196]

images—Uriel, Gabriel, Phlogotheël, Raphael, and the rest—are large and comfortably set within their round frames. So too the prophets of the soffits breathe amply above the subsidiary arches of the peripheral bays (Pl. 33). They stand transfixed; open scrolls cascading from their left hand proclaim ageless familiar wisdoms. Solomon, in priestly garb: "A wise son maketh a glad father: but a foolish son is the heaviness of his mother." (Proverbs 10:1) Jeremiah, bearded and in the time-honored costume of the classical philosopher: "Am I a God at hand . . . and not a God afar off?" (Jeremiah 23:23)

By comparison to this upper sphere of heaven the subjects of the Christian feasts are more palpable, within reach of the worshiper. Perspective views end with them right and left, large enough in scale to fix his attention individually, in contrast to the tapestry-like sheath of continuous surfaces in the narrative cycles of Archaic churches. At Karanlĭk Kilise, for example, at the end of the north arm of the cross, he would recognize the Nativity (Pl. 34). It is ensconced within a grotto in the flank of a rocky knoll sparsely touched with vegetation. In the center of this natural arc the Virgin sits languidly on an embroidered mattress, her head turned toward the cradle. On the other side of it, the ass and the cow look on as a shaft of light falls down on the nimbate head of the Infant. Its source, the star of Bethlehem, lies outside the architectural boundary of this tympanum, on the barrel vault over the arm of the cross. By this simple means the composition spills outside the tympanum and here the painter has incorporated the apparition of the angel to the shepherds, and the arrival of the Magi. A further visual link between tympanum and vault is established by the glance that Joseph directs toward the star as he sits huddled outside the grotto. To balance his splendid mass, on the right side of the Virgin is shown the bathing of the Infant by Salome and the midwife. And then, unaccountably, in the caesura between Joseph and the Virgin, who face away from one another, a pair of rabbits stand back to back on their hind legs—as if in symbolic imitation of this strange, disjunctive couple.

Diagonally across the subtile space of the nave, beyond the baldachin of the central bay, the worshiper's eye would catch another scene: the Raising of Lazarus. Lazarus, still enshrouded, or rather enswathed, stands upright in the mouth of a rock cave, his eyes open anew. A man sweeps away to one side the stone lid of the sarcophagus while his head snaps toward Christ,

who is rushing in from the left attended by St. Thomas. Martha and Mary prostrate themselves before him. "Loose him, and let him go." (John 11:44)

Clear at the other end of the church, over the south apse, the Last Supper. The moment is the crucial one: Christ seated at one end of the long table has just announced that he will be betrayed by him who dips his hand in the dish (Matthew 26:23). The hand of Judas is already so engaged: his face is sad, downcast, his gesture almost reluctant. Ten apostles crowding in on either side of him respond variously. St. Peter sits at the other end of the table, opposite to Christ: he is shown at the moment when he is beckoning to St. John, who draws close to his Master, "that he should ask who it should be of whom he spake." (John 13:24)

Around the corner, the resurrected Christ descends into Limbo. Or better, reemerges, having earlier forced his way through, and drags behind him now an aged Adam and a supplicant Eve. The crumpled Devil grovels underfoot, his beastly head upturned imploringly to the victorious Son of God. The bars and locks of the crashed gate of Hell lie about in disorder. A chorus of prophets stand witness led by the diademed princes David and Solomon.

These pictures are of such notable quality as to need no special plea. They are also readily comparable to their metropolitan counterparts in composition. The painter was clearly au courant, abreast of the late formulations of these festival subjects, and were it not for the endearing misspellings in the captions and idiosyncratic touches like the rockcone-like burial ambient of Lazarus, one would be tempted to imagine that a learned painter, a recent arrival from the sphere of the capital, might be responsible. But in fact no such hypothesis is called for. As the new Middle Byzantine iconography was codified, pattern books and painting manuals disseminated it. A late sample of the latter, the Painter's Guide of Mount Athos, has been known to us for some time.

Once again, as we have done in the architecture, we can contrast the Cappadocian version of this standard iconography with its less provincial models; that should be our first task. But at the same time we should be willing to allow that the detection of local variants, and stylistic juxtapositions between Karanlĭk Kilise, say, and Daphni or Hosios Lukas will not in themselves be adequate. Our eventual task should be to probe intangibles. Pictures mean in correspondence to the ethos of their audience. The Descent into Limbo will mean one thing to the

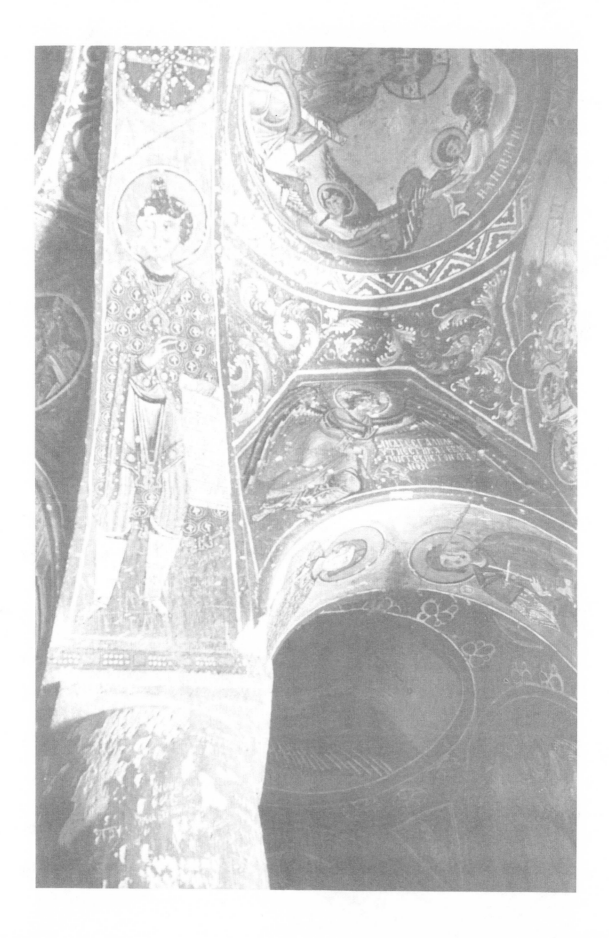

Plate 33
Göreme, Elmalǐ Kilise (Cat.
no. 57), view of the inte-
rior with standing figure
of Daniel.
[Photo David Gebhard]

Plate 34
Göreme, Karanlǐk Kilise
(Cat. no. 59, tympanum of
north arm: Nativity.
[Restle plate 229]

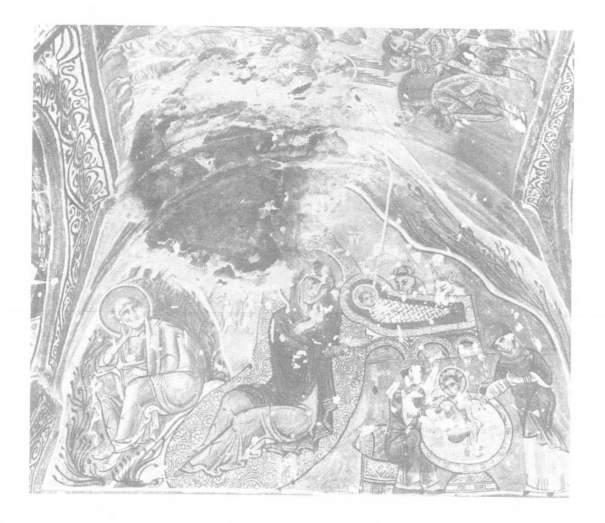

monk of Karanlĭk, quite another to the monk of Daphni or Hosios Lukas, even though in their composition the two versions are virtually identical. And this is not alone because the cumulative experience of the Cappadocian cenobite will inevitably have differed from that of his Greek counterpart, but also because of the nature of the church environments in which the two Descents exist.

I leave aside the question of natural environment: the pleasant coastal site of Daphni, and the lush, mountainous Stiris of Hosios Lukas a short distance from the precipitous extravagance of ancient Delphi. It should go without saying, though perhaps we have gone too long without saying it, that a Middle Byzantine church in such settings as these will not inspire the same appeal of faith as the cross-in-square of sere, rockbound Göreme. But within? We admire justly the clean classic look of Daphni, the exquisite complexity of Hosios Lukas. Yet how much of their effect is a gift of light! The crown of windows in the drum of the principal dome setting aglow the image of the Pantokrator: the banked windows that flood the apse with brightness: and that profusion of subtly placed perforations in the fabric of the building, windows divided by slender colonnettes into two lights or three and screened, filtering daylight to the supple interior across the narrow ring of aisles and narthex and into the openness of the central baldachin. It is this insinuating film, as much as the delicate proportions of the supporting members, that dissolves any weight the architecture might have and transforms walls and vaults into texture, especially since they have already been sheathed with applied marbles and goldback mosaic.

Now it is clear that by denying himself the use of natural light the carver-architect of Göreme has forfeited dematerialization. What light is allowed in through the entrance or an occasional small window cannot conjure away the sense of obtuse matter nor bring the images of the upper reaches, domes and vaults in particular, to exist in an aura of muted radiance. Liturgically the least important images—saints, donor portraits, and the like—having the lowest emplacement, will be most emphasized by the light from the entrance, while the true realm of Heaven farther up will remain lackluster, obscure. And since it is to shafts of light that our eyes are drawn in enclosed spaces, the worshiper's awareness of iconic priorities will be sharply curtailed. The primacy of the Pantokrator dome cannot be appreciated unless it is dramatized by something other than mere height. But the carver-architect not only forgoes the benefit of

fenestration for this purpose, he does not sufficiently differentiate the width of the central square from that of the surrounding bays to bring home the programmatic logic of his scheme. To all this let us add, to complete the comparison, that paint cannot hope to rival colored marbles and goldback mosaic; and the triumphant Christ of the Descent into Limbo will impress differently on a background of blue in relative obscurity than would the Christ of the Descent as he is depicted in Hosios Lukas, gleaming on a field of gold.

But I think we have said enough to indicate that form in a physical sense may be importable, but not its consequence; or to put it differently, that formal imitation provides a mere container in which the imitator deposits his own private purpose. This is true even where the parallels are closest, as they are between the three cross-in-square churches in Göreme and their metropolitan prototypes. Other examples of the type in Cappadocia are by no means as literate. Our drawings should make extended comment unnecessary. The cross-in-square of Eski Gümüş, for example, is overwhelmed by its four supports: huge columns coated with plaster, resting on octagonal plinths (Fig. 23). Except for the disproportionately sized dome which takes off from these, all the other bays are barrel-vaulted. In the case of the corner bays, the emplacement of the giant columns forced upon the carver the unhappy solution of two barrel vaults set at right angles. In the so-called Church A at Soğanlï Dere, too, the arms of the cross as well as the corner bays culminate in barrel vaults; but the plan here is quite regular, somewhat larger than the three cross-in-squares at Göreme (Fig. 24). (The northwest angle was not completed.) This vaulting scheme, which contrary to the proper definition of *quincunx* does not distinguish the four corner bays by covering them with small cupolas or at the least groin vaults, is standard for masonry churches in Anatolia that follow the type. About a dozen or so survive in Cappadocia and adjacent areas.[58] None is quincunx. And before leaving Church A we might also remark on one further point of interest: that the three apses of the sanctuary intercommunicate by passages—a feature unique among the rockcut cross-in-square churches we have been considering, but common in Constantinople.

One last church, Sarïca Kilise, merits comment, and that because it complicates the cross-in-square scheme with a triconch arrangement by adding, at the ends of the north and south arms of the cross, two further apses to the conventional three (Fig. 25).[59] These are extended, moreover, rather singularly, beyond their semicircles to form roomy *arcosolia* or burial niches,

Figure 23
Monastery of Eski Gümüş,
near Niğde, church: plan.
(Cat. no. 49)

Figure 24
"Church A", Soğanlï Dere:
plan.

Figure 25
Sarïca Kilise ("Yellow
Church"), near Ortahisar:
plan. (Cat. no. 36)

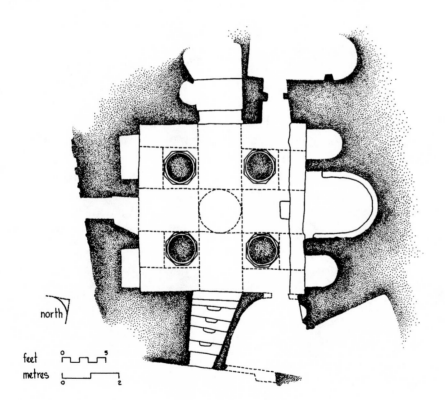

north

feet 0 _____ 5
metres 0 _____ 2

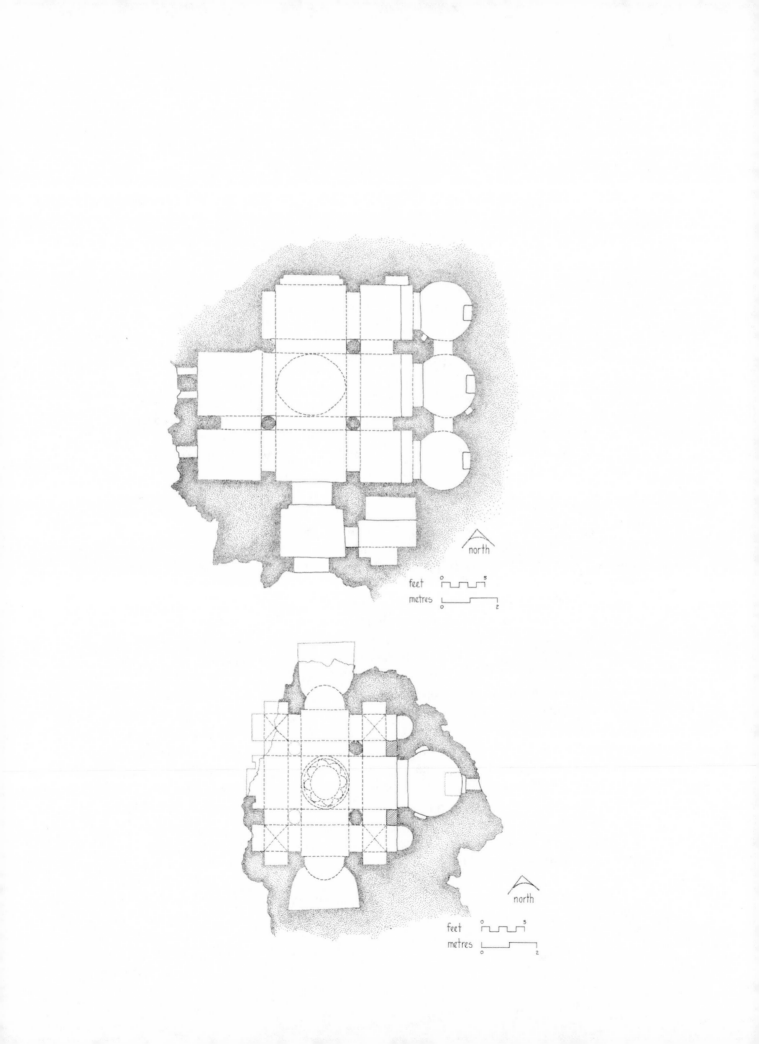

north

feet 0 5

metres 0 2

north

feet 0 5

metres 0 2

possibly because the church seems to have been devoid of a narthex, where burials would be housed ordinarily. The corner bays imitate groin vaults, and the central dome is notable in that it sits on an attenuated drum whose cylinder has been cut into to create eight niches which once had standing figures painted in them. The earliest instance we have of a cross-in-square and triconch combination occurs at the katholikon of the Lavra Monastery on Mt. Athos, and it continues afterward as an Athonite peculiarity. This is certainly far afield from Cappadocia, but I can find no more plausible source for Sarĭca Kilise. Miss Lafontaine-Dosogne's suggestion that we look to Armenia is not encouraging. The church of the Virgin at Thalin, which she invokes in this context, strikes me as being incomparable. It combines, in the manner of many Armenian churches, early and late, a three-aisled basilica with a domed cross; the north and south apses provide only a superficial similarity.

These, then, are the permutations of that cardinal Middle Byzantine church type, the cross-in-square, in the backwater of monastic Cappadocia. That it should have left so many examples, several of them of more than passing distinction, is itself remarkable. Such is the tenacity of symbolic form in architecture that the monk at Göreme or Peristrema should be moved to approximate a building type of great complexity in his limiting medium of native rock, even when the exigent device to bring it off, light, was denied him. Something more than ritual conformity with the leading centers of the empire induced him to try. It was, I think, the perennial wish of the province to renew its identity with the generative source of its existence, to make contact, to belong. And in this sense the abandonment of the cross-in-square after 1150, the return to Archaic forms, is poignant. It is Cappadocia's admission that it itself has been abandoned; that the aegis of Constantinople has been once again, and this once finally, withdrawn; that Seljuk occupation will endure. The monk now reverts to the old, the tide turns back upon itself after two centuries of hope, the ring closes.

At first most building and painting stops. There is no church that can be assigned securely to the later twelfth century. The land feels its way with the conqueror: he stakes his claim forcefully. Then, when the land is his and the monk has learned to accept this change of guard in the unpredictable flatlands of Anatolia, the rock is carved again and painted. But the mood is recessive. The humble one-aisled basilica takes over; the pictures copy extant programs of the

eleventh century. And in the apse, behind the now standard iconostasis, the creatures and props of apocalyptic visions reappear. Tetramorph and hexapteryx, crystal sea and wheel of eyes, interpose themselves between the great mediators, the Mother of God and the Precursor, and that source of ultimate authority and judgment, the enthroned Christ of the Second Coming.[60]

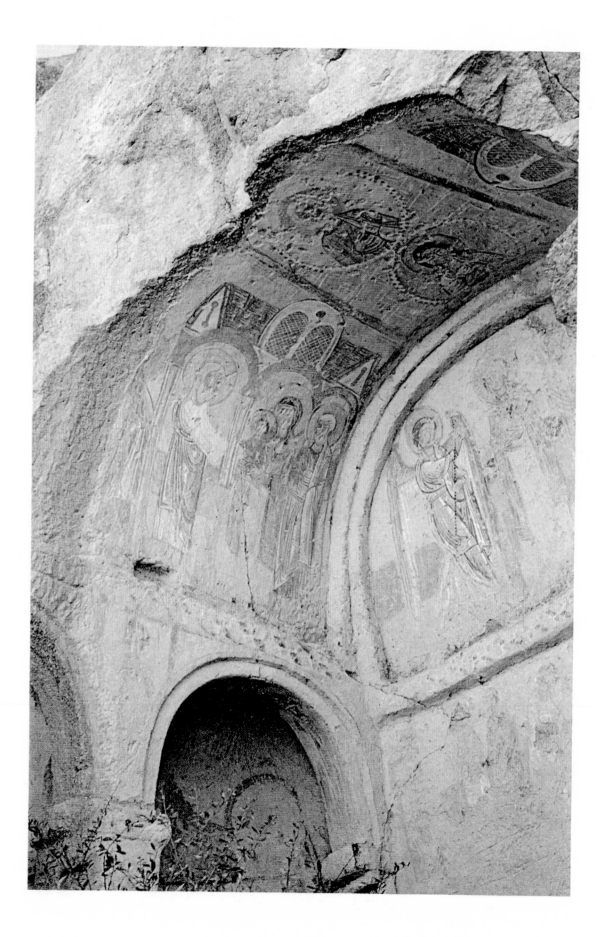

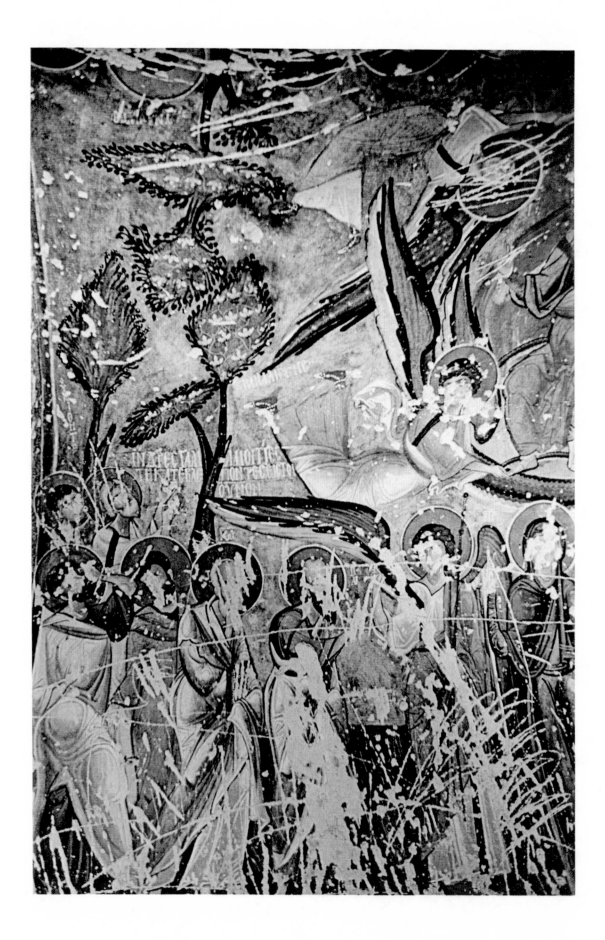

3
The Paintings

Cappadocia competes with Mistra in southern Greece as the most concentrated environment of Byzantine wall painting. A visit to either place allows one to experience the full effect of Byzantine church interiors and to study at leisure and with abundant illustration the pictorial art of this eastern medieval culture. The heyday of Mistra came late: its best churches date from the last two centuries before the fall of Constantinople. For this final sustained bloom of Byzantine painting remains are, actually, ample. In addition to Mistra there are numerous scattered fresco programs in Serbia, Bulgaria, Cyprus, Trebizond, and other peripheral centers to which patronage had extended during the sunset vicissitudes of the capital. It is for the period of Byzantium's eminence, the ninth to the twelfth centuries, that surviving material is scant. And it is precisely because of this dearth that attention focuses upon the painted churches of Cappadocia as an invaluable storehouse of Byzantine pictorial art in the centuries immediately following the resolution of the Iconoclastic Controversy.

But this is to think historically. Cappadocian wall paintings have, of course, more than this relative, art-historical worth. Their meaning is absolute in the context of their own creation. This context affords them their prime importance, the reason for their being. It behooves us, then, not to treat the paintings primarily as documents useful in the charting of a general course of development for Byzantine art. And more: it is proper to remember that even to isolate the paintings for study, as we are now doing, is an expedient of convenience. We must remind ourselves that the paintings have no existence divorced from their architectural ambience. They are an integral component of a total environment of which the other components are the landscape, the buildings, the ritual. If we then deal with the paintings here under a separate heading, it is for the sake of clear organization and at the expense of a more properly integrated discussion.

We have in fact already spoken of paintings in the preceding section on architecture; first, because the dating of many Cappadocian buildings is possible only with the aid of their decoration, and second, because we did not wish to discuss the architectural skeleton of major churches like the triconch of Tağar or the cross-in-square churches of Göreme without outlining in brief how this skeleton was made whole with its own discrete scheme of religious imagery. We can now take a longer look at the decoration, reviewing its method of execution, its iconography and style, and its intended function insofar as we can presently understand it.

Folk Decoration

Any church or chapel in Cappadocia, when first carved out of the live rock, was already imbued with sanctity, the sanctity of its shapes. The apse, the triumphal arch, the chancel screens—these were rock made ritual setting, because of the established symbolism of their forms. But apparently the setting was not deemed worthy of use until some painted ornament had altered its native austerity. A first system of decoration, as we have pointed out elsewhere, was applied quickly and crudely on the untreated rock surfaces. This system was, for the most part, non-representational; with the exception of the cross, the motifs used seem to have had no symbolic value. And yet, executed in cheerful red and green paint, most probably by the carver of the rock himself,[1] the rough folk decoration brought color and life to the freshly excavated container of liturgy, and indeed seems to have been a prerequisite to official consecration of the new church. It would be nearly impossible to date this folk decoration independently, since being innocent of artistic consciousness it is immune to the passing of time. Some of the anonymous conventions of design used in the churches go back a long way into the Anatolian past, and one can still see their application today on objects of everyday use like basketry and crafted tools.

On occasion, however, specially conceived motifs betray topical interest. In several churches, notably in St. Barbara at Göreme (Cat. no. 56), a rich variety of unusual designs has recently been identified to be Byzantine military standards and scepters (Pl. 35).[2] In a theater of regular contest like Cappadocia, where the presence of armies was continually felt, the choice of the designs and the attention with which various military emblems were distinguished should not surprise us. We should also allow for the possibility of soldiers who might have elected to join monastic communities, transferring their profession to a realm no less demanding of vigilance and combat. For the paths of soldier and monk were in truth analogous. To fight the Muslim at the empire's frontiers, was it not to fight the Devil in disguise? The monk did just as much in his solitude, and that daily, and he did so for no lesser master than the Lord God.

It may be that for some monasteries this first system of folk decoration, humble and un-storied, proved adequate. One should not underestimate the long-enduring aversion of the Christian hinterland for the religious image,[3] and the injunction of monastic thought against anything that might be deemed inessential to the faith. Idolatry and luxury—they were the two persistent arguments of iconoclasts since early Christian times. But such scruples against the

making of images, though doubtless always present, were certainly not held universally, and the ambition of most superiors or parish priests would appear to have been to supplant the folk decoration with a comprehensive program of religious painting modeled after traditional cycles or recent metropolitan prototypes.

The project was costly and difficult. The painter's skill was more complex and rarer than the labor of the carver. The rough surfaces of the church had to be treated specially to receive his art. Many communities were content, it would seem, to include a small number of isolated figural panels in the general scheme of nonrepresentational design. The panels were added to in the course of time; given the nondescript character of their execution, to date them is no easy matter. For these the wall was coated with a mixture of plaster and sand into which, for greater cohesion, vegetable additives such as straw, tow, and plant stems were mixed. The binding medium was gypsum or lime. The simple images were painted in somber earth colors; the effect was that of individual icons attached to otherwise coarse and unpretentious church walls.

But the goal remained the complete pictorial sheath. When a community was fortunate enough to be able to afford it, most often through the kindness of donors, the entire church interior including the columns was smoothed over, either with the same mixture of plaster, sand, and vegetable additives, or else with a thin coat of pure plaster, as at Tokalĭ II and the chapel of Joachim and Anna in the valley of Kĭzĭl Çukur (Cat. nos. 39 and 13). The initial folk decoration and, where they existed, the few figural panels would thus disappear from view. Ordinarily, the rough surface of the excavated rock provided sufficient traction for the plaster. But in the church at Eski Gümüş (Cat. no. 49) the walls were carefully chiseled before plastering. At Yĭlanlĭ Kilise in the valley of Peristrema (Cat. no. 31), on the other hand, the walls were regularized by a layer of hard cement, very thick at places, and over this the plaster for the paintings was then put on. This arrangement is, to my knowledge, unique in Cappadocia. Occasionally the painter would dispense with the plaster altogether; the smooth rock would be coated with lime or casein, on which the painting was applied in secco. This is the case with the church at Çavuşin (Cat. no. 38).

Plate 35
Göreme, St. Barbara (Cat.
no. 56), view of the inte-
rior, detail.
[Photo David Gebhard]

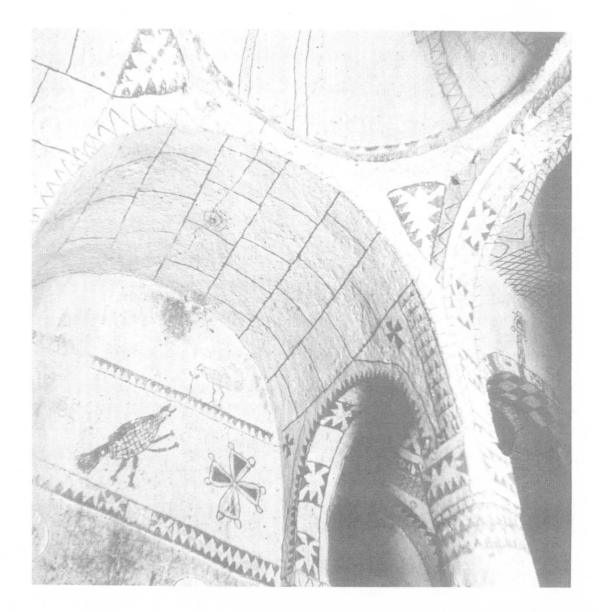

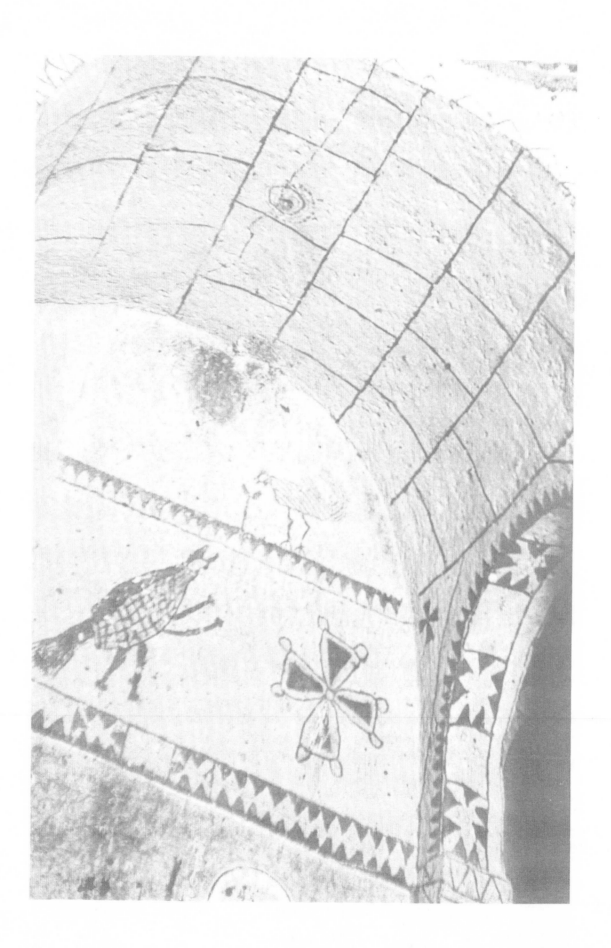

Painters

On the wall surfaces so prepared, the painter sketched out, in broad outline, the saintly figures and the Christological scenes of his projected scheme of decoration. In a small chapel at Boyalĭ Dere (also called Kemerli Dere) near Cemil, where the paintings have faded away, it is possible to study these preliminary sketches. They consisted of simple brush lines in ocher red, tracing the general contour of the figures, the main features of the faces, and the main drapery folds. They appear to have been made without the aid of instruments, such as compass or ruler. For standing, frontally disposed personages, a vertical line passing between the eyes and through the body assured that the figures would not be off plumb. Then these outlines were colored and built up.

The technique was only rarely true fresco, wherein paint is directly laid on wet plaster and becomes one with it upon drying. Rather, one used here a variety of secco painting, or perhaps tempera might be more accurate, with some sort of varnish as fixative. A first coat of uniform grayish paint was applied on the dry plaster bed, and over this a limited palette of colors slowly brought out in chiaroscuro the drapery folds and the plasticity of the flesh. The background for the figures was divided in two monochrome color zones, usually green to represent the ground and blue for the sky. But in St. Theodore and the chapel at Kĭzĭl Çukur (Cat. nos. 12 and 13), as well as in several churches in the valley of Peristrema, there is a third zone of a lighter hue in between to represent a transitional horizon.

There is evidence that, in addition to regular brushes, color was sometimes daubed on the walls by means of bits of cloth rolled into pellets. Samples were found in the vicinity of the newly discovered Saklĭ Kilise (Cat. no. 53), but it should be noted that, quite exceptionally, the walls of this church were not plastered before painting, and it may be that the artist found it easier in this one case to apply paint on the raw rock with cloth balls rather than normal brushes.

Who were the artists? How did they come by their craft? We know nothing about them except, in a very few cases, their names. In the ruins of a church at Elevra, an inscription reads: "For the blessing and salvation and the remission of sins of the servant of God Sisinios, who painted this house of the Virgin."[4] The word is *anistorisanta*, literally "who storied." Two other verbs used to record the completion of a painting program are *eteleōthē* and *ekaliergēthē*. The

painter is sometimes coupled with the donor, as in the church of the Forty Martyrs at Suveş (Cat. no. 62), where the phrasing used is "by the hand of Etios the monk."

They were undoubtedly, most of them, local talents—monks, like Etios. In a few instances, due to particular details in the costumes and buildings represented, Jerphanion surmised that the painters were Armenian. Given the historical possibility of an Armenian presence in eastern Cappadocia beginning perhaps in the ninth century, this conjecture should not be entirely dismissed. To the contrary. We shall note in due time some connections, both stylistic and iconographic, between Armenia and a group of churches in the valley of Peristrema, which would suggest that the activity of Armenian colonists, in this case monks, or at least their influence might have spread further west than we have so far been willing to admit.

Whatever their provenance, the Cappadocian painters, like their less artistic brethren, were not very literate. They confused scripture, as when, in the church of Forty Martyrs, a passage from Zechariah is attributed to Solomon, or at Karanlĭk Kilise (Cat. no. 59) an image of the prophet Daniel is labeled Solomon. Captions and dedicatory or pious inscriptions abound in misspellings, that is, if one assumes the standards of the official language of the court and the Church. But taken at face value this infelicitous writing provides a remarkable monument of demotic Greek in the Middle Ages. The distinction of *demotikē*, the common spoken language of the people, and the formal *katharevousa* was as sharp then as it continues to be today. What were misspellings according to the latter can be considered in demotic usage to be simplified spelling. And since the simplifications were often phonetic rather than grammatical, they are a valuable transcript of Cappadocian diction. One meets with colloquialisms too, phrases that are not recognizably scriptural attached to Christological scenes. In some representations of the Entry into Jerusalem, two boys are shown atop a palm tree. One, securely lodged at a bifurcation, is busily hacking branches with his hatchet. His companion clings to the tree trunk, his hatchet tucked in his belt. Beside them a caption in demotic phraseology reads: "Sisinios, cut me off a branch." Words borrowed, perhaps, from a locally known homily in dialogue form.

Little progress has yet been made in identifying the stylistic personalities of individual painters. The process of establishing a painter's oeuvre by means of visual analysis alone is slow and treacherous, particularly in periods like Middle Byzantine art, where the iconography and the

expressive language of form are, in large measure, prescriptive conventions. In any case the effort is cumulative. For decades now, art historians have been building an artistic who's who of painters of Attic black-figure and red-figure vases, sculptors of Roman sarcophagi, and painters of Pompeian murals. Cappadocia, indeed most Byzantine art, has still a long way to go. There is no question, for example, that in some rockcut churches the program of painting is by more than one hand. The eventual problem would be to distinguish one style from another, and to decide what is from the master's hand and what the work of assistants. Some progress on this score has already been made in the work of M. Restle. Conversely, paintings in different churches are sometimes so close in execution and detail that one is encouraged to view them as the product of a single painter, or at the very least of the same school; we shall try to group some of these painting programs into schools a little further on in our discussion. But the attempt must remain, at this stage of Cappadocian scholarship, tentative and incomprehensive.

Donors

Most of the painting programs were undoubtedly commissioned and paid for by wealthy donors, and in their case we have a little more to go on than names. Donations, of course, took other forms as well. From an inscription in the cutstone triconch of Ortaköy, we learn that that monastic church was given a sum of money by a certain Koulep, forty-nine *hyperpyrs* to be exact, and that a Basil, son of Michael, donated a *modium* of land to the monastery, and a walnut tree.[5] But the pictorial decoration of a church ranked as the most popular consequence of native generosity. Not uncommonly, full-length portraits of the donors would be included in the program; these, together with dedicatory inscriptions, assist us in determining the donor's station. As we have already noted in Part 1, the caftan and turban worn by the donor Basil in the late church of St. George (Kĭrk Dam Altĭ Kilisesi; Cat. no. 64) and the title of *emir* with which he is designated prove him to have been in the employ of the conquering Seljuk Turks. A nimbus, on the other hand, probably indicates proximity to the imperial family, or high noble status at the very least. An example is the lady donor at Karşĭ Kilise (Cat. no. 61), pictured nimbate below a scene of the Last Judgment, laying hands on the heads of her two children, who flank her. Two names only are legible: Eirene and Maria.

The majority of donors, as is to be expected in this borderland, were monks, nuns, and military personnel. Only once is there reference to a businessman. This is at Karanlĭk Kilise (Cat. no. 59), where two male donors are actually included in a Christological scene. They are Genethlios and John, and they are shown prostrate before Christ in the scene of the Benediction of the Apostles on the narthex vault. John is further identified as *entalmatikos,* an epithet probably equivalent to *entolikarios,* which means, roughly, entrepreneur. Of two more donors in the same church, these prostrate in the Deisis panel of the central apse, one, Nikephoros, is a priest; the other, a layman named Bassianos.

Military donors have resounding titles. The Christopher who made possible the painting program at Eğri Taş Kilisesi (Cat. no. 29) carries the title of "spatharokandidatos and turmarchos of Spadiata and Pates (. . .)," a high-ranking military chief of the Taurus frontier to the south. The Michael Skepides of Karabaş Kilise (Cat. no. 50) is a "protospatharios": he is depicted holding a lance, the left hand placed on the hilt of his sword. The patronage of this particular church is perhaps the most elaborate to be recorded in Cappadocia. The church was carved apparently sometime around 900, in the form of four parallel naves. Only the first nave received a repre-

sentational program of painting, while the others retained their initial folk decoration and a few portraits. These were of the abbot Bathystrokos, and three other monks, Photios, Bardas, and Zacchariah, who might have been his adoptive children. All were entombed in the fourth nave, which was a funerary chapel. Sometime later the main nave was repainted, and the name of the monk Rustiakos is attached to this second program of decoration. Then this too was overlaid, in the reign of the emperor Constantine Dukas, by a third program at the expense of the protospatharios Michael Skepides. He is cited in an inscription together with the nun Catherine, almost certainly his wife, and the monk Niphon. Niphon and a woman named Eudokia are represented in the church at the feet of the archangel Michael, the patron saint of the protospatharios. Nearby are portraits of two other women, called Eirene and Maria, prostrating themselves at the feet of St. Catherine, patron saint of the nun. These four—Niphon, Eudokia, Eirene, and Maria—are probably the children of Catherine and Michael. The manner of the paintings they sponsored is very distinguished and matched nowhere else in Cappadocia. It is likely that competent artists were imported from the outside by the Skepides family, who obviously took their artistic patronage seriously. Incidentally, another member of the family, John Skepides, protospatharios and consul-strategos, is commemorated as donor in the nearby church of Geyik Kilise (Cat. no. 46).[6]

How much say had these rich donors on the content and arrangement of the painting programs they sponsored? Not much it would appear. The selection, placement, and iconography of the pictures were determined by tradition, and the donor would no more think of imposing undue novelties than he would disregard the pattern of liturgy. His influence probably extended no further than the inclusion of his portrait and those of his patron saints. It is clear, for instance, that the salient position of an obscure saint, Nikandros bishop of Myra, in one of the side apses at Kuşluk near Kılıçlar (Cat. no. 51) owed to the fact that one of the donors was the saint's namesake.

There is one inscription, at Tokalı II (Cat. no. 39), that would seem to contest this assessment of the donor's participation in the painting program. It is a long statement in verse that runs in a single line around the nave. It commemorates a certain Constantine as the man responsible for the nave decoration (his son Leo is named separately for meeting the expense of the paintings in the left apse), and then goes on to list the twenty Christological subjects with which

Constantine had the nave pictured. But some of the subjects mentioned, like the Multiplication of the Loaves, do not in fact figure in the painting program, and others, like the Passion Sequence and the Pentecost, which figure notably, are omitted from the list. Quite possibly this is a case of borrowing a dedicatory formula used elsewhere.

With one or two startling digressions, decoration confined itself to Christian content. We seem to have some genre painting in Ballĭk Kilise (Cat. no. 28), apparently not unlike the charming scenes that illustrate the description of spring in the Gregory of Nazianzus manuscript at Paris (Bibl. nat. gr. 533), but the murals in question are too mutilated to be read with certainty. The frivolous nature of another painterly digression is, however, not in doubt. In the monastery of Eski Gümüş near Niğde (Cat. no. 49), the excavators recently uncovered a crude frieze on the walls of a cell above the church narthex. Its subject: selected fables from Aesop, including the tale of the Man and the Ungrateful Snake, the tale of the Wolf and the Lamb, and the tale of the Eagle and the Flighted Arrow. "Illustrations from Aesop may appear out of keeping in a monastery," Professor Gough charitably remarks, "and the moral of (the Man bitten by the Ungrateful Snake)—'Do no good to the evil'—is hardly Christian sentiment. Their contemplation may have given some diversion, however, to a solitary monk, and can have done him little harm."[7]

The Iconography
of Saints

Christ and his saints—that was the chief staple of Cappadocian iconography. As befitted the King of Heaven, Christological imagery occupied the heights of the church interior: apse conch, vaults, and ceilings. The walls and pillars that held up this divine superstructure were lined in turn with the single ceremonial effigies of Christian heroes—the prophets of the Old Testament and the apostles of the New; martyrs of the early Church, male and female; sainted bishops and emperors; and anchorites, monks and stylites who had been, in their earthly life, exemplary athletes of the soul.[8] They stood fullfront, every one, crowned by the nimbus of immortality: with fixed and often terrible stares they faced the congregation on all sides. Here in the dim caves of God, they and the living became one in the celebration of the Eucharist. Was not the body of the Church one, and that the body of Christ? Did not *ecclesia* mean more the assembly of Christians past and present, the spiritual children of Israel, than it meant a temple in the pagan sense, a building to house the image of the deity? To the Christian the community was the temple. "Know ye not that ye are the temple of God and that the Spirit of God dwelleth in you?" Paul had said. And the church building was accordingly that container of supranatural space shared alike by the sainted and the simple in witnessing the sacrament of the Lord.

To establish the identity of the saintly host, the name of each was inscribed next to his painted effigy. But the faithful, for the most part, had no need of captions to recognize their heroes. Costume and special attributes revealed the station of each one, revealed whether he had been emperor in his mortal career, deacon or bishop, medical man, monk, or soldier. Biblical personages wore classical garb and stood barefoot. They included apostles and Old Testament prophets, with the exception of the kings—David, Solomon, Hezekiel, and Daniel—whose outfit was regal. Daniel invariably appeared in the long pants, cloak, and peaked cap associated with Oriental, specifically Persian, monarchs. In their hand these biblical personages held books or scrolls, the latter sometimes unfurled to display a passage of scripture.

Priests and bishops carried ecclesiastical robes appropriate to their rank: these were of course identical to contemporary robes worn by their living counterparts. The deacons, like Sts. Lawrence, Romanos, and Stephen the protomartyr, were distinguished by the *orarion,* an ornamental band that fell from the left shoulder over a simple tunic called the *stikharion.* One hand held the censor, the other a small box which at first contained incense, but which by the time of our Cappadocian murals, should probably be interpreted as a eucharistic *pyxis* for the species. In

consonance with their duties, these sainted deacons were commonly pictured close to the sanctuary, usually on either side of the triumphal arch that curtained the apse.

The ascetic saints whose life on earth had been taken up, foremost of all, by prayer were traditionally represented with open arms. Most other saints rested one open hand on their breast while with their right they held up the cross in emulation of the words of the Lord: "If any man will come after me, let him deny himself, and take up his cross, and follow me." (Matthew 16:24). The exceptions are striking. St. Onuphrios, whose feast day came on the twelfth of June, was always depicted nude. There is a delightfully ascetic portrait of him in a chapel at Göreme, where a cactus stiffly planted in the earth does him service as the fig leaf of pudency. A very special class of saints called *anargyroi,* physicians who practiced their art for the love of God and not for gain, were shown holding professional instruments; they include Sts. Hermolaos and Panteleïmon. For the Byzantine emperors canonized by the Church—among them Constantine the Great, his mother Helena, and the empress Eirene, who briefly restored the veneration of images during the Iconoclastic Controversy—the chief attribute was the globe, symbol of sovereignty. Only Christ and the archangels Michael and Gabriel made use of the same attribute. Finally, military saints exchanged the cross with a sword or lance. Of them, St. George, the national hero of Cappadocia, was of course the most popular. At Chapel 28 at Göreme (Cat. no. 52) he is represented mounted on a white horse, which was de rigueur, confronting St. Theodore, also on horseback. Between them the dragon lies transfixed by their lances (Pl. 36).[9]

You will notice that this particular representation of St. George departs from the conventional format of saintly portraiture, that is, the frontal ceremonial effigy in suitable clothing and with distinguishing attributes. The St. George type, which we might call "narrative portraiture," rather elects to show the saint in question engaged in the episode of his life most associated with his legend in the popular mind. For St. George that episode was of course the slaying of the dragon, and the dragon is no other than that which guards a magic plant on the heights of Mt. Erciyas in numerous tales of later Anatolian mythology. We have several other examples of narrative portraiture in the rock churches. Let me single out St. Eustathios, St. Marina, and the Forty Martyrs of Sebaste.[10] All of them are, of course, portrayed in the conventional manner as well.

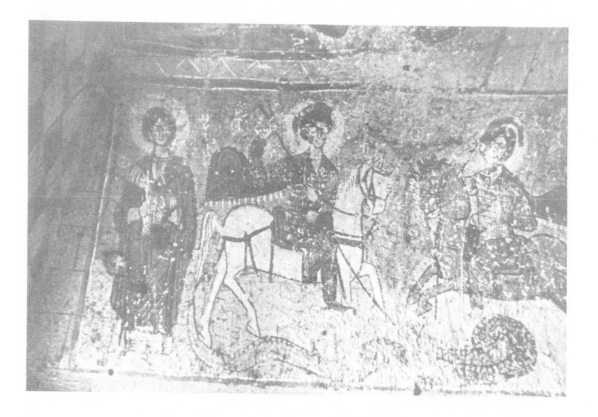

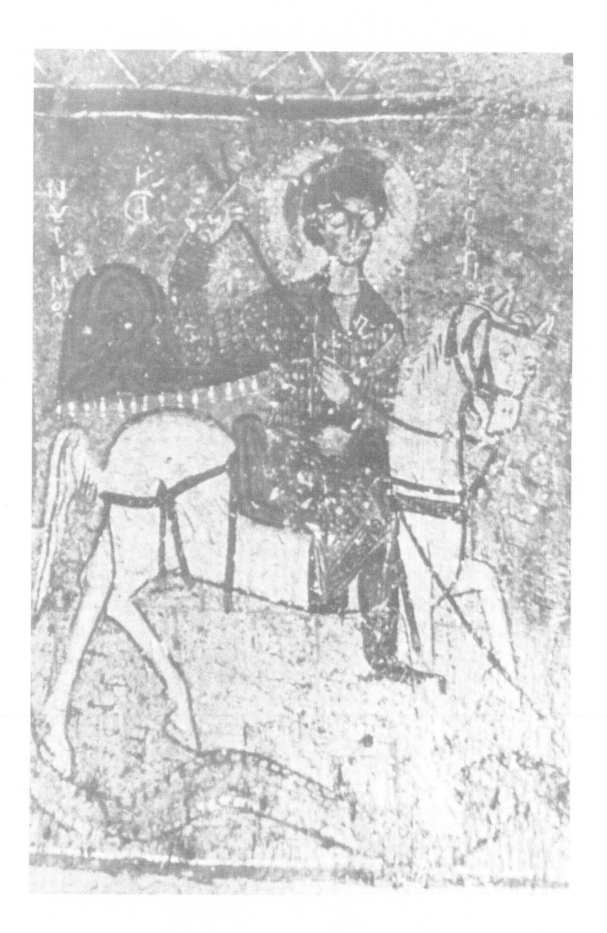

In the case of St. Eustathios the episode chosen is his pursuit of the hart which turned out to be Jesus Christ. The best-preserved versions are in a chapel at Göreme and at Geyik Kilise, whose Turkish name derives in fact from the hart in this particular scene (Cat. nos. 27 and 46). The saint rides on a red horse in a rocky landscape, his cloak aflutter and the lance lowered for the charge. Perched on escarpment pinnacles, more like a mountain goat than a hart, the animal turns to look curiously at its pursuer, a cross fixed between its glowing horns. An inscription between it and the rider reads as follows: "Plakides, why are you chasing me? I turned myself into a beast for you, and now by you I am chased."[11] It may be worth noting that the scene was not found by the Thierrys in any of the churches of Peristrema, and seems a specialty of the region investigated by Jerphanion.

The episode of St. Marina, who was martyred in Antioch of neighboring Pisidia under the emperor Diocletian, is unique in Cappadocia and late in origin.[12] It figures in the church of St. George at Peristrema (Kĭrk Dam Altĭ Kilisesi, Cat. no. 64) which dates from the end of the thirteenth century. The scene is not well preserved. Marina has grabbed by the hair a small nude creature labeled Beelzebub while in her upraised hand she holds some sort of instrument which must be the providential mallet that appeared in her prison cell. According to the legend she had been visited there by a demon with whom she struggled purposefully. First, so the account has it, she sealed herself with the sign of the cross against her tempter, and so fortified she made for him and in the struggle half of his beard came out in her hand. She attacked once more and put out his right eye. And while the demon groaned and cried "Woe is me," as well he might, a mallet miraculously appeared, seizing which Marina pummeled him thoroughly until he was downed. And now she saw a cross surmounted by a dove, and the cell and the entire city were brilliantly illuminated. Marina then asked the demon his name. "Beelzebub," he said; "I have tempted many saints in my time, and now I am myself defeated by this young maiden of Christ, Marina."

Our final example, the Forty Martyrs of Sebaste, we have already met twice before, in other contexts: once in the large church of Çavuşin (Cat. no. 38), where they were seen in the company of Melias magistros, the great tenth-century Armenian general who was taken prisoner by the Muslims in the siege of Amida; and again, in the narthex of Yĭlanlĭ Kilise (Cat. no. 31) as part of an elaborate cycle of the Last Judgment. Neither of these two series of the Forty really

fits what we have called narrative portraiture. In the case of Çavuşin, the martyrs are dressed in military costume, but otherwise their images are devoid of narrative content. The costume is different at Yĭlanlĭ, long oriental robes with slits at thorax and skirt, but they are still conventional icon-like effigies. Of the seven representations of the Forty so far known in Cappadocia (four in Jerphanion's territory and three in the valley of Peristrema), only one refers explicitly to the chief episode of their legend. This is in the early thirteenth-century painting program of a church at Suveş, dedicated in fact to the Forty Martyrs (Cat. no. 62). Here they are mostly elderly men, naked but for loincloths, clearly conceived to be in the icy waters of the lake where they slowly and painfully succumbed. But you would not know it to look at them. There is no trace of feeling on their faces: it is the impassive, at most sad, mask of Byzantine sainthood that they are wearing.

This type of narrative portraiture for the Forty Martyrs of Sebaste, one encounters in earlier Byzantine programs outside of Cappadocia, and it is in fact the standard Middle Byzantine scheme for this particular group of saints. We might mention as examples the *Menologion* of Moscow and the painting program of the prothesis at St. Sophia at Ochrid, both of the eleventh century, and the fragmentary frescoes from Vodoca (Macedonia) almost contemporary with Yĭlanlĭ Kilise. Here at Yĭlanlĭ the painter went further. In the west tympanum of the nave he rounded up the story of the Forty by depicting the scene where one of their number, unable to withstand the slow death by freezing, yields to the temptation of the warm bathhouse placed near the lake and apostatizes. But in no time one of the guards in charge of their execution joins the Christian cause by stripping and jumping into the lake, and the number of the Forty thus remains intact. And the Devil speaks his disappointment in a manner that echoes St. Marina's Beelzebub, "Woe is me, I am defeated by these saints." Now, taken together, the series of the martyrs and this extra scene form a kind of *narrative cycle* which adds a new method of presenting saintly iconography to the two, *ceremonial effigy* and *narrative portrait,* that we have so far been considering.

Accounts of saints' lives were plentiful and rich in Christian literature, many of them the product of the popular apocryphal imagination of the East. They teemed with visions, prodigious happenings, and all manner of picturesque torture, and their message came through loud and clear even for the ordinary reader. To the monk these lives surely had a special reality. The

story of a St. Simeon the Stylite or a St. Marina would have seemed to him the very paradigm of a steadfast faith, something to be studied and emulated in his solitude; and the marvelous encounters with demonic creatures would have possessed an eminent, indeed one might say professional, relevance since he too had to battle with such creatures as he struggled "within his earthly and soiled body . . . towards the rank and state of the incorporeal beings"—to quote from St. John Climacus' definition of the ideal Christian monk.[13] One should therefore expect to find in the monastic environment of Byzantine Cappadocia numerous narrative cycles of saints' lives, and these painted with more detail and invention than the syncopated version of the legend of the Forty Martyrs at Yĭlanlĭ. But the truth is that such extended cycles are quite rare.

This may be an accident of survival, but I doubt it. The cause is to be sought, rather, in the iron imposition of the Church, which set about strictly to regulate the choice of subject, and the interpretation of monumental religious painting in the wake of the Iconoclastic Controversy. Painters were henceforth to restrict themselves to the telling of the story of Christ, and even that was to be presented not so much as a chronological narrative but as a set number of formally composed episodes chosen for and arranged in accordance with their liturgical import. Old Testament iconography was almost totally excluded, or better, reduced to the frontal effigies of the major prophets and kings. Similarly, the iconography of saints and martyrs was itself limited to the familiar ascetic portraiture, stereotyped and pedantically labeled; and to the occasional narrative portrait like the ones of St. Marina and Beelzebub, and St. Eustathios and the hart. Rich narrative cycles had no room in the rigid post-Iconoclastic system of church decoration.

That there had been a flourishing tradition of non-Christological religious painting in the East in the centuries before the official policy of Iconoclasm we cannot reasonably doubt. On more than one occasion our sources describe extended martyrial cycles, apparently rendered with pronounced realism of expression and detail. The long passage of Asterios, bishop of Amasia, describing the painting cycle of the martyrdom of St. Euphemia is well known, and I have referred to it once before, on p. 90. Closer home, we should cite St. Basil's statement about a monumental narrative cycle in his panegyric on St. Barlaam, and St. Gregory of Nyssa's in his panegyric on St. Theodore.[14] In a little-known passage of the latter text, Gregory extolls the

painter's art that can depict "the feats of the martyr, the sufferings, the pain, the savage faces of his tormentors, the insults, that fiery furnace, and the blessed end of this spiritual athlete, this very type (ἐκτύπωμα) of the human nature of Christ the judge—all these pictured for us in paint as if written in a book." Such cycles, to be sure, were invented for specific memorial buildings, but shortly they spread to congregational churches as well and became part of the common repertory of Christian artists.

But when in the early eighth century Constantinople officially pronounced that image-making was tantamount to idolatry, the eastern love for storytelling, that natural accomplice of superstition which is to say of indiscriminate faith, came under attack. Many existing painting programs were destroyed. In Part 2 we have already spoken of the ensuing hiatus of roughly two hundred years, and we have spoken too of Cappadocia's resistance during this time against the fury and fanaticism of Iconoclasm. When it was all over and a new modus operandi had been spelled out for artists throughout the empire, storytelling succumbed to formulaic panels hierarchically disposed on the surfaces of church interiors. And those pictures that told stories of martyrdom "as if written in a book" were now largely confined in fact to books, inasmuch as the descriptive invention of Byzantine artists was channeled to the more private realm of illumination for gospel books and psalters, and for popular manuscripts like the *Ladder of Divine Ascent* by St. John Climacus, the writings of St. Gregory of Nazianzus, and the *Christian Topography* of Cosmas Indicopleustes.

In the monastic churches of Cappadocia, acquiescence with the new mode of monumental painting was slow. Though most of the surviving painting programs are subsequent to the Iconoclastic Controversy, the painters persist for a time in depicting the story of Christ in the form of long, continuous narrative bands grouped into three sequences: the Childhood, the Miracles, and the Passion. To these I shall turn shortly. But even saintly cycles do not disappear entirely. One, the story of St. Simeon the Stylite as painted in the chapel of a hermitage at Zilve, we have already mentioned in Part 2. And the narrative portraits we have just discussed are themselves nothing less than remnants of ampler stories that in one or two cases can be pieced together. Thus the mounted St. George slaying the dragon, which stands for the official portrait of the saint in several of the churches, was just one of the scenes in a St. George cycle of which other scenes were "St. George before the Persian king," which survives in the chapel of the Theotokos

(Cat. no. 21), and "the martyrdom of St. George," in the same chapel and also in Chapel 16 at Göreme. The entire story seems to be present in the very poorly preserved paintings of the masonry church of St. Hermolaos (Karagedik Kilisesi) in the valley of Peristrema, dating from the eleventh century.[15] So too with the isolated scene of St. Mary the Egyptian receiving communion from St. Zosimus. It was known from two instances in Jerphanion's territory, until a new discovery of the Thierrys proved it to be part of a cycle. This is at Yĭlanlĭ Kilise (Cat. no. 31), where the communion scene is followed by the burial of St. Mary in the care of St. Zosimus and the lion. An additional bit of the cycle is preserved in Ala Kilise (Cat. no. 42).[16]

One further saintly cycle must be remarked upon and at some length, not only because it concerns the greatest religious figure of Cappadocia but also because it seems native in origin, if not from Cappadocia itself then from some proximate Anatolian realm.[17] The subject is the Life of St. Basil as composed by a native writer who used to be thought to be Amphilochios, bishop of Iconium and St. Basil's near contemporary, but who is now rightly identified with a later date and with more demotic, probably monkish, circumstances. The painting cycle exists in two rock churches, but in fragmentary and poor condition. Tokalĭ II (Cat. no. 39) has the earlier part, while bits of the later story are preserved in a chapel at Balkam Deresi. In both cases it is the long captions which accompany the pictures, derived from the text of Pseudo-Amphilochios, that enable us to identify the content with certainty.

The first major episode, pictured in a series of several scenes, concerns the debate over the custody of the cathedral of Nicaea. The emperor Valens, following his religious sympathies, had assigned the church to the Arians in the city. Now St. Basil, an ardent foe of Arianism, which had, after all, been condemned as heretical by the Council of Nicaea in 324, intervened and proposed that the matter be submitted to the arbitration of God. The church gates were to be locked, and the Arians given three days and three nights of prayer to set them open. Should their piety be successful, the church would be turned over to them. Otherwise, the same feat would be attempted by the Orthodox with one sole night of praying. Inevitably, the cause of heresy lost, and the church of Nicaea was put in the custody of St. Basil's party. Captions at Tokalĭ II read: "Prince Valens, what did I do wrong that you should give the church to the infamous Arians?"; "and coveting the church, the Arians prayed for three days"; "the church would not open for them"; "and when the church of God refused to open for them, the in-

famous ones turned back empty-handed"; "and St. Basil gathered the Christians and intoned the 'God have mercy' and the church gates opened"; "and St. Basil . . . gave thanks to God."

The second episode: the meeting of St. Basil with St. Ephraim. Ephraim, having heard of the fame of Caesarea's bishop and wishing to meet him, arrived there exactly at the time when Basil was delivering a sermon in his church. Ephraim stood at the edge of the crowd and listened respectfully. But Basil recognized him and sent out his archdeacon, who called Ephraim by name and asked him to join Basil at the sanctuary. Which was indeed remarkable since the two saintly men had never met before. Ephraim humbly refused the invitation, but after the service he sought out the bishop in the sacristy and was ordained deacon by his hand.

The third episode preserved at Tokalĭ involves the lady who recorded her sins in writing and having affixed a seal to the scroll, took it to St. Basil and asked him to obtain for it God's pardon. The bishop prayed, and when on the following day the seal was broken and the scroll opened, all but one of the listed sins was effaced, but that, alas, the greatest. For this one sin the bishop now sent the lady to St. Ephraim, who, however, refused to absolve her. When she returned to Caesarea, she met with a funeral procession in the street. To her great distress it turned out to be Basil's own. The bishop, it appeared, had passed away during her absence. The desperate lady now threw the scroll of sins on St. Basil's corpse as a last resort. A deacon retrieved it, broke the seal, and lo there was no writing upon it whatever. One will recognize the popular nature of these proceedings that go against the grain of established official patterns of oral confession and due penitence for the remission of sins. To the wishful faith of the vulgar, Church stricture notwithstanding, no sin, however major, was unpardonable.

The rest of the cycle, completely destroyed at Tokalĭ, can be reconstructed from the few fragments of painting and the accompanying captions in the little chapel at Balkam Deresi, near Ortaköy. Included here were scenes telling of St. Basil's last miracle, his baptism of the Jew Joseph a day after the latter had given him up for dead; and other scenes depicting St. Basil's actual death and his burial rites.

All this is hardly enough. We get, unhappily, a very poor notion of the pictorial character and richness of the St. Basil cycle from the tantalizingly meager remains at Tokalĭ and Balkam Deresi. Now, it is true that scenes from the great bishop's life are represented elsewhere, in other eastern programs of Byzantine painting, but these are of no assistance in envisaging the missing

portions of the Cappadocia cycle. The most notable case is the famous illuminated manuscript of the sermons of St. Gregory of Nazianzus (Paris, Bibl. nat. gr. 510) made about 880 at Constantinople for the emperor Basil I, namesake of the bishop and founder of the Macedonian dynasty. But the Basilian episodes illustrated here do not derive from the popular account of Pseudo-Amphilochios, and so, with the sole exception of the burial rites, there is nothing in common between the manuscript and the murals.

Still, the Tokalĭ-Balkam Deresi cycle is not an *hapax legomenon*. Far away from the Anatolian plateau, on the other side of the Christian world, chance disclosed that the same popular story of St. Basil's life was spread on the walls of another medieval church, the converted Temple of Fortuna Virilis in Rome, known until the late fifteenth century as the church of Sancta Maria de Gradellis and thereafter as Sancta Maria Egiziaca. In 1931 Jerphanion was able to observe here that a rather well preserved picture with the Latin inscription HIC MULIER DEPRECANS S̄CM̄ BASILIUM UT PRO EIS CRIMINA D̄NM̄ EXORARET represented in fact one scene of that telltale episode of Pseudo-Amphilochios, the persistent lady and her scroll of sins. The lady is shown prostrating herself at the feet of the bishop, who marches toward a double arcade, representing the portico of a church, in the company of his priests and deacons; and Jerphanion, with his fresh knowledge of the rockcut churches, could complete the missing parts of the entourage with a fragment at Tokalĭ that seemed to preserve the other half of this panel. "This is certainly not the least surprise of our career as archaeologist," Jerphanion comments, "than to meet, two thousand kilometers apart, two images . . . which complete one another so well that they would form a homogeneous whole if one were to juxtapose the half that any man is at liberty to contemplate in Rome and the half that rare travellers can still go and see in Cappadocia."[18]

The frescoes of S. Maria de Gradellis date from the later ninth century. It is surely not accidental that the first popular Latin translation of the life of St. Basil by Pseudo-Amphilochios should appear in the West only a little before this time, under Pope Nicholas I (856–867). Now the painting program of Tokalĭ II came about a hundred years later. But this would not trouble us in proposing an eastern inspiration for the St. Basil cycle in S. Maria de Gradellis. We have to assume that both the Cappadocian and the Roman artists were following not only a common text but also a common pictorial model, now lost, which originated in the East sometime before the latter half of the ninth century—following, but not slavishly. There was indeed some indi-

vidual digression from the model, primarily in details that would bring scenes up to date, as when the painter of Tokalı II provided for a contemporary tenth-century edifice in his retelling of the episode concerning the custody of the cathedral of Nicaea.

The transport to the West of the pictorial model for the Basilian cycle is not problematical. It could easily have arrived with its text, that is, in the form of an illustrated manuscript of the Life of St. Basil by Pseudo-Amphilochios. Portable objects such as illustrated manuscripts, ivory panels, icons, and the like were the principal means for dissemination of iconographic themes and also, of course, for stylistic conventions. For the latter, there was, however, a more direct agent: the artist himself. He would carry his mode of painting, his style, wherever he chanced to travel, and he could thus transplant it in traditions far away from its place of inception. We would have no difficulty substantiating such a claim historically for the case under discussion. I have spoken elsewhere about the exodus of thousands of Basilian monks during, and even after, the Iconoclastic Controversy, and Rome had several functioning Greek monasteries by the ninth century. Jerphanion, in fact, professed to see Cappadocian connections in the compositional scheme, in certain decorative details, and even in the style of the fresco program at S. Maria de Gradellis, and asserted that the artist, whoever he may have been, could not have been innocent of the painted churches in St. Basil's own homeland.

Now, Jerphanion was certainly overstating, as he did generally when assessing the influence Cappadocia may have exerted outside its boundaries, and particularly in the West. There is actually no stylistic element in the frescoes of S. Maria de Gradellis that cannot be viewed within the context of a local Roman school of painting of the ninth century, the school which was also responsible for some painting fragments that survive in S. Clemente and in S. Passera. The point is worth making. It demonstrates neatly that an artist could borrow iconographic types from a foreign source and proceed to translate them into his own pictorial idiom. And the reverse is equally demonstrable: that stylistic peculiarities may be borrowed from a foreign source and applied to schemes of iconography that are exclusively native. Both practices were common enough in the Middle Ages and must be constantly kept in mind when one tries to establish the origins or the inspiration of a particular picture that is not an obvious copy of a known original.

Cycles of
the Life of Christ

It is well that we should clarify this point before we go on to discuss the dominant subject of Cappadocian murals—the life of Christ. The topic is exceedingly complicated, but without disciplined methodology it is bound to become confused into the bargain. It involves more than a score of individual scenes; three separate "chapters," the Childhood, the Miracles, and the Passion; and at least three major Christological cycles, each with its own history and problems.[19]

Two of the cycles are narrative, meant to be disposed in uninterrupted bands and to develop the story of Christ in chronological sequence. We might call one of them the *Archaic cycle* since it belongs in date to the period we have named the Archaic Phase in our discussion of the church architecture. The term is Jerphanion's and the Archaic cycle figures preponderantly, but not one might say exclusively, in the majority of churches within his territory, that is, the eastern portion of troglodytic Cappadocia. For this one cycle we have Jerphanion's exhaustive study, though at present some of his arguments and conclusions bear revision. The other narrative cycle is less familiar. We meet with it in a group of churches in the valley of Peristrema only freshly introduced to the scholarly public by the Thierrys. Let us call it, for easy future reference, the *Ihlara cycle,* from the fact that its use is restricted to the churches in the southern half of this valley, near the village of that name. It is alien in iconography and style to the Archaic cycle, and its affiliation is as yet by no means certain. The third Christological cycle is not narrative in intention. Its circumstances and origin seem, on the whole, clear. Initiated largely by artists in Constantinople in the period after the Iconoclastic Controversy, it consists of a specified series of liturgical pictures designed to illustrate the major feasts of the Orthodox calendar; and it is directly associated, one will remember, with the new post-Iconoclastic church architecture of the Byzantine world, of which the prime scheme was the cross-in-square or quincunx, discussed already in some detail in Part 2. I should like to call this the *Middle Byzantine cycle.*

The Archaic Cycle: Iconography

Following pages
Plate 37
Göreme, Tokalĭ Kilise I
(Cat. no. 14), vault paint-
ings showing the Annun-
ciation, Visitation, and
Bitter Draught (top row);
the Pursuit of Elisabeth
and Calling of John
(middle row); and the
Entry into Jerusalem and
Last Supper (bottom row).
[Photo Harold Stump]

We might begin with the Archaic cycle. Its most complete version survives in the older church of Tokalĭ (Cat. no. 14), a one-aisled basilica in form. It was for this type of church that the special arrangement of this cycle seems to have been created. Standard disposition of the narrative was on superposed bands that started at the level of the haunch of the nave vault, or sometimes a little lower down, and culminated in a long row of medallions forming the spine; the walls themselves were occupied with portraits of saints. At Tokalĭ I there are six bands of narrative, three pairs on either side of the crowning row of medallions, which contain portraits of Old Testament prophets. Each pair carries the story of one of the three "chapters" in the Life of Christ (Pls. 37–38). The cycle starts off at the southeast corner of the topmost band with the Annunciation, continues to the west end of the nave, and then passes to the other side of the row of medallions until it reaches the northeast corner with the Murder of Zacchariah, (Zacharias in the King James Version), the father of St. John the Baptist. This is the chapter of the *Childhood of Christ*. The next chapter, Christ's public life or *Miracles,* occupies the second or intermediate pair of bands, always reading from left to right and progressing, like the Child-hood chapter, from southeast to northeast. The opening scene of this sequence picks up the narrative after the Murder of Zacchariah: his wife Elizabeth, fleeing to save the life of their son, John, in the face of Herod's orders for the murder of male infants, takes refuge in the side of a mountain, which opened to receive her. We proceed hence to the calling of St. John by the angel, his preaching in the desert, and his baptism of Christ. Next come the miracles proper, starting with the Marriage at Cana and ending with the Raising of Lazarus, with which this chapter closes. Finally, the lowermost pair of bands tells the third and last chapter of the story, the *Passion of Christ,* from the Entry into Jerusalem to the Descent into Limbo (Anastasis). On the east tympanum of the nave the story is completed with a representation of the Ascension. The west tympanum, on the other hand, carries a displaced Transfiguration, which, if properly situated, would have preceded the Raising of Lazarus in the intermediate pair of narrative bands.

Now clearly this is a considerable repertory of scenes for a provincial artist. Thirty-two of them to be exact, run together without formal divisions and supplied with names, identifying titles, and direct quotations, much in the nature of a cartoon strip. Most churches, depending on their size and the means of their community, reduced the cycle at Tokalĭ in one way or an-

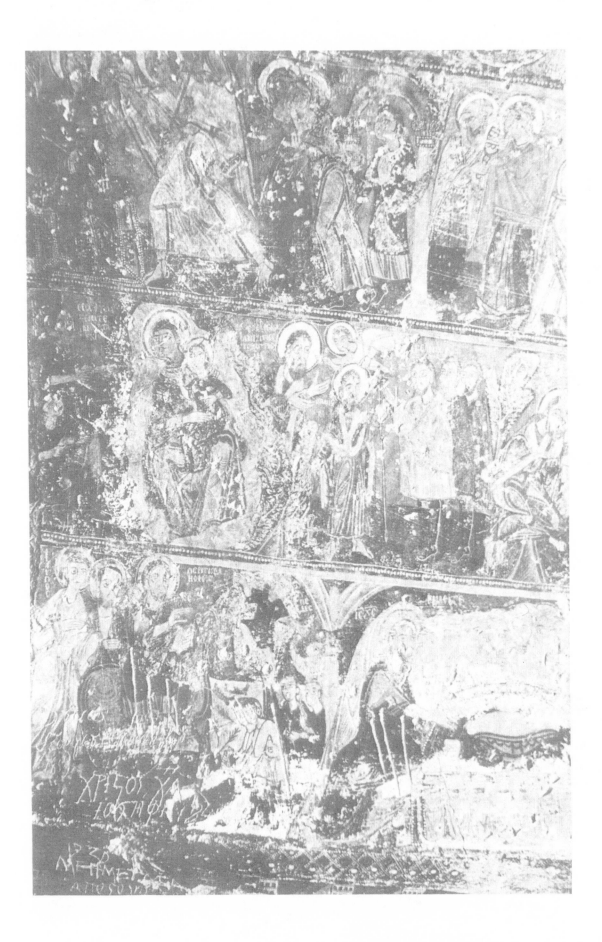

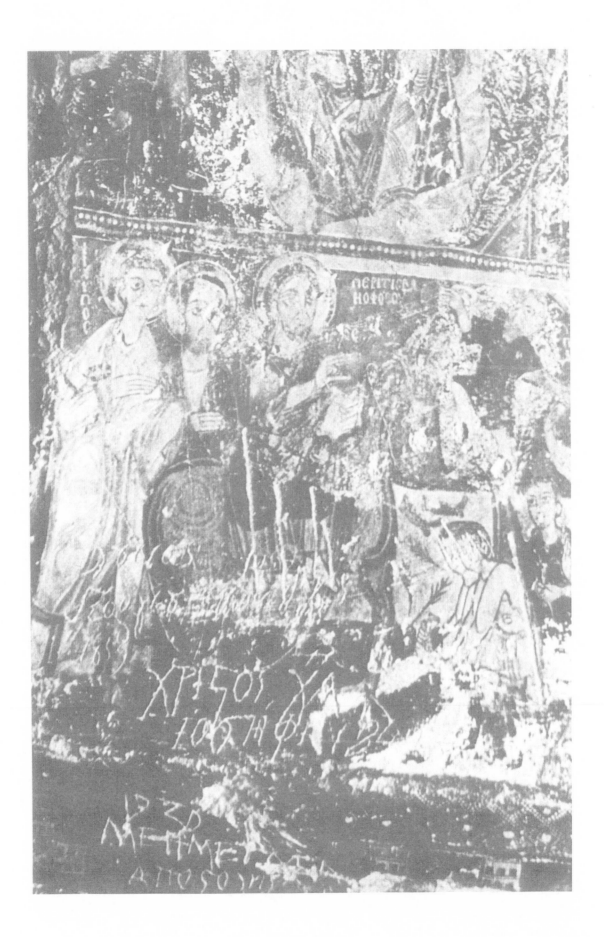

Plate 38
Göreme, Tokalï Kilise I
(Cat. no. 14), vault paint-
ings showing the Massacre
of the Innocents and Flight
into Egypt (top row); and
the Calling of the Apostles
at the Lake, Multiplication
of the Loaves, and Healing
of the Blind (bottom row).
[Photo Harold Stump]

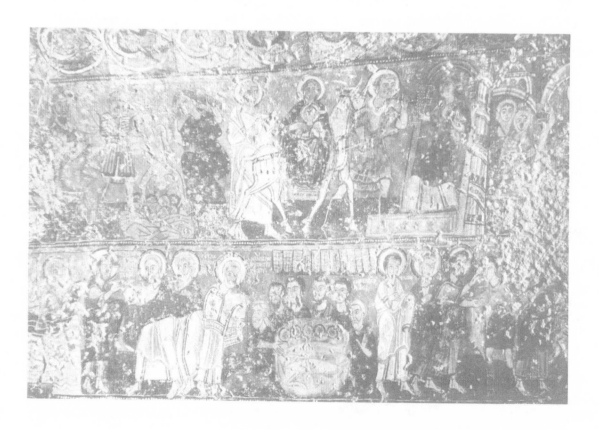

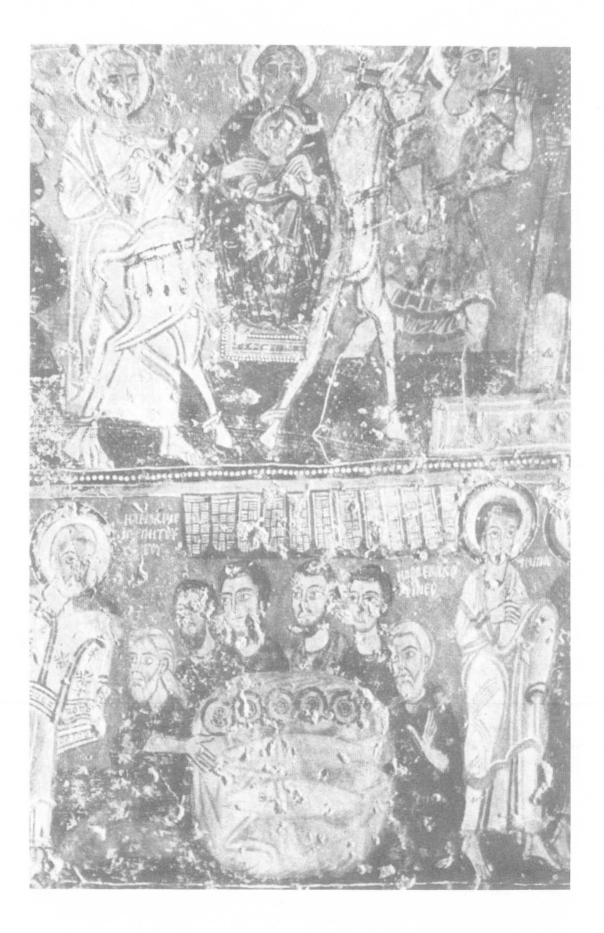

other to a more manageable version. The Childhood sequence was rarely tampered with. It appears to have been the least dispensable part of the cycle; and sometimes, when pressed to economize, a church would make do with it alone, omitting Miracles and Passion altogether. St. Eustathios (Cat. no. 27) is one instance. But mostly these two sequences were present in more or less abridged form. The miracles sequence may be reduced to the single scene of the Baptism of Christ. Of the Passion sequence, only the Crucifixion must figure without fail: the rest—the Last Supper and the Betrayal of Judas; the Burial episode, consisting of the Deposition, the Entombment, and the Women at the Tomb; the Descent into Limbo; the Ascension—were all expendable.

One is touched to see in this monastic environment of Göreme and Soğanlı Dere, which by the solemn vow of its inhabitants had ever to be maintained as a stronghold of celibacy, the attentive care lavished on the birth and infancy of Jesus. But that after all was the Christ's special truth, as the fathers of the Church knew well enough: Christ was what each man wanted. Those gifted with restless intelligence or the dialectic urge, weighed down with erudition or driven to seek the shelter of dogma and its elusive comfort of invulnerability, these could thrive on his peculiar godhead. It was there to dispute: his two natures, the human and the divine, and which predominated, and whether it was possible or proper in fact to distinguish between them; his place in the Trinity; his relation to the Father (of the same substance? of similar substance?); his aspect as Holy Wisdom, Hagia Sophia. To such, Christ was the magic cloth of argument that could be cut to any shape and still remain intact. To others, women whose minds refused to unfasten virtue from their virginity, he was the spotless bridegroom, the ideal mate disburdened of all carnality. And mothers of children and chaste, childless monks, the makers and deniers of life, could choose to focus on Jesus, the precious infant, born commonly to a mortal mother but for an immortal, and immaterial, destiny.

There was too little of the early history of Jesus in the four canonical Gospels of the New Testament to satisfy the curious. Their sober account passed quickly to his public ministry, about which the evangelists had more immediate information. But it was not long before the inquiring mind of the vulgar could be appeased by apocryphal fabrications such as the *Childhood Gospel of Thomas,* the *Arabic Gospel of the Childhood,* the *History of Joseph the Carpenter,* and, most popular of all, the *Book of James* called "Protoevangelion," which dealt with

the early life of the Virgin Mary (her parents, her birth, and the cohabitation with Joseph) before it proceeded to an embellished version of Jesus' infancy based on the account of the Gospel according to St. Luke. It is on the apocryphal Book of James that the Childhood sequence of the Archaic cycle at Cappadocia depends. We need to review briefly at this point the scenes involved, so we shall later be in a position to contrast them with the Childhood sequence of the Ihlara cycle and the corresponding iconography of the Middle Byzantine cycle.

According to the Book of James, the Virgin Mary witnessed a double annunciation. She had left her home to go to the well for water, and of a sudden, a voice was heard which said to her, "Hail, thou that are highly favoured; the Lord is with thee; blessed art thou among women." (XI.1)[20] Terrified, she ran indoors, put down her pitcher, collected the spool where she had been spinning the yarn for the new curtain of the Temple, and sat down—when the angel of the Lord stood before her, visible now, to announce that she shall conceive by God's word. This is the moment chosen for the first scene. Before some kind of architectural backdrop, usually a column or two, Mary makes as if to rise from a bejeweled throne, yarn in hand. The white-clad angel rushes toward her, the right hand raised in the gesture of speech, the left holding the floriate scepter.

The Annunciation is followed by a standard picture of the Visitation. Mary had gone to pay a call on her cousin Elizabeth, who was pregnant with John the Baptist (another divinely directed conception), and according to the Book of James, "she knocked at the door. And Elizabeth, when she heard it, cast down the scarlet and ran to the door and opened it, and when she saw Mary, she blessed her." (XII.2) The two women are duly shown outdoors, but they are tightly embracing. To the right, at the door of the house, a maidservant draws aside the curtain to look on, an open hand raised to her bosom in a gesture of marveling.

Joseph protested to the High Priest that he was innocent of Mary's condition inasmuch as he had never touched her since bringing her home from the Temple, where she had been consigned by her parents. Mary protested that she had known no man, that "as the Lord my God liveth, I am pure before him and I know not a man." (XV.3) To test the veracity of these claims, the priest subjected them both to an old test of chastity which involved their drinking a bitter draught and then going up a mountain. This they did. But they both "returned whole. And all the people marvelled because sin appeared not in them." (XVI.2) The scene, labeled "the Trial

by Water" (τὸ ὕδωρ τῆς ἐλέγξεως) is hardly ever absent in Archaic churches. The High Priest, identified as Zacchariah the father of John the Baptist, is shown applying a goblet to Mary's mouth while Joseph, his back toward them, manfully downs his own potion.

"Now there went out a decree from Augustus the king that all that were in Bethlehem of Judaea should be recorded . . . And (Joseph) saddled the she-ass and set her upon it, and his son led it . . . And they came to the midst of the way, and Mary said unto him: 'Take me down from the ass, for that which is within me presseth me, to come forth'." (XVII.2–3) Rather than a title to identify this fourth scene of the Archaic cycle as the journey to Bethlehem, the painter quotes the first words of Mary, "Take me down from the ass." She rides sidesaddle facing the viewer, her head slightly turned to Joseph on the left. One hand holds on to the beast's neck for support. James, the son of Joseph from a previous union, in traveling outfit complete with a pack thrown across his shoulder at the end of a stick, leads the ass toward the right. We might draw attention here to a small detail that bears upon a point we will revert to shortly: the ass wears above its hooves silk ribbons such as were worn by the imperial steed in ceremonial processions at Constantinople.

The Nativity follows, a large scene that includes the bathing of the Infant and the annunciation to the shepherds. Mary reclines on an embroidered mattress set diagonally in the center of the picture. Her pose is relaxed, and she gazes abstractedly in the opposite direction from the cradle where Jesus lies, nimbate and stiffly swaddled and stared at intently by the ox and the ass. Above his head is a huge star, the one that the Magi describe to Herod, in the words of the Book of James, as "a very great star shining among those stars and dimming them, so that the stars appeared not." (XXI.2) Joseph squats by the cradle at the far left of the picture. His sad face, lost in thought, looks out into space. His mass is balanced, on the other side of the Virgin, by the two women, Salome and the midwife, who are bathing the Christ Child in a studded basin on a stand. Further to the right is the annunciation to the shepherds. They are three in number, usually pictured to represent the three ages of man. The youth and the old man stand looking in wonder at the angel who floats down toward them. The third shepherd, in his middle years, sits on a rock, playing the flute, seemingly indifferent to the news. The caption is drawn from a liturgical text in the *orthros* of December 24, "Cease your dwelling in the fields ye leaders

of the flock." More often than not, the shepherds have names. These derive from the five words of the famous magic square and palindrome

S A T O R

A R E P O

T E N E T

O P E R A

R O T A S

The formula, which has fascinated so many in recent times, was of pagan origin; early examples were uncovered as far back as Pompeii. Its meaning for the Romans remains elusive, but in the third century it was adopted by the Christians, apparently because they saw in the square an anagram for the words Pater Noster accompanied by the Alpha and Omega, or A and O, the Beginning and the End. Coptic usage linked it in prophylactic prayers with the names of the three Hebrew youths in the Fiery Furnace, the Forty Martyrs of Sebaste, and the Seven Youths of Ephesos. In Greek lands, bits of the formula were turned into names for the Magi. And here in the Archaic churches of Cappadocia, quite unprecedentedly, the magic words became attached to the three shepherds of the Nativity.[21]

The next scene in the Childhood sequence is the Adoration of the Magi. Here, the Virgin, seated on a lavishly ornate throne, is seen in profile. Joseph stands behind her with his habitual meditative cast of countenance. The Magi arrive in single file from the right, sometimes led by an angel. They too, like the shepherds, represent the three ages of man: their names—Melchior, Gaspar, and Balthasar—may or may not be indicated. The Christ Child sits formally in the Virgin's lap, fully dressed, and blesses them as they present their gifts. His free hand holds a scroll or book.

Infrequently, the Adoration may be followed by a representation of the Massacre of the Innocents. In the scene, Herod himself presides, attended by a scribe who stands behind his throne recording the progress of the massacre that is being carried out in the center of the pic-

ture. Here, a soldier steps on a pile of dismembered bodies and raises his sword to hack one more naked child, which he holds upside down from one ankle. A woman balances the figure of Herod on the right side of the composition: she is shown tearing at her hair in anguish. The painter identifies her, in the words of Matthew 2:18, as "Rachel weeping for her children."

The scene of the Flight into Egypt which follows is constructed very much like the Journey to Bethlehem, with James leading the ass and Joseph bringing up the rear. Mary, with the infant Jesus now in her lap, again sits facing the viewer. The picture is closed off at the right by an architectural motif symbolizing a city gate in which a lady stands holding a torch to illuminate the night. She is the allegorical figure of Egypt.

In extended versions of the Archaic cycle, the Childhood sequence goes on with three more scenes, the Murder of Zacchariah and the Flight of Elizabeth, both based faithfully on the account of the Book of James, and the Presentation of Jesus in the Temple that illustrates Luke 2:22–39. Zacchariah was dispatched by Herod's apparitors in front of the Temple of which he was High Priest because he would not tell where his newborn son John was to be found. The murderers are represented as two archers in the picture. They are repeated again in the following scene before the cave in the mountainside, where Elizabeth and the infant John sit waiting for the pursuers to give up their hunt. The cave is bright in accordance with the text of James, "And there was a light shining always for them: for the angel of the Lord was with them, keeping watch over them." (XXII.3)

The placement of the Presentation is not fixed, nor for that matter is its composition. On occasion it comes immediately after the Nativity, as for example at St. Eustathios and the cruciform chapel of El Nazar (Cat. nos. 27 and 25). If however the artist chooses to abide by the combined order of Matthew and the Book of James, neither of which recounts the Presentation episode, then the scene is relegated to the very end of the Childhood sequence or is omitted altogether. In Tokalı I (Cat. no. 14), where the Presentation is absent, we noted that the Childhood sequence ends with the Murder of Zacchariah: and the Flight of Elizabeth begins the second chapter, at the head of several scenes dealing with the early life of John the Baptist. But this adjustment is unusual.

We need not be as thorough with the sequence of the Miracles and the Passion, both dependent, in the main, on the canonical New Testament, since as we have already remarked, they

were most often abbreviated to a few major scenes. These few we must, however, describe, if only because they correspond to the most important feast pictures of the Middle Byzantine cycle and are for that reason essential in charting the change that was entailed, both in iconography and composition, when the narrative point of view was officially abandoned in post-Iconoclastic art in favor of the liturgical.

The Archaic Baptism, which was hardly ever waived, has two variants. In one, the Jordan rises to sheathe the nude Christ as with a blanket. In the other, an allegorical figure, her back turned to the viewer, stands for the river in the antique manner. She sounds a trumpet to proclaim the prodigious goings on during the Baptism, as prefigured in two separate verses from the Psalms: "Jordan was driven back" (Ps. 114:3) and "The waters saw thee, O God, the waters saw thee; they were afraid: the depths also were troubled" (Ps. 77:16). Christ always covers his nudity with one or both hands. St. John is always on the left of the picture, and one or two angels bow respectfully at the right while they proffer a cloth to the Anointed.

No mountainous landscape is indicated for the scene of the Transfiguration. Thabor is forgotten: the two prophets, Moses and Elijah, and a frontal Christ in between, are all three shown on level ground, framed by two trees. The apostles Peter, John, and James, who witnessed the miracle, are disposed to right and left of this central tableau in varying postures of wonderment. As for the Raising of Lazarus, which often closed the Miracles sequence, it conforms to the account in the Gospel of St. John 11:16–44. Christ approaches from the left, accompanied by one apostle, probably Thomas, who said, "Let us also go, that we may die with him." Lazarus, swathed in bandages, stands upright in a small aedicule which serves as his tomb. Nearby two men stop their noses, as though responding to Martha's words, "Lord, by this time he stinketh: for he hath been dead four days." She and her sister Mary have prostrated themselves at the feet of Christ. The raising is about to be effected.

The Passion sequence opens with the Entry into Jerusalem. Christ arrives from the left, mounted on an ass and accompanied by St. Thomas. A uniformly youthful crowd meets him at the city gate: they are all "the children of Israel" to the painter and so indeed they are labeled, οἱ παῖδες τῶν ἐβραίων or simply παῖδες. The Last Supper and the Betrayal are rare. In the first, we might note that the table is always semicircular with Christ seated at the left extremity and Judas, facing the viewer, at the right. When the apostles are shown nimbate, which is not al-

ways, he alone goes bareheaded, and his extended hand denotes that he has just reacted to Christ's prophecy that one among them shall betray him. "Master, is it I?" Across the table Christ responds with the same gesture of speech: "Thou hast said." (Matthew 26:25) A burning torch at the back illuminates the nocturnal scene.

The Betrayal, too, takes place in the dark. The crowd carries torches and an assortment of weapons, in accordance with the Gospel of St. John, "Judas then, having received a band of men and officers from the chief priests and Pharisees, cometh thither with lanterns and torches and weapons." (18:3) There are no soldiers. These are all Jews who came to seize him, and they are invariably identified as such, οἱ Ἰουδαῖοι. Christ marches slowly toward the right, his hand raised in speech: "Friend, wherefore art thou come?" (Matthew 26:50) And the friend, who shows signs of having rushed up in a hurry, takes him up in his arms for the kiss of betrayal.

He is crucified in the company of two thieves. (Tokalï I is the one Archaic example that omits them.) He is stretched out firmly on his Cross, the body still living, the head inclined gently in the direction of the Virgin; the thieves are tied instead to theirs, short crosses with abbreviated parallel bars over which most often their arms are racked. The rest of the composition is also symmetrical. The Virgin and St. John the Evangelist flank the cross, she on the left and he on the right. Their heads are on a level slightly below that of Christ. Inscriptions convey that special relation he has just prescribed for these two mourning intimates: "Mary, behold thy son," and "Behold thy mother." Further in and much smaller in size is the soldier Aisopos, whose name derives from the word *hyssop* in John 19:29 ("and they filled a spunge with vinegar, and put it upon hyssop, and put it to his mouth"); he is balanced on the right side by Longinus, itself a possessive (*longhe* = spear), who is piercing Christ's side. And one more detail is not overlooked: above the parallel bar of the Cross the sun and the moon are painted in, sometimes full and at others in partial eclipse.

Then the triple sequence of the Burial episode. Joseph of Arimathaea and Nicodemus are both present in the Deposition and in the Entombment. Joseph is shown supporting Christ's dead body, while Nicodemus is removing the nails from His feet with a pair of tongs. Like the preceding scene of the Crucifixion, the painter is obviously following the Gospel of St. John, which alone of the four mentions Nicodemus. The Women at the Tomb, on the other hand, relies on Matthew. There are two women, Mary Magdalene and the other Mary, bearing phials

of "sweet spices"; they approach the angel seated on the stone lid of the empty tomb toward which he points. The only exception is in the chapel of the Theotokos (Cat. no. 21), where three women are pictured.

The Descent into Limbo is apocryphal: it derives from the so-called Gospel of Nicodemus. Christ, engulfed in a luminous aureole, vigorously grasps Adam by the arm while Eve stands quietly behind him. "The king of glory stretched forth his right hand and held and raised Adam our forefather." Satan, in chains, is trampled underfoot. To the left of the composition, busts of the two Old Testament kings, David and Solomon. The latter is actually a substitute for Isaiah. It is Isaiah who is mentioned with David, in the Gospel of Nicodemus, before the section on Christ's arrival for the harrowing, as having prophesied this very event.

This does not quite end the Archaic cycle, though it does end the continuous bands of narrative. The Ascension and the Descent of the Holy Spirit (Pentecost), when present, are awarded special attention. The Ascension is meant to be placed in a cupola as the crowning feature of the life of Christ and an event whose locale is the heavens; but since the architecture of the one-aisled basilica does not afford a cupola, the scene is placed on the triumphal arch instead, as at Tokalı I, or in a conspicuous part of the vault as at Ayvalı (Cat. no. 16), where it occupies the entire west half of the vault, the east half being given up to the Childhood sequence.[22] The Pentecost is relegated to the vestibule of the church, not without reason, as we shall see. And in the apse is the vision of Christ in Majesty, which was described in Part 2—surrounded by the four beasts of the Apocalypse, by seraphim, tetramorphs, and the archangels Gabriel and Michael.

The Archaic Cycle:
Sources

I have so far avoided speaking of iconographic sources for these many scenes of the Archaic cycle. It seemed proper to convey first a sense of the sweep and total pictorial impact of the Christological narrative. For this is what is truly original—this, and the meaning the total decoration had for the monkish users of the churches. Individually, hardly any of the scenes may be said to be new. The pictorial solution of each event represented is typical. Its initial formulation reaches back to the early Christian centuries. The scenes that illustrate events based on the canonical Gospels have been exhaustively investigated, one by one, and their history plotted, in an early work by Gabriel Millet which has to this day lost little of its validity.[23] But apocryphal scenes as well, even without the benefit of such exemplary attention, can be shown to have a respectable ancestry.

The reason is obvious. Like the early texts of Christianity, so also their illustration carried an authority that could not be handled cavalierly. Some subjects had been monumentalized in painting or mosaic, specifically for the great memorial places of the Holy Land, beginning with the elevation of Christianity by Constantine the Great to the official faith of the empire. Bethlehem surely had its Nativity; the Mount of Olives, its Ascension. These pictures acquired an almost canonical stature, and their basic scheme was widely reproduced in the coming centuries. They are all gone now, with the exception of the sixth-century mosaic picture of the Transfiguration in the apse of St. Catherine, the monastery church of Mount Sinai. But the general pattern of most can be recreated from small-scale copies on objects made for public consumption, like the *ampullae* in which pilgrims took away sacred oil from the sanctuaries of the Holy Land;[24] and on articles for church use like censers and reliquaries. Icons, of which early ones have newly been discovered in the monastery of Mount Sinai, were often portable replicas of prestigious church paintings.[25] Last, illuminated manuscripts could also act as repositories and transmitters of seminal iconography. The form of some of the miniatures betrays their archetype. The Judgment of Annas and Caiaphas and the Judgment of Pilate, two Passion miniatures in the fragmentary Gospel book at the cathedral of Rossano in South Italy, are framed within a semicircular outline—a fact that probably links them with monumental painting of these subjects in arched recesses of church interiors, like tympana or lunules.

The case for direct inspiration on early Christian miniaturists from the mural programs of churches and *memoriae* in the East has often been made, not least forcefully by Jerphanion in

the summing up of his great work on Cappadocia. There, he chides previous scholars for attributing too much of a part to original miniatures in the formation of Christian iconography, and asserts the priority of monumental painting over book illumination. But the evidence is unfairly strained to prove the thesis. Some of the scenes in the Archaic cycle could not have relied on mural paintings for the simple reason that there is no trustworthy reflection of such paintings on any portable object (or in any literary source) related certainly with the place of their presumed origin. This is most notably so for the Childhood sequence. Now, it is true that some least obvious scenes in it have been successfully attached to monumental creations. Millet has demonstrated, for example, that the annunciation to the shepherds for one, as we see it in the Archaic cycle, that is, with one of the three shepherds playing on the flute and the standard liturgical inscription "cease your dwelling in the fields," is ultimately dependent upon a mural painting in the monastery of the Poimnion near Bethlehem.[26] Captions from liturgical texts, as opposed to narrative texts like the canonical or apocryphal Gospels, are usually an indication that the picture in question originated in a liturgical context, in other words for a church. But more often, Jerphanion has to resort to imagining such pictures, for example the Murder of Zacchariah, or conjuring them through very flimsy evidence, as with the Flight of Elizabeth—both of these postulated by him for the cave sanctuary of Ayn Karem, which since the sixth century was believed to have been the spot where Elizabeth took refuge with her newborn son, John the Baptist, to escape Herod's mass infanticide.[27] And sometimes the sanctuaries themselves have to be postulated to hold the presumed mural painting: as with the martyrium of the Proof by the Bitter Draught which "devait s'élever," says Jerphanion, somewhere at Ayn Karem, even though "nous ne possedons ni eulogie ni ampoule" to prove its existence.[28]

But the truth is surely simpler. There is no doubt now that a continuous picture cycle, and a very extensive one at that, existed for illustrated Gospel books in the same early Christian centuries when mural programs were being formulated. This cycle was by no means exclusively a collection of the schemes invented by mural painters and mosaicists. That it borrowed from them is demonstrable but not crucial. On the contrary, the character of illustrative types without formal divisions into panels, the close reliance on a text from which one borrows quotations and identifying titles, and above all the profusion of scenes used to carry along the pictorial

counterpoint to the sacred narrative—these set apart, it seems to me, the method and product of the early Christian miniaturist from the artist of Christological panels for churches and martyria. And a mural program that reflects the miniaturists' method and product cannot, by the same token, be innocent of influence at whatever remove from the picture cycles associated with illuminated manuscripts. It behooves us therefore not to belittle, as Jerphanion is inclined to do, the original contribution of miniaturists to early Christian iconography.

No complete pictured Gospel book, alas, survives from the early Christian centuries. But we have fragments such as the Gospels of Rossano, already mentioned, and the fragment of Matthew from Sinope; and, further, two profusely illustrated Gospel books from the eleventh century, one in Paris (Bibl. nat. gr. 74) and one in Florence (Bibl. Laurentiana Plut. VI, 23) reproduce quite well this early Christian system of pictorial narrative. It is not hard to spot intimate similarities in iconography between miniatures in some of these illustrated Gospels and corresponding scenes of the Archaic cycle in Cappadocia. For example, the essence of the Archaic Massacre of Innocents, Flight into Egypt, and other scenes is preserved intact in the Gospel book at Paris. Similarly, the Entry into Jerusalem miniature of the Rossano Gospel supplies the iconographic skeleton for the same scene in the Archaic cycle.

At the risk of being accused of straining the evidence myself, let me go a step further and suggest that an illustrated Gospel book was not the only miniature cycle behind the story of Christ as told in the Archaic churches of Cappadocia. It is almost unavoidable to think of an illustrated Book of James (Protoevangelion) as the archetype, however distant, of the Childhood sequence in the Archaic cycle. Now, evidently certain details of this apocryphal account had already found their way into the earliest iconography of Christ's childhood as told in the canonical Gospels of Luke and Matthew. But this is not the case with the Archaic Childhood sequence. Here, rather than following the canonical account with apocryphal details, the painter was faithfully illustrating the apocryphal account of James, with some additions from Matthew.

Actually, we have some added proof in the eastern troglodytic area that a picture cycle of the Book of James was in circulation. On the vault of a small chapel discovered in 1954, in the valley of Kĭzĭl Çukur near Çavuşin (Cat. no. 13), there is painted a unique narrative program dealing with the Virgin Mary's parents, Joachim and Anna, and the Virgin's early childhood.

These pictures are clearly illustrating the first section of the Book of James. A number of details, not the least being the iconography of a Virgin in a mandorla of light,[29] would indicate that the painter of Kīzīl Çukur was using an early Christian model in the form of a miniature cycle for his murals—which in turn would ascertain the existence of an illustrated Book of James in the pre-Iconoclastic period of Byzantine art, and no later than the sixth century. I am of course not proposing that all we have to do is to append the archaic Childhood sequence to the Marianic half in the Kīzīl Çukur chapel to produce our missing prototype, the complete Eastern version of the illustrated Book of James. The tradition is undoubtedly more complicated, and it will have to await clarification until the later half concerning the Childhood of Christ is subjected to as thorough an investigation as the childhood of the Virgin has received from J. Lafontaine-Dosogne.[30] This is obviously not the place for such a separate study. For the purpose of this book, it might be permissible to accept the presence of an illustrated James in the background of our Archaic cycle.

Having maintained so far the traditionalism of Christian iconography, two more points must now be made to modify the claim. (a) Once invented, an iconographic scheme did not remain static. It was added on to and otherwise altered while all the time retaining the basic structure of the type. The eastern Crucifixion type is an instance in point. There are at least two significant variations (not counting the partly symbolic parent formula from the Holy Land, as reproduced on Palestinian *ampullae,* that substitutes the bust of a bearded Christ at the summit of the empty Cross in place of his crucified body). One variation shows Christ dressed in a *colobium,* a long tunic that leaves only the arms bare. In the other he is nude but for a loincloth, like the two thieves. The version where Christ wears the colobium is earlier in origin. Both variations are present in Cappadocia. But, Jerphanion's insistence notwithstanding, one has to beware of taking the colobium as an index for the antiquity of those painting programs in Archaic churches in which this detail of dress is to be found.[31] Two recently published icons from Sinai, unknown to Jerphanion, represent the oldest extant examples of each version: they do not seem to me to be appreciably apart in time. In any case, the icons prove that the nude version was in the repertory before the end of Iconoclasm and that therefore the Cappadocian artist of the ninth and tenth centuries could take his pick from between the two.[32]

(b) Contrary to the more uniform conventions of iconographic schemes that would prevail

throughout the empire after the Iconoclast ban had been lifted, the period prior to the Controversy was noteworthy for its regionalism. By this I mean not only that there was often more than one pictorial solution current for a Christological theme, each solution identified with the artistic products of one province in the empire; but also, that certain themes would find individual expression in one particular province and not in any other. With these precautions in mind, it is a patent oversimplification to conclude with Jerphanion that the Archaic painters in Cappadocia were faithful propagators of "Syro-Palestinian" iconography of the sixth century.[33] If we cannot speak generically of the "Christian East," in matters of art at any rate, much less can we assume that the term "East" is somehow largely coterminous with Syria and Palestine. Armenia is East and so is Asia Minor and Coptic Egypt; and over and against the provincial or vulgar tradition that these regional schools might be said to constitute, East is also the capital city, Constantinople, and the immediate circle of metropolitan centers to which the influence of its aristocratic tradition, broadly based as it was on the classical past, extended.

Now little monumental art has come down to our day to establish the identity of any one of these early Christian schools, with the exception of Coptic Egypt. Since the evidence is almost exclusively on portable objects, very few of which have stayed on in the area of their origin, the description of "schools" has been at the mercy of authoritative assignment of manuscripts, ivory panels, sarcophagi, and the like to various locales of production. In Jerphanion's day and until quite recently, in fact, much of this unattached material was attributed by scholars to Syria and Palestine; and the city of Alexandria was thought to be the main center of production for those works that seemed classically inspired, most particularly those whose technique derived from the illusionist, painterly tendencies in Hellenistic-Roman art.

Present scholarship, soundly in my opinion, has tended to discount a classical continuity in Alexandria, or Antioch for that matter. For both, it can be more credibly argued that the classicism of their Roman days was overcome in the fourth and fifth centuries by the abstract, popular, distinctly nonclassical mood in the art of their respective hinterlands. It was Constantinople alone that sustained, unbroken, the classical spirit of its pagan past, together with the other traditions of the Roman empire. A good deal of what was hitherto ascribed to the elusive "Alexandrian" school of early Christian art is therefore more equitably relocated in Constantinople. At the same time, "Syrian" works too have been shifting their allegiance, as it were, to

other parts of the empire. The Rossano and Sinope Gospels, associated by Jerphanion and others with Syria and more narrowly by Charles Rufus Morey with the city of Antioch, are now believed by some to be closer to the circle of Constantinople—if not the capital itself, than the metropolitan centers of western Asia Minor.

What all this discussion urges upon us is a much less restrictive affiliation for the Archaic Phase of Cappadocian painting than was insisted upon by Jerphanion. The first point to re-member in this context is the inherent mobility of iconographic themes. Three centuries sepa-rate "Syro-Palestinian" art from the Archaic cycle of the rock churches. Iconoclasm affected only part of this interval, and not every corner of the Byzantine empire with equal force. It is certain that this early regional iconography of Syria and the Holy Land, particularly because of its special prestige, traveled and spread during this time, and that Archaic church programs in Cappadocia are only one late manifestation of its continuity. In other words, Cappadocia might well have absorbed the influence of this one Eastern tradition via intermediate agents and not directly from Syria and Palestine. Second, it seems clear, as I have argued above, that the proto-typical sources for the Archaic cycle included original iconography not simply from monumen-tal painting but from illustrated manuscripts as well, both canonical Gospels and the book of James. And finally, if we insist on linking Archaic art to individual extant early Christian objects, regardless of the time gap involved, the recent reassignment of some of these objects encour-ages the opening up of Cappadocia to western Asia Minor and Constantinople and not simply eastward.

Historically, such a reorientation makes eminent sense since Cappadocia was after all part of the Byzantine empire, its easternmost province for long periods after the advent of Islam: it had little direct relation, culturally or politically, with Syria and Palestine, which after the seventh century and until the onslaught of the Crusades stayed solidly in Muslim hands. A western affinity would also tone down the dramatic nature of the change that Jerphanion has presumed to see when Cappadocia, of a sudden in the end of the tenth century or thereabouts, supposedly turned its back on Syria and Palestine and exposed itself to the penetration of Constantinopolitan influence. In style, yes: Cappadocia was on the whole (but not entirely) independent of, or even insensitive to, metropolitan tendencies of form until fairly late when the new post-Iconoclastic schemes from the capital, both architectural and decorative, began

to be imported. But as we warned at the beginning of this discussion, style and iconography do not always travel in tandem, and the absence of one in the Archaic Phase would not preclude the impact of the other.

But the contribution of one more province of early Christian art on the iconography of the Archaic Phase should be recognized and circumscribed. Jerphanion is vague about Egypt, which he considers allied to his "Syro-Palestinian" school. And yet it is in the monastic chapels of the Coptic hinterland, in the sixth and seventh centuries, that an important feature of the Archaic churches, the apse composition of Christ in Majesty, had its origin. From Egypt it seems to have spread to central Anatolia and further east (e.g., Georgia, rockcut church of David-Garedja in Dodo) probably by way of western Asia Minor and more specifically the monastic communities of Latmos in Herakleia. There is now little doubt that this unique representation of Christ as the King of Heaven, surrounded by apocalyptic imagery, was exclusively the creation of monkish vision.[34] The earliest apse decoration to carry the theme is in the chapel of Hosios David, of the Latomos monastery at Thessaloniki. It probably dates in the mid-fifth century. But here the iconography was derived from the visionary accounts of the Old Testament, chiefly Ezekiel and Isaiah. In the Thessalonikan mosaic, Ezekiel and another prophet, Habakkuk or Zechariah, are portrayed flanking the figure of Christ, who holds in his hand an unfurled scroll with a paraphrase of Isaiah 25:9, "this is our God; we have waited for him, and he will save us . . . we will be glad and rejoice in his salvation."

What the painters of Egypt shaped a century or so later is rather different. The composition is now based squarely on the Apocalypse of St. John the Divine, a text not generally admitted into the canonical New Testament by the Eastern Church but popular nonetheless, particularly in monkish thought. Furthermore, the details of the theme are drawn in part from liturgical texts like the Trisagion (Sanctus) and others. And it is this "liturgical Majesty," as it has been called, that was adopted in Cappadocia, where the meshing of eucharistic and biblical texts was advanced further, to the point of naming the four beasts of the Apocalypse (that is, the four symbols of the evangelists) in the words of the prayer that introduces the Trisagion in Byzantine liturgy: "singing, crying out, shouting, and saying." The inclusion of Isaiah, whose lips are being purified with a live coal, and Ezekiel devouring the scroll sent down to him by God seems to be also a Cappadocian specialty. Between the monk and the apparition of godhead, the

prophets serve as visual intermediaries. Through their eyes, he is able to behold Christ in majesty. Contrary to this literal conception of theophany, in Constantinople, where the apocalyptic vision of Christ was also rehabilitated after the Iconoclast ban (as in the ninth-century redecoration of Hagia Sophia), the prophets are dispensed with. Theophany, in metropolitan thought, does not require the presence of the witnessing prophets of the Old Testament since man, through the special grace of the Incarnation, may perceive God directly.[35]

The Archaic Cycle:
Interpretation

So much then for sources. We have said enough, I think, to place the iconography of Archaic churches within a more precise general context. And in the process I fear we may have conveyed the impression that Cappadocia was preponderantly derivative. For this is the inevitable by-product of the historical search for sources, that it is liable to overwhelm the uniqueness of the work of art so subjected to analysis. But how telling after all is the broad picture of influence in one's effort to understand the private purpose that informs a historic environment? What Byzantine mural program, no matter how extraordinary in itself, would not be undermined if one were to be content merely to see how it is determined by its tradition? And yet **for all our bridge building with the early Christian past, our insistence on the contribution of** Asia Minor and Egypt in addition to that of Syria and Palestine and on the medium of manuscript illumination as well as mural painting—for all this, it remains true that there is not a single Byzantine program outside troglodytic Cappadocia that looks anything like the interior of, say, Tokalı I. In this sense the Archaic cycle is eminently original. Originality, in art, does not proceed most happily from boundless freedom to invent but from restriction. What the Archaic cycle really is and what it means rest in the painter's selection of traditional units, the way these units are retouched, and the manner in which they are put together on the liturgical frame prepared for him by the carver-architect.

Let us remark, for one, that the type of portraiture used for Christ by the Cappadocian painter is singular. Both Christ and his companions are of peasant stock, short and large-headed, as much a part of the immediate milieu of central Anatolia as is the dialect of some of the inscriptions and the demotic casualness of the spelling. His is neither the elegant and abstract asceticism of Middle Byzantine saints, nor the classical beauty of the Christ in the miniatures and murals of Constantinople. "The perfection of his humanity," to quote Dorothy Wood, "is not aesthetic or athletic, but consists in truth of word and act, and can be taken as a model therefore by any human."[36]

Here and there we have pointed out in our lengthy description of the Archaic cycle, individual details in standard iconographic themes—private touches that bear witness to a local tradition. I note: the names of the shepherds in the Nativity, drawn from the magic square of SATOR/AREPO, the gesture of pudency in the Christ of the Baptism; and others. But what is omitted is quite as eloquent as what is altered. Several scenes with a long antiquity seem of no inter-

est to the Archaic painter. The so-called Chairete, or Christ's encounter with the two Marys after his Ascension (Matthew 28:9–10), is almost unknown.[37] Other scenes are unpopular, and the category would surely include most of the miracles of Christ, generally a favorite subject with Christian artists in the past.

The frequent absence of the miracles from the Archaic cycle may, in point of fact, be a clue to its meaning. For to say the cycle was narrative is not enough. Clearly its originators were not narrating the life of Christ as a simple story. There was a frame to the story, a structure of moral meaning, much as there was a frame to the life of the ideal monk, that Ladder of Divine Ascent with its thirty marked steps to be climbed painfully one at a time. Christ's too was an Ascent, the heavenly model of all such moral journeys. The goal of the Archaic artist was to paint the *Progress of Christ,* from his prodigious birth to his Ascension into the Heavens. That much is evident. What counted most in this was the march of time. In consequence those episodes were favored which constituted concrete steps in the Progress. An extensive Childhood sequence was particularly appropriate for that very reason. The miracles, on the other hand, would be underplayed because they are, for the most part, static episodes that aid little in graduating the greatest moral story onward. They were in a sense redundant for the purposes of the Progress: one did service for them all.

And now let us look at Tokalĭ I again. Let us consider the Archaic cycle, which we have been dissecting so far, for once in concert with its architectural mold. Much falls in place, and the true originality of the Archaic painter is at last brought out. The row of medallions at the spine of the vault, the highest point in the structure of the church, contains busts of twelve Old Testament prophets. And that is where it all begins. This is the *first age* of revelation. Their prophecies foretold the *second age,* the coming of Christ and his Progress on earth. This then is represented lower down, in the remainder of the vault: his infancy, when as a human child he was subject to the authority of parents, priests, and State; his public ministry, when he himself was the new priest, the Anointed one acknowledged by God the Father as His only son; his Passion, when he allowed himself to suffer for the regeneration of mankind. The Progress ends with his Ascension, and with it the *third* age begins. Christ is enthroned as the King of Heaven, and he sends down the Holy Spirit to create thereby the Church of Christ on earth. The Enthronement occupies the most sacred and secret part of the church: the apse conch. The Descent of the Holy

Spirit upon the apostles, or Pentecost, is placed by the artist in the entrance vestibule whence those come in who have been taught in Christ's word and baptized in his name.

Theirs is the *fourth age,* and it has its own progress in time. The period of the *Christian Empire* comes first, founded by the soldiers of Christ, the martyrs of the early Church. They are shown on the nave walls: the undefeated heroes of the Christian army who fought the good fight and won their crowns of immortality. Among them is the first Christian emperor, Constantine the Great, and his mother Helena, with the True Cross held between them. With them is ushered in the period of *historical empire.* The anointed princes will hereafter act as vicars of Christ on earth, ruling with his authority and responsible, ultimately, to him alone. And the last period of all is the present, the *celebration of the Liturgy.*

The common man stood in this fixed frame of the universe, the church, a microcosm of all human history and the essence of all morality, and he participated in the sacrifice which revealed again and again the central mystery of his existence: that humanity in the person of Christ was made divine and the spirit triumphed over flesh. But the common man in Tokalı was also a monk, and a monk was an athlete of the soul who "aims at ascending with the body to heaven."[38] His progress must be labor and pain, as Christ's Progress on earth had been, and the martyrs' and saints' path. His destination must be the Kingdom of God where Christ, at the glorious summit of his progress, ruled in majesty and where martyrs and saints lived eternally as blessed spirits. The lesson had been set: it behooved the monk to repeat it. And he heard the admonition of St. John Climacus when he looked about him in the church: "Ascend, brothers, ascend eagerly, and be resolved in your hearts to ascend and hear Him who says: Come and let us go up to the mountain of the Lord and to the house of our God, who makes our feet like hind's feet, and sets us on high places, that we may be victorious with His song."[39]

In parts of this interpretation I am in substantial agreement with the late Dorothy Wood. Her brief recent essay on Tokalı I constitutes the first serious attempt to get at the total meaning of a Cappadocian church—always more this than the sum of parts—and that, in my view, is the art history of Byzantine Cappadocia, in contrast to its archaeology so unexceptionably supplied since Jerphanion. But Miss Wood's thesis is much more precise, and there I cannot follow her. She sees Tokalı I as a highly literary, not to say propagandistic, work designed to illustrate in

terms of a Christological cycle the imperial theory of the time, specifically the reign of Leo VI (886–912). Every scene is read by her in the context of Leo's life, his concept of the divinity of the imperial office, and the further molding of this concept under his immediate successors on the throne: briefly his brother Nicholas, and then his wife Zoë, formerly the imperial mistress, whose legitimatization by Leo in 905 and that of their son Constantine VII caused a lengthy storm in the higher realms of State and Church bureaucracy.

To give one example of Miss Wood's method: the Baptism scene, "an exceptional instance of a lesser person (the Baptist) conferring status on a greater person, but only as a deputy of God, was a justification for the Emperor claiming authority over both Church and State, although consecrated by the Patriarch: the Patriarch in the coronation ceremony represented only the Baptist, while the Emperor represented Christ."[40] It is this intimate identification of the emperor's life with Christ's that accounts, according to Miss Wood, for all the imperially inspired details of the Archaic cycle, such as the silk ribbons worn above the hooves of the ass in the Journey to Bethlehem; the throne with the curved back in the Enthronement of the apse, a type present on coins of Leo's Macedonian dynasty and on the narthex mosaic at Hagia Sophia showing Leo's obeisance to Christ; and the court dress of the saints on the nave walls, whose placement in relation to the enthroned Christ in the apse reflects the position of court dignitaries waiting to be received by the emperor in the throne room.

Such a narrow reading of the painting program at Tokalı I is in itself doubtful. But it does illustrate the susceptibility of the total scheme to ordered interpretation. The Archaic cycle in short was not a naïve and mindless reiteration of generic Christological iconography. It was selective. It had a system that, whether actually devised in the monastic milieu of eastern Cappadocia or outside it, was the outcome of disciplined thought. The program may well have been initiated specifically for Tokalı I or a church like it since destroyed. Only fragments of this total program were adopted in lesser chapels—sometimes the apse composition, sometimes, additionally, abridged versions of the Progress of Christ, or one sequence only of the three, and that usually the Childhood sequence. But it appears evident that the program had a general coherence and meaning only when it was spread in all its elaboration on the walls and vaults of a one-aisled basilica and in harmony with the symbolic spaces that they created.

The Ihlara Cycle

The intellectual order of what we have called the Ihlara cycle, our second generic narrative program of the life of Christ, is not as readily construed. It pertains to five rock churches in the south end of the valley of Peristrema, a distinct cluster consisting of Eğri Taş, Ağaç Altï, Yïlanlï, Kokar, and Pürenli Seki Kilisesi (Cat. nos. 29–33). That the region knew of the Archaic cycle which predominated in the eastern part of the province is not in doubt. A church less than a mile to the north of this cluster, the one-aisled basilica of Bahattin Samanlïğï (Cat. no. 18), exhibits its main features, even though the apse composition has been modified to show the enthroned Christ flanked only by two archangels in classical garb and, quite exceptionally, by medallions of Sts. Peter and Paul. Clearly then the different cycle of the five Ihlara churches was not due to their isolation but to deliberate choice. And the choice was also consistent, if we allow for the diversity of plan within the group. Only two of the five qualify as one-aisled basilicas: Kokar and Pürenli Seki. A third, Eğri Taş, comes close to being one but in a very irregular manner. The sanctuary for one thing is not only well off center, it is also heterodox in shape. The remaining two are cruciform churches, Yïlanlï with a flat ceiling for the central square (Fig. 14), Ağaç Altï with a cupola of unusual form, described in Part 2. But the method, substance, and emphasis of their decoration are shared.

To begin with, the telltale "liturgical Majesty" of the Archaic cycle is missing from the apse. The east end of two churches is unfortunately destroyed, and the rectangular apse of Eğri Taş has suffered too much for its painting to be read securely. It seems to have shown the enthroned Christ in a medallion, flanked at some distance by two angels standing against a starry sky; and below this, the Virgin was pictured in the center of a gallery of apostles—a scheme in the main not unlike that of the apse of Chapel 17 in the Coptic necropolis of Bawit in the Libyan desert. The Virgin and apostles occupy the lower half of the apse in two other churches as well—Yïlanlï and Pürenli Seki—but here they are associated with an Ascension of Christ in the conch. Framed in an ornate medallion, Christ sits on an arc that stands for the skies—"The heaven is my throne" (Isaiah 66:1). Four named archangels, in vigorous midflight, bear the medallion aloft. It is unlikely but not impossible that the Ascension figured in the now destroyed apse of the remaining two churches; the theme already exists elsewhere in their naves—the cupola in the case of Ağaç Altï, the east half of the nave vault in the case of Kokar—but, as we shall note presently, the Ihlara cycle was not afraid of redundancies.

Where there is an Ascension in the apse, it is balanced at the opposite end of the church, that is to say the entrance vestibule or narthex, by a grand display of the Last Judgment, a subject totally absent in Archaic churches, where the narthex ordinarily is devoted to the Pentecost. I have described the Last Judgment of Yïlanlï in Part 2. On the short west wall facing inward toward the nave, is the Christ of the Second Coming in a mandorla, attended upon by the twenty-four elders of the Apocalypse of St. John the Divine, who are shown standing rather than seated on twenty-four thrones as the text has it; each one carries a placard with a letter of the Greek alphabet (Pl. 39). And below this, in a long register that stretches on three sides of the large narthex, the Forty Martyrs of Sebaste in their Arab tunics, also standing and frontal like the elders. Lower still on the west side, Heaven (as symbolized by the three Old Testament patriarchs holding little children in their laps), and the tortures of Hell (Pl. 28), with the weighing of the souls in between. The disposition and details are almost identical in the much ruined Last Judgment of Pürenli Seki, where in addition we have a Deisis, that is, the Virgin and St. John the Baptist on either side of a seated Christ, interceding on behalf of humankind. A large fragment of a Last Judgment at Eğri Taş Kilisesi was found in 1966, fallen to the ground. It includes the striking iconographical detail of the women tortured by snakes more completely preserved at Yïlanlï.

The Deisis and the protracted iconography of the Last Judgment mark a strong concern in this particular monastic community with the consequences of death. Now the ideal monk was enjoined to think on death without letup. This is an early step to master on the Ladder of Divine Ascent. "The remembrance of death," advised St. John Climacus, "is a daily death; and the remembrance of our departure is an hourly sighing and groaning."[41] In his serious thought of death the monk must beware of sparing himself about the truth of the judgment that will be passed upon him when the final reckoning day arrives. "Never, when mourning for your sins accept that cur [i.e., the devil] which suggests to you that God is tenderhearted."[42] The Ihlara monks seem to be heeding that admonition. They set the taut choice between damnation and bliss forever before their eyes. To the users of the Archaic churches, one will recall, *victory* was preeminent. The painting program there celebrated the triumph of the strait path by focusing on the Progress of Christ and the attendant army of victorious martyrs and saints. In the Archaic context the narthex of the church was the seat of dissemination, with the apostles forever pass-

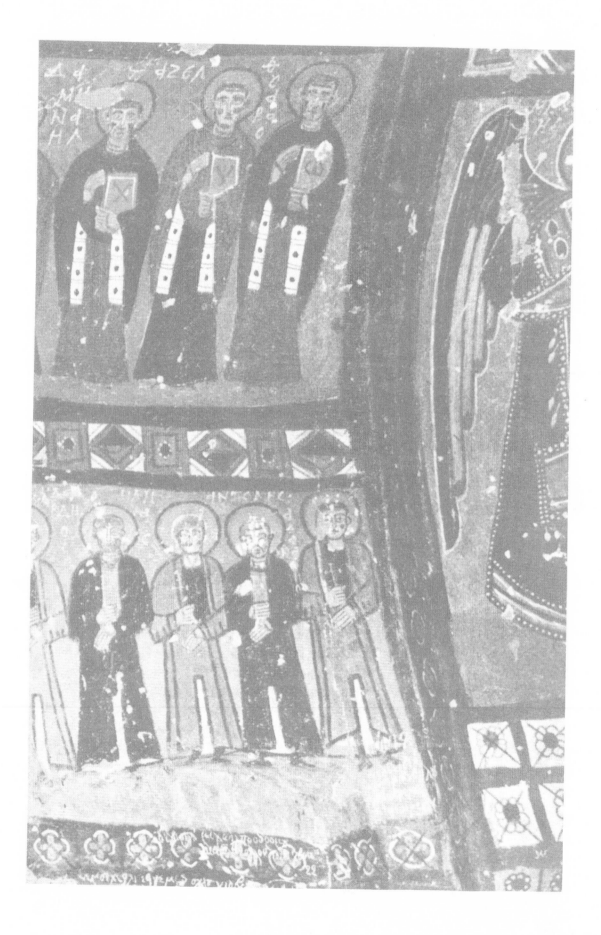

ing on, through the Spirit that descended upon them on the day of Pentecost, the truth of God to those who enter. The act of entering was tonic. At Ihlara, to the contrary, the narthex holds a warning, or better still a well-spelled-out threat. It is transformed into the battleground for the fateful decision: memento mori, the paintings say; and God will not be tenderhearted.

With impending punishment comes the will for propitiation. The iconography of the Ihlara cycle evinces much precautionary detail. First, there is the formidable chorus that attends the Lord of Judgment. The twenty-four elders and the Forty Martyrs of Sebaste figured as part of numerous mystical texts, specially in Coptic circles; their names could be rattled off in prophylactic incantation—Ael, Bael, Gael, Dael . . . ; Sabaoth, Adonail, Azail, Daminail The presence of these auspicious personages in the panorama of the Last Judgment on the walls of the church narthex was therefore seemly. But they were not all to depend on. The Virgin and St. John the Baptist were ready to intercede for the salvation of the errant monk. At the entrance to the church proper there stood another pair of divine mediators, the archangels Gabriel and Michael. All the churches of this Ihlara group except Kokar add also an unusual Old Testament scene, Daniel in the Lions' Den, which is a salvation image of great antiquity.

Within the nave, where the iconography is more narrowly concerned with the life of Christ on earth, we find further proof of the monks' familiarity with mystical texts and their illustration. Eğri Taş has a remarkable short sequence on the vault that deals with the Visions of the Magi, a unique iconography drawn from the Armenian *Book of Childhood*. According to this apocryphal text, the three kings, Melchior, Gaspar, and Balthasar, approached three times to adore the Infant, and each time the vision of him they had was different. They saw him as the Son of God incarnate seated on a throne of glory; as the son of an earthly king; and, last, as the infant in the manger. Note that these pictures at Eğri Taş are additional to the standard representation of the Adoration of the Magi that is part of the Childhood sequence on the other side of the vault. Thematic repetition, intolerable in the Archaic churches, has its role of reinforcement in a decorative system like the Ihlara cycle, where the aim is not a balanced Progress per se but a Christological ensemble of magic potency.

In addition to the Armenian *Book of Childhood,* the early scenes of the Ihlara cycle depend heavily on the apocryphal gospel of Pseudo-Matthew but, and this is important, only very little on the Book of James or Protoevangelion which, you will recall, was the prime text of the

Archaic Childhood sequence. Consequently, the texts being different, the iconographic schemes are often distinct from those of the Archaic cycle, or at the least contain peculiarities of detail. The Virgin of the Annunciation is shown standing, for example, and not seated on a throne; the scene is set outdoors, except at Eğri Taş, where there are two Annunciations, the first at the well, the second within Joseph's house. The maidservant of the Visitation has the mysterious name of ΟΥΘΑΝ, perhaps the Judith of the Book of James II.2. There are five shepherds at the Nativity, each bearing one of the five words of the magic square SATOR/AREPO for a name.

These divergences from the Archaic formulas extend into the rest of the cycle, notably the Passion sequence. The Agony of Christ in the garden of Gethsemane (Eğri Taş) has no equivalent in the Archaic cycle. In the Last Supper a colorful touch is the little demon called Selephouze: he hovers behind Christ at Yīlanlī, and at Kokar, with more fitness, behind Judas. The Crucifixion is distinguished by the presence of Caiaphas. And last, both Ağaç Altī and Yīlanlī feature the Dormition of the Virgin (Koimesis) in very original schemes totally independent of the Middle Byzantine Dormition type that became standard after about 1000. In the former church, the event is rendered in two superposed scenes with a common inscription that reads: "The Dormition of the Holy Mother of God in the month of August." The Virgin in a pale blue robe lies recumbent on a bed, attended by St. John. Christ sits on one side of the bed to recover her soul. In the upper scene he is shown holding up the soul, a tiny figure wrapped in a garment of blue; behind him comes the angel who will be the bearer of this precious being to the next world. The version at Yīlanlī is quite different but equally unparalleled in Cappadocia. Here the Virgin (washed out) is surrounded by the eleven apostles. Christ and the angel *psychopompos* are to the right of the composition. The Jew Jephonias "mighty of body," who tried to obstruct the Virgin's Assumption, stands in the foreground, arms raised above him to display the consequence of his opposition: the hands have been cut off with a sword of fire by "an angel of the Lord with invisible power."[43]

Differences between the Archaic and Ihlara cycles do not end here. It seems amply clear that the latter does not strive to preserve a flowing, uninterrupted narrative. Ornamental bands or mere lines may divide one event from another. Complementary scenes tend to be grouped into grand tableaux composed as long, framed pictures. The Nativity and the Adoration are united

into one such tableau; the Betrayal, Arrest, and Judgment of Pilate into another. To be inclusive or complete seems inessential. There is a very selective number of Christological scenes at Yĭlanlĭ: the Annunciation, Visitation, and Flight into Egypt only from the Childhood sequence, and the Entry into Jerusalem, Last Supper, Crucifixion, and Ascension from the Passion sequence; the Miracles are wholly unrepresented. Furthermore, the disposition is not strictly sequential, either chronologically or visually. The Flight into Egypt is placed at an outer vestibule at Yĭlanlĭ, linked, topically I presume, with a short cycle of St. Mary the Egyptian; the Entry into Jerusalem occupies the north wall of the narthex next to the Last Judgment. At Pürenli Seki a seemingly regular Childhood sequence ends abruptly in the middle of a narrative band with scenes of the Women at the Tomb of Christ and the Anastasis.

But perhaps the most striking distinction of the Ihlara cycle is formal. The effect produced by the painting ensemble may be described as high-pitched, or even feverish. Colors are bright and employed most often in harsh and unsubtle juxtaposition. No surface is exempt from decoration. Ornamental patterns of an extraordinary variety fill in spaces left over by the figural scenes. The clash of color and pattern becomes at times almost riotous. The dome system of Ağaç Altĭ is a case in point (Pl. 29). And the idiom of narrative is itself anything but restful. A high-strung, vivacious brushstroke sketches in spirited contours for the figures and strongly linear drapery folds. Proportions are generally thin and tall. Faces are pointed ovals, the eyes awestruck, watery or pathetic, the brows quizzical or obstinately Jovian. Like colored marionettes these nervous figures are caught in spry but wooden exertion. They lean unstably or lunge forward, their heads cocked at improbable angles. When called upon to fly, as are the angels of the Ascension, they kick their heels and swoop enthusiastically with all of the élan, but none of the grace, of acrobats on the trapeze.

How unlike is this raw exuberance from the tenor of Archaic churches, to return to these for a moment, as reflected in the interiors of Tokalĭ I and several programs contracted to it in style. These include Ayvalĭ, Holy Apostles at Sinassos, and the unnamed chapel recently discovered near Tokalĭ, as well as Bahattin Samanlĭğĭ in the Valley of Peristrema (Cat. nos. 15–18). We have remarked already on the short stocky figures and heavy heads. The faces, female faces in particular, are modeled to look roundish and pudgy, with beestung mouths and an expression that is, if anything, a trifle bloated. The same sense for mass brought out by modeling affects the

bodies as well, so that seated figures, like Elizabeth in the cave or the Joseph of the Nativity, are painted with protruding knees, or again the peculiar flip of striding figures is utilized to stress the shape of the thigh under tight drapery. But, somewhat paradoxically, the reality of the folds is unstudied, and the painter's interest in them appears to be for the most part decorative. They are bunched into patterns of parallel, repetitive lines, as though the direction of one pleat, once established, reverberated in sympathetic waves. Hair too succumbs to this reflective abstraction. And the unresolved but attractive tension between the intent at fullness and plasticity on the one hand and this love for flat surface patterns on the other is exacerbated by the generous use of strings of pearls to lace the edges of priestly robes, mattresses, and saddles, and to stud thrones, footstools, and details of architectural settings. Even the separation of narrative tiers from one another is achieved by pearly lines.

The five Archaic churches just mentioned obviously belong to the same school of painting, or at any rate share the same pictorial model both in iconography and style. We might designate them as School A. It is important to underline that its products are confined not to Jerphanion's territory alone but include a church at Peristrema on the other side of Cappadocia. A second group of Archaic churches displays a style slightly at variance with that of School A, but not enough to require special analysis. This might be called School B: its painters seem to have been active locally at Göreme, if one should judge from the fact that the products of the atelier that have come to light so far are all centered there. They include Chapels 3 (in part), 6, 8, 13, 15a, the Chapel of the Theotokos, and possibly St. Simeon in nearby Zilve (Cat. nos. 19–23). A third group, School C, is hybrid in a telling way. I would include here Tavşanlı, St. Eustathios at Göreme, and Ballık Kilise at Soğanlı Dere (Cat. nos. 26–28). The iconography stays loyal to the Archaic cycle, but the style leans heavily on the distinctive form of the Ihlara cycle as we have characterized it earlier. Jerphanion himself, without the advantage of the later discoveries at Peristrema, was careful to note the heterogeneity of form in these three churches we have labeled School C, and he decided that they were inept interpretations of the Archaic cycle by Armenian immigrants.

If Jerphanion was right, it should follow that the creators of the Ihlara cycle to which School C is indebted for its style must also be Armenian. I consider this at least a possibility. Now the parentage of this strange and endemic decoration has confounded the Thierrys, who published

the churches of the Peristrema Valley. In attempting to circumscribe it, they proposed contingencies with a bewildering number of sources—Coptic, Armenian, Visigothic, Sassanid, even Mozarabic and Catalan. Most of these have one thing only in common: they are "oriental" or "orientalizing" traditions. But it seems to me that rather than evoke such far-flung forebears for the Ihlara cycle on the basis of a bit of ornament here or a detail of iconography there, it would be more sensible to think in terms of one or two Eastern regions, close to Cappadocia and with demonstrable links to it, where the peculiar amalgam would have been concocted sometime before the painting of the Ihlara churches and carried hither by its originators or otherwise disseminated. This amalgam is so distinct, both in iconography and style, from the Archaic cycle that we should exclude much of the territory under consideration for the parentage of the latter. Of remaining possibilities, Armenia, with a notoriously impure pictorial tradition, is a likely candidate.

The proof, unfortunately, is more circumstantial than not, since very little Armenian art has survived from the early centuries of Christianity. This is true of mural painting as well as illumination. Pictorial decoration for churches had widespread practice in the sixth and seventh centuries, but unhappily most of it has disappeared together with the architecture. What remains is too fragmentary and moot. Afterward, murals were much less common but, paradoxically, a sufficiently large number of churches from this later period have survived, especially of the tenth and eleventh centuries, to supply us with a sample of religious pictures. Illustrated Armenian manuscripts do not go further back than the ninth century.

Even so, however, the evidence for an Armenian connection is varied and, on the whole, encouraging. In the nonfigural parts of the Ihlara decoration, motifs that tend to be associated by the Thierrys with one or another exotic tradition are often also traceable to Armenia. The "tresse simple" on the pilasters of the cupola drum in Ağaç Altï Kilisesi (Cat. no. 30) is not only to be found in so-called barbarian reliefs of the West (Merovingian, Ostrogothic, or Lombard) but also on Armenian and Georgian reliefs. Coptic parallels first come to mind for the large crosses in quatrefoil aureoles painted in the narthex of Pürenli Seki Kilisesi (Cat. no. 33), but then we think also of crosses in relief on Armenian hatchkars or funerary stelai. As for the figural parts of the Ihlara decoration, a dependence for subject matter on Armenian apocrypha has already been indicated. Of these texts the most important is the Armenian Book of Childhood;

but there are others, for example the Armenian *Dormitio Mariae*, which is the probable source for the iconography of the Yïlanlï Dormition.

Similarities with extant Armenian painting are not entirely lacking either. Let me draw attention to one manuscript in particular, the fragmentary Gospel book in the Mechitaristes Library of Vienna (Codex 697), dating from the beginning of the eleventh century.[44] The Annunciation on folio 6 corresponds in scheme to the Annunciation of Eğri Taş Kilisesi (Cat. no. 29); and the peculiar manner in which a hand is placed on the breast of the infant Jesus by one of the women in the bathing scene that forms part of the Nativity is common to both. But the style too of the miniaturist, with the odd cocking of heads and the crude linearism, especially for drapery folds, is akin in spirit to the style of the Ihlara cycle. These parallels in manuscript illumination can be multiplied to strengthen the case for Armenia. And above all one should keep in mind the documented presence of Armenian colonists in eastern Cappadocia since the ninth century. The case is not conclusive of course. Resemblances in style and iconography may derive from a common source, eastern Asia Minor generally. But N. Thierry's recent polemical rejection of any link between the Ihlara churches and Armenia is, in my view, unreasonable.[45]

I believe that the Ihlara cycle cannot be any earlier than the ninth century. The tentative conclusion of the Thierrys that the five churches in question were painted in the period between the seventh and the ninth centuries, with Eğri Taş being the first in the series and Pürenli Seki the most recent, seems unwarranted. It is based ultimately on no firmer ground than that long-lived art-historical prejudice that crude, raw artistic expression within one past environment, in contrast to something smoother, more accomplished, or more restrained, presages antiquity. Historical conditions in Cappadocia, for one thing, are against the earlier date. There are also architectural reasons to doubt it. I have suggested in Part 2 that the character of the cupola on a tall articulated drum in the church of Ağaç Altï is not likely to be encountered in the East before the mid-ninth century. Some help is also forthcoming from iconography. We might cite here the Dormition of the Virgin, present at Ağaç Altï and Yïlanlï. The pictorial formulation of this theme, in whatever form, probably has its origin in *post*-Iconoclastic art. The earliest known example in monumental painting, East or West, is the detailed Dormition sequence in S. Maria de Gradellis in Rome at the end of the ninth century, a program we have already encountered in the discussion of Basilian picture cycles. But there is more. The Arme-

nian manuscripts that afford comparative visual material for the style of the Ihlara churches are themselves of advanced date. And, as a last argument against the Thierry conclusion, let us remember that the stylistic identification of School C in the eastern region of Cappadocia with the Ihlara cycle would suggest that the two were roughly coeval. Now one church program within School C, Tavşanlı Kilise (Cat. no. 26), is exactly dated by inscription to the reign of Constantine Porphyrogenitos. Since no corulers are mentioned, the program must fall in the period when Constantine ruled alone, that is between 913 and 920. This document would free the discussion, partly at least, from conjecture. One other Archaic church, Ayvalı Kilise (Cat. no. 16) in the valley of Güllü Dere, is also ascribed to the reign of this Constantine. Since Tavşanlı is a product of the most important Archaic atelier, the one we have called School A, the approximate date of this group of churches too is established, with a degree of certainty, in the early tenth century.

The New Look:
Constantinople

Let us pause for a moment to sum up the results of the preceding discussion. Judging from native literary evidence (St. Basil and the two Gregorys), there is every reason to believe that Cappadocia had been vigorously active in religious painting since the fourth century. In subject matter, congregational churches undoubtedly emphasized the story of Christ as told in schemes derived at first, generally speaking, from the paintings of the memorial places of Christ in the Holy Land; but also from the illustration of Gospel books where one recorded side by side the spoken word and the pictured. Occasional cult buildings on the other hand were decorated with pictorial narratives of the lives of local martyrs with whom they were associated, narratives rendered with gripping immediacy and authenticity of detail. The division between this topical imagery and the more pervasive Christological imagery of congregational buildings was by no means rigid, and very soon picture cycles of martyrs' lives found their place on the walls of regular churches. The painters of Cappadocia borrowed, manipulated, and invented, forging an indigenous tradition that served the region well until the imperial decree of 726 against religious imagery had precipitated a severe crisis of allegiance throughout the Byzantine empire.

None of the known major painting programs in Cappadocia can be confidently assigned to the period before the ban. The only satisfactorily published exception, a cruciform chapel at Balkam Dere (Cat. no. 1), retains figural imagery in its cupola, namely, a rather badly damaged composition that combines the Ascension and the Second Coming; otherwise, we have painted ornament of a distinct Early Christian nature in the surviving south arm of the church. St. John at Çavuşin has badly worn pictures, probably early, which await fresh study. The cruciform church at Mavrucan (Cat. no. 2) is problematical. The top coat of painting has peeled off for the most part to reveal an older figural program that might antedate the Iconoclastic Controversy. The church interior is in a bad state of preservation; it would be futile to attempt to date this older program on the basis of style when the paintings have lost most of their surface detail. Iconography too must be only cautiously exploited for this purpose; I have warned previously on attaching too much faith to the antiquity of the Crucifixion type that shows Christ dressed in a colobium. But though no one piece of evidence is conclusive, the general impression one gets from the photographs published by Jerphanion would tend to support his early attribution.

In fact, the very unusual whitish-yellow background of the Çavuşin paintings may well be in imitation of early Christian goldbacked mosaic murals.

This same color forms the main band of three in the background painting of the decorative scheme at Açĭkel Ağa Kilisesi (Cat. no. 9) near Belisĭrma in the valley of Peristrema. Other, more telling features of the program also point to an early phase of Byzantine art. In fact, in some respects, the program is unique in Cappadocia. The walls of this aisleless chapel are taken up by a broad frieze of painting composed of alternating panels of standing saints and large crosses flanked by drapes. A continuous frieze of drapery runs along the bottom of the walls and is carried into the apse. The vault contains a very abbreviated Christological cycle that emphasizes the Incarnation and the Resurrection. Three scenes of the Infancy—the Annunciation, Nativity, and Presentation at the Temple—are matched on the other side of the vault with the Crucifixion, the Descent into Limbo, and Christ's appearance to the two Marys. In their iconography most of these scenes find echoes in the proto-Byzantine art of the sixth, seventh, and eighth centuries, notably the frescoes of Santa Maria Antiqua and the mosaics of the lost chapel of John VII in Old St. Peter's.

But the presence of the Descent into Limbo in a formula undocumented in existing works before the first years of the eighth century, and the general style of the figural parts of the program, speak against an earlier date. And furthermore there is the possibility that the Açĭkel Ağa painter may have been creating a pastiche of past art during the Iconoclastic Controversy, perhaps during the brief intervals of permissiveness. Indeed the thrust and tone of the decoration in its totality cannot be said to be innocent of the problems raised by the Controversy, or at least the dogmatic struggle that led up to it. We might point out too the portrait of St. Euphemia, the insistent use of the cross, and the special exaltation of the divinity of Christ. An unusual inscription on the triumphal arch, drawn from the Letter to the Hebrews, makes the point that He is the priest of a Church of which this one on earth is only an image: "a minister of the sanctuary, and of the true tabernacle, which the Lord pitched, and not man." The four Evangelists are figured in the intrados of the triumphal arch associating them with the Christ in Majesty of the apse—a unique emplacement and reminiscent of the intimate relation of the Pantokrator with the four evangelists in the central superstructure of the later cross-in-square churches. And

the stress on the Incarnation and Resurrection in the Christological cycle is itself exceptional and noteworthy.

Whatever the true scope of painting activity in Cappadocia in the early Christian centuries, one thing is certain: the long Iconoclastic interlude proved disastrous for this pictorial tradition. Though figural imagery did not cease altogether, as it did in areas more strictly under imperial jurisdiction, the practice of it was sparse and defensive until the second half of the ninth century, when the ban was officially and finally revoked and brushes could move again.

At Constantinople, and the areas in its firm control, the revival of religious painting was extremely cautious and gradual. At first there were no narrative scenes at all: only the Virgin in the apse, standing or else seated with the Child in her lap, a medallion of Christ All-Ruler in the dome, and for the rest rows of hieratic saintly protraits. When attention was slowly focused on Christological subjects again, the choice fell to a very limited number of events with liturgical significance, corresponding to the major feasts of the Orthodox calendar, and for these, new pictorial schemes were devised consonant with the prescriptions of the Church. Only very exceptionally do we have record of a narrative cycle in the old manner, for example, Holy Apostles at Constantinople, where the cycle renews a pre-Iconoclastic scheme. Miniaturists participated in the creation of this new iconography due to the crucial role of Lectionaries, a new kind of Gospel book where the New Testament texts were dissembled and rearranged according to feast readings. The illustration of a Lectionary no longer yielded itself to the continous narrative bands of ordinary Gospel books, but as a book for church services it required, rather, standard full-page miniatures for the major feasts.

The aim in all this revival of images was not of course total invention. Elements of specific scenes from the older narrative cycles were retained where possible, and two or more such scenes were sometimes merged into one panel of monumental scale and static, centralized composition. For churches at any rate, the complete development of the new decorative system, what we have called the Middle Byzantine cycle, took more than one hundred and fifty years. Classic examples like Hosios Lukas at Stiris and the church at Daphni date in the eleventh century: the one in the first third of the century, the other about 1100.[46]

In Cappadocia, on the other hand, the aftermath of the Iconoclastic Controversy was quite different. As soon as the ban for imaging had been lifted, the rich narrative tradition returned,

if indeed it had ever entirely subsided. Picture cycles of saints' lives, it is true, became much less favored and were reduced more often than not to ceremonial effigies or simple one-scene narrative portraits. But the Christological narrative was hardly curtailed.

Two separate cycles, or rather decorative systems, were in circulation at about the same time, the early tenth century according to two examples dated by inscription; they probably started somewhat earlier and lasted in the same form at least until the middle of the century. One of the systems was largely native; the other was probably brought along by Armenian colonists who were pushed into the Anatolian plateau by the Muslim offensive from the East, or, if we are unwilling to accept their presence any further west than Caesarea, inspired by these Armenians. The latter system of decoration, our so-called Ihlara cycle, is only secondarily narrative: its intention, as explained here, seems to have been in part propitiatory or magic. Its essence is in any case rather unorthodox and more in tune with a restricted monastic thought tinged with remnants of Gnosticism. It does not seem to have been invented with one specific church type in mind.

The second system, the so-called Archaic cycle, relies closely on the framework of a one-aisled basilica. Now this type of church building had a long early history in central Anatolia including Cappadocia, but in the absence of any securely *pre*-Iconoclastic example with a painting program on its walls (the one possible exception being Açıkel Ağa Kilisesi; Cat. no. 9) it is hard to say how much of the Archaic cycle was freshly invented after the ban had been lifted and how much simply retained from earlier local tradition. At any rate, this system of decoration, though in general look retardataire or, better, conservative, was not entirely devoid of metropolitan connections. Witness the striking similarities of form between the Ascension at Ayvalı Kilise (Cat. no. 16) and the Ascension in the post-Iconoclastic program of Hagia Sophia at Thessaloniki; and iconographic details such as the active role of the Virgin in the Deposition scene, a post-Iconoclastic innovation. And the intention of the Archaic cycle, clearly revealed in a conscious and consistent intellectual order, was anything but conservative. As a decorative system, the cycle—a system based on the triumphant Progress of Christ and its implications for the common Christian, or more accurately for the Christian monk—was an alternative to the slowly maturing Middle Byzantine church scheme of the capital.

The rest is a tale of modernism. Beginning about 950 the post-Iconoclastic developments in

Constantinople, architectural and pictorial, became current in Cappadocia. The pattern of this intrusion was complex. At least three major trends can be isolated: (1) There were cases where architectural schemes from the capital traveled alone, and the Cappadocian artist endeavored to accommodate his own decorative system, chiefly the Archaic cycle, to the new frames. (2) Non-Constantinopolitan building types, both native ones and others borrowed from the East, were held on to, but the decorative system was modernized by exchanging some of the iconographic schemes in the Archaic cycle with the new formulations of the capital for these same subjects. And, more importantly, the paintings affected an air of refinement, the "feel" of stylistic sophistication if not the competence that should go with it, that was unmistakeably Constantinopolitan in inspiration. (3) Both the new building types and their decoration were imported in unison. This trend should be considered, in one sense, to be at once the most enterprising and the least original.

Let me illustrate the first trend with the church of Kĭlĭçlar (Fig. 18). Its plan is the cross-in-square, the modern church type par excellence of post-Iconoclastic architecture in the metropolitan areas of Byzantium. The decoration, however, is the old standby, the Archaic cycle, which if anything has grown richer in scenes than its predecessors. The two, plan and decoration, are obviously incompatible, since the ideal building type for the Archaic cycle is the one-aisled basilica. The cross-in-square plan burdens the artist with three apses instead of one; and in the place of one continuous painting field, the barrel vault of the nave, which can be sliced up lengthwise into bands suitable for an uninterrupted narrative, the artist has to cope here with the complicated superstructure of domes, short barrel vaults, and flat ceilings that cover the nine bays. What he does with this is not felicitous, but it is probably the best that could be done to fit an old dress on a new body. The central apse is still devoted to the Archaic Christ in Majesty, and in the opposite end the vault of the little inner vestibule houses the Pentecost. One of the side apses, that to the north, contains a seated Virgin holding the Christ Child—a concession to the new post-Iconoclastic iconography of the capital. (The paintings of the south apse are destroyed.)

The rest of the church absorbs the Christological narrative. The walls are left blank up to about six feet, since the tall, sprightly proportions of this modern interior afford too much wall surface to fill with saints, besides being visually unsuited to be grounded with images. But with

the saintly effigies high above the ground level, on archivolts and engaged piers, that intimate communion in the tight space of the Archaic churches between the heavenly congregation and the human is here compromised. The Christological narrative begins at the southeast corner of the main apse and tries to progress as usual, from left to right. The Childhood sequence is spread on the vaults of the east, north, and south arms of the central cross; the Miracles, on the upper wall of the first two bays on the southern flank of the church; and a very extended Passion sequence is distributed rather awkwardly in the west and north corner bays. In the Crucifixion scene of this last sequence, Christ's eyes are closed in death; the portrayal of Christ as dead is a post-Iconoclastic invention and serves here as a small indication of the sensitivity to the new iconography emanating from the capital.

The second trend of modernism is represented by three important and attractive painting programs related to one another in feeling, a feeling that draws its strength, unquestionably, from the post-Iconoclastic revival in the capital. Two of these, the programs of the so-called Great Pigeonhouse at Çavuşin and St. Barbara at Soğanlï (Cat. nos. 38 and 40), are dated by inscription. Çavuşin's invokes the emperor Nikephoros Phokas, a native son of Cappadocia, and his wife Theophano: their portraits and those of his father Bardas Phokas and his brother Leo figure below the inscription, in the northern of three apses. The imperial couple had toured the region in 964, in preparation for the campaign of Cilicia against the Muslim that was to prove spectacularly successful in the following year. When Nikephoros crossed the Taurus chain at the head of his army, the empress and their two young daughters stayed behind at the fortress of Drizion near Tyana, some sixty miles south of Çavuşin. The church was doubtless executed during this unwonted imperial passage and in celebration of the recovery of this battered corner of the empire, so long at the mercy of Muslim attack. In fact, as Jerphanion has suggested, the unique picture of the apparition of the angel to Joshua on the eve of the fall of Jericho, painted in proximity to the imperial portraits, might have been intended as a metaphor for Nikephoros' Cilician campaign. The theme of military victory is further fortified, I think, by the equestrian portrait of his Armenian general Melias in another part of the church, at the head of the Forty Martyrs of Sebaste.

St. Barbara is dated fifty years later in the reign of Constantine VIII and Basil II; the mention of a specific indiction would yield 1006 or 1021. The third painting program, at the new church

of Tokalï (Cat. no. 39), is undated but could not be too far removed from the others. Jerphanion put it close to the mid-tenth century on the basis of his contention that it served as the model for the slightly later painting program at Çavuşin. We can dismiss the tedious polemic of the 1930s between Jerphanion and E. Weigand, who stubbornly insisted on assigning Tokalï II to the fourteenth century.[47] Much of the latter's argument, specious and misguided for the most part, has since been refuted. There is, on the other hand, no compelling case for Jerphanion's proposal (recently adopted and amplified by R. Cormack) that the artist of Çavuşin was copying Tokalï II. The two programs have a generic similarity only; the form and impact of each are discrete. Based on more recent stylistic comparisons, Tokalï II should be assigned in my view to about 1000, somewhere between the Great Pigeonhouse at Çavuşin and St. Barbara.

One other painting program should be associated with this group, that of Chapel 16 at Göreme (Cat. no. 39a). Had it been better preserved, it would warrant as much attention as the three already mentioned, for the quality exhibited in some fragments that survive is notable. These include the Presentation at the Temple and the Annunciation from a Childhood sequence that occupies the barrel vault and lunettes of the southern half of the chapel (Pl. 43). The northern half is totally destroyed. I would judge this program to be almost exactly contemporary with Tokalï II.

All four churches, paradoxically, look away from Constantinople in their architecture. I have discussed Tokalï II at length in Part 2, linking its special plan of a transverse basilica to Mesopotamia. St. Barbara's is a traditional double nave, a variation of the standard one-aisled basilica. And the Great Pigeonhouse too is anything but metropolitan. It is a simple, almost square, barrel-vaulted space with three apses in the east end; its only distinction is its unusually large size for a Cappadocian church, a full thirty feet high from ground level to the crown of the vault. Chapel 16 is a smaller version of this same scheme. In general the iconography of their decorative systems is also not fashionably modern. Basically it is the Archaic cycle that is being kept in service, considerably amplified in Tokalï II (Pl. 41).

And yet, for all this, the impression of contemporaneity, of liberation from the more obvious aspects of the provincial mode, is inescapable. Old scenes are updated or sometimes drastically reinterpreted. This is most true of those Christological subjects that carry exceptional weight in the liturgy, that is, subjects corresponding to the major Orthodox feasts. The Nativity of

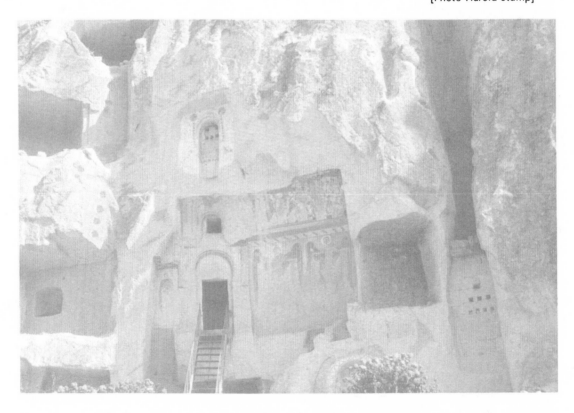

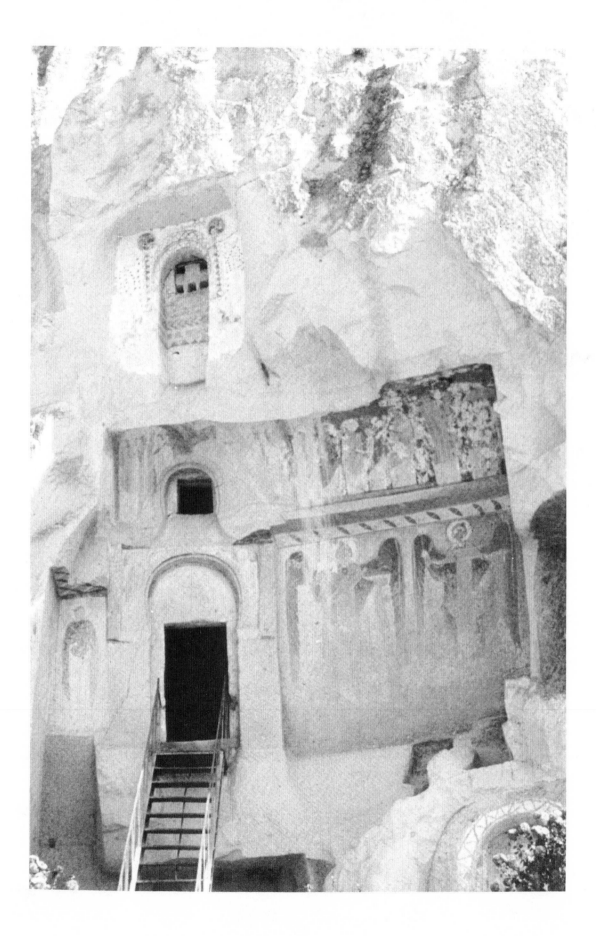

Plate 41
Göreme, Tokalı Kilise II
(Cat. no. 39), north apse,
Christ in Majesty.
[Photo David Gebhard]

Plate 42
Göreme, Tokalı Kilise II
(Cat. no. 39), main apse,
Crucifixion.
[Photo David Gebhard]

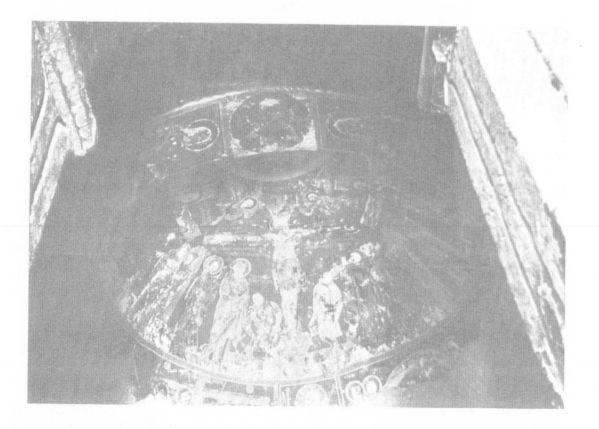

Tokalï II, for example, gets a whole chorus of angels. The Baptism changes character altogether. Christ, at ease now in his nudity, forgoes the clumsy gesture of pudency and stands in water that the artist has attempted to depict naturally. Only the presence of the two thieves carries over from the Archaic Crucifixion; otherwise the scene, stretched out and placed extraordinarily in the curve of the main apse, is quite new (Pl. 42). Mourning angels float above the Cross. A crowd of people gathers about, including the three women who will later visit his tomb and a group of soldiers looking on as Longinus spears his side. Blood spurts out from the wound, and blood issues from the nailed feet and hands. Behind the soldiers one sees the Temple whose veil was rent in two from the top to the bottom when Christ yielded up the ghost. The Crucifixion occupies the conch of the central apse at Tokalï II, with the single figure of St. Basil below, right behind the altar. This unusual placement, Robin Cormack suggests, might be an echo of the tenth-century ritual in a chapel of the Great Palace at Constantinople dedicated to the same St. Basil, which involved the display of the relic of the True Cross at the beginning of January.[48] At Çavuşin there are two Crucifixion scenes, one to show Christ's tribulation on the Cross, the other his passing.

These enriched and fattened scenes slow down the pace of the story, so that the viewer's eye does not rush on to complete a sequence but surges and stops with the varied rhythm of short expository narrative and grand set pieces. The bands into which the picture field is divided are tall, the intervals less cramped than in Archaic programs; a breathing margin between the heads of standing figures and the top limit of the band contributes a sense of studied amplitude. The figures themselves are tall, the heads moderately sized in proportion to the elongated bodies. They stand or move with great dignity. Their costumes are intricately pleated as if the painter were anxious to show off his skill, but yet it is never pattern for pattern's sake: the structure of the bodies that are so clothed is enhanced rather than obfuscated. Gestures are lively with expression. Their rise and fall is calculated to bridge the separate accents of mass within one composition. Glances, flexible and likewise expressive, provide the vehicle for psychological interplay between protagonists and subsidiary characters. Everywhere the painter eschews episodic shorthand in favor of a full, rounded presentation for the subject at hand, both in accessories and in dramatic atmosphere.

The revolution of visual form, and that I think is what it is, is now, and would have been then,

most strikingly apparent at Tokalï. There the two worlds of imagery, the Archaic and the modern, were serially arranged (Fig. 13). In passing through the older church to reach the new transverse basilica, the user would have felt palpably, indeed physically, the distance between what he had been accustomed to and this singular beauty that had sprung from a source closer to the heart of empire. His experience would have been expansive in more than one way. The tight nave of Tokalï I, which once had been the entire place of worship, was now no more than a painted vestibule; its constriction and directional axis underlined the impression of *passage* and conditioned the user for the exciting spatial release into the grand nave of Tokalï II. And the stature of the holy images itself exploded with the space. The blue background grew brighter and on it stood now somber, stately figures in classical robes of light brown and white—a grave counterpoint to the taut and jerky crowd on the vault of the older church, dappled in ocher red.

In mood the art of Tokalï II can be described with reason as monumental. There is a splendid generosity of scale and conception in scenes like the Adoration of the Magi, the Presentation of Jesus in the Temple, and the Ordination of the First Deacons by St. Peter. The painter was conscious of setting, which he established expertly by spare means; simple but imposing architectural backdrops for scenes like the Calling of St. Matthew, or the Wedding Feast at Cana; a rocky eminence, indicating desert land, against which Christ blesses the kneeling St. John and asks to be baptized by him; two upright trees to frame the frontal figure of Christ as he extends his benediction to banks of bowing apostles on either side. The sprinkling of landscape features conjures enough of a sense for the outdoors so that empty stretches in the picture field are easily taken to be real space in which the figures act with assurance and elegant dignity. They are in the main full-bodied; broad, billowing curves of drapery round out their mass and on more than one occasion, notably in the Presentation and Baptism, bracket a composition laterally like a set of parentheses. The line is suple, firm, confident. The brush sweeps when it has to, or can start up ripples of energy. Or again it falls unwaveringly to shape straight pleats from neck to hem, as witness the columnar posture of the deacons in the Ordination scene.

The modeling of faces is peculiar. Over a bone-and-muscle structure in brown and ocher tones the brush leaves daredevil highlights of grayish blue—thick dabs on the length of the nose, streaks across the brows, beard, and hair. It is hard to know how much of this character

Plate 43
Göreme, Chapel 16 (Cat.
no. 39a), interior showing
the Presentation at the
Temple (left) and the
Annunciation.
[Photo Harold Stump]

is due to the cleaning and repainting (perhaps around 1300) which, according to Restle, affected the entire surface of the painting program. In any case, the texture of the faces is not unknown in the monumental painting of the tenth and eleventh centuries (cf. the paintings of Taïk, Ishran, and Hahul in Georgia).[49] This texture also occurs in gouache miniatures, and the chance is not precluded that the original painter had been looking at illustrated manuscripts. Indeed, the Gospel fragment of the later tenth century at Leningrad (Codex gr. 21) had close relevance to the paintings at Tokalĭ II, as Morey, Millet, and Kurt Weitzmann pointed out several decades ago.[50] The Benediction of the Apostles is near identical in the two places. At the same time there is a finer stylistic affinity, particularly with the "fifth master" of the Leningrad manuscript, to use Weitzmann's distinctions. Morey and Millet, on the basis of this correspondence between the miniatures and the paintings at Tokalĭ II (and to a lesser extent of Kĭlĭçlar), proposed that the manuscript must have been produced in Cappadocia. Weitzmann is rather inclined to locate it in Trebizond in a scriptorium with ties both to Constantinople and to Armenia. The current from the capital, as seen in the style of the "fifth master," is what Tokalĭ II shares with the manuscript, and in both cases it is the strong classicizing movement in the courtly art of the Macedonian dynasty that constitutes the immediate formal context.[51] The dependence can be pursued further: the miniatures of Codex 204 at the monastery of St. Catherine on Mt. Sinai, made in Constantinople during the same Macedonian Renaissance, include figures transparently comparable, it seems to me, to figures in Tokalĭ II;[52] and Jerphanion himself had noted similarities with tenth-century and eleventh-century Byzantine ivories originating in the same imperial milieu.

The character of the Çavuşin paintings is different. It is dainty and finespun where Tokalĭ was resonant. There is something a trifle memorized about the painter's approach, as though he were following a stronger model whose compositional structure he liked but whose impact he felt should be minced. We illustrate the narthex with paintings of the two archangels Gabriel and Michael (Pl. 43). You might be able to see there something of the delicacy of the brushstroke, the thinly drawn drapery folds, and the general proclivity for attenuation, evident in everything from human proportions to the long "Ottonian" fingers and the scythelike wing tips. But it is the palette that speaks most eloquently of a refined, almost affected beauty. Color is applied lightly on a bed of plaster so thin as to allow the rock texture to show through at places.

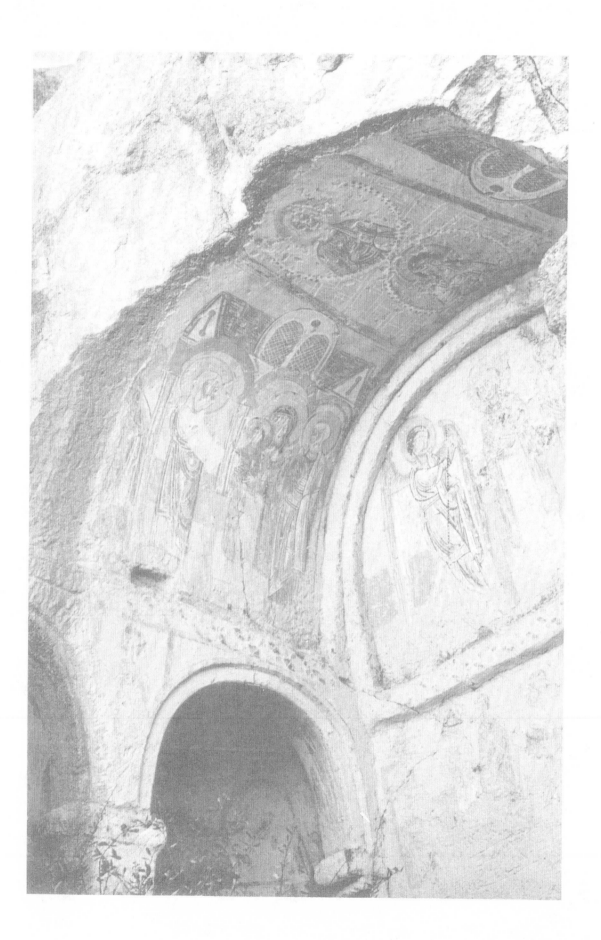

Plate 44
Soğanlï Dere, St. Barbara
(Cat. no. 40), the Descent
into Limbo.
[Restle plate 440]

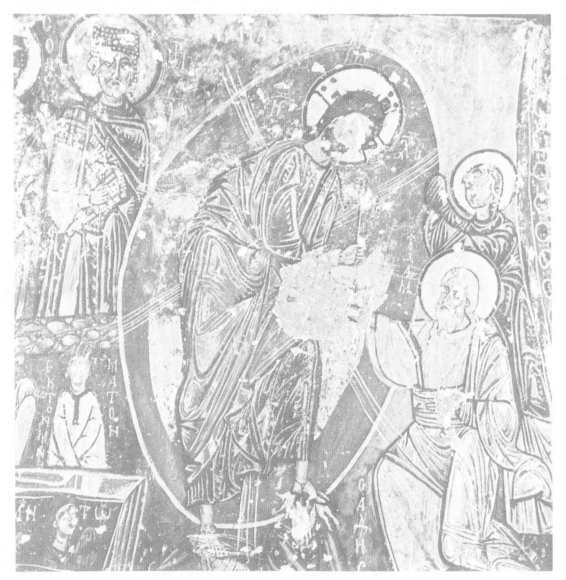

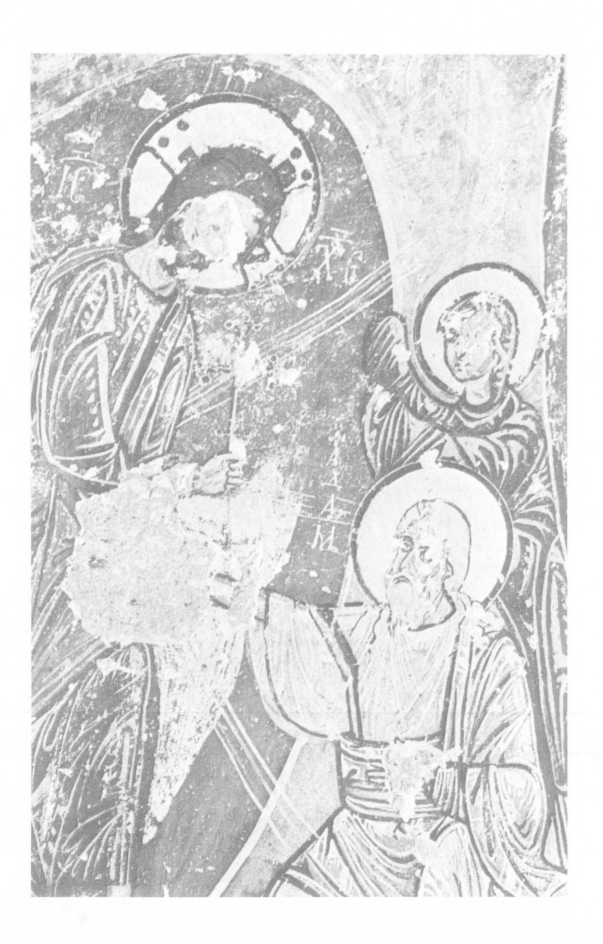

Pale red, a kind of bluish white, and green predominate, with no trace of the gouachelike high-lighting of Tokalī. An overall translucency, made all the more effective by glowing all around the dim, cavernous, vast interior space.

St. Barbara, illustrated here with the Anastasis or Descent into Limbo (Pl. 44), is in turn of another character. The key word is harshness, a generally coarse execution most notable in the dourly painted drapery folds, and fingers done in single strokes of light and dark colors. Notice also the practice of dividing a surface, be it of costume or of landscape, into definite shapes like triangles, irregular ovals, etc., which are then filled in with subsidiary features. Good examples are the Christ of the Anastasis and the rock against which Joseph is shown in the scene of the nativity.

The point to stress is that though all three churches under discussion share the same goals of modernity and the same field of sources, they are each one by painters of independent personality. The probability is that these men were physically aware of one another's work and not merely using indiscrepant models. But there is no reason to see the three programs, which cover a period of fifty years or so, as well-defined stages in a sensible development of painting style. The art of Cappadocia, like most provincial art, is not susceptible to neat developmental analysis. Its growth has, I suggest, no internal, organic logic such as one might be able to plot for the intellectually conscious, formative cultural milieux like Constantinople. Provincial art is open-ended and unpredictable. It draws strength from a multiplicity of sources, often manifest in a single work of art, or one period of time, but the blend is more an additive jumble than the aesthetically smooth and one-minded language of metropolitan eclecticism. So too its progress follows a jerky path. It may hold back its energies while metropolitan artists advance along a sophisticated line of formal and technical innovation; and then, aberrantly perhaps but not inexplicably, it might decide to ape or import a forward stage of this progressive line without rehearsing any of the preliminaries. The historian must resist the temptation to impose an orderly structure on the study of a provincial school of art where none in truth existed.

The Middle Byzantine
Cycle

And so we should not be surprised to find that while some communities in Cappadocia, like the monastery of Kılıçlar, chose after 950 to reproduce the new Constantinopolitan cross-in-square plan but persevered in their archaic decoration, and while others at roughly the same time rejected modern architecture but aired the Archaic cycle, in the ways we have just described, with artistic and iconographic currents from the capital, a third group opted for total modernism by importing the cross-in-square and the decoration devised for it in Constantinople. One cross-in-square church, Direkli Kilise at Peristrema (Cat. no. 41), whose painting program is dated by inscription to the reign of Constantine VIII and Basil II, that is, exactly the same period as St. Barbara at Soğanlı, demonstrates that the three trends of modernism were not consecutive stages in a gradual Cappadocian adaptation of Middle Byzantine developments in Constantinople but that the process of assimilation was disjointed, capricious, and complex.

I do not propose to say much about the Middle Byzantine cycle proper. Several times before we have had occasion to speak of it, particularly in the detailed architectural account of the cross-in-square churches in Part 2, where we sketched in outline the distribution of the panels and described some of them. Suffice it to repeat here that the principle of the new decorative system is no longer narrative but wholly liturgical, that the selection of Christological scenes is in accordance with the feast calendar of the Orthodox Church, and that the disposition of the images on the available surfaces follows a symbolic hierarchy that starts at the highest point, that is, the intrados of the central dome, with a bust of Christ Pantokrator (All-Ruler) and proceeds downward to the saintly portraits on the lower walls (Pls. 30–34). There is no interest in an inclusive Progress of Christ with the three narrative sequences of the Childhood, the Miracles, and the Passion. The painter obeys the interpretation of the canonical Gospels to be found in the liturgy. His choice, rigidly prescribed by the Church, is guided by the concern to represent the major stations of the work of Salvation, that is to say, those Christological events that constitute the main "mysteries" of the Incarnation.

The Childhood sequence according to the apocryphal Book of James, so stable a component of the Archaic cycle, is now suppressed. The Annunciation, doubtless because it is considered a feast of the Virgin rather than of Christ, is only exceptionally included. The Visitation, for which there exists no liturgical celebration during the year, is omitted altogether. In the spirit

of the Byzantine liturgy for the last week in December, the Nativity and the Adoration of the Magi are merged into one episode (Pl. 34). The Pentecost too is regularly bypassed. And that handful of festival pictures that are retained present a new iconography distinct from the corresponding iconography of the older narrative cycles in composition or in detail, or at least in emphasis. Great rays of light emanate from the glory that surrounds Christ in the Transfiguration: he and two prophets are shown now on the summit of three small hills. The Last Supper no longer focuses on the pithy exchange between Judas and Christ (Matthew 26:25) but depicts rather the moment when Christ has declared "He that dippeth his hand with me in the dish, the same shall betray me." (Matthew 26:23) The two thieves disappear from the Crucifixion scene. And the apse now regularly receives an image of intercession, the Deisis, to replace the fearsome Christ in Majesty in Archaic churches or the Ascension scheme of the Ihlara cycle (Pl. 32).

It is also necessary to underline one other point: that the career of the Middle Byzantine cycle in Cappadocia was by no means brief. We are not dealing with a one-shot experiment. The cross-in-square churches in the Peristrema valley and in Jerphanion's territory to the east illustrate, in fact, different stages of the cycle's development in the capital and its immediate domain. Direkli Kilise (Cat. no. 41) for one, dated in the early eleventh century, reflects that inceptive stage in the post-Iconoclastic revival of imagery when Christological scenes were as yet not tolerated. Its decoration consists overwhelmingly of portraits of saints. There is in addition a Deisis in the conch of the main apse and a seated Virgin with the Christ Child in the north apse—and that is all. A very lean, non-narrative, scrupulously iconic program indeed. The model being emulated seems to have come from the first important post-Iconoclastic systems in Constantinople like those for the Nea (or New Church) built by Basil I in 880 within the Great Palace, the monastery church of Kauleas, and the first decor of Hagia Sophia.

A more advanced attitude holds in Ala and Sümbüllü Kilise (Cat. nos. 42 and 43), both in the Peristrema valley. Here a token number of festival panels is sprinkled throughout the church interior without any particular system. Saintly effigies, however, still prevail. These programs are perhaps attributable to the middle of the eleventh century. It is only in the three well-known cross-in-square churches at Göreme—Elmalï, Çarïklï, and Karanlïk (Cat. nos. 57-59)—that the full, classical Middle Byzantine solution makes its appearance. Now these stand to Ala and

Sümbüllü Kilise much as, in the Constantinopolitan sphere, the program of Daphni with its less than fifty saintly effigies and thirteen festival panels in the nave stands to the Hosios Lukas program, perhaps as much as three-quarters of a century earlier, with only four panels but more than one hundred and fifty effigies. Daphni dates around 1100. It seems quite improbable to me that the three Göreme churches, whose near classical Middle Byzantine decoration comprises an average of thirteen festival pictures and only about fifty to sixty single figures, could be any earlier. Jerphanion's mid-eleventh-century date for them is surely premature. I think the question should rather be to establish how much later than Daphni the Göreme programs belong. And here our only criterion is style.

Though executed by more than one artist, the three Göreme programs are too patently cognate not to be seen for what they are: the work of an identifiable school of painting. Their iconographic affiliation needs no comment. The model was doubtless supplied by the central tradition of Middle Byzantine art with no significant intermediaries. And the style of this model suffered little in being transposed. From the illustrations we include, one can see that formally this Göreme school was quite accomplished. Perhaps alone in the art of troglodytic Cappadocia, its product looks sophisticated enough to belie its provincial origin. In its case, then, we might more confidently determine an approximate chronological position through comparison with metropolitan monuments.

The Göreme style, it seems to me, approaches none of the known Byzantine modes of the eleventh century. The key monumental programs on which the central development of Byzantine style is postulated are Hosios Lukas for the early third, Nea Moni at Chios for the second third, and Daphni, with its beautiful blend of abstraction and classicism, for the end of the century. No single painting program in Cappadocia quite parallels the style of Hosios Lukas; but insofar as it derives directly from the tradition of the capital, the formal idiom of St. Barbara at Soğanlï Dere (Cat. no. 40) may be taken to represent this early eleventh-century phase of Byzantine art.

Somewhere between this date and the middle of the century may be the proper place for at least the inception of a rather problematical style that on the one hand approximates some of the conventions of the Hosios Lukas master, and on the other recalls distinctly a vernacular mode present since the early eleventh century in the art of the Greek islands, Georgia, Armenia,

and such peripheral places. Now this style is seen to best advantage in the church at Ayvalï Köy (Cat. no. 48), a simple one-aisled basilica of which only the apse was painted. The iconography is rather muddled. There is a Deisis in the conch, but Archaic leftovers—symbols of evangelists, wheels of fire—clutter the image of the enthroned Christ of mercy. Below are two ranges of apostles advancing toward a central Holy Table, and a final tier of sainted bishops. The faces are extraordinary. They are built up by means of a featureless coat of paint as though encrusted with a poreless, opaque skin. The staring almond eyes, black solid cordlike brows, and mouths composed of two angular circumflexes, all convey the frigid stylization of a mask. The ponderous brushwork extends to the draperies as well. Dense strokes, dark and wooden, establish the pockets of the folds, and then yield with perfunctory transition to bright hues for the raised parts—a forceful pattern of harsh contrasts. In the monastery church at Eski Gümüş (Cat. no. 49) this same style was used in an apse composition of similarly hybrid iconography, to complete an already existing nave program. At least that is what the excavator, Michael Gough, thinks. He attributes this earlier program to a little after the middle of the century, and the additions in the hard mode we have been describing to perhaps a hundred years later.

And indeed there would be nothing unreasonable in a twelfth-century date for this vernacular substyle, here and at Ayvalï Köy, especially in view of its astonishing resemblance to the Romanesque idiom of Italy and Catalonia. The only problem is a recently published inscription in a small chapel at Ihlara dedicated to St. Michael (Cat. no. 47). It mentions a Porphyrogenitos, and though the name of the imperial personage that the epithet (meaning "born in the purple") accompanied has been obliterated, it could only have been one of three: Constantine VII (913–945), Constantine VIII (1025–1028), and Theodora (1055–1056). The inscription pertains to the topmost of two superposed programs of painting, the first being Archaic. Now this second program, poorly preserved, is near identical in style to Ayvalï Köy and the later paintings at Eski Gümüş, and that is why we are forced to look to the eleventh century for the origins in Cappadocia of this distinctive style. I say the origins because it is possible that as a formal convention it may have continued for some time.

The middle phase of metropolitan Byzantine art in the eleventh century, of which Nea Moni at Chios is the central existing monument, is matched in Cappadocia by the painting program of Karabaş Kilise (Cat. no. 50) at Soğanlï, dated by inscription to 1060/61, and by three other

churches that approximate its style: Saklĭ Kilise, Kuşluk near Kĭlĭçlar, and the triconch of Tağar (Cat. nos. 53, 51, and 54). Indeed it would be simple in a book of larger scope than the present to demonstrate at length the formal affinity between the Nea Moni mosaics and the frescoes of Karabaş. Let me single out the thickly sketched, emphatic robes with frigid, rather lifeless folds, and the faces haunted by deepset dark-ringed eyes.

To complete the centurial analogy we might now be tempted, finally, to make the three Göreme cross-in-square churches—Elmalĭ, Çarĭklĭ, and Karanlĭk—collateral to the last eleventh-century metropolitan phase, that typified by Daphni. But here we would not be accurate; for the balance of elegant abstraction and pictorial corporeality, so subtly maintained at Daphni, has already been upset at Göreme in favor of the former. The figures are real enough. The bodies for the most part seem full and convincing beneath their sheath of drapery. Thighs and knees are articulated by what Wilhelm Koehler long ago called the "damp fold," soft clinging drapery that envelops the limbs to bring out their volume (Pl. 45).[53] But the mood is playful. The forms ripple with a kind of lilting energy that has no prosaic justification. The damp folds themselves set up curvilinear patterns that spread infectiously across the surface with linear eddies and swirls.

Now the damp fold is the shibboleth of Byzantine style in the first half of the twelfth century. From Byzantium it soon spreads westward to help contrive an international idiom of art. As the century progresses, this linear agitation, which is of course at odds with the solidity of modeled form, gains in impetus and leads after 1170 to mannered but engaging excesses. E. Kitzinger has recently labeled the period "dynamic."[54] And the point we have been driving toward is that compared to its products (the church of St. George at Kurbinovo or the cathedral mosaics of Monreale) the Göreme school is still quite restrained. I would therefore propose that Karanlĭk, Elmalĭ, and Çarĭklĭ Kilise belong somewhere between Daphni and the "dynamic" style, in the first half of the twelfth century, perhaps at 1130.[55]

The resemblance of the vernacular substyle of Eski Gümüş and Ayvalĭ Köy to the Romanesque idiom of Italy and Catalonia should be recalled at this point. We may well have here a second international language of form in the twelfth century coexistent with the Byzantine language that emanated from Constantinople. Recent scholarship is making us increasingly aware of common trends in later medieval art that would minimize the artificial separation of

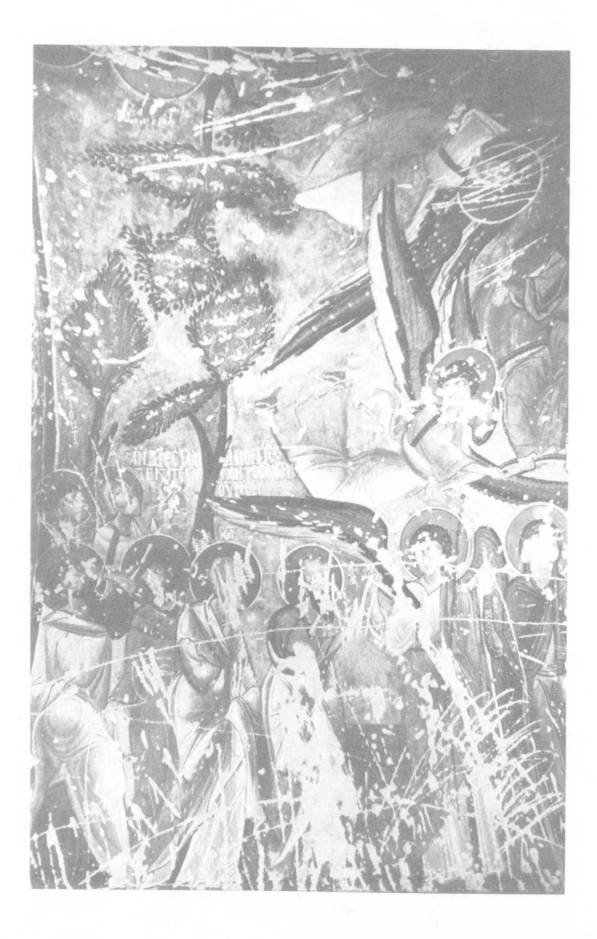

Plate 45
Göreme, Karanlĭk Kilise
(Cat. no. 59), entrance
vestibule, Ascension,
detail.
[Photo David Gebhard]

East and West. This attitude is healthy in my judgment, and also historically sound. In art as in history the destinies of Christian Europe and the Christian East are thoroughly interlocked. Having once recognized this, we shall understand better both West and East—provided, that is, that we are able to refrain from cultural chauvinism. To admit that the splendid flowering of Gothic sculpture in France may not have been altogether independent of Byzantium is not to belittle the Western achievement. And in this context, Jerphanion's last chapter, where Cappadocian influence is made to account for much Western iconography down to Giotto and Verrocchio (even though "Cappadocian" is equated with the broader term "monastic"), is misleading to say the least. The value of recognizing universal trends lies precisely in avoiding such parochial inflations.

Turkish Epilogue

Sometime shortly afterward the artistic influx from Constantinople was abruptly turned off. It was two full generations after the battle of Manzikert. That Byzantine debacle had let the Seljuk Turks pour unopposed into Anatolia. By 1130 they were everywhere. To a new generation of Cappadocians they were a fact. The imperial armies had proved incapable of dislodging them from the ancient heartland of eastern Christendom. Having methodically interposed themselves between it and the capital, the Turks had blocked the flow of form and fashion that had managed to modernize Cappadocia down to its remotest valley. To be honest, modernism at its best had always been a surface thing. When that was dammed, Cappadocia once more felt the inevitable isolation of the provinces. Its art had of course its own roughhewn tradition to fall back on, and like all provincial art it would continue to absorb what influence it could, but this time from ancillary regions that shared Cappadocia's plight. The virtuoso rhythms of the full "dynamic" style, the neoclassicism that followed it as a reaction in the early thirteenth century, and that exquisite and melancholy refinement of Paleologan art—these later metropolitan developments would leave not even a distant echo in the land of the troglodytes.

Architecturally, as we saw in Part 2, the erstwhile one-aisled basilica was now duly revived. Of the last few painting programs produced under Turkish domination there is not much to say. Their artistic merit is negligible. The faint resemblance to metropolitan Byzantine style in their rude forms is due to their imitation of local masterworks and not to any new infusion from Constantinople. The capital was itself unfree. The Latins who arrived with the Fourth Crusade of 1204, ostensibly to aid the beleaguered empire, chose to stay and for sixty years made of Constantinople, that greatest and richest city of the medieval world, a treasure quarry and a base for exploitation. A new emperor of Byzantium was crowned at Nicaea in 1208; it is he, Theodore Laskaris, who is invoked in the precisely dated painting program of Karşı Kilise (Cat. no. 61)—25 April 1212. Unfortunately, one has little to see there today. The church continued in use until the modern exodus of the Greeks from Anatolia in 1922, and the paintings have been badly blackened by centuries of smoke from candles and incense.

The condition of Forty Martyrs at Suveş (Cat. no. 62) is much better. Here too the paintings are dated in the reign of Theodore, in 1216. The work is clearly derivative, archaizing. Most of the inspiration comes from the Göreme school; a few scenes, like the Annunciation, are copied without much subtlety from the nearby church of Cambazli (Cat. no. 44). The general style re-

calls that of the miniatures in an early thirteenth-century Syriac Lectionary (Bibl. Nat., Paris, Syr. 355), according to a notation by "the painter Joseph, deacon of the city of Melitene, which is at the confines of Cappadocia."[56] It is a hybrid art—part Armenian, part Muslim, part Latin—pinned clumsily on the skeleton of the pictorial schemes of the accomplished cross-in-squares of Göreme, now nearly three generations old.

And the Göreme school goes on being exploited at the end of the century in the church of St. George at Peristrema (Cat. no. 64). Then nothing more. By the time the remnants of Greek monasticism at Soğanlï Dere had decided to add a Last Judgment at Canavar Kilise (Cat. no. 66) two centuries or more later, the painter's memory of his able ancestors is a mere crude ghost, as corrupt as his turkicized tongue.

Glossary

Ambo
Pulpit.

Anastasis
Christ's descent into Limbo.

Apse
The eastern or altar end of a church, in Cappadocia almost always horseshoe-shaped in plan.

Arcosolium
An arched burial niche.

Barrel vault
Semicircular vaulting unbroken by ribs or groins.

Basilica
A longitudinal church composed of a nave with or without side aisles.

Cathedra
The bishop's throne.

Ciborium
Altar canopy.

Conch
The half-dome that surmounts an apse.

Cross-vault
The vault over a square bay formed by the interpenetration of two barrel vaults.

Diakonikon
A room adjacent to the apse of a church that serves as vestry and library-archive.

Diaphragm arch
A transverse arch that runs across the nave vault.

Iconostasis
The tall screen that separates the chancel from the nave in a Byzantine church; painted with images, or covered with icons.

Impost
The top element of a pier or column from which an arch springs.

Intrados
The curved inner surface of an arch or a vault.

Katholikon
The main church in a monastery.

Martyrium (adj. martyrial)
The sacred structure erected over a holy spot of Christianity or over the grave of a martyr.

Orthros
The morning service in the Eastern Church that corresponds to Lauds in the West.

Prothesis
A room adjacent to the apse of a church, that serves for the preparation and storage of the Eucharist species, the bread and the wine, before and after Mass.

Secco
Painting on dry plaster.

Synthronon
The bench for clergy, outlining the apse curve and/or the sides of the nave.

Triconch
A building with three semicircular niches surmounted by half-domes.

Triumphal arch
The arch that circumscribes the opening of the apse toward the nave.

Tympanum
The area enclosed by the line of a semicircular panel over a door or similar opening.

Notes

Abbreviations

BCH
Bulletin de correspondance hellénique

Budde
L. Budde, *Göreme. Höhlenkirchen in Kappadokien* (Düsseldorf, 1958)

BZ
Byzantinische Zeitschrift

Cahiers
Cahiers archéologiques, fin de l'antiquité et moyen âge

Corsi
Corsi di cultura sull'arte ravennate e bizantina

ERC
G. de Jerphanion, *Une nouvelle province de l'art byzantin: Les églises rupestres de Cappadoce*, 2 vols. of text and 3 vols. of plates (Paris, 1925–1942)

Grégoire
H. Grégoire, "Rapport sur un voyage d'exploration dans le Pont et en Cappadoce," *Bulletin de correspondance hellénique* 33 (1909), pp. 1–170.

Holzmeister/Fahrner
C. and G. Holzmeister and R. Fahrner, *Bilder aus Anatolien: Höhlen und Hane in Kappadokien* (Vienna, 1955)

Monuments Piot
Académie des inscriptions et belles lettres, Paris. Commission de la fondation Piot. Monuments et mémoires.

NERC
N. and M. Thierry, *Nouvelles églises rupestres de Cappadoce, Région du Hasan Dağî* (Paris, 1963)

Oberhummer/Zimmerer
R. Oberhummer and H. Zimmerer, *Durch Syrien und Kleinasien* (Berlin, 1899)

OCP
Orientalia christiana periodica

PG
J. P. Migne, ed., *Patrologiae cursus completus, series graeca* (Paris, 1857–1866)

Ramsay/Bell
W. M. Ramsay and G. L. Bell, *The Thousand and One Churches* (London, 1909)

REB
Revue des études byzantines

Restle
M. Restle, *Byzantine Wall Painting in Asia Minor,* 3 vols. (New York, 1967), translated by Irene R. Gibbons from the original German version, *Die byzantinische Wandmalerei in Kleinasien* (Recklinghausen, 1967).

Rott
H. Rott, *Kleinasiatische Denkmäler aus Pisidien, Pamphylien, Kappadokien und Lykien,* Studien über christliche Denkmäler 5/6 (Leipzig, 1908)

Séféris
G. Séféris, *Trois jours dans les églises rupestres de Cappadoce* (Athens, 1953)

Swoboda
K. M. Swoboda, "In den Jahren 1950 bis 1961 erschienene Werke zur byzantinischen und weiteren ostchristlichen Kunst," *Kunstgeschichtliche Anzeigen* 5 (1961–1962), 9–183

1
The Setting

1
J. Garnier and P. Maran, eds., *In Famem,* 63 D, cited in M. M. Fox, *The Life and Times of St. Basil the Great as Revealed in His Works,* Catholic University of America, Patristic Studies 7 (Washington, D.C., 1939), p. 7.

2
St. Basil, *De Grat. Act.,* 25 E, cited in ibid., p. 1.

3
W. M. Ramsay and G. L. Bell, *The Thousand and One Churches* (London, 1909), p. 297; hereafter Ramsay/Bell.

4
Herodotus, 1:71 ff., and 5:49.

5
W. M. Ramsay, *The Church in the Roman Empire Before A.D. 170* (London, 1898), p. 10.

6
Tertullian, *Apologeticus,* 5:6, *Ad Scapulam,* 4; Eusebius, *Ecclesiastical History,* 5:5, cited by E. Kirsten in article on "Cappadocia" in *Reallexikon für Antike und Christentum,* 2 (Stuttgart, 1954), col. 861 ff.

7
Eusebius, *Ecclesiastical History,* 6:11.

8
Philostorgios, *Ecclesiastical History,* 2:5.

9
R. Oberhummer and H. Zimmerer, *Durch Syrien und Kleinasien* (Berlin, 1899), pp. 188–197; hereafter Oberhummer/Zimmerer.

10
Strabo, *Geography* 12:1–2.

11
Ibid., 12:2.10; Pliny, *Historia Naturalis,* 36:46. For Roman Cappadocia in general, see Pauly-Wissowa, "Cappadocia," in *Realencyclopädie der classischen Altertumswissenschaft,* 2 (Stuttgart, 1842); M. H. Griffin, "The Administration of the Roman Province of Cappadocia," unpublished dissertation (Chapel Hill, North Carolina, 1929); W. E. Gwatkin, *Cappadocia as a Roman Procuratorial Province* (Columbia, 1930), for the first century A.D.; D. Magie, *Roman Rule of Asia Minor,* 1, 3 (Princeton, 1950), especially pp. 200 ff., 491 ff., 1435 ff.

12
St. Basil, *In Illud Lucae,* 49 D, cited in Fox, *Life and Times of St. Basil the Great,* p. 42.

13

See, among others, E. F. Morison, *St. Basil and His Rule: A Study in Early Monasticism* (Oxford, 1912); and M. G. Murphy, *St. Basil and Monasticism,* Catholic University of America, Patristic Studies 25 (Washington, D.C., 1930).

14

For these accounts and others, see J. R. S. Sterrett, "Troglodyte Dwellings in Cappadocia," *The Century,* 60 (1900), pp. 677–679.

15

The Koran, 89:9, translation by N. J. Dawood, revised edition (Penguin Books, 1959), p. 25.

16

In Anatolia, note especially the rock tombs of ancient Phrygia (A. Gabriel, *Phrygie II. La cité de Midas,* Paris, 1952). These have recently and convincingly been reinterpreted to be cult buildings and not tombs (R. D. Barnett, "The Phrygian Rock Monuments," *Bibliotheca Orientalis,* 10:3, 10:4 [1953], pp. 77–82). Note also, in the region of the Pontus, tombs at Amasya (G. de Jerphanion in *Mélanges de l'Université Saint Joseph,* 13 [1928], pp. 5–23); at Samsun, the ancient Amisos; at Todurga; and at Güvercinlik (H. Grégoire in *Bulletin de correspondance hellénique,* 33 [1909], pp. 5–9, 40; hereafter *BCH*).

17

See the catalogue of a recent exhibit in the Museum of Modern Art in New York: Bernard Rudolfsky, *Architecture without Architects* (New York, 1964).

18

I. Bidder, *Lalibela: The Monolithic Churches of Ethiopia* (London, 1959); G. Gerster, *Churches in Rock: Early Christian Art in Ethiopia* (New York, 1969).

19

Example at Eğri Taş Kilisesi (Cat. no. 29): N. and M. Thierry, *Nouvelles églises rupestres de Cappadoce, Région du Hasan Dağı* (Paris, 1963), p. 39 and pl. 26a; hereafter Thierry, *NERC.*

20

P. Peeters, ed., *Acta sanctorum,* 66 (Brussels, 1910), pp. 329–339.

21

E. Schwartz, *Acta conc. oec.* 2:1, 2, p. 114, line 32 (as cited in M. Restle, *Byzantine Wall Painting in Asia Minor* [New York, 1967], 2, p. 15; hereafter Restle.)

22

Leo the Deacon 3:1 (in J. P. Migne, ed., *Patrologiae cursus completus, series graeca* [Paris, 1857–1866], 117, col. 715; hereafter Migne, *PG.*)

23

K. N. Sathas, ed., in *Bibliotheca graeca medii aevi,* 7 (Paris and Venice, 1894), p. 205.

24

See for example churches at Eghvard and at Tekor: J. Strzygowski, *Die Baukunst der Armenier und Europa* (Vienna, 1918), pp. 143 ff., 335 ff.

25

For example, the basilica at Eski Andaval (the ancient Andabalis) believed by tradition to have been founded by St. Helena on her way to the Holy Land (J. Strzygowski, *Kleinasien* [Leipzig, 1903], pp. 67-68, 159, 201, and figs. 55-57; and Hans Rott, *Kleinasiatische Denkmäler aus Pisidien, Pamphylien, Kappadokien, und Lykien,* Studien über christliche Denkmäler 5/6 [Leipzig, 1908], pp. 102-108, hereafter Rott); the triconch church of St. George at Ortaköy (Rott, pp. 149 ff.); the inscribed cross church called Karagedik Kilisesi, near Belisĭrma in the valley of Peristrema (Rott, pp. 274 ff.; Ramsay/Bell, pp. 418 ff.—misnamed "Ilanli Kilise"; Thierry, *NERC,* pp. 34-35).

26

This is the name given to it by Rott (pp. 192 ff. and figs. 65-68). It was known in Turkish as Sarĭ Kilise, the Yellow Church, and it was originally the cathedral of the bishopric of Aragina, the present Ağĭrnas (H. Grégoire, "L'évêché cappadocien d'Aragina," *Byzantis,* 1 [Athens, 1909], pp. 51-56). The site of the church is about two miles to the south of Ağĭrnas, not far from the villages of Küçük Bürüngüz and Isgubi, Rott's Skupi, derived from the Greek word *episkope,* or "episcopal church." See Lafontaine-Dosogne, *Byzantion,* 33 (1963), pp. 139-140.

27

Theodoret, *Ep. 146,* cited by Morison, *St. Basil and His Rule,* p. 4.

28

See Gregory of Nazianzus, *Oratio III* (Migne, *PG,* 35, col. 515 ff.) and Sozomenus, *Ecclesiastical History,* 5:2.

29

Perhaps as many as 50,000 between the reign of Leo the Isaurian and Constantine Kopronymos, i.e., between 726 and 775 (A. A. Vasiliev, *History of the Byzantine Empire,* 2d ed., Madison, 1961, p. 262).

30

See *Paris Match,* 13, no. 905 (1966), pp. 48-49.

31

G. Séféris, *Trois jours dans les églises rupestres de Cappadoce* (Athens, 1953), p. 11.

32
Thierry, *NERC,* pl. 50b.
33
For example, the fort of Argos near Bor, on an outcrop of Hasan Dağı; it was a Hellenistic fort, mentioned by Strabo, which was restored by the Byzantines (W. M. Ramsay, *Historical Geography of Asia Minor* [London, 1886–1893], pp. 308, 340, 353).
34
H. F. Tozer, *Turkish Armenia and Eastern Asia Minor* (London, 1881), p. 145.
35
K. Weitzmann, *Die byzantinische Buchmalerei des IX. und X. Jahrhunderts* (Berlin, 1935), pp. 58 ff.
36
G. de Jerphanion, *Une nouvelle province de l'art byzantin: Les églises rupestres de Cappadoce* (Paris, 1925–1942), 2:2, pp. 397–400; hereafter Jerphanion, *ERC.*
37
First by H. Gelzer in *Abhandlungen der K. bayer. Akademie der Wissenschaften,* 1, series 21, vol. 3 (Munich, 1900), pp. 560 ff. On the question of Armenians in Cappadocia, see most recently P. Charanis, "The Armenians in the Byzantine Empire," *Byzantinoslavica,* 22:2 (1961), pp. 196–240, especially 203 ff., 215 ff., and 233 ff. (published subsequently as a book with the same title by the Calouste Gulbenkian Foundation Armenian Library, Lisbon, 1963); and N. Thierry in *Revue des études byzantines,* 26 (1968), pp. 339 ff; hereafter *REB.*
38
See H. Grégoire, "Notes épigraphiques, VII. Mélias le magistre," *Byzantion,* 8 (1933), pp. 79–88.
39
See S. Runciman, *A History of the Crusades,* 1 (Cambridge, 1951), pp. 175–194.
40
Actually Caesarea was found destroyed when the crusaders passed through Cappadocia. Modern Kayseri was built in the 12th century over the remains of the Roman-Christian city. (Kirsten, "Cappadocia," col. 869.)
41
For a scholarly account of these, see K. Erdmann *Das anatolische Karavansaray des 13. Jahrhunderts,* Istanbuler Forschungen, 21 (Berlin, 1961). Good plates of some in Holzmeister and Fahrner, *Bilder aus Anatolien: Höhlen und Hane in Kappadokien* (Vienna, 1955); hereafter Holzmeister/Fahrner.

42

This was deduced by Jerphanion from the fact that inscriptions in Karşī Kilise at Arabsun (Gülşehir), in the Church of the Forty Martyrs at Suveş, and in the octagon at Suvasa, all name Theodore Laskaris. *Orientalia Christiana Periodica,* 1 (1935), p. 247, hereafter *OCP*; and Jerphanion, *ERC,* 2:1, 5-6. For a criticism of this view see P. Charanis, "On the Asiatic Frontier of the Empire of Nicaea," *OCP,* 13 (1947), pp. 58-62; R. L. Wolff, "The Lascarids' Asiatic Frontiers Once More," *OCP,* 15 (1949), pp. 194-197, and most recently G. P. Schiemenz, "Zur politischen Zugehörigkeit des Gebiets um Sobesos und Zoropassos in den Jahren um 1220," *Jahrbuch der österreichischen byzantinischen Gesellschaft,* 14 (1965), pp. 206-238.

43

I follow the reading of Thierry, *NERC,* p. 202; as amended and clarified by V. Laurent in *REB,* 26 (1968), pp. 367-371. An alternative reading given by Lafontaine-Dosogne in *Byzantion,* 33 (1963), p. 149, where Basil is called *hypatos* of Georgia, is clearly mistaken. A similar inscription naming the same two rulers existed in the church of Panagia Spileotissa at Sille, a troglodytic village to the north of Konya. See N. A. Bees, *Texte und Forschungen zur byzantinisch-neugriechischen Philologie: Die Inschriftenaufzeichnung des Kodex sinaiticus graecus 508 (976) und die Maria-Spiläotissa-Kloster-Kirche bei Sille (Lykaonien),* 1 (Berlin, 1922), pp. 6-7; also Jerphanion in *OCP,* 1 (1935), p. 296.

44

W. J. Hamilton, *Researches in Asia Minor, Pontus, and Armenia,* 1 (London, 1842), p. 296.

45

D. G. Hogarth, *A Wandering Scholar in the Levant* (New York, 1896), p. 7.

46

Hamilton, *Researches,* 2, p. 381.

47

For this account of the missions see Henry O. Wight in Oberhummer/Zimmerer, pp. 450-464.

48

Born 1877 at Pontéves in the Var; died 1947 in Rome. For an appreciation of the man and his work, see *OCP,* 14 (1948), pp. 419-423; and *Byzantion,* 20 (1950), pp. 389-396. His bibliography was published earlier in *OCP,* 13 (1947), pp. 6-17.

2
The Buildings

1

Troglodytic monasteries and churches extend beyond Cappadocia, of course, throughout Asia Minor, but these are not the concern of this book. There are a great number of them in the Pontus, including the famous monastery of Sumela: see D. T. Rice, "Notes on Some Religious Buildings in the City and Vilâyet of Trebizond," *Byzantion,* 5 (1929), pp. 47-81; Rice and G. Millet, *Byzantine Painting at Trebizond* (London, 1936), pp. 121-137, 144-150; J. P. Fallmerayer, "Das Höhlenkloster Sumelas," in *Byzanz und das Abendland* (Vienna, 1943), pp. 189-225. For Lycia, see R. M. Harrison in *Anatolian Studies,* 12 (1963), pp. 117-151, especially 129, 136-137. A rockcut town at Sille, about eight miles north of Konya, includes a church with paintings: see S. Dell'Oca and M. Pavan in *Rassegna speleologica italiana,* 8:2 (1956), pp. 122-123. For rockcut hermitages and chapels in the region to the south of Miletus, Th. Wiegand's *Der Latmos: Milet,* 3:1 (Berlin, 1913), is still standard. Across the straits in Thrace, at least one region has been investigated: see F. Dirimtekin, "Les monastères et les églises rupestres dans la région İnceğiz," *Türk Arkeoloji Dergisi,* 7:2 (1957), pp. 26-37.

2

St. Gregory of Nazianzus, *Poemata moralia,* 17:1-2 (in Migne, *PG,* 37, col. 781).

3

Jerphanion, *ERC,* 1:1, pp. 51-52; 1:2, pp. 551-569; and pls. 10.3, 10.5, and 27.1. Also Restle, 1, pp. 142-143. For a good photograph of the interior, see *National Geographic Magazine,* 76 (December, 1939), p. 779. See also Jerphanion, "Les inscriptions cappadociennes et le texte de la *Vita Simeonis auctore Antonio,*" *Recherches de science religieuse,* 21 (1931), pp. 340-360.

4

Jerphanion, *ERC,* 1:2, pp. 570-580.

5

See the discussion by Schiemenz in *Jahrbuch der österreichische byzantinische Gesellschaft* 18 (1969), and notes, apropos the recently discovered Chapel of Niketas the Stylite (Cat. no. 7) in a rock that presents the same eremitical planning as the Zilve hermitage—a cell at the top and a chapel at ground level.

6

Gregory of Nazianzus in his funeral oration for St Basil; *Orations,* 43:62 (translation from *Fathers of the Church,* 22, p. 80).

7

Ramsay/Bell, pp. 468, 470.

8

Jerphanion, *ERC,* 1:1, pp. 48-49, 498-503.

9
Thierry, *NERC,* pp. 35–37.
10
This question is studied in detail by J. Mateos, "L'office monastique à la fin du IVe siècle: Antioche, Palestine, Cappadoce," *Oriens christianus,* 47 (1963), pp. 53-58.
11
St. Basil, *Letters,* 2 (Loeb ed., vol. 1, p. 9). Cf. D. Savramis, "'Ora et labora' bei Basilios dem Grossen," *Mittelateinisches Jahrbuch,* 2 (1965), pp. 22–37, esp. 30 ff.
12
For example, over an *arcosolium* in Eğri Taş Kilisesi (Cat. no. 29) there is the following inscription: "For the repose of the servant of God, Anne the nun." (ὑπέρ ἀναπαύσεως τῆς δούλης τοῦ θεοῦ Ἄννης μο[να]χ[ῆς].) See Lafontaine-Dosogne in *Byzantion,* 33 (1963), p. 168.
13
St. Basil, *Letters,* 14.
14
Gregory of Nazianzus, *Letters,* 4:5-9 (Gallay ed., Paris, 1964, pp. 4–5).
15
Thierry, *NERC,* p. 31 and pl. 15; Holzmeister/Fahrner, pls. 87–88. The monastery is also noted, and two of its halls briefly described, by Lafontaine-Dosogne in *Byzantion,* 33 (1963), pp. 174–175.
16
Jerphanion, *ERC,* 1:1, pp. 49–50.
17
A Survey of Persian Art, 7 (Oxford, reissue 1964-1965), pls. 128A and 149–152.
18
K. A. C. Creswell, *Early Muslim Architecture,* 2 (Oxford, 1940), fig. 44 and pls. 12a, 12b, and 12c.
19
Jerphanion, *ERC,* pl. 6.5 A clearer image is given by J. R. S. Sterrett in *The Century,* 60 (1900), p. 681.
20
Holzmeister/Fahrner, pl. 70; and *National Geographic Magazine,* 113 (January, 1958), pp. 126–127.
21
R. Kautzsch, *Kapitellstudien,* Studien zur spätantiken Kunstgeschichte 9 (Berlin-Leipzig, 1936), pls. 644a and 644b.

22

Among surviving cutstone churches, note the church of St. Constantine at Eski Andaval (Andabalis) near Kemerhisar (Tyana) (Rott, pp. 103 ff.); the church of the Panagia on the south slope of Mt. Erciyas (Rott, pp. 166 ff.). To the rockcut examples discussed in the text, one chapel in the group known as Belli Kilise (Cat. no. 24) and the inadequately published Kale Kilisesi at Selime (Cat. no. 11) should be added.

23

For example, Chapel of the Theotokos (Cat. no. 21).

24

There is a very late example (13th century) of the synthronon in Trebizond, but without the cathedra (*Anatolian Studies,* 10 [1960], pp. 162–163). One example in Cappadocia seems late, but need not be so. It is in the apse of the main nave of Karabaş Kilise at Soğanlı Dere, whose painted program is dated by inscription to 1060/61. But this is the last of several coats of decoration. The one immediately below was clearly Archaic (apocalyptic Christ in apse). Underneath this the decoration has not left many legible traces—it may well date from the Iconoclastic Phase or earlier. For the Archaic and Iconoclastic Phases, see above, pp. 84–94.

25

See N. Thierry in *Journal des Savants* (1965), pp. 627–630; and also in *Information d'histoire de l'art,* 14 (1969), pp. 10–11.

26

See F. E. Brightman, *Liturgies Eastern and Western* (Oxford, 1896), p. 323. The identification of each of the four words with the particular evangelist is made by St. Germanus, patriarch of Constantinople (Migne, *PG,* 98, col. 429).

27

See Jerphanion, *ERC,* 1:1, pp. 67 ff.

28

Restle, erroneously in my opinion, uses this observation as support for his attempt to discredit the Iconoclastic date of these churches (1, pp. 15–17).

29

A. Grabar, *Martyrium,* 2 (Paris, 1946), pp. 72 ff. The Cross of St. Euphemia is also painted in the Iconoclastic chapel at Kīzīl Çukur (Cat. no. 6). At Ayvalī Kilise (Cat. no. 16), below the present paintings of the vault in the south nave, there are traces of an Iconoclastic program showing a cross set in a coffered ceiling, similar to the ceiling painting of St. Stephen. Here too, as at St. Stephen, remnants of faces prove that the Iconoclastic program was not entirely nonrepresentational.

30

Jerphanion, *ERC,* 1:2, 583. There is, by the way, contemporary record of Iconoclast monks in Asia Minor. See F. Dvornik, *La vie de saint Grégoire le Décapolite* (Paris, 1926), and F. Dvornik, *Les légendes de Constantin et Méthode Vues de Byzance* (Prague, 1933), especially pp. 119–121 (as cited by R. Cormack in the *Journal of the British Archaeological Association,* 3:30 [1967], p. 27, n. 2).

31

Jerphanion, *ERC,* 1:2, pp. 492 and 486. Chapel 3 is doubtful. The east end is totally destroyed, but the width of its nave suggests that the church was of this type. The nave was covered by a flat ceiling, not a vault. Kuşluk near Kīlīçlar Kilisesi (Cat. no. 51) has a ground plan which would fit the type, but instead of a transverse barrel vault over the nave, it has two parallel barrel vaults, without supports—a good instance of the licentious nature of troglodytic architecture. Saklī Kilise (Cat. no. 53) should perhaps also be called a transverse church, though its form is very irregular.

32

Brief description by J. Lafontaine-Dosogne in *Cahiers,* 22 (1962), pp. 282–284.

33

Its case is not unique. Eğri Taş Kilisesi at Peristrema (Cat. no. 29) has a similar crypt, so do the churches of St. Eustathios (Cat. no. 27) at Göreme and the cruciform chapel at El Nazar (Cat. no. 25). This arrangement is probably to be distinguished from cases where two distinct churches are superimposed: Belli Kilise (Cat. no. 24), Karşī Kilise (Cat. no. 61).

34

The passageway is also present, in a simpler form, at Chapel 16, which seems to be a small-scale copy of Tokalī II (Jerphanion, *ERC,* 1:2, pp. 492–493 and plan on pl. 136).

35

For the following discussion, see U. Monneret de Villard, *Le chiese della Mesopotamia* (Rome, 1940); monastic churches in Mesopotamia were studied closely only in one region, the Tur Abdin, for which see G. M. L. Bell, *Churches and Monasteries of the Tur Abdin* (London, 1913).

36

For example, St. Eustathios (Cat. no. 27). That the prothesis chamber is an afterthought is proved by the fact that its excavation destroyed part of the original painting program on the east wall of the nave.

37

S. Guyer in *Repertorium für Kunstwissenschaft,* 35 (1912), pp. 483–508. Direct contact between Cappadocia and Mesopotamia is not demonstrable. The only scrap of evidence we possess is

late—and in any case rather dubious. It is an illustrated manuscript (Paris, Bibl. Nat. Coislin 263) which consists of the text of St. John Climacus' *Ladder of Divine Ascent* and the testament of one Eustathios Boilas, a Byzantine official with the rank of *protospatharios*. A note records the date as 1059 and the name of the scribe, "Theodoulos, monk and presbyter of the monastery of the Virgin of Salem," who prepared the manuscript on the orders of Eustathios. Both men, the note says, are Cappadocians. A third person named, a John Douketzes, is said to be ruling over Edessa in Mesopotamia. On the basis of this statement R. Devreesse has suggested that the manuscript may have been written in Mesopotamia after a Cappadocian model (*Catalogue des manuscrits grecs de la Bibliothèque Nationale, II, Les fonds Coislin* [Paris, 1945], p. 77). See also J. R. Martin, *The Illustration of the Heavenly Ladder by John Climacus* (Princeton, 1954), pp. 172–174 and pls. 78–80.

38

For cruciform martyria in general, see A. Grabar, *Martyrium*, 1, pp. 152 ff.; for the cruciform chapels of Binbirkilise, Ramsay/Bell, pp. 340 ff.; for southern and central Anatolia, Rott, passim.

39

St. Gregory of Nyssa, *Letter 16, Nicene and Post Nicene Fathers,* 5, ser. 2 (New York, 1893), p. 540.

40

St. Gregory of Nazianzus, *Poemata de seipso,* 16:49–50 (in Migne, *PG,* 37, col. 1258).

41

St. Basil, *Regulae fusius tractatae,* 1 (translation in Morison, *St. Basil and His Rule,* p. 138). Actually the representation of the Last Judgment is rare in Cappadocia. For its use in what we will call the Ihlara cycle, see p. 195. There are two major examples in Father Jerphanion's territory: at Canavar Kilise (Cat. no. 66) and a much condensed version at Karşĭ Kilise (Cat. no. 61), both of which are quite late, and their style has little in common with the Last Judgment at Yĭlanlĭ Kilise.

42

Jerphanion, *ERC,* 1.2, pp. 480–481.

43

Of those still standing let us note (a) *Kemer Kilise at Viranşehir* in the valley of Peristrema, 5th or 6th century, with its north arm longer than the other three (W. J. Hamilton, *Researches in Asia Minor, Pontus, and Armenia,* 2, p. 228; Rott, pp. 266–268; Ramsay/Bell, p. 363; Thierry, *NERC,* p. 23 and pl. 4); (b) *The monastic church at Büslük Fesek* (Pesek) near Tomarza, probably about 600 (Rott, pp. 188–190); and (c) *Kĭzĭl Kilise at Sivrihisar,* to the east of the valley of Peristrema, well preserved, with a funerary chapel attached to the north side of the west arm (Rott,

pp. 276-283; Thierry, *NERC*, pp. 25-26 and pls. 6-7). The date of this church is certainly not as early as has been held (Charles Diehl's fifth-century date is recorded without comment by the Thierrys). R. Krautheimer is surely right in putting it "possibly as late as the ninth century" (*Early Christian and Byzantine Architecture,* Pelican History of Art series [Harmondsworth, 1965], pp. 123-124). If anything I am inclined to go beyond and settle for a date about 900. The vaulting scheme of the central bay with its tall polygonal drum is close to the rockcut church of Ağaç Altĭ Kilisesi nearby (see text).

44

See Thierry, *NERC,* figs. 15-16 and pl. 41.

45

S. K. Yetkin, *L'architecture turque en Turquie* (Paris, 1962), pp. 9-10.

46

Rott, pp. 149-151; Jerphanion, *ERC,* 2:1, pp. 240-245. Rott's plan is inaccurate; it should be corrected in accordance with the remarks in *ERC,* 2:1, p. 240, n. 2.

47

Ramsay/Bell, pp. 70-71.

48

Life of St. Theodore, Chapter 55; English translation in E. Dawes and N. H. Baynes, *Three Byzantine Saints* (Oxford, 1948), p. 127.

49

Paulinus, *Epistula* 32:16. English translation in R. C. Goldschmidt, *Paulinus' Churches at Nola* (Amsterdam, 1940), p. 45.

50

R. M. Harrison in *Anatolian Studies,* 13 (1963), pp. 130-131, 136-137, 148-149.

51

See Monneret de Villard, *Le chiese della Mesopotamia,* pp. 58-59 and fig. 61. On the subject of the triconch in general, see idem, *Les couvents près de Sohâg* (Milan, 1925-1926), pp. 47-60; Grabar, *Martyrium,* 1, pp. 102 ff. I exclude Armenian trefoil churches from the discussion (Talin, Dvin, etc.) since the three conches never meet in these, and their schemes are really cross-domed basilicas with three apses added to the sanctuary end and to the middles of the north and south aisles. I also exclude the triconch scheme used in other than church architecture. It was a common form for palatine halls, and as such it is to be encountered in early Muslim architecture as well.

52

St. Basil, *Letter* 349, perhaps spurious.

53

St. Theodore of Sykeon described by his biographer (Dawes and Baynes, *Three Byzantine Saints*, p. 95).

54

The standard work on Middle Byzantine decorative schemes is still O. Demus, *Byzantine Mosaic Decoration* (London, 1948, reissued 1953, 1964).

55

On these intricate issues, the reader is referred to the recent masterly summation by Krautheimer, *Early Christian and Byzantine Architecture*, pp. 240–257.

56

In addition to Cat. nos. 35–37, 41, 42, 44, 49, 55–59, for which bibliography is given in their catalogue entries, these include the following: (a) church at Karlīk, a little north of Tağar, which duplicates the architecture of Kīlīçlar Kilisesi (Cat. no. 37)—Jerphanion, *ERC*, 2:1, p. 183; (b) the church at the ravine formerly called Panagia near Sinassos, where the central dome has been left out (!) and the four arms of the cross are flat-roofed—*ERC*, 2:1, pp. 112–113; (c) Chapel 17 at Göreme, located in the monastery of Kīzlar Kalesi with a central dome and eight clumsily cut cupolas over the peripheral bays—*ERC*, 1:2, pp. 488–491; (d) Chapel 25 at Göreme, in the same rock as Karanlīk Kilise (Cat. no. 59), a perfect example of the type and well preserved—*ERC*, 1:2, p. 479; (e) the church of the monastery at Bezirhane (see p. 126 and fig. 20); (f) Church A at Soğanlī Dere (see p. 137 and fig. 24)—Rott, pp. 124–26 and *ERC*, 2:1, p. 379; (g) and a chapel in a cone next to that housing Sarīca Kilise (Cat. no. 36), with a plan like the latter's but without lateral apses and with flattened cupolas instead of groin vaults over the corner bays—*Cahiers*, 12 (1962), pp. 282–284.

57

Compare this arrangement with Cambazlī Kilise (Cat. no. 44), where the corner bays are missing on the east side as well as the arm of the cross, and the dome rests on two west columns and extensions of the central apse which serve as engaged piers. This variation of the cross-in-square is found in Crete and Macedonia, as well as in Georgia and Armenia; but we do not have to look that far in either direction. There is a good parallel in nearby Konya, in the masonry church of St. Amphilochios (Ramsay/Bell, p. 405).

58

I note the following: the mostly subterranean church at Mavrucan, used as a mosque at least since Jerphanion's day (*ERC*, pl. 24.2; also Rott, pp. 151–153); Karagedik Kilise in the valley of Peristrema (Rott, pp. 274–276; Ramsay/Bell, pp. 418–421, where it is erroneously called "Ilanliklisse"; and Thierry, *NERC*, p. 34 and pl. 18); Çanlī Kilise on Hasan Dağī (Krautheimer,

Early Christian and Byzantine Architecture, p. 282 and the bibliography cited in his note 60); nos. 35 and 39 at Değile which have no apses (Ramsay/Bell, pp. 183–184, 199–200); the church on Çet Dağ (ibid., p. 272); Ala Kilise at Ali Summasï Dağ (ibid., pp. 399–400); St. Amphilochios already mentioned in the preceding note; and two churches outside of Konya, at Sille and Miran (Ramsay/Bell, pp. 403–404).
59
There are exceptions to the convention: Köy Ensesi Kilisesi (Cat. no. 35) has only one apse; so also does the cross-in-square chapel adjacent to Sarïca Kilise, already referred to in note 56(g). The variation is not unknown among masonry churches; see, for example, the church at Side, in Pamphylia, recently published by S. Eyice in *Anatolia,* 3 (1958), pp. 35–42.
60
For very early examples of this corrupt imagery, see the apse decoration of Eski Gümüş (Cat. no. 49) and the apse of an inadequately published church at Ayvalï Köy (Cat. no. 48) that is not to be confused with Ayvalï Kilise (Cat. no. 16).

3
The Paintings

Note that at Tokalĭ II the invocation of the architect that accompanies the folk decoration is in the same green paint as the designs.
2
D. Wood in *Archaeology,* 12 (1959), pp. 38 ff.
3
See A. Grabar, *L'iconoclasme byzantin* (Paris, 1957), chapter 4, pp. 93 ff.
4
Jerphanion, *ERC,* 2:1, p. 116.
5
Jerphanion, *ERC,* 2:1, pp. 243–244.
6
Perhaps we have still another member of the family in the Eustathios Skepides, strategos of Lucania, whose signature is affixed to a document dated 6551 (i.e., A.D. 1042), recently published by A. Guillou. See *Byzantion,* 35 (1965), pp. 119–49.
7
M. Gough in *Anatolian Studies,* 15 (1965), p. 164.
8
On the iconography of saints in Cappadocia, several articles by Jerphanion are still serviceable. Note especially "L'attribut des diacres dans l'art chrétien du Moyen Âge en Orient," in the *Mélanges Lambros* (Athens, 1953); "Les caractéristiques et les attributs des saints dans la peinture cappadocienne," in *Analecta Bollandiana,* 15 (1937)—both reprinted in *Voix des Monuments,* new series (Rome/Paris, 1938), pp. 283–322.
9
Other representations of this St. George portrait type are found in Chapels 15, 21, and 28 (Cat. no. 52) at Göreme; St. Barbara at Soğanlĭ Dere (Cat. no. 40); Canavar Kilise (Cat. no. 66); Yĭlanlĭ Kilise (Cat. no. 31). In many other churches he is represented standing, with a lance in one hand on which he leans and a shield in the other (Cat. nos. 41, 59, 64, etc.). The St. George bibliography is considerable. See generally C. S. Hübst, *St. George of Cappadocia* (London, 1909); H. Delehaye, *Les légendes grecques des saints militaires* (Paris, 1909); W. F. Volbach, *Der heilige Georg* (Strassburg, 1917); and J. Myslevic in *Byzantinoslavica,* 5 (1933–1934), pp. 304–375.
10
Other such narrative portraits include St. Theopiste and her two sons and the brass statue of an ox (Tokalĭ II); St. Orestios dragged about by a horse (Ballĭk Kilise); and St. Mary the Egyptian receiving communion from St. Zosimos (Kĭlĭçlar, Tokalĭ II).

11

A paraphrase of the *Acts of St. Eustathios,* Migne, *PG,* 105, col. 381.

12

See J. Lafontaine-Dosogne, "Un thème iconographique peu connu: Marina assommant Belzé-buth," *Byzantion,* 32 (1962), 251–259.

13

Ladder of Divine Ascent, 1:4 (trans. by L. Moore, London, 1959, p. 50).

14

Migne, *PG,* 31, col. 489; and *PG,* 46, col. 737.

15

Thierry, *NERC,* p. 35.

16

There are several later examples of saintly cycles outside Cappadocia. For these, see A. Grabar, *Martyrium,* 2 (Paris, 1946), p. 318, n. 2.

17

The following discussion is based on Jerphanion, "Histoires de Saint Basile dans les peintures romaines du Moyen Âge," *Byzantion,* 6 (1931), pp. 535–557 (reprinted in *Voix des monuments,* new series, [Rome/Paris, 1938], 153–173).

18

Ibid., p. 545. For the Roman frescoes see now J. Lafontaine, *Peintures médiévales du temple dit de la Fortune Virile à Rome* (Brussels, 1959).

19

Rare pictorial sequences of the martyrdoms of major apostles, specifically Sts. Peter, Paul, Andrew, and James, belong here and not with the saintly cycles discussed above. The iconography is based on the *Acts of the Apostles,* and on the Apocryphal Acts which though not included in the Bible had great prestige and were considered almost official scripture. Fragments of these apostolic sequences are found in a chapel at Balkam Deresi (Jerphanion, *ERC,* 2.1, pp. 54–55) and at Belli Kilise (Cat. no. 24).

20

The text used is M. R. James, *Apocryphal New Testament* (Oxford, 1953), pp. 38 ff.

21

See chiefly Jerphanion in *Voix des monuments,* new series, pp. 38–94; J. Carcopino, *Études d'histoire chrétienne* (1953), pp. 11–91; and Ch. Picard in *Revue archéologique* (1965), pp. 101–102.

22

It is true that until the ninth century the standard place for the Ascension in surviving Christian churches was the apse. Hagia Sophia in Thessaloniki is sometimes cited in recent literature as the earliest surviving example (later 9th century) of an Ascension placed in the dome of the church; and this new position is associated with the first post-Iconoclastic efforts in the restitution of religious imagery. If this were exactly the case, Cappadocia might be said to be responding at this point to the revised status of the Ascension in the circle of Constantinople, without as yet showing any desire to import new architectural types from the same source. And yet there is circumstantial evidence that the Ascension as the subject for a dome had a much earlier history. The domed church erected over the presumed spot of Christ's Ascension on the Mount of Olives may well have been first. In the Ascension miniature of the Rabula Gospels (586), which clearly derives from a monumental prototype, the crown of a dome is actually represented. Among the standard church types in Cappadocia, the cruciform church that afforded a dome often received an Ascension there. The cruciform chapel at Mavrucan (Cat. no. 2) is one instance, and it almost certainly predates the dome mosaic of Hagia Sophia at Thessaloniki. Another instance is the cruciform chapel at El Nazar (Cat. no. 25).

23

Recherches sur l'iconographie de l'Évangile aux XIVe, XVe et XVIe siècles d'après les monuments de Mistra, de la Macédoine et de l'Athos, Bibliothèque des Écoles Françaises d'Athènes et de Rome, 109 (Paris, 1916); reissued in 1960.

24

See pictures in A. Grabar, *Les ampoules de Terre Sainte* (Paris, 1958).

25

For these early icons, see G. and M. Sotiriou, *Icons du Mont Sinaï,* 2 vols. (Athens, 1956–1958); K. Weitzmann, M. Chatzidakis, et al, *Frühe Ikonen* (Vienna, 1965); Weitzmann in *Tortulae: Studien zu altchristlichen und byzantinischen Monumenten* (Freiburg i. B., 1966), pp. 317–325; and M. Chatzidakis in *Art Bulletin* 49 (1967), pp. 197–208.

26

Iconographie de l'Évangile, 130–132.

27

Actually he does cite a Palestinian copy for the Flight of Elizabeth—this is on a terra cotta medallion at Bobbio (see Jerphanion, "La véritable interprétation d'une plaque aujourd'hui perdue de la chaise d'ivoire de Ravenne," *Rendiconti della Pontificia Accademia Romana di Archeologia,* 14 [1938], pp. 29–46, esp. 35–37; better illustration of the medallion in Grabar, *Ampoules*

de Terre Sainte, pl. 54) But this representation is not comparable to the Flight of Elizabeth in the Archaic cycle, and could not have served as the model.

28
Jerphanion, *ERC,* 2:2, p. 440.

29
On this subject, see A. Grabar "The Virgin in a Mandorla of Light," in *Late Classic and Medieval Studies in Honor of Albert Matthias Friend, Jr.* (Princeton, 1955), pp. 305–311.

30
J. Lafontaine-Dosogne, *Iconographie de l'enfance de la Vierge dans l'empire byzantin et en Occident,* 2 vols., Mémoires de l'Academie Royale de Belgique, Classe des Beaux-Arts, 2 (Brussels, 1964).

31
Mavrucan, and the Chapel of the Theotokos (Cat. nos. 2 and 21). Actually, the type has since proved much more common. The Crucifixions of the chapel of Niketas, Açıkel Ağa, Çömlekçi, Kokar, and Pürenli Seki (Cat. nos. 7, 9, 10, 32, and 33) all follow it.

32
Bibliography previous to the publication of the icons is therefore outdated. See now H. Belting and Ch. Belting-Ihm, "Das Kreuzbild im 'Hodegos' des Anastasios Sinaites," *Tortulae,* pp. 30–39.

33
Jerphanion, *ERC,* 2:2, p. 446; "Les continuateurs fidèles, mais non serviles, des iconographes syriens et palestiniens du sixième [siècle]."

34
See Christa Ihm, *Die Programme der christlichen Apsismalerei vom vierten Jahrhundert bis zur Mitte des achten Jahrhunderts* (Wiesbaden, 1960), especially Chapter 3, "Die liturgische Maiestas," pp. 42–51.

35
Cf. Theodore Stoudites VI, Migne, *PG,* 99, cols. 740–741; as quoted and interpreted by Lafontaine-Dosogne in *Synthronon* (Paris, 1968), pp. 136 and 143.

36
Dorothy Wood, *Leo VI's Concept of Divine Monarchy* (London, 1964), p. 34.

37
The only existing instances in Cappadocia are in Açıkel Ağa Kilisesi (Cat. no. 9), which may be pre-Iconoclastic, and in Bahattin Samanlığı at Peristrema (Cat. no. 18), a painting program in the main close to the Archaic cycle, but with novelties from a different source. For the early

history of the Chairete in Christian art, see K. Weitzmann, "Eine vorikonoklastische Ikone des Sinai mit der Darstellung des Chairete," *Tortulae*, pp. 317–325.

38

Ladder of Divine Ascent, 1:8 (trans. Moore, p. 51).

39

Ibid., 33:36 (Moore, p. 266).

40

Wood, *Leo VI's Concept of Divine Monarchy*, p. 39.

41

Ladder of Divine Ascent, 6:2 (trans., Moore, p. 110).

42

Ibid., 6:10 (ibid., p. 111).

43

The Greek *Assumption of the Virgin* 46 (James, *Apocryphal New Testament*, p. 208).

44

For illustrations, see F. Macler, *Miniatures arméniennes* (Paris, 1913), pls. 1–8.

45

Thierry in *REB,* 26 (1968), pp. 344–349.

46

For this gradual development of the Middle Byzantine cycle, see chiefly O. Demus, *Byzantine Mosaic Decoration* (London, 1948), esp. pp. 50 ff.; S. Der Nersessian, "Le décor des églises du IXe siècle," *Actes du VIe congrès international d'études byzantines* (Paris, 1948), pp. 315 ff.; and K. Weitzmann, "The Narrative and Liturgical Gospel Illustrations," *New Testament Manuscript Studies* (ed. M. M. Parvis and A. P. Wikgren) (Chicago, 1950), pp. 151 ff.

47

For specific references, see Bibliography, "Problems of Date and Style." Weigand's method was based for the most part on "comparative iconography." Selecting a small number of iconographic details, he subjected these to an exhaustive study with the purpose of establishing the earliest date when each became current and, concomitantly, its geographical provenance. Then the results would be used as criteria for dating and placing Cappadocian painting programs. For the discussion of Tokalĭ II, details included the ring on St. Peter's finger in the Ordination of the First Deacons; the crying angels over the crucified Christ; the spoon with which St. Zosimus is shown administering communion to St. Mary the Egyptian; names, ages, and details of dress of the three magi in the Adoration scene. Weigand's conclusion was that the Archaic cycle was really archaizing ("archaistisch"), including the letter forms in its inscriptions, which

ordinarily are a fairly useful index of date in Cappadocia; that it was heavily influenced by the West; and that it dated in the fourteenth century. The trouble with comparative iconography **is that somebody else usually finds an earlier use of a detail than one's own earliest, and in** another region than the one that one has established. The references for this scholarly controversy are given in the Bibliographical Note.

48

Journal of the British Archaeological Association 3:30 (1967), p. 33. Earlier A. Grabar had explained the peculiar position of the Crucifixion scene at Tokalï by recalling that the apse was sometimes interpreted by Christian writers, for example Pseudo-Cyril of Jerusalem and Pseudo-Sophronios, as the image of the cave of the Nativity and Death of Christ. See *Martyrium* (Paris 1946), 2, p. 273, n. 1.

49

See S. J. Amiranachvili, *Histoire de la peinture monumentale Géorgienne* (Tiflis, 1957), pls. 90, 96; this resemblance was first noted by N. Thierry in *REB,* 26 (1968), p. 363.

50

See C. R. Morey, "Notes on East Christian Miniatures," *Art Bulletin,* 11 (1929), pp. 53 ff., esp. 91; Millet, *Iconographie de l'Évangile,* passim; K. Weitzmann, *Die byzantinische Buchmalerei des 9. und 10. Jahrhunderts* (Berlin, 1935), pp. 59 ff. Morey's eighth-century date is generally no longer accepted.

51

This Macedonian Renaissance has most exhaustively been studied, for over thirty years, by K. Weitzmann. See the most recent summary of his long research, *Geistige Grundlagen und Wesen der makedonischen Renaissance,* Arbeitsgemeinschaft für Forschung des Landes Nordrhein-Westfalen 107 (Cologne and Opladen, 1963).

52

Weitzmann, *Byzantinische Buchmalerei,* pp. 28 ff. and pl. 385 figs. 211–212; cf. Jerphanion, *ERC,* pls. 74.1, 78, 94, etc.

53

W. Koehler, "Byzantine Art in the West," in *Dumbarton Oaks Papers,* 1 (1940), pp. 61–87.

54

Ibid., 20 (1966), pp. 29 ff.

55

A general twelfth-century date for this Göreme school is advocated by J. Lafontaine-Dosogne, R. Cormack, and also by Restle, who favors the later decades of the century. It is unwarranted to insist, as N. Thierry does (*REB,* 26 (1968), pp. 338–339), that no painting program in Cappa-

docia can be dated to this century or the last quarter of the eleventh because of the Seljuk take-over. The lack of inscriptions securely pertaining to this period is taken by her as proof of a painting hiatus, until a presumed renaissance in the thirteenth century under the aegis of the Sultanate of Roum. Dated inscriptions are rare at all times, and a matter of accident; their absence alone at one time or another means little if anything.
56
J. Leroy, *Les manuscrits syriaques à peintures* (Paris, 1964), pp. 268 ff. and pls. 67–69.

Catalogue

The following is a chronological list of most of the known rockcut churches of Cappadocia. I leave out churches without figural decoration (e.g., Karabaca Kilisesi, Peristrema), and churches where modern repainting has masked the original work beyond recognition (St. John the Baptist, Çavuşin). These monuments are, however, discussed in the text if their architectural form warrants it.

The five phases into which the catalogue is divided are only rough working categories. Within each phase the churches are listed chronologically. In many cases the dates assigned to monuments in this book are at variance with previous scholarship. Our reasoning for these decisions will be found in the text.

The bibliography for each church is not exhaustive, but it includes the most important references, however short they might be. Roman numerals in brackets refer to the numbering of the churches in the catalogue of Restle's *Byzantine Wall Painting in Asia Minor* (3 vols., New York, 1967, translated by Irene R. Gibbons). The order of this major new catalogue is topographical and not chronological.

I
Early Christian and
Iconoclastic Phase
(about 550–850)

1

Chapel 1, Balkam Dere, near Ortahisar.
Thierry in *Synthronon* (Paris 1968), pp. 53–59.
Plan: cruciform; only south arm and part of central cupola survive. Early Christian program, in part figural.

2

Cruciform Church, Mavrucan (now Güzelöz).
Jerphanion, *ERC,* 2:1, pp. 206–234, and pls. 173–176. Oldest figural program of two is perhaps Early Christian; the more recent is almost entirely destroyed.

3

St. Basil (Hagios Vasilios), Elevra.
Grégoire, pp. 91–92; Jerphanion, *ERC,* 2:1, pp. 105–111, and pls. 154–155.
Other names: Timios Stavros (Grégoire).
Plan: two parallel naves. Iconoclastic program.

4

St. Stephen (Hagios Stephanos), monastery of the Archangelos, near Cemil. [XLIII]
Jerphanion, *ERC,* 2:1, pp. 146–155, and pls. 155, 158; Lafontaine-Dosogne in *Byzantion,* 33 (1963), p. 137; Restle, 1, pp. 16–17, and pls. 409–413.
Plan: one-aisled basilica. Iconoclastic program, superimposed on earlier iconic paintings.

5 [XXXIV]
Haçlï Kilise ("Church of the Cross"), in the valley of Kïzïl Çukur, between Göreme and Çavuşin.
Thierry in *Journal des Savants* (1964), pp. 241–254; Restle, 1, p. 145.
Plan: one-aisled basilica. Discovered in 1963. Building and original sculpted program, Iconoclastic; painting program of apse, Archaic.

6 [XXXIII]
Chapel, valley of Kïzïl Çukur.
Thierry in *Monument Piot,* 50 (1958), pp. 105–146. Discovered in 1954. One of two parallel chapels (south) is Iconoclastic; for north chapel see Cat. no. 13.

7

Chapel of Niketas the Stylite, Ortahisar.
Budde, pl. 34; Schiemenz in *Zeitschrift für Kunstgeschichte* (1965), pp. 258–261, in *OCP,* 34 (1968), 70–96, and in *Jahrbuch der österreichische byzantinische Gesellschaft,* 18 (1969), pp. 239–258.
Plan: one-aisled basilica; the northern of two parallel naves. Name derives from an invocatory inscription.

8

Church of Three Crosses, in the valley of Güllü Dere, between Göreme and Çavuşin. [XXVIII]
Jerphanion, *ERC*, 1:2, pp. 592–594, and pl. 136; J. Lafontaine-Dosogne in *Byzantion*, 35 (1965),
pp. 175–207; N. Thierry in *REB*, 26 (1968), pp. 357–358; Restle, 1, pp. 79–80, 139–140, and pls.
333–339.
Other names: Gulli Dere, chapel 3 (Jerphanion); Güllü Dere No. 3 (Restle).
Plan: one-aisled basilica. Building and original sculpted program, Iconoclastic; painting pro-
gram, Archaic. Dedicated to St. Agathangelos?

9

Açikel Ağa Kilisesi ("Church of the Ağa with the Open Hand"), Peristrema.
Lafontaine-Dosogne in *Byzantion*, 33 (1963), pp. 143–144; N. Thierry in *Cahiers*, 18 (1968), pp.
33–69.
Other names: Batkïn Kilise.
Plan: one-aisled basilica.

II
Archaic Phase
(about 850–950)
[See also Cat. nos. 5, 8]

10

Çömlekçi Kilisesi ("The Potter's Church"), Gelveri.
Lafontaine-Dosogne in *Byzantion,* 33 (1963), pp. 179–180 and fig. 41.
Plan: one-aisled basilica, with later chapel to the north.

11

Kale Kilisesi ("Church of the Castle"), Selime, Peristrema.
Rott, pp. 263–265; Thierry, *NERC,* p. 31, and pl. 15. Lafontaine-Dosogne in *Byzantion,* 33 (1963), pp. 174–176 and fig. 40.
Earlier spelling: Kaleklisse.
Plan: three-aisled basilica. The building is earlier (7th century?); painting program very faint.

12

St. Theodore, Susum Bayrĭ near Ürgüp. [XXXVI]
Rott, pp. 204–208; Jerphanion, *ERC,* 2:1, pp. 17–47, and pls. 147–148; Budde, pp. 11–13 and pls. 37–41, 44, and 45 in color; Swoboda, p. 123; Restle, 1, pp. 17–18, 148–149, and pls. 374–387.
Other names: Pancarlĭ Kilise ("Church of the Beet").
Plan: one-aisled basilica. Dedication given in facade inscription.

13 [XXXIII]

Chapel of Joachim and Anna, in the valley of Kĭzĭl Çukur, between Göreme and Çavuşin.
Thierry in *Monument Piot,* 50 (1958), pp. 105–146; Thierry in the *Acts of the 11th International Conference of Byzantinists* (1958), pp. 620–623; Lafontaine-Dosogne, *Iconographie de l'enfance de la Vierge dans l'empire byzantin et en Occident,* 1 (Brussels 1964), figs. 13–17; Restle, 1, pp. 25–26, 144–145, and pls. 344–354. Discovered in 1954. North one of two parallel chapels, of which the other is Iconoclastic (see Cat. no. 6).

14

Tokalĭ Kilise, I ("Boss Church"), Göreme [X]
Rott, pp. 224–228; Grégoire, pp. 81–84; Jerphanion, *ERC,* 2:1, pp. 262–294, and pls. 33, 36, 42, 63–69; Séféris, pp. 22–24 and 41–45, and pls. 33–39; Holzmeister-Farhner, pls. 42–45; Budde, pp. 13–14 and pls. 48–50; Swoboda, pp. 45–46 and 124; D. Wood, *Leo VI's Concept of Divine Monarchy Illustrated in a Cave Chapel,* Monarchist Press Association Historical Series 1 (London, 1964); Restle, 1, pp. 23–27, 111–116, and pls. 61–97.
Earlier spellings: Toqale Kilissé; Doghaliklisse; Tokale.
Other names: The "Court Chapel" (Wood); Göreme, Chapel 7 (Restle). The earlier of two churches: see Cat. no. 39. Name derives from circular bosses in relief on the vault of the later church.

15

Unnamed Church near Tokalï, Göreme. [IX]

Schiemenz in *BZ,* 59 (1966), pp. 307–333; Restle, 1, pp. 110–111, and pls. 57–60. Discovered in 1959. Plan type in doubt because of destroyed sections, but probably cruciform.

16

[XXIX]

Ayvalï Kilise ("Quince Church"), in the valley of Güllü Dere between Göreme and Çavuşin. Jerphanion, *ERC,* 1:2, p. 594; Thierry in *Cahiers,* 15 (1965), pp. 97–154; Restle, 1, pp. 79–80, 140–141, and pls. 340–341.

Other names: Gulli Dere, chapel 4 (Jerphanion); Güllü Dere No. 4 (Restle).

Plan: two parallel naves. Dedicated, according to an inscription, to "St. John." Paintings dated by inscription to ca. 913–920 in the reign of Constantine Porphyrogenitos; below these, traces of an earlier figural program.

17

Holy Apostles, near Sinassos (Mustafapaşa). [XL]

Rott, p. 240; Grégoire, pp. 90–91; Jerphanion, *ERC,* 2:1, pp. 59–77 and 149–151; Thierry in *Cahiers,* 15 (1965), fig. 8 on p. 109; Restle, 1, pp. 25–26, 153–154, and pls. 403–404.

Other names: previously known to local Greeks also as Church of the Pentecost; Rott mistakenly calls it St. Theodore.

Plan: two parallel naves.

18

Bahattin Samanlïğï Kilisesi ("Church of Bahattin's Hayloft"), Peristrema. [LXI]

Lafontaine-Dosogne in *Byzantion,* 28 (1958), p. 475, and 33 (1963), pp. 147–149; Thierry in *REB,* 19 (1961), 427–428; Thierry, *NERC,* pp. 155–173 and pls. 71–77; Restle, 1, pp. 41–42, 177–178, and pls. 517–520.

Plan: one-aisled basilica.

19

Chapel 6, Göreme. [VIII]

Jerphanion in *Revue de l'art chrétien,* 64 (1914), pp. 153–157; Jerphanion, *ERC,* 1:1, pp. 95–112, and pls. 28–33; Restle, 1, pp. 27–28, 109–110, and pls. 53–56.

Plan: transverse basilica. Almost completely destroyed in recent years.

20

Chapel 8, Göreme. [XI]

Rott, pp. 232–233; Jerphanion, *ERC,* 1:1, pp. 113–120, and pls. 28, 35, 36; Restle, 1, p. 117.

Plan: one-aisled basilica. Destroyed before 1927.

21

Chapel of the Theotokos, Göreme. [IX]

Rott, pp. 229–230; Grégoire, p. 85; Jerphanion, *ERC,* 1:1, pp. 121–137, and pls. 34, 35, 37; M. Beck, *Anatolien* (Zurich-Stuttgart, 1956), fig. 10; Budde, pl. 46; Restle, 1, pp. 117–119, and pls. 124–133; W. F. Volbach and J. Lafontaine-Dosogne, *Byzanz und der chrisliche Osten,* Propyläen Kunstgeschichte 3 (Berlin, 1968), p. 175, and color pl. VIII.

Other names: Göreme, chapel 9 (Jerphanion, Restle).

Plan: single nave with three apses. Dedication to the Theotokos, St. John the Baptist, and St. George is given in an inscription.

22

Chapel 15a, Göreme. [LXXVI]

Jerphanion, *ERC,* 1:1, pp. 145–146; N. Thierry in *Journal des Savants* (1965), 625–627; Restle, 1, p. 192; G. P. Schiemenz in *OCP,* 34, fasc. 1 (1968), pp. 70–96.

Plan: one-aisled basilica.

23

St. Simeon, Zilve. [XXXI]

Jerphanion, *ERC,* 1:2, pp. 552–569, and pls. 10, 27, 143; Restle, 1, pp. 142–143.

Plan: one-aisled basilica.

24

Belli Kilise ("The Obvious Church"), Soğanlï Dere. [XLVII]

Rott, pp. 139–144; Grégoire, 108–109; Jerphanion, *ERC,* 2:1, pp. 273–306, and pls. 15, 24, 181–184; Séféris, p. 33; Restle, 1, pp. 161–162, and pls. 444–454.

Earlier spelling: Beliklisse. Name applies to a group of chapels in three rock cones. Chapel I has an elaborate Archaic cycle. It is known also as Kubbeli Kilise ("Domed Church") and Halkalï Kilise ("Ringed Church").

25

Chapel at El Nazar, between Maçan (now Avcïlar) and Göreme. [I]

Jerphanion, *ERC,* 1:1, pp. 177–198, and pls. 28, 39–42; Swoboda, p. 124; Restle, 1, pp. 28–29, 101–103, and pls. 1–20.

Plan: cruciform.

26 [XXXIX]

Tavşanlï Kilise ("Church with the Rabbits") between Ortahisar and Sinassos (now Mustafapaşa).

Jerphanion, *ERC,* 2:1, pp. 78–99 and pls. 152–153; Lafontaine-Dosogne in *Byzantion,* 33 (1963), 131 and figs. 9–10; Restle, 1, pp. 152–153, and pls. 388–402.

Earlier spelling: Tavchanle Kilissé.

Plan: one-aisled basilica. Probably dedicated to St. Eustathios (Eustace). Name may derive from two goats flanking a bush (between the scenes of Nativity and Flight into Egypt) whose earlike horns give them the appearance of rabbits. Painting program dated by inscription to the reign of Constantine Porphyrogenitos, i.e., Constantine VII (912–959). The possibility, advanced by Restle, that the reference might be to Constantine VIII (1025–1028) is remote.

27

St. Eustathios (Eustace), Göreme. [XIII]

Rott, 230–232; Jerphanion, *ERC*, 1:1, pp. 147–170, and pls. 9, 28, 36–38; Lafontaine-Dosogne in *Byzantion*, 33 (1963), pp. 127–128 and fig. 5; Restle, 1, pp. 67–69, 119–120, and pls. 134–154.

Plan: two parallel naves. Paintings in prothesis niche to the left of the main apse, for which a dated graffito of 1148–1149 provides a terminus ante quem, are more recent than paintings of the nave. The dedication is conjectural.

28

Ballïk Kilise ("Honeyed Church"), Soğanlï Dere.

Rott, pp. 129–132; Grégoire, 109–111; Jerphanion, *ERC*, 2:1, pp. 249–270, and pls. 160, 176, 177–179; Séféris, pp. 30–32.

Earlier spellings: Balleq Kilissé; Balyqklisse.

Plan: two parallel naves. Two successive coats of painting: one aniconic, the other Archaic, have been destroyed in recent years. A date on a graffito provided a terminus ante quem of 1051.

29

Eğri Taş Kilisesi ("Church of the Crooked Rock"), Ihlara, Peristrema. [LIII]

Thierry *NERC*, pp. 39–72, and pls. 24, 26–37; Lafontaine-Dosogne in *Byzantion*, 33 (1963), pp. 167–170 and figs. 38–39; Restle, 1, pp. 69–70, 169–171; N. Thierry in *REB*, 26 (1968), p. 351.

Plan: one-aisled basilica. Name derives from oblique rupture in the rock. Dedicated, according to an inscription, to the Virgin the All-Holy Mother of God (Panagia Theotokos).

30

Ağaç Altï Kilisesi ("Church under the Tree"), Ihlara, Peristrema. [LV]

Lord Kinross, *Turkey* (New York, 1959), pl. 156 (erroneously named "Yilan Kilisse"); Thierry in *REB*, 19 (1961), pp. 432–434. Thierry, *NERC*, pp. 73–87, and pls. 38–43; Lafontaine-Dosogne in *Byzantion*, 33 (1963), 159–162 and fig. 35; Restle, 1, pp. 69–71, 172, and pls. 488–492.

Other names: église de Daniel (Lafontaine-Dosogne).

Plan: cruciform.

31

Yïlanlï Kilise ("Church of the Serpents"), Ihlara, Peristrema. [LVII]

A. M. Levidis, *Rock-cut Monasteries of Cappadocia and Lycaonia* (in Greek; Constantinople, 1899), p. 117; Rott, pp. 271–273; Lord Kinross, *Turkey,* pls. 155, 157, 158; Lafontaine-Dosogne in *Byzantion,* 28 (1958), 476–477 and ibid., 33 (1963), pp. 162–165 and fig. 36; Thierry in *Anatolia,* 5 (1960), pp. 159–168; Thierry in *REB,* 19 (1961), pp. 430–432; Thierry, *NERC,* pp. 89–114 and pls. 44–57; Restle, 1, pp. 69–70, 72–73, 173–174, and pls. 498–506; N. Thierry in *REB,* 26 (1968), pp. 351–352.

Earlier spellings: Jilanliklisse, Yilan Kilisse.

Plan: cruciform. Name derives from the picture of the Last Judgment, where four women are shown tangled by serpents.

32

Kokar Kilise ("Smelly Church"), Ihlara, Peristrema. [LII]

Thierry, *NERC,* pp. 115–136 and pls. 57–64; Lafontaine-Dosogne in *Byzantion,* 33 (1963), pp. 166–167 and fig. 37; Ch. Picard in *Revue archéologique,* (1965), pp. 101–102; Restle, 1, pp. 69–70, 72–73, 168–169, and pls. 474–482.

Plan: one-aisled basilica.

33

Pürenli Seki Kilisesi ("Church with the Terraces"), Ihlara, Peristrema. [LIV]

Thierry, *NERC,* 137–153, and pls. 65–70; Thierry in *REB,* 19 (1961), 434–435; Lafontaine-Dosogne in *Byzantion,* 33 (1963), 165–166; Restle, 1, pp. 69–73, 171, and pls. 483–487; Volbach and Lafontaine-Dosogne, *Byzanz,* pp. 173–174 and pl. 30.

Plan: two parallel naves, of which only the main nave (north) has painted program.

III
Transitional Phase
(about 950–1020)

34

Ballĭ Kilise ("Honeyed Church"), Peristrema

Lafontaine-Dosogne in *Byzantion,* 33 (1963), p. 159 and fig. 34.

Plan: two parallel naves, of which only the two apses of the main nave were painted. Figural program is superimposed on earlier aniconic decoration.

35

Köy Ensesi Kilisesi ("Church behind the Village"), Mamasun.

Levidis, *Rock-cut Monasteries* (in Greek), pp. 131–133; Thierry in *REB,* 19 (1961), 436; Thierry, *NERC,* p. 27 and pl. 10; Lafontaine-Dosogne in *Byzantion,* 33 (1963), pp. 177–178.

Plan: cross-in-square.

36

Sarĭca Kilise ("The Yellow Church"), Kepez, SE of Ortahisar. [XXXVII]

Rott, pp. 208–209; Lafontaine-Dosogne in *Cahiers,* 12 (1962), pp. 263–284; Restle, 1, pp. 150–151.

Earlier spellings: Saradschaklisse; Saredja Kilisse.

Plan: combines cross-in-square with triconch. Figural program is superimposed on earlier aniconic decoration. Dedicated to the Virgin? Names derives from the hue of the rock.

37

Kĭlĭçlar Kilisesi ("Church of the Swords"), Göreme. [XXIV]

Rott, pp. 234–236; Grégoire, pp. 88–89; Jerphanion, *ERC,* 1:1, pp. 199–242 and pls. 9, 33, 43, 44–58; Séféris, pp. 20–22 and 48, and pl. 50; Swoboda, 126; Restle 1, pp. 18–22, 25–27, 131–134, and pls. 251–278.

Earlier spelling: Qeledjlar.

Other names: Hemsbeyklisse (Rott); Göreme, Chapel 29 (Restle).

Plan: cross-in-square.

38

Great Pigeonhouse, Çavuşin. [XXVI]

Jerphanion, *ERC,* 1:2, pp. 520–550, and pls. 136, 138–142, 143; Lanfontaine-Dosogne in *Byzantion,* 33 (1963), 128–131 and figs. 6–8; Swoboda, p. 124; Restle, 1, pp. 30–36, 135–138, and pls. 302–329. Name is Jerphanion's: "Grand pigeonnier." It is now referred to in recent literature by the Turkish word for pigeonhouse: Kuşluk.

Plan: single nave with three apses. Inscription that mentions the emperor Nikephoros Phokas and his wife Theophano, as well as his brother Leo and their father Bardas Phokas, yields the date 964–965 for the painting program. Recently cleaned and opened to visitors.

39

Tokalï Kilise II, ("Boss Church"), Göreme. [X]
Jerphanion in *Revue archéologique,* 20 (1912), pp. 236–254; Jerphanion, *ERC,* 1:2, pp. 297–376, and pls. 70–94; E. Weigand in *BZ,* 35 (1935), pp. 131–135 and ibid., 36 (1936), pp. 337–397; Jerphanion in *OCP,* 2 (1936), pp. 191–222; Jerphanion in *OCP,* 3 (1937), 141–160; M. Hadzidakis in *Byzantion,* 14 (1939), pp. 95–113; Swoboda, pp. 125–126; R. Krautheimer, *Early Christian and Byzantine Architecture* (Baltimore, 1965), p. 281 and pl. 164b; Restle, pls. 98–123; Volbach and Lafontaine-Dosogne, *Byzanz,* p. 174, and pl. 31a. See also references given under Cat. no. 14. The later of two churches; transverse basilica. The paintings were restored at a later date, perhaps around 1300. Restle calls the original program "Tokalï IV" and its restored form "Tokalï VI."

39a

Chapel 16, Göreme. [XV]
Jerphanion, *ERC,* 1:2, pp. 492–495, and pls. 134.3, 135.2; Restle, 1, pp. 40, 55, 121–122, and pls. 155–159.
Plan: single nave with three apses; the northern half of the chapel is destroyed.

40

St. Barbara, Soğanlï Dere. [XLVI]
J. Strzygowski, *Kleinasien* (Leipzig, 1903), p. 151 (after J. I. Smirnov); Rott, pp. 145–148; Jerphanion in *Mélanges de l'Université de Beyrouth,* 6 (1913), pp. 382–385; Jerphanion, *ERC,* 2:1, pp. 307–332 and pls. 186–194, 202; Restle, 1, pp. 41–46, 160–161, and pl. 455.
Other names: Tahtalï Kilise ("Timber Church"). Main one of two parallel naves has figural program which is dated by inscription to reign of Constantine VIII and Basil II, probably 1006 or 1021.

IV
Middle Byzantine Phase
(about 1020-1130)

41

Direkli Kilise ("Pillared Church"), Peristrema. [LXII]
Lafontaine-Dosogne in *Byzantion,* 28 (1958), 473-475; Thierry in *REB,* 19 (1961), 426-427;
Thierry, *NERC,* pp. 183-192 and pls. 82-89; Restle, 1, pp. 42-43, 46-47, 178-179, and pls. 521-522;
Volbach and Lafontaine-Dosogne, *Byzanz,* p. 174, and pl. 32.
Plan: cross-in-square. Painting program dated by inscription to reign of Constantine VIII and
Basil II, 976-1025.

42

Ala Kilise ("The Mottled Church"), Peristrema. [LXIII]
Ramsay Bell, fig. 348 on p. 451; Thierry in *REB,* 19 (1961), pp. 423-426; Lafontaine-Dosogne in
Byzantion, 33 (1963), 142-143; Thierry, *NERC,* pp. 193-200 and pls. 90-92; Restle, 1, pp. 179-180.
Plan: cross-in-square.

43

Sümbüllü Kilise ("The Church with the Lilies"), Peristrema. [LVI]
Rott, pp. 274-275; Lafontaine-Dosogne in *Byzantion,* 28 (1958), 476 (mistakenly called Eski Hoca
Altĭ Kilisesi) and *Byzantion,* 33 (1963), pp. 158-159 and fig. 33; Thierry in *REB* 19 (1961), 429-430;
Thierry, *NERC,* pp. 175-181 and pls. 78-82; Restle, 1, pp. 172-173 and pls. 493-497.
Plan: irregular; a domed single nave with additions.

44

Cambazlĭ Kilise ("Church of the Acrobat"). Orthahisar. [XXXVIII]
N. and M. Thierry in *Journal des Savants* (1963), pp. 5-23; Restle, 1, pp. 65-66, 151-152.
Other names: Aşağĭbağ Kilisesi ("Church of the Lower Vineyard").
Plan: cross-in-square. Figural program is superimposed on earlier aniconic decoration. Lafon-
taine-Dosogne's suggestion (*BZ,* 58 [1965], p. 132, n. 3a) that the figural program dates rather
in the 13th century seems unjustified.

45

Chapel of Daniel (Chapel 10), Göreme.
Rott, pp. 232-233; Grégoire, p. 85; Jerphanion, *ERC,* 1:1, pp. 171-176 and pls. 39, 43.
Other names: chapel next to Katyrdschamy (Rott; his spelling for Katĭrcĭ Cami).
Plan: one-aisled basilica. Name is based on large image of Daniel facing the entrance.

46

Geyik Kilise ("Church with the Hart"), Soğanlĭ Dere. [L]
Strzygowsky, *Kleinasien,* pp. 203-204 (after J. I. Smirnov); Rott, pp. 144-145; Jerphanion, *ERC,*

2:1, pp. 369–372, and pls. 25, 200, 201. Restle, 1, pp. 166–167, and pl. 467.

Earlier spelling: Gueik Kilissé.

Other names: Chapel of St. Eustathios (Rott); Gök Kilise (Restle).

Plan: two parallel naves. Name derives from picture of St. Eustathios chasing the hart.

47

Kuzey Anbar Kilisesi ("Church of the North Warehouse"), Ihlara.

J. Lafontaine-Dosogne in *Byzantion,* 33 (1963), p. 53; N. Thierry in *Journal des Savants* (1968), pp. 45–61.

Other names: Uzun Ağıl Monastır.

Plan: One-aisled basilica. Archaic program superseded by a second coat of painted decoration. An inscription pertaining to the latter gives dedication (to St. Michael), donor ("Arsenios the monk"), and date ("in the reign of . . . Porphyrogenitos," most likely Constantine VIII [1025–1028] or Theodora [1055–1056]).

48

Church at Ayvalı Köy, near Ürgüp. [LXXVIII]

N. Thierry in *Journal des Savants* (1965), pp. 633–635; Restle, 1, p. 193.

Plan: one-aisled basilica.

49

Church at Eski Gümüs, near Niğde. [LXIV]

Grégoire, pp. 132–135; G. Jacopi in *Bollettino del reale istituto di archeologia e storia dell'arte* 8:1 (1938), p. 20 and fig. 68; M. Gough in *Illustrated London News,* 244 (1964), pp. 50–53; idem in *Anatolian Studies,* 14 (1964), pp. 147–161, and 15 (1965), pp. 157–164; idem in *Archaeology,* 18 (1965), 154–163; Restle, 1, pp. 180–181.

Plan: cross-in-square. According to Gough the paintings of north wall are from the middle of the 11th century, and those in the apse in the later 12th century. The latter date should be moved backward by at least fifty years.

50

Karabaş Kilise ("Church of the Black Head"), Soğanlı Dere. [XLVIII]

Rott, pp. 135–139; Séféris, pp. 33–34, and pl. 32; Grégoire, pp. 95–101; Jerphanion, *ERC,* 2:1, pp. 33–60, and pls. 195–205; Lafontaine-Dosogne in *Byzantion,* 33 (1963), figs. 13–14; Thierry in *Corsi,* 12 (1965), 597; Thierry in *Cahiers,* 17 (1967), pp. 165–175; Restle, 1, pp. 46–52, 162–164, and pls. 456–464; Volbach and Lafontaine-Dosogne, *Byzanz,* p. 174 and pl. 31b.

Earlier spellings: Karabaschklisse; Qarabach Kilissé. Painting program is in the main one of four adjacent naves; it is superimposed on two earlier programs of which little can be seen, and is dated by inscription to 1060/61 in the reign of the emperor Constantin Dukas.

51

Kuşluk near Kılıçlar Kilisesi, Göreme. [XXV]
Jerphanion, *ERC,* 1:1, pp. 243–253, and pls. 42, 43, 59–60; P. L. Fermor in *Horizon,* 6 (Winter 1964),
pp. 68–69 (colored plate of interior); Restle, 1, pp. 134–135, and pls. 279–301.
Other names: Göreme, chapel 33 (Restle).
Plan: single nave but culminating in two parallel barrel vaults.

52

Chapel 28, near Karanlık Kilise, Göreme. [XXIII]
Jerphanion, *ERC,* 1:2, pp. 481–483, and pls. 12, 133–135; Séféris, pp. 18–19, and pls. 29–30; Budde,
p. 15, and pls. 52, 54–55; Lord Kinross, *Turkey,* pl. 151 (erroneously named "Ouva Kilisse");
Swoboda, p. 125; Restle, 1, pp. 130–131, and pls. 245–250.
Other names: Chapel of St. Onuphrios (Séféris).
Plan: one-aisled basilica.

53

Saklı Kilise ("The Hidden Church"), near Ortahisar. [II]
M. S. Ipşiroğlu and S. Eyuboğlu, *Saklı Kilise* (Istanbul 1958); Budde, pp. 21–26 and pls. 78–96;
Budde in *Pantheon,* 19 (1961), pp. 263–271; Swoboda, pp. 122 and 125; Restle, 1, pp. 50–52,
103–105, and pls. 21–44.
Other names: Church of St. John (Budde); Göreme, Chapel 2a (Restle). Discovered in 1957.
Plan: irregular. Figural program is superimposed on earlier aniconic decoration. Budde dates
figural program to late 10th–11th centuries; Restle to the second half of the 11th century;
Ipşiroğlu-Eyuboğlu to 12th–13th centuries.

54

Triconch Church, Tağar. [XXXV]
Jerphanion, *ERC,* 2:1, pp. 187–205, and pls. 164–172; Holzmeister/Fahrner, pp. 29–30; Lafon-
taine-Dosogne in *Byzantion,* 33 (1963), 132–133; Restle, 1, pp. 53–56, 146–148, and pls. 355–373.
Painting program left incomplete by one painter, and reworked and completed by a second,
probably of the same school.

55

Yusuf Koç Kilisesi, near Maçan. [LXXVII]
N. Thierry in *Journal des Savants* (1965), pp. 630–633, and in *Information d'histoire de l'art,*
14 (1969) pp. 12–13, Restle, 1, pp. 192–193. So named after its present owner, Yusuf Koç.
Plan: irregular cross-in-square.

56

St. Barbara, Göreme. [XIX]

Jerphanion, *ERC,* 1:2, pp. 484–486 and pl. 133; Holzmeister-Fahrner, pls. 38–40; Budde, p. 15, and pls. 51, 53; Lord Kinross, *Turkey,* pls. 148–149 (erroneously named "The Church of Eve, Ouva Kilisse"); D. Wood in *Archaeology,* 12 (1959), pp. 38–46; Restle, 1, p. 126.
Other names: Göreme, chapel 20 (Restle).
Plan: cross-in-square; carved in the same rock as the following church. Over a painted decoration of military standards of later 11th–early 12th century date, one or two figural compositions.

57
Elmalĭ Kilise ("Church of the Apple-Tree"), Göreme. [XVIII]
Rott, pp. 220–221, Jerphanion in *Revue Archéologique,* 12 (1908), pp. 18–32; Grégoire, pp. 86–87; Jerphanion, *ERC,* 1:2, pp. 431–454 and pls. 95, 112–124, 135; Séféris, pp. 25, 47–48, and pls. 46–48; Budde, pp. 20–21 and pls. 70–76; Lord Kinross, *Turkey,* pls. 152–154; Krautheimer, *Early Christian and Byzantine Architecture,* p. 281, and pl. 165; Restle, 1, pp. 56–63, 124–125, and pls. 160–192.
Earlier spellings: Elmalyklisse; Elmale Kilissé.
Other names: Chapel of the Ascension; Göreme, chapel 19 (Restle).
Plan: cross-in-square. Figural program is superimposed on earlier aniconic decoration.

58
Çarĭklĭ Kilise ("Church of the Sandals"), Göreme. [XXI]
Rott, pp. 216–219; Grégoire, p. 85; Jerphanion, *ERC,* 1:2, 455–473, and pls. 95, 111, 112, 125–132; Séféris, p. 26, and pl. 49; Budde, p. 20, and pl. 77; Restle, 1, pp. 56–61, 127–128, and pls. 193–217.
Earlier spelling: Tschariklisse.
Other names: Göreme, chapel 22 (Restle).
Plan: cross-in-square. Name derives from two imprints of footsteps cut in the floor of the south arm under a picture of the Ascension. Vestibule, now mostly destroyed, had aniconic decoration.

59
Karanlĭk Kilise ("The Dark Church"), Göreme. [XXII]
Rott, pp. 212–216; Grégoire, p. 86; Jerphanion, *ERC,* 1:2, pp. 393–430, and pls. 95–112; Séféris, 25, 45–47, and pls. 40–45; Budde, pp. 16–20, and pls. 56–69; Lord Kinross, *Turkey,* pls. 144–147; Fermor in *Horizon,* 6 (Winter 1964), p. 70 (photograph of interior) and p. 73 (colored plate of interior); Restle, 1, pp. 56–58, 63–64, 129–130, and pls. 218–244; Volbach and Lafontaine-Dosogne, *Byzanz,* p. 175, and pl. 33.
Other names: Analipsis or Peleme (Rott); Göreme, chapel 23 (Restle).
Plan: cross-in-square.

V
Late Byzantine Phase
(from late 12th century)

60

Bezir Ana Kilisesi ("Church of the Bezir's Mother"), Peristrema. [LIX]
Lafontaine-Dosogne in *Byzantion,* 33 (1963), 154–155 and fig. 31; Restle, 1, pp. 175–176.
Plan: one-aisled basilica. Paintings probably date from end of 12th or early 13th centuries.

61 [LI]

Karşĭ Kilise ("The Church across the Way"), Arabsun (the Greek Zoropassos, now Gülşehir).
Oberhummer-Zimmerer, p. 145; Rott, pp. 245–246; Jerphanion, *ERC,* 2:1, pp. 1–16, and pls. 145–146; Lafontaine-Dosogne in *Byzantion,* 33 (1963), 123–127, figs. 2–4; Restle, 1, pp. 167–168, and pls. 468–473.
Earlier spellings: Karschiklisse; Qarche Kilissé.
Other names: St. Michael (Oberhümmer-Zimmerer); Church of the Taxiarchs (Rott); "Saint Juan" according to a current official sign. Two superimposed churches, of which the upper has figural program precisely dated by inscription to 25 April 1212 in the reign of the emperor Theodore Laskaris.

62

Church of the Forty Martyrs, near Suveş (ancient Sobesos; now Şahinefendi). [XLV]
Jerphanion, *ERC,* 2:1, pp. 156–174, and pls. 161–164; Lafontaine-Dosogne in *Byzantion,* 33 (1963), 136–137 and fig. 19; Thierry in *Corsi,* 12 (1965), fig. 6 on p. 599; Restle, 1, pp. 64–66, 158–160, and pls. 414–432.
Plan: two parallel naves, both painted. An inscription gives the dedication, the date (1216–1217), and the name of the painter (Etios). These figural programs are superimposed on an earlier largely aniconic decoration. A small number of figural panels, notably the Crucifixion in the large niche of the north wall, belongs to a third layer.

63

Church of the Stratilates (Sts. George and Theodore), Mavrucan (now Güzelöz).
Jerphanion, *ERC,* 2:1, pp. 236–237. Fragmentary painting program dated by inscription to 1256–1257.

64

Kĭrk Dam Altĭ Kilisesi ("Church of the Forty Roofs"), Peristrema. [LX]
Lafontaine-Dosogne in *Byzantion,* 32 (1962), 251–259, and ibid., 33 (1963), 148–154 and figs. 27–30; Thierry, *NERC,* 200–213, and pls. 93–100; Restle, 1, pp. 176–177, and pls. 510–516; V. Laurent in *REB,* 26 (1968), 367–371.
Plan: one-aisled basilica. An inscription gives dedication (to St. George), names of donors, and date (in the reign of the emperor Andronikos II Paleologos and Sultan Mas'ud II, i.e., ca. 1283–1295).

65

Chapel of the Archangelos, monastery of the Archangelos, near Cemil. [XLII]
Jerphanion, *ERC,* 2:1, pp. 128–145 and pls. 156–158, 160; Restle, 1, p. 156.
Plan: two parallel naves with paintings from several different periods; some may date in the 13th
century, some others in the 14th century.

66

Canavar Kilise ("The Church with Dragon"), Soğanlï Dere. [XLIX]
Rott, pp. 143–144; Grégoire, pp. 101–104; Jerphanion, *ERC,* 2:1, pp. 361–368 and pls. 206–208;
Lafontaine-Dosogne in *Byzantion,* 33 (1963), 133; Restle, 1, pp. 164–166 and pls. 465–467.
Earlier spellings: Tschanavarklisse; Djanavar Kilissé. Name derives from picture of St. George
killing the dragon.
Plan: two parallel naves with paintings from several periods. Paintings of north nave now com-
pletely destroyed; paintings of south nave (a vast Last Judgment) are dated to early 13th century
by Jerphanion, to 15th–16th centuries by Lafontaine-Dosogne. The latter date is more plausible.

Bibliographical Note

The following descriptive bibliography includes only those books and articles that are directly pertinent, wholly or in part, to the subject of this book, that is, Byzantine Cappadocia. It is not meant to cover Cappadocia in general. Comparative or supplementary material has been cited in the Notes and is not repeated here. The entries are grouped around topics, in preference to listing them without comment either chronologically or alphabetically by author. Under each topic, however, the listing is chronological.

Geology

The most useful, technical accounts are
1
W. J. Hamilton, "On the Geology of Part of Asia Minor, between the Salt Lake of Kodj-Hissar and Caesarea of Cappadocia," *Transactions of the Geological Society of London,* series II, vol. 5 (1840), pp. 583–597.
2
W. Belck, "Die sogenannte Troglodyten-Landschaft westlich von Caesarea-Kaisarieh," *Berliner Gesellschaft für Anthropologie, Ethnologie und Urgeschichte* 33 (1901), 505–522; part of a longer travel piece on Anatolia.
3
G. Bartsch, "Über Tuffkegelbildung in der Ausraumungslandschaft von Ürgüp in Mittelanatolien," *Zeitschrift der Gesellschaft für Erdkunde zu Berlin* (1936), pp. 1–11; brought up to date in, "Die mittelanatolische Tufflandschaft um Ürgüp und Nevschehir," *Landschaft und Land, Festschrift Erich Obst* (Remagen, 1951), pp. 38–49.

History and Geography

Though details have been revised since, W. M. Ramsay's *The Historical Geography of Asia Minor* (London, 1886–1893) remains the best historical atlas for central Anatolia. The most reliable modern survey map for the region is that prepared by the British War Office, Geographical Section, 1941 ff. (reprinted by the United States Army Map Service).

Two historical accounts in modern Greek, by local authors, are still of use: N. S. Rhizos, *Kappadokika* (Constantinople, 1856); B. A. M. Mystakides, "Kappadokika," *Parnassos,* 15 (1893), pp. 368–379, 445–458, 600–615. Both deal, most specifically, with Caesarea and environs.

For a general historical summary of Cappadocia, see the entry "Cappadocia" by E. Kirsten in

Reallexikon für Antike und Christentum, 2 (Stuttgart, 1954), col. 861 ff. See also note 11 of Part 1 for bibliography on Roman Cappadocia.

Travel Pieces and Surveys

A comprehensive annotated list of travel pieces by some fifty authors, from Paul Lucas in 1712 up to World War II, will be found in Jerphanion, *ERC,* 1:1, pp. xxxiii–xlviii. It is unnecessary to reproduce it here, specially since most of the entries have little or no direct reference to the churches and monasteries. This list should now be brought up to the present, as follows:

1

J. R. Sterrett, "The Cone Dwellers of Asia Minor," *National Geographic Magazine,* 35 (1919), pp. 281–330.

2

G. Jacopi, "Esplorazioni e studi in Paflagonia e Cappadocia," *Bollettino del reale istituto di archeologia e storia dell'arte,* 8:1 (1938), pp. 3–43.

3

J. D. Whiting, "Where Early Christians Lived in Rock Caverns," *National Geographic Magazine,* 76 (1939), 763–802.

4

A. Costa, photographs of the troglodytic landscape, *Architectural Review,* 101 (February 1947), p. 70.

5

P. L. Fermor, *A Time to Keep Silence* (London, 1953), pp. 75–84; reprinted as "The Rock Monasteries of Cappadocia," in *Horizon,* 6 (Winter 1964), pp. 66–73.

6

G. Séféris, *Trois jours dans les églises rupestres de Cappadoce* (Athens, 1953); brief but sensitive impressions.

7

C. and G. Holzmeister, and R. Fahrner, *Bilder aus Anatolien: Höhlen und Hane in Kappadokien* (Vienna, 1955); English version: *The Face of Anatolia;* a picture book.

8

"Cappadocia, the Moon on Earth," unsigned article in *Réalités* (November 1956), pp. 38–43.

9

M. Beck, *Anatolien: Gedanken und Beobachtungen von Fahrten in die Levante* (Zurich–Stuttgart, 1956) pp. 49–59 and figs. 8–10; pleasant generalities.

10

M. B. Grosvenor, "Cappadocia," *National Geographic Magazine,* 113 (1958), pp. 122–146.
11

"The Exploring Eye," *Architectural Review,* 124 (1958), 237–239; photographs. Also ibid., 135 (1964), pp. 261–263.
12

W. F. Volbach and J. Lafontaine-Dosogne, *Byzanz und der Christliche Osten,* Propyläen Kunstgeschichte 3 (Berlin, 1968); several good photographs of paintings.

Archaeology

The earliest attempt to record the troglodytic monuments was made by a local Greek academic, A. M. Levidis, *Rockcut Monasteries of Cappadocia and Lycaonia,* in Greek (Constantinople, 1899). The book is not available in this country; it is apparently surprisingly unreliable. The first archaeological account by an outsider is H. Rott, *Kleinasiatische Denkmäler aus Pisidien, Pamphylien, Kappadokien und Lykien,* Studien über christliche Denkmäler 5/6 (Leipzig, 1908), pp. 81–294; a careful, observant commentary that is still indispensable today. A year later H. Grégoire covered much of the same ground in "Rapport sur un voyage d'exploration dans le Pont et en Cappadoce," *BCH,* 33 (1909), pp. 1–170; these are brief notes, mostly epigraphical, complementing Rott's descriptions.

 In the next three decades these preliminary explorations were consolidated and published in great detail by Guillaume de Jerphanion. After several tentative reports (for which see *ERC,* 1:1, pp. xlv–xlvii), the authoritative presentation appeared as follows: *Une nouvelle province de l'art byzantin. Les églises rupestres de Cappadoce,* two volumes of text and three of plates (Paris, 1925–1942. Text: vol. 1, part 1, 1925; 1:2, 1932; vol. 2, part 1, 1936; 2:2, 1942. Plates: 1, 1925; 2, 1928; 3, 1934). The area covered is eastern Cappadocia; the arrangement of the monuments is topographical, beginning with Göreme, and not chronological. During its lengthy publication, this magisterial work was summarized and commented on by several prominent Byzantinists, among whom I note C. Diehl, "Les peintures chrétiennes de la Cappadoce," *Journal des Savants* (1927), pp. 97–109; L. Bréhier, "Les églises rupestres de Cappadoce et leur temoignage," *Revue archéologique* (1927), pp. 1–47; and idem, "Les peintures cappadociennes de l'époque pré-iconoclaste au XIV siècle," *Revue archéologique* (1935), pp. 236–253. Jerphanion himself summarized his studies in *Bulletin de la commission monumentale historique de Roumanie,* 27 (1934, appeared 1936). A picture book by L. Budde, *Göreme, Höhlenkirchen in Kappadokien* (Düsseldorf, 1958), deals briefly with this same material, except for the inclusion

of Saklĭ Kilise (Cat. no. 53), unknown to Jerphanion; the photographs, by V. Schamoni, are excellent.

In the last decade newly discovered churches significantly enlarged the corpus of the early archaeologists. The relevant publications are the following:

1

N. and M. Thierry, "Église de Kizil Tchoukour, chapelle iconoclaste, chapelle de Joachim et Anne," *Monuments Piot,* 50 (1958), pp. 105–146; on Cat. nos. 6 and 13.

2

M. S. Ipşiroğlu and S. Eyuboğlu, *Saklĭ Kilise* (Istanbul, 1958), in Turkish and French; on Cat. no. 53.

3

J. Lafontaine, "Note sur un voyage en Cappadoce (été 1959)," *Byzantion,* 28 (1959), pp. 465–477; a brief review of the troglodytic territory, with observations of the present state of the known churches and the introduction of new ones, specially in western Cappadocia.

4

Ch. Delvoye, "Chronique archéologique. Découvertes en Cappadoce," *Byzantion,* 29–30 (1959–1960), pp. 334–338; insignificant; a report on the activity of the scholars mentioned in 1–3 of this section.

5

N. and M. Thierry, "L'église de Jugement Dernier à Ihlara, Yĭlanlĭ Kilise," *Anatolia,* 5 (1960), pp. 159–168; on Cat. no. 31.

6

L. Budde, "Die Johanneskirche von Göreme," *Pantheon,* 19 (1961), pp. 263–271; on Cat. no. 53.

7

N. and M. Thierry, "Voyage archéologique en Cappadoce, dans le massif volcanique du Hasan Dağ," *REB,* 19 (1961), pp. 419–437; a preview of their book (see 9).

8

J. Lafontaine, "Sarĭca Kilise en Cappadoce," *Cahiers,* 12 (1962), pp. 263–284; on Cat. no. 36.

9

N. and M. Thierry, *Nouvelles églises rupestres de Cappadoce. Région du Hasan Dağĭ* (Paris, 1963); a detailed presentation of the churches in the valley of Peristrema. See the review by J. Lafontaine-Dosogne in *BZ,* 58 (1965), pp. 131–136.

10

J. Lafontaine-Dosogne, "Nouvelles notes cappadociennes," *Byzantion,* 33 (1963), pp. 121–183; a more extended discussion of the material in 8, with a useful group of new photographs.

11

N. and M. Thierry, "Une nouvelle église rupestre de Cappadoce: Cambazlĭ Kilise à Ortahisar," *Journal des Savants* (1963), pp. 5–23; on Cat. no. 44.

12

N. and M. Thierry, "Haçlĭ Kilise, l'église à la croix en Cappadoce," *Journal des Savants* (1964), pp. 241–254; on Cat. no. 5.

13

M. Gough, "The Monastery of Eski Gümüş—A Preliminary Report," *Anatolian Studies,* 14 (1964), pp. 147–161; and idem, "The Monastery of Eski Gümüş—Second Preliminary Report," *Anatolian Studies,* 15 (1965), 157–164; on Cat. no. 49. Summary treatment of the same church by Gough in *Illustrated London News,* 244 (1964), pp. 50–53; and *Archaeology,* 18 (1965), pp. 254–263.

14

J. Lafontaine-Dosogne, "L'église aux trois croix de Güllü Dere en Cappadoce et le problème du passage du décor 'iconoclaste' au décor figuré," *Byzantion,* 35 (1965), pp. 175–207; on Cat. no. 8.

15

N. Thierry, "Quelques églises inédites en Cappadoce," *Journal des Savants* (1965), pp. 625–635; on Cat. nos. 22, 48, 55 and on a three-aisled basilica called Durmuş Kilisesi.

16

N. and M. Thierry, "Ayvalĭ Kilise, ou pigeonnier de Gülli Dere: église inédite de Cappadoce," *Cahiers,* 15 (1965), pp. 97–154; on Cat. no. 16.

17

N. Thierry, "Églises rupestres de Cappadoce," *Corsi,* 12 (1965), pp. 579–602; an attempt at a contemporary summation of the subject.

18

G. P. Schiemenz, "Eine unbekannte Felsenkirche in Göreme," *BZ,* 59 (1966), pp. 307–333; on Cat. no. 15.

19

N. Thierry, "Peintures paléochrétiennes en Cappadoce. L'église no. 1 de Balkan [sic] Dere," *Synthronon* (Paris, 1968), pp. 53–59; on Cat. no. 1.

20

N. Thierry, "Un décor pré-iconoclaste de Cappadoce: Açïkel Ağa Kilisesi (Église de l'Ağa à la main ouverte)," *Cahiers,* 18 (1968), pp. 33–69; on Cat. no. 7.

21

G. P. Schiemenz, "Verschollene Malereien in Göreme: Die Archaische Kapelle bei Elmali Kilise und die Muttergottes zwischen Engeln," *OCP,* 34, fasc. 1 (1968), pp. 70–96; on Cat. no. 22.

22

G. P. Schiemenz, "Die Kapelle des Styliten Niketas in den Weinbergen von Ortahisar," *Jahrbuch der österreichische Byzantinische Gesellschaft,* 18 (1969), 239–258; on Cat. no. 7.

An unpublished thesis by N. Thierry, "Monuments inédits des régions de Göreme et Mavrucan; notion de centres ruraux et monastiques en Cappadoce rupestre" (Thèse du IIIe cycle, Sorbonne, 1968) was unavailable to me. A summary of the thesis has been published, however: "Quelques monuments inédits ou mal connus de Cappadoce. Centres de Maçan, Çavuşin et Mavrucan," *Information d'histoire de l'art,* 14 (1969), pp. 7-17.

Architecture

In addition to those reports where architectural descriptions of the monuments in question will be found, the following deal with specific problems of Cappadocian building.

1

J. I. Smirnov, "Die Höhlenbauten Kappadokiens," in J. Strzygowski, *Kleinasien* (Leipzig, 1903) pp. 149–153; brief comments on the monastery of Ayvalï Kilise, Chapel 21 at Göreme, etc.

2

P. Verzone, "Gli monasteri de Acik Serai in Cappadocia," *Cahiers* 13 (1962), pp. 119–136; a discussion of rockcut facades.

3

M. Charney, "Troglai: Architecture troglodyte en Cappadoce," *Vie des arts* (Spring 1964), pp. 46–52.

Iconography

In addition to the archaeological reports that include discussion of iconography, there have been a number of articles dealing specifically with selected iconographic problems. Most of these are by Jerphanion: on the pictorial cycle of St. Basil; on saints and their attributes: on the

magic square, SATOR/AREPO; on St. Simeon the Stylite; on the "thorakion," etc. All these papers have been collected in *Voix des monuments,* vol. 1 (Paris–Brussels, 1930); vol. 2 (Paris–Rome, 1938). More recently have appeared the following:

1

N. and M. Thierry, "Iconographie inédite en Cappadoce: le cycle de la conception et de l'enfance de la Vierge à Kĭzĭl-Tchoukour," *Acts of the 11th International Conference of Byzantinists,* 1958 (Munich, 1960), pp. 620–623; on a Marianic sequence in Cat. no. 13.

2

J. Lafontaine-Dosogne, "Un thème iconographique peu connu: Marina assommant Belzébuth," *Byzantion,* 32 (1962), 251–259; on a scene in Cat. no. 64.

3

N. Thierry and A. Tenenbaum, "Le Cénacle apostolique à Kokar Kilise et à Ayvalĭ Kilise," *Journal des Savants* (1963), pp. 228–241). (Cat. nos. 32 and 16.)

4

D. Wood, *Leo VI's Concept of Divine Monarchy* (London, 1964); a new interpretation of the painting program of Tokalĭ, Cat. no. 14. See text, Part 2.

5

J. Lafontaine-Dosogne, "Théophanies-visions auxquelles participant les prophètes dans l'art byzantin après la restauration des images," *Synthronon* (Paris, 1968), pp. 135–143. Discusses the iconography of apocalyptic vision in the painting programs of Cat. nos. 8, 12, 16, 17.

Problems of Date and Style

The chronological order developed for the painting programs by Jerphanion was first questioned by E. Weigand in a review of *ERC,* 1:2, in *BZ,* 35 (1935), pp. 131–135, where he proposed a fourteenth-century date for Tokalĭ II. Jerphanion defended his own chronology in "La date des plus récentes peintures de Toqalé Kilissé en Cappadoce," *OCP,* 2 (1936), pp. 191–222. Weigand's lengthy rebuttal followed immediately: "Zur Datierung der kappadokischen Höhlenmalereien," *BZ,* 36 (1936), pp. 337–397. (Cf. Part 3, n. 47.) Jerphanion rejected these new arguments in "Sur une question de méthode: à propos de la datation des peintures cappadociennes," *OCP,* 3 (1937), 141–160. Weigand's case was further weakened in an article by M. Hadzidakis, "A propos d'une nouvelle manière de dater les peintures de Cappadoce," *Byzantion,* 14 (1939), pp. 95–113. The only Byzantine scholar to support Weigand has been A. M. Schneider (*BZ,* 45 [1952], pp. 96–97).

In recent years Jerphanion's dates began to be revised in a more reasonable and measured way. Brief suggestions, without adequate argument to support them, were made by K. M. Swoboda in a review of recent Byzantine scholarship, "In den Jahren 1950 bis 1961 erschienene Werke zur byzantinischen und weiteren ostchristlichen Kunst," *Kunstgeschichtliche Anzeigen,* 5 (1961-1962), pp. 9-183. N. and M. Thierry and J. Lafontaine-Dosogne have also proposed some adjustments to Jerphanion's chronology in the various publications listed under Section 4, "Archaeology." See in addition a convenient new summary of this shifting chronology by N. Thierry, "Les peintures de Cappadoce de la fin de l'Iconoclasme à l'invasion turque (843-1082)," *Revue de l'Université de Bruxelles,* 19 (1966-1967), pp. 136-163; a stylistic study of the paintings of Karabaş Kilise, also by N. Thierry, "Étude stylistique des peintures de Karabaş Kilise en Cappadoce (1060-1061)," *Cahiers,* 17 (1967), pp. 161-175; and a stylistic analysis of the paintings of Kuzey Anbar Kilisesi (Cat. no. 47), "Un style byzantin schématique de Cappadoce daté du *XIe* siècle d'après une inscription," *Journal des Savants* (1968), pp. 45-61. The chronology and style of the Archaic group of churches in Jerphanion's system has been the topic of a recent London Ph.D. thesis by Robin Cormack; its results are published by the author in "Byzantine Cappadocia: The Archaic Group of Wall Paintings," *Journal of the British Archaeological Association,* 3:30 (1967), pp. 19-36.

By far the most ambitious review of Jerphanion's chronology is the recent work by M. Restle, *Byzantine Wall Painting in Asia Minor* (New York, 1967; published simultaneously in a German edition, *Die byzantinische Wandmalerei in Kleinasien,* Recklinghausen, 1967). Restle disputes the Iconoclast character of St. Basil and St. Stephen (Cat. nos. 3 and 4), and Chapel 3 at Göreme; claims for Kīlīçlar Kilisesi a place as the earliest extant picture cycle in Cappadocia, ascribing to it a date ca. 900; argues for the Ihlara cycle (Cat. nos. 29-33) the general date of the eleventh century, with Ağaç Altī and Pürenli Seki in the first half, and Eğri Taş, Kokar, and Yīlanlī in the latter half; and, finally, for the cross-in-squares of Göreme (Cat. nos. 57-59), he proposes a date in the later twelfth century. These and other revisions put forward in the book are based on comparative style analysis and on a thorough examination of plaster layers, painting techniques, binding media, and the like. The argument is unhappily at the mercy of a misguided scientificism which, more often than not, defeats common sense. See my review in the *Art Bulletin,* 52 (1970), pp. 88-94; also reviews by N. Thierry in *REB,* 26 (1968), pp. 362-366, and O. Demus in *Jahrbuch der österreichische byzantinische Gesellschaft,* 18 (1969), pp. 291-293.

Epigraphy

Inscriptions are recorded and commented on in the archaeological reports of Section 4,

"Archaeology." The following are articles dealing with special problems of Cappadocian epigraphy:

1

H. Grégoire, "Notes épigraphiques, VIII, Saint Georges le Diasorite," *Revue de l'instruction publique en Belgique,* 52 (1909), 1-3; on an inscription in the constructed triconch of Ortaköy.

2

H. Grégoire, "Notes épigraphiques, XIV, Une épigramme de saint Grégoire le Nazianze," ibid., pp. 164-166; on an inscription in the church of the Holy Apostles at Sinassos, Cat. no. 17.

3

G. Millet, "Les iconoclastes et la croix. A propos d'une inscription de Cappadoce," *BCH,* 34 (1910) pp. 96-109; the inscription in question is in Cat. no. 3.

4

H. Grégoire, "Notes épigraphiques. VII, Mélias le Magistre," *Byzantion,* 8 (1933), pp. 79-88; on an inscription in Cat. no. 38. See text, Part 1, p. 28.

5

G. de Jerphanion, "Les inscriptions cappadociennes et l'histoire de l'empire grec de Nicée," *OCP,* 1 (1935), pp. 239-256. See Part 1, note 42.

Ornament

D. Wood, "Byzantine Military Standards in a Cappadocian Church," *Archaeology,* 12 (1959), pp. 38-46; on the nonfigural designs in Cat. no. 56.

Index